Spirit and Ancestor

Thomas Burke Memorial Washington State Museum Monograph 4

Spirit and Ancestor

A Century of Northwest Coast Indian Art at the Burke Museum

BILL HOLM

Photographs by Eduardo Calderón

Burke Museum *Seattle*

University of Washington Press *Seattle and London*

Composition by University of Washington, Department of Printing
Printed and bound by Toppan Printing Company, Tokyo, Japan
Designed by Audrey Meyer

Publication of this work was made possible by a grant from the National Endowment for the Arts, and
by a generous contribution from Mr. John Hauberg.

Library of Congress Cataloging-in-Publication Data

Holm, Bill, 1925–
 Spirit and ancestor.

 (Thomas Burke Memorial Washington State Museum monograph; 4)
 Bibliography: p.
 Includes index.
 1. Indians of North America—Northwest coast of North America—Art—Catalogs. 2. Thomas Burke
Memorial Washington State Museum—Catalogs.
 I. Calderón, Eduardo. II. Thomas Burke Memorial Washington State Museum. III. Title. IV. Series.
 E78.N78H63 1987 704'.03970795 87-8298
 ISBN 0–295–96509–6 (cloth)
 0–295–96510–X (paper)

58,898

Burke Museum Publications Program

Dr. Patrick V. Kirch, Director
Dr. Susan D. Libonati-Barnes, Editor
Jenifer Young, Editorial Associate

Thomas Burke Memorial Washington State Museum Monographs

1. *Northwest Coast Indian Art: An Analysis of Form,*
 by Bill Holm
2. *Edward S. Curtis in the Land of the War Canoes: A Pioneer Cinematographer in the Pacific Northwest,*
 by Bill Holm and George Irving Quimby
3. *Smoky-Top: The Art and Times of Willie Seaweed,* by Bill Holm
4. *Spirit and Ancestor: A Century of Northwest Coast Indian Art at the Burke Museum,* by Bill Holm
 with photographs by Eduardo Calderón

Cloth stamping design: sea lion motif from Haida dance tunic (no. 57).

Contents

Foreword

In 1985–86, the Burke Museum celebrated its first century of endeavor as a natural history institution dedicated to preserving and understanding the cultural legacy of Pacific Rim peoples and their natural environments. Mindful that a centennial provides opportunities both to mark past accomplishments and to reaffirm longstanding commitments, we seized on the idea of publishing a selection of the museum's finest pieces of Northwest Coast Indian art and material culture. Such a volume would be a tribute not only to the artistically rich cultures represented by these tangible symbols, but to the foresight and years of effort that went into building the Burke Museum's present Northwest Coast collection. As a lasting record to be used by scholars and students for years to come, such a catalogue of the Burke Museum's collection would also signal the museum's continuing commitment to preserving and interpreting the cultural heritage of the Pacific Northwest.

When the concept of a lavishly illustrated catalogue of selected Northwest Coast pieces was first suggested to me by Eduardo Calderón, there was no difficulty in deciding who must not only select the hundred key artifacts from among the museum's eight thousand Northwest Coast specimens, but also author the text that would complement the photo essay. Bill Holm literally grew up among the storage stacks of the old Washington State Museum and, under the tutelage of former Director Erna Gunther, came to know and appreciate virtually every specimen in the museum's collection. Although Holm—typically—was immersed in several major projects at the time, he graciously accepted the centennial catalogue project. With characteristic enthusiasm, he selected (not without several painful decisions of elimination) the hundred pieces to be illustrated and described, worked closely with Calderón to achieve the most appropriate photo orientation and lighting, and authored the insightful text for this volume, all on a particularly tight deadline.

Representing slightly more than one percent of the total Northwest Coast holdings in the Burke Museum, *Spirit and Ancestor* provides a sampling of one of the five most significant Northwest Coast ethnographic collections in the United States. The pieces illustrated here, all part of the museum's permanent holdings, were chosen to represent the geographic coverage of the collection, its range from functionally elegant utilitarian objects to ceremonial regalia of great artistic sophistication, and its historical depth. Our hope is that *Spirit and Ancestor* will not only reflect the Burke Museum's commitment to the preservation and study of the cultures of the Pacific Rim, but also provide an important contribution to the scholarly literature on Northwest Coast art and culture.

The successful completion of this project owes a great deal to many individuals, most of whom are acknowledged directly in the Preface. The Burke Museum, however, is particularly grateful to John Hauberg, whose timely contribution allowed the crucial photographic work to go forward, and to the National Endowment for the Arts, which generously underwrote the costs of publication. We also thank the University of Washington Press, its Director, Donald Ellegood, and its Editor-in-Chief, Naomi Pascal, for their cooperation in the production of this volume.

Patrick V. Kirch
Director, Burke Museum

Acknowledgments

In an undertaking of this sort, there are many people whose contributions should be acknowledged. The Burke Museum found in photographer Eduardo Calderón an enthusiastic proponent of the idea of an illustrated catalogue of Northwest Coast artifacts as a centennial volume. Dr. Patrick V. Kirch, Director, accordingly marshalled the museum's resources. Ellen Ferguson, Development Officer, composed grant applications. John Hauberg, Seattle art patron and longtime supporter of the Burke Museum, offered generous funding for the necessary photography. With the help of Gary Wingert, Curator of Exhibitions, Calderón converted a section of the Burke's ethnology storage into a studio and commenced photography.

As the writing progressed, Dr. Susan Libonati-Barnes, Burke Museum Editor, assisted by Editorial Associate Jenifer Young and Editorial Assistants Carla Hartwig, Shannon Kipp, and Cathy Dooley, shaped up my prose and checked the accuracy of the text against the Burke catalogue entries. The help of Acting Curator of Native American Art Dr. Robin Wright was invaluable in resolving problems when I was not available to do so.

Editor-in-Chief Naomi Pascal and Managing Editor Julidta Tarver of the University of Washington Press helped with the manuscript; Audrey Meyer, Art Director, designed the volume. Historical photographs came from the Alaska Historical Library, the British Columbia Provincial Museum, the Burke Museum Collections, the Oregon Historical Society, the Peabody Museum of Harvard University, and the Special Collections Division, University of Washington Libraries.

The efforts and contributions of all these individuals and institutions in the preparation and publication of this book were supported by a generous grant from the National Endowment for the Arts.

Many, many thanks.
Bill Holm

Preface

A celebration of the first hundred years of a museum's life ought to be marked by some kind of memorial, and a book illustrating and describing objects from the museum's collections seems an appropriate commemoration, especially given the museum's role in scholarship and education. The Burke Museum is a museum of natural history and anthropology, housing collections from many fields; it could be argued that a centennial volume ought to include objects from all of them. The decision to limit the objects not only to the ethnological collections but specifically to those from the Northwest Coast was in part arbitrary. But the Burke Museum and its progenitors (the Young Naturalists' Society Hall, the University Museum, and the Washington State Museum) have been known to the public largely for their ethnological material, of which the Northwest Coast Indian collection is the largest and best-known part. Among the many Northwest Coast objects of scientific and artistic importance are famous pieces that have come to be veritable symbols of the museum. And so the choice was made: to feature the Burke Museum's Northwest Coast material, represented by photographs and descriptions of one hundred objects symbolizing a century of collection, exhibition, and interpretation.

The selection of those one hundred artifacts from a Northwest Coast collection numbering more than eight thousand was not an easy task. It was agreed that all areas of the coast represented in the collection, from the Columbia River to Southeast Alaska, should be included, and that objects illustrating the diversity, both of the cultures and of the Burke collection, should be shown. Through both the circumstances of collecting and the relative availability of different materials, the museum is especially rich in artifacts from some geographical areas and less so in pieces from others. Of the fifteen hundred baskets collected from all parts of the Northwest Coast, only a few—representing some of the principal types—have been included here. While some tribal groups with distinctive and important art traditions, such as those of the central British Columbia coast north of Vancouver Island, are sparsely represented, material from the Tlingit makes up one-third of the Burke's Northwest Coast collections.

Certain choices were easy. I have been associated with the Burke Museum in one way or another for nearly half of its hundred years, beginning in 1937 when, as a twelve-year-old transplanted Montanan, I first discovered its treasures. I have many old favorites among them, and have over the years seen other wonderful things come into the collection to join those I most admire. The greatest difficulty has been to keep within the allotted hundred. While some wonderful pieces have been excluded, those selected represent well both the rich cultures from which they originally came and the fine public collection of which they are now a part.

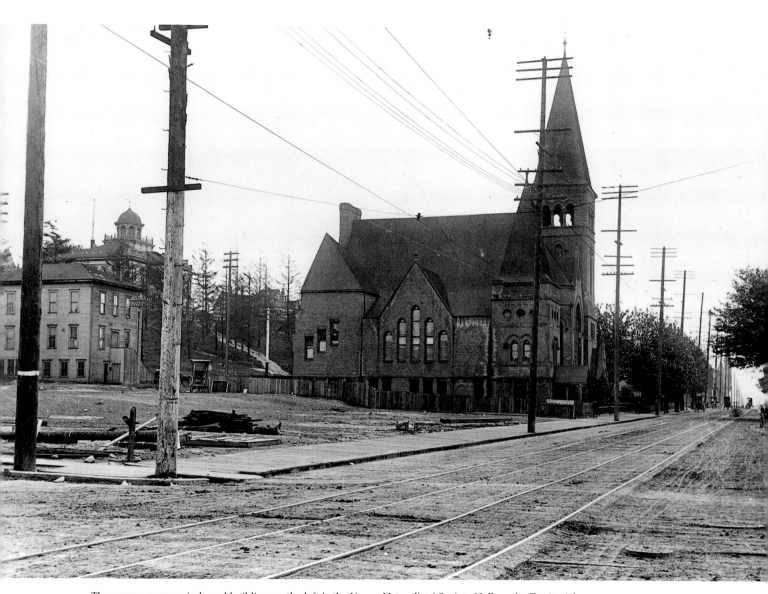

The square, many-windowed building on the left is the Young Naturalists' Society Hall on the Territorial University campus, the museum's first home. In the foreground stands the Plymouth Congregational Church. Photograph ca. 1902. *Special Collections Division, University of Washington Libraries.*

The Northwest Coast Indian Art Collections in the Burke Museum

T he year 1985 marks the centennial of the institution now known as the Thomas Burke Memorial Washington State Museum. In 1885 the Young Naturalists' Society, an organization of young Seattle pioneers dedicated to the study of natural history, began to construct a building on the campus of the University of Washington under an agreement that the association with the university was for the "purpose of the study of the natural sciences . . . and to acquire and maintain for said purpose a collection of specimens pertaining to natural history" (Benson 1985). That occasion—the initiation of construction of the Young Naturalists' Society building and the inception of a formal association with the University of Washington—has been accepted as the birthday of the Burke Museum.

The collections, however, had been accumulating for some time, for the Young Naturalists began gathering specimens shortly after the founding of their organization in 1879, some years before their association with the university. The first natural history specimens actually to become the property of the University of Washington were, interestingly enough, Indian artifacts donated by Alexander J. Anderson, president of the university from 1878 to 1882. Frank S. Hall, curator and later director of the museum, published a little pamphlet as *State Museum Bulletin Number 1,* titled "Sketch of the State Museum, University of Washington." Hall wrote that "the first collection made was a small ethnological collection consisting of spears, arrows, stone implements, and other Indian material, which was brought together by Dr. A. J. Anderson, president of the University in the late '70s (Hall 1910:3). In the Burke catalogues and accession records there is no indication of which of the many spears, arrows, stone implements, and other Indian materials these specimens might be. They could have been merged with the Young Naturalists' artifacts at the time of the society's association with the university and thus lost their identity. Records from that period are sketchy or non-existent. Some of the Anderson pieces may be represented by a few artifacts identified as "from the Old University Museum," which were entered in the accession records as having come to the State Museum "around 1890." One of them is a remarkable Duwamish spirit canoe figure (no. 11). If, in fact, it is one of the examples of "other Indian material" acquired during the tenure of President Anderson, then not only is it the earliest known Puget Sound spirit canoe figure, but it is part of the earliest ethnological collection in the Burke Museum.

Northwest Coast Indian artifacts were among the natural history specimens assembled by the individual members of the Young Naturalists' Society for their museum. Even together with Dr. Anderson's collection, the native cultures of the Northwest Coast were sparsely represented until the fortuitous association of the society with Dr. James T. White. Dr. White was a physician assigned as a surgeon with the United States Revenue Cutter Service, serving on cruises in Alaska in the years between 1889 and 1901. During that time he assembled a remarkable collection exceeding five hundred objects, mostly from the Arctic, but including more than fifty Northwest Coast pieces. At one point Dr. White spent some time in Seattle, where he met with and joined the Young Naturalists' Society, to which he gave his collection. When the society's materials were transferred to the new campus, Dr. White's original notes were lost. About 1904, he again visited Seattle, where he made a new but abbreviated catalogue at the suggestion of his friend Edmond Meany, a Young Naturalists founder and by then a well-established faculty member.

It is unfortunate indeed that Dr. White's original collection notes were lost. A fragment of a single page now in the accession record at the Burke Museum hints at richly detailed information recorded by the collector himself, rather than the sketchy, secondhand, and often fanciful descriptions that accompanied so many collections at the turn of the century.

One of the great world's fairs of all time was held in Chicago in 1893: the World's Columbian Exposition, commemorating the 400th anniversary of the landing of Christopher Columbus in the New World. In the 1890s there was enormous interest in the various peoples and cultures of the world, especially the non-Western and "primitive" societies; the Indians of the Northwest Coast were well represented at the exposition. Organized by Franz Boas, a spectacular Northwest Coast exhibit included a village of full-sized houses of several tribal types, examples of art and artifacts from different parts of the coast, and dance performances by a large troupe of Kwakiutl Indians from Fort Rupert, British Columbia. Another important Northwest Coast exhibit was that brought by the German impresario and father of the modern zoo concept, Karl Hagenbeck. The various states had their own exhibits; those with substantial Indian populations included Indian artifacts in their displays. To gather such a collection to be shown in the Washington State Pavilion at the exposition, the Washington World's Fair Commission (a planning committee for Washington's exhibit in Chicago) hired two of the state's citizens: James G. Swan and the Reverend Myron Eells.

James Swan was a remarkable man who had left New England for the California gold rush, settling in the Northwest in 1852. During his long and varied career as an oysterman, teacher, customs agent, author, and judge (among other vocations too numerous to mention), he had become the friend of many Indians and a recognized authority on the native people of the Northwest and their customs. The Columbian International Exposition was not his first world's fair: he had done important collecting for the Smithsonian Institution beginning in 1860 and had made collections for the 1876 Centennial Exposition in Philadelphia. Although Swan gathered much of the material for the Washington World's Fair Commission among Washington State Indians, he also included pieces that he had collected in British Columbia (among them nos. 29, 44, 45, 46, 47, and 57).

Myron Eells was a Congregationalist missionary in the Puget Sound region from 1874 until his death in 1907. His expertise was in the local Salish cultures, and much of the collection he made for the World's Fair Commission was from the Twana of Hood Canal, the people among whom he worked for most of his mission. When the Chicago fair was over, the state exhibit returned to Washington, and "two carloads of additional material were secured" for the Washington State Museum (Hall 1910:3). This addition of the Swan and Eells collections greatly increased the amount of Northwest Coast ethnological material in the museum and set the tone for its later specialization.

When the campus of the University of Washington was moved from its location in what is now downtown Seattle to its present site north of the ship canal in 1895, the Young Naturalists' Society Hall was left behind. Under the terms of the 1885 agreement, many of the collections were in use by university faculty members and were moved to the new campus and installed in the Administration Building (since named Denny Hall and now the home of the Department of Anthropology). In 1899 this university museum was designated by the state legislature as the Washington State Museum. New buildings were rising on the forested campus and when the Science Hall (now Parrington Hall) was built in 1902 it became the museum's home. Expositions continued to be sources for ethnological material. At the close of Portland's Lewis and Clark Centennial Exposition in 1905, in addition to a large and important collection of Philippine Islands material, the Stewart collection of over 20,000 historic and prehistoric artifacts from the Columbia River region was purchased. Then in 1909 came the Alaska-Yukon-Pacific Exposition, an extravaganza that altered the face of the university and transformed the Washington State Museum's Northwest Coast material into a major collection.

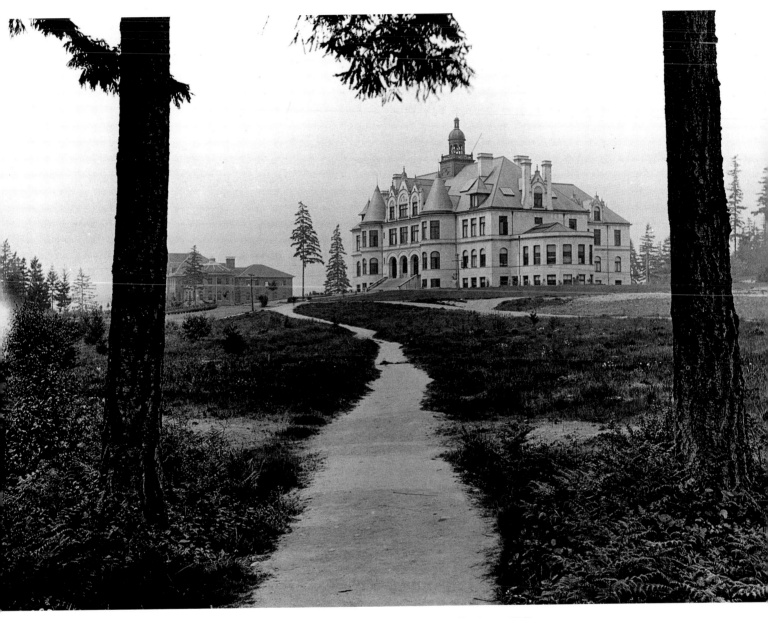

The Administration Building (center, now Denny Hall) and Science Hall (left, now Parrington Hall), two of the museum's former homes. *Photograph by Webster and Stevens. Special Collections Division, University of Washington Libraries.*

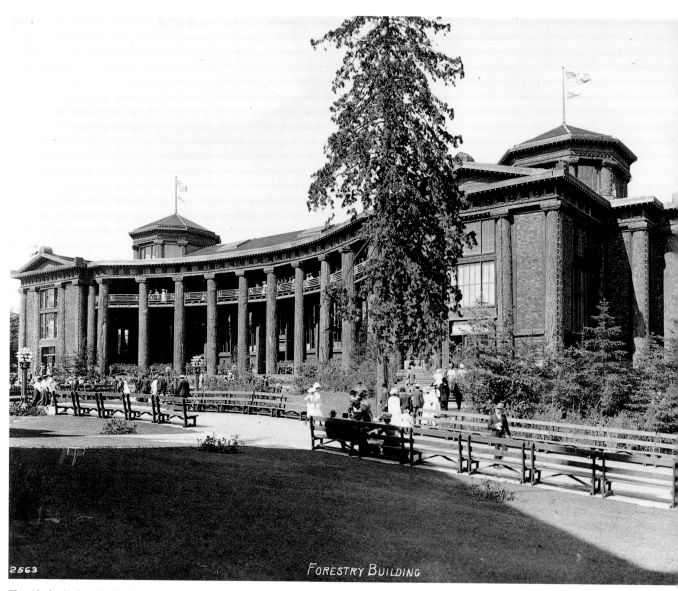

The Alaska-Yukon-Pacific Exposition's Forestry Building. *Photograph by Frank H. Nowell. Special Collections Division, University of Washington Libraries.*

Interior of the Forestry Building. The Kwakiutl canoe (no. 34) was prominently displayed between a mounted sea lion and a slice of a giant tree. *Photo: Special Collections Division, University of Washington Libraries.*

The A-Y-P, as the exposition is popularly known, also marked a change in home for the museum, and the appointment of its first official curator, Frank S. Hall. At the close of the fair in 1909, the collections were moved to new quarters that had been constructed for the A-Y-P: the California State Building, reminiscent of a Spanish mission, and the Forestry Building, a monumental wooden structure noteworthy for its gargantuan colonnades of Douglas fir logs. But the most important change for the ethnology collection was the acquisition, from the Alaska exhibit, of a very important assemblage of more than eighteen hundred Alaskan native artifacts collected by George T. Emmons, primarily from the Tlingit. The history of almost every major Northwest Coast museum collection in North America is laced with references to Lt. George Emmons. He made two major and several smaller collections that were acquired by the American Museum of Natural History, others for the Smithsonian Institution and the Field Museum in Chicago, still other collections now in the Museum of the American Indian and in Harvard's Peabody Museum of Archaeology and Ethnology; his smaller collections and numerous individual pieces reside in many other museums. Most of these collections are documented, and the collection notes are regarded as informative and reliable. Lt. Emmons was persuaded by the organizers of the Alaska-Yukon-Pacific Exposition to display the Tlingit collection he had been assembling with the possibility that it would be purchased following the fair. In part by means of a popular subscription, the regents of the university raised the necessary money and the collection was acquired by the growing museum (Cole 1985:221). The Emmons collection is the primary reason for the preponderance of Tlingit material in the museum's Northwest Coast collection, a dominance reflected in this catalogue.

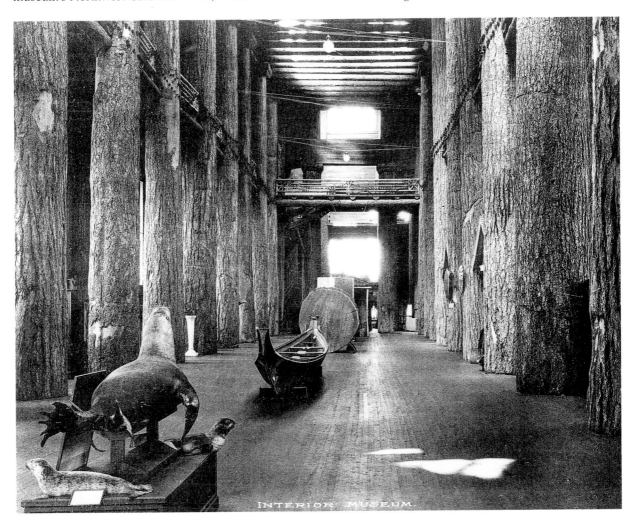

INTERIOR MUSEUM.

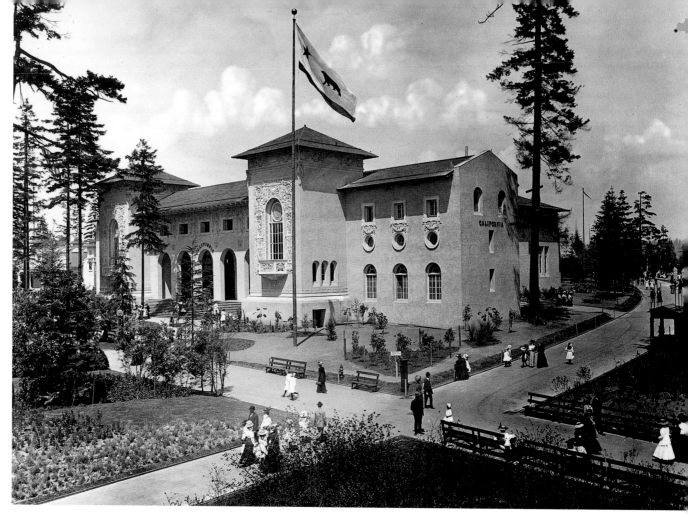

The Alaska-Yukon-Pacific Exposition's California State Building. *Photograph by Frank H. Nowell. Special Collections Division, University of Washington Libraries.*

The Emmons collection of Tlingit artifacts exhibited in the California State Building. *Photo: Burke Museum Collections, University of Washington.*

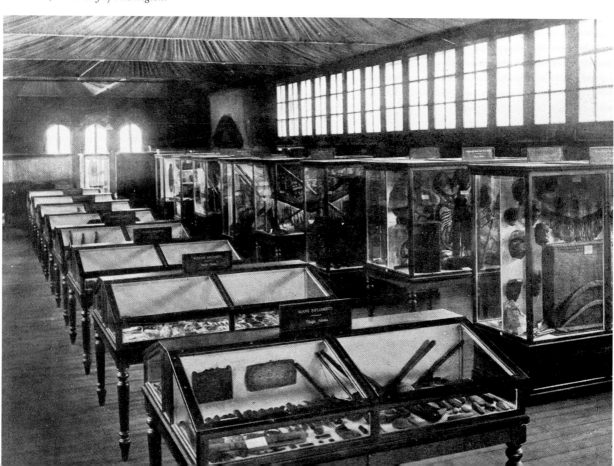

Although the museum had been operating in one form or another for over twenty years, there was no catalogue of the collections before Frank Hall was named curator. The move into the California and Forestry buildings and the increasing size of the collections probably motivated Hall to begin the monumental task of recording the collections. Nothing was catalogued before 1909, making it very difficult to sort out the history of the collections before that date, but Hall began the task, arbitrarily starting with the Washington World's Fair Commission material acquired after the Chicago fair of 1893. Catalogue Number 1 was assigned to a Haida dance tunic collected by James G. Swan; Number 2 was given to its mate (no. 57). The cataloguing system is still being refined to this day and is now in the process of being computerized.

At the close of the A-Y-P the Northwest Coast collections were installed in rows of glass cases in the former California State Building. A few years later, in 1913, all the collections were combined in the giant, log Forestry Building. Before long, however, beetle infestation, rot, and the difficulties of maintaining the unconventional building made it clear that new quarters were needed. The former A-Y-P Washington State Building had been remodeled to house the university library after the fair. A new library building was under construction; upon its completion in 1927 the museum moved into the Washington State Building.

The portico of the Washington State Building, with its imposing colonnade and glass-paneled doors. *Photograph by Frank H. Nowell. Special Collections Division, University of Washington Libraries.*

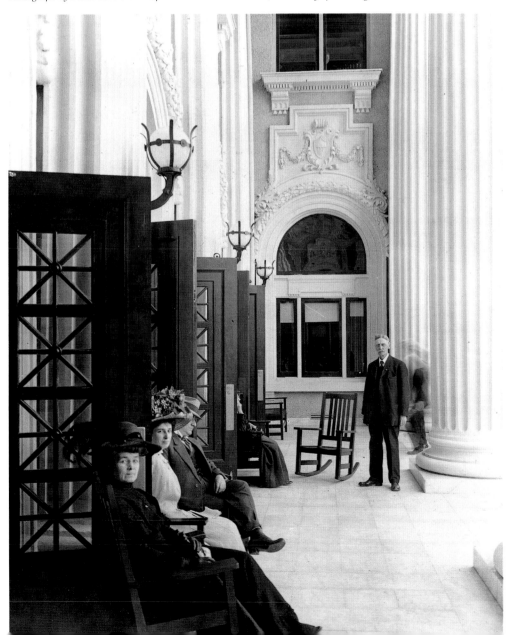

The grand staircase of the Washington State Building. *Photograph by Frank H. Nowell. Special Collections Division, University of Washington Libraries.*

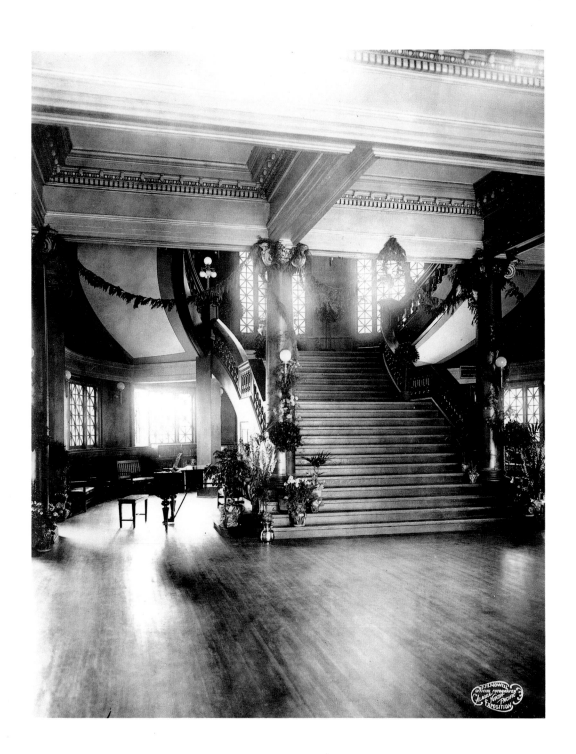

For the next thirty years the Washington State Museum occupied this building, which had been built as a temporary fairground pavilion. Although not up to contemporary museum standards by any means, it proved a remarkably successful solution to the museum's needs and is fondly remembered by many Seattleites. The director for nearly the entire time was Dr. Erna Gunther, an anthropologist with a Northwest Coast specialization. During Dr. Gunther's tenure the Northwest Coast collection continued to grow. One of the largest additions was the collection made by Caroline McGilvra Burke, given to the museum in 1932. Mrs. Burke's collection included material from many parts of North America, but the majority of the artifacts were from the Columbia Plateau and the Northwest Coast, among them a very large and important basket collection (nos. 9, 10) and several full-sized canoes (no. 34).

The former Washington State Building was the first structure to bear the museum's name. Constructed for the Alaska-Yukon-Pacific Exposition, it later became the university library, and finally housed the museum until 1957. *Photo: Burke Museum Collections, University of Washington.*

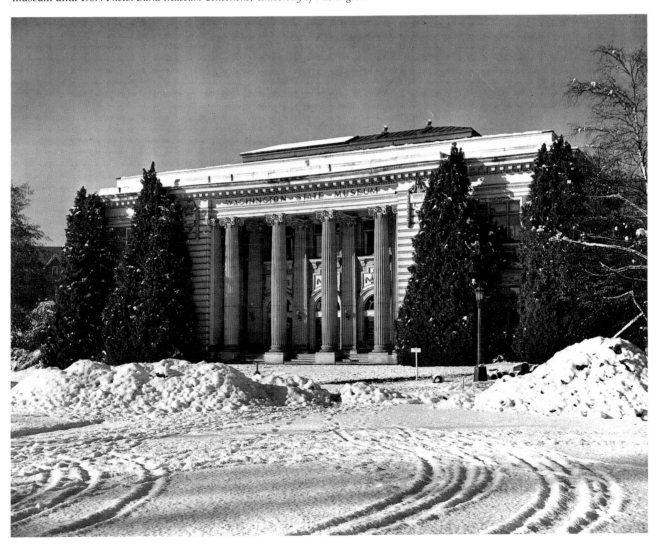

Dr. Gunther's efforts—toward bringing the museum to prominence as an educational and research institution and toward full recognition of its public displays—led to the acquisition of other important collections. In 1953, after long negotiations, the Washington State Museum and the Denver Art Museum jointly purchased the collection of the late Walter Waters, a Wrangell, Alaska, collector and dealer. After the sale had been made but before the material could be shipped to Seattle, a disastrous fire on the Wrangell waterfront destroyed the dock on which Waters' totem poles and several large canoes, including Chief Shakes' "Killer Whale" canoe, were stored. (Their loss underscored the vulnerability of collections to fire and the importance of secure storage facilities.) Nevertheless, the Waters collection increased the Northwest Coast material in the Museum by some three hundred objects, among them treasures of the chiefly lineage of the Nanyaayi clan of the Stikine Tlingit (nos. 79–85). Walter Waters' collection included material from other parts of the coast as well: the meager Kwakiutl representation in the museum was greatly improved by its acquisition (nos. 33, 36, 38, 41, 42).

During Erna Gunther's administration, many other acquisitions of important Northwest Coast material were made through museum expeditions, purchase, exchange, and gifts. For example, the Cowichan spirit dance tunic (no. 18) was collected by Dr. Gunther, the Tlingit house post (no. 88) was acquired by exchange with the University of Michigan, and the Kwakiutl Hamatsa mask (no. 35) was donated by John Hauberg, a Seattle collector and friend of the museum. Through lectures, telecourses, articles, exhibits, and catalogues of Northwest Coast Indian material, Erna Gunther enormously increased public awareness of Indian culture and the museum. Scholarly attention was focused on the museum, and the collections became internationally known. Time was running out, however, for the old building.

In 1957, after three decades of service as the Washington State Museum, the old Alaska-Yukon-Pacific Exposition Washington State Building was declared unsafe and was evacuated. The collections were dispersed around the campus for safekeeping during the construction of a new building. Most of the Northwest Coast collection was moved to the upper floors of a storage warehouse that had been converted by the university for the use of the Applied Physics Laboratory. Large objects, such as Mrs. Burke's Kwakiutl canoe (no. 34), were shuttled from place to place as the borrowed storage spaces were re-allocated. During this period, a few masterpieces were displayed in the lower exhibit galleries of the Henry Art Gallery and some educational exhibits were mounted in the museum's offices in a small, temporary building that had been used by the university's fledgling television studio. Finally the collections were reassembled in a newly constructed building, named for Seattle pioneer judge and philanthropist Thomas Burke. Caroline Burke's will had provided for the establishment of a museum as a monument to her late husband's life and work. The Burke bequest was an impetus to the state and university to erect a fitting museum building; the resulting edifice was opened in 1964 as the Thomas Burke Memorial Washington State Museum.

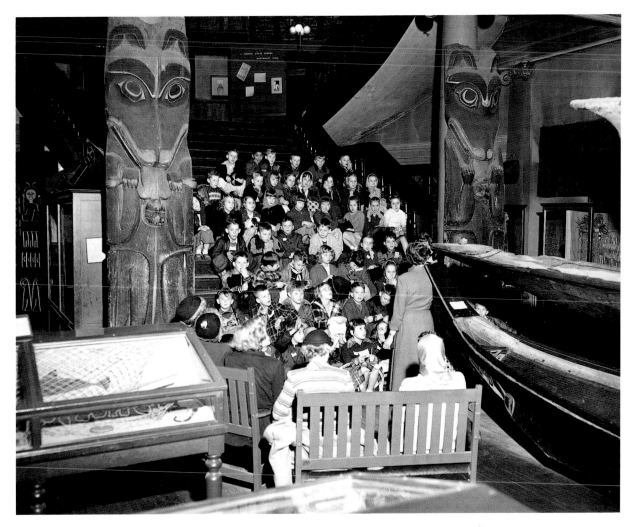

A third-grade class in the Washington State Museum in 1950. The two Tlingit houseposts from Cape Fox (no. 88) flank the grand staircase, which doubled as seating for school lectures. The stern of the Kwakiutl canoe (no. 34) appears at the bottom of a display of native watercraft. *Photo: Special Collections Division, University of Washington Libraries.*

Most of the Northwest Coast additions to the new Burke Museum collections were in the form of gifts of single pieces or small collections by private individuals. A major addition came in 1969, with the gift of a very important collection especially strong in Kwakiutl ceremonial material and Haida argillite carving, both of which were heretofore sparsely represented in the museum. The collection had been made by Sidney and Anne Gerber, much of it purchased directly from the Indian owners in British Columbia. The Gerbers were patrons of the arts and leaders in the fight for equal opportunities in Seattle and the Northwest. After the death of her husband Sidney, Anne Gerber donated their collection to the Burke Museum. Five of the 124 pieces given by the Gerbers and catalogued in *Crooked Beak of Heaven* (Holm 1972) are illustrated here (nos. 31, 39, 63, 64, 70).

The most recent large addition to the Burke Museum's Northwest Coast collection was acquired by exchange with Seattle's Museum of History and Industry. Historical material that had accumulated in the Burke Museum but was not directly related to the natural and cultural history of the Pacific Northwest and the Pacific Rim was exchanged for Native American artifacts from the Museum of History and Industry which were more appropriate to the Burke Museum's collections. Among those artifacts are many from the Northwest Coast, two of which, a Westcoast wolf mask (no. 28) and a Tlingit beaded basket (no. 94), are included in this volume.

Old, traditional Northwest Coast artifacts continue to come to light and to make their ways by purchase, exchange, or gift to the Burke Museum. As the museum moves into its second century, the work of contemporary carvers, weavers, printmakers, and other artisans is taking its place among the treasures of the past preserved for study, education, and enjoyment.

The Thomas Burke Memorial Washington State Museum in its centennial year.
Burke Museum Collections, University of Washington.

Spirit and Ancestor

Yakutat Bay 98

99 Klukwan

TLINGIT

89, 100

Stikine River

72, 73

Sitka

76, 77, 79-85
90, 96, 97

(67-71, 74, 75, 86, 87, 91-95)

78

Wrangell

59
62

Howkan

TSIMSHIAN
53

55
51

88

Skeena River

Dixon Entrance

(52, 54)

HAIDA

56-58
60, 61
63-66

QUEEN CHARLOTTE

ISLANDS

BELLA BELLA

(49, 50) 44-48 **BELLA COOLA**

NORTHERN WAKASHAN

KWAKIUTL

39

40 (30-38
41-43)

17

VANCOUVER

15

Fraser River

Nootka Sound

ISLAND

16
18

12 14 **SALISH**

13

Clayoquot Sound 29

SAN JUAN ISLANDS

20-28

CAPE FLATTERY

19

10

Puget Sound

MAKAH

OLYMPIC
PENINSULA

Ozette

Hood Canal

Seattle

16

5

7-9

QUINAULT

6

HARTSTENE
ISLAND

(4)

CHINOOK

1, 2

Portland 3

Columbia River THE DALLES

The area occupied by the people known as Northwest Coast Indians is a long and narrow stretch of land and intertwined waterways fronting the Pacific Ocean on the west and limited by the coastal range of mountains on the east. The northern boundary of Northwest Coast culture is relatively easy to fix: the Yakutat Tlingit, whose principal winter villages fronted the great bay in Southeast Alaska that takes its name from that tribe, are the northwesternmost group whose language, culture, and traditions match the characteristics considered typical of the culture area. The southern limit of the Northwest Coast is far less precise. Many scholars, with considerable logic, extend the area to include northwestern California; coastal Oregon is often included. Perhaps arbitrarily, perhaps because of lack of evidence for some kinds of art activities to its south, for our purpose we take the Columbia River as the southern boundary of the art traditions of the Northwest Coast.

The Lower Columbia River People
Nos. 1–3

The coastal range is not an impenetrable barrier throughout its length, but for the most part is a difficult—and in many places insurmountable—obstacle to travel and trade. Today, despite all our technology and resources, these coastal mountains (the Cascades in Washington, the Coast Range in British Columbia) limit land travel to fewer than a dozen crossings in their thousand-mile length; only half of these can be negotiated in the winter. Most of the passes used today were trade routes in the days before European contact, narrow channels through which the coast dwellers extended their influence and were in turn influenced by the interior people. The greatest of the southern trade routes was the Columbia River valley, through which goods and ideas moved back and forth from the rain forests of the coast to the dry plateau of the interior. The lower Columbia, that part of the river between the Pacific and The Dalles, was in most respects truly a part of the Northwest Coast, although the narrow, rocky channels and falls were upriver from the last dark slopes of the western forest. The Dalles was one of the great trading centers of the aboriginal West, and it is here that we begin our journey through the Burke Museum's treasures of the Northwest Coast.

1. **Net Gauge** Wishram; The Dalles, Columbia River; 19th c.
Elk antler; 7 cm × 7 cm
Museum expedition; received 1955; cat. no. 2–3845

F ishing was the industry that made the stretch of the Columbia called The Dalles one of the great commercial centers of pre-European western America. Here the mighty river plunged through a ten-mile series of falls, rapids, and narrow rocky slots, forcing the upstream-battling salmon into the reach of the long-handled dip nets of Indian fishermen perched on precarious ledges and platforms. Salmon by the ton were netted and their flesh was dried in the sun and wind of the arid valley. Reduced almost to a flour by being pounded in tall wooden mortars, the salmon were staple winter food not only for the permanent dwellers at The Dalles, but for thousands of Indians from the treeless Columbia Plateau to the east and down the Columbia to the Pacific Coast. These people came to barter for salmon and exchange other goods, to gamble and socialize with one another. Even after successive epidemics of introduced diseases (from around 1780 to 1830), which left the native population a fraction of its former size, and even after the settlement of the Pacific Northwest by Euro-Americans, which drastically altered native economy and lifestyle, The Dalles remained the principal fishing site of the interior. The end of this era came in 1957 when the waters of Celilo Lake, behind the new Dalles Dam, covered The Dalles of antiquity from the Long Narrows to above Celilo Falls. Until their perilous platforms were finally submerged in the tamed waters, the Wyam fishermen of Celilo continued to snatch their salmon from the surging river in exactly the manner of their ancient fathers.

At the head of the Long Narrows, near the center of The Dalles, stood a stratified mound called Wakemap (Wock-em-up). It was a rich site in a miles-long area of some of the richest archaeological sites in western North America. From the mound and the surrounding river banks have come thousands of artifacts—of stone, bone, antler, and wood—that record the ten-thousand-year evolution of cultures and art traditions of the area and establish the relationships among art styles along the lower Columbia and the coast of Washington.

Net gauges are tools used by fishermen all over the world in the manufacture and repair of nets. The gauges are flat rectangles of hard material around which twine is wrapped and tied to form the meshes of nets. Different sizes of gauges are used to produce smaller or larger mesh, according to the size and type of fish to be caught and the technique used to catch them. Both large salmon and slender eels were fished at The Dalles, and the mesh sizes of the nets varied accordingly. This antler net gauge, although similar in style to objects from precontact archaeological sites at The Dalles, was purchased near Wakemap in 1955 from its Wishram Indian owners, who considered it a family heirloom. Its deep color and polished surface speak of long use. It could be as old as some of those recovered from the ancient middens, and yet it may have measured the mesh of dip nets or beach seines knotted around it until the time it was collected, just before the river no longer flowed free through the gorge of the Long Narrows. The two birds, perhaps eagles, soar across the polished antler. One grasps a salmon in its talons; its head, breaking the silhouette of the gauge, adds a startling dimension of movement.

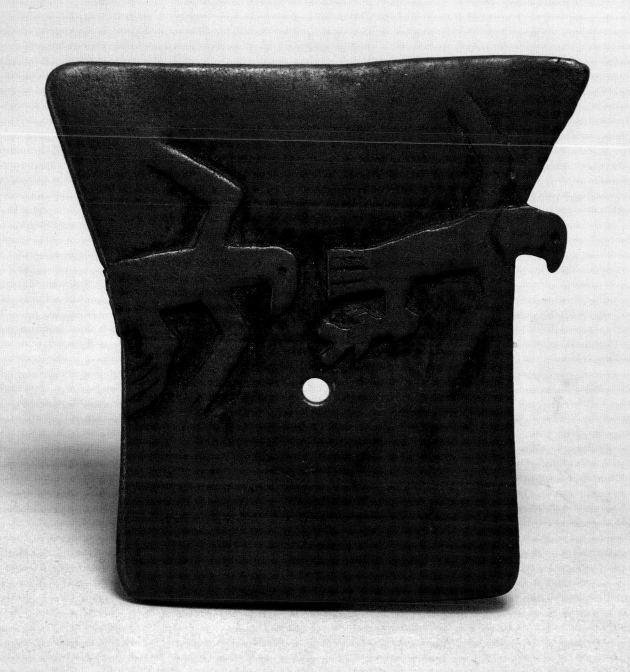

2. Spoon Columbia River (?); 19th c.

Mountain sheep horn; 22.5 cm × 9.5 cm × 9 cm

Collected by Mrs. H. B. Ferguson at Cape Flattery; received 1915; cat. no. 4858

Throughout western North America, the spiraling horns of the mountain sheep have been used for centuries as the material for ladles and bowls. In principle all ladles and bowls are constructed by the same procedure: the great horn is freed from its bony core; a piece large enough to form the vessel is cut from the outer curve and carved to the basic shape; the piece is heated by boiling and is spread to its final width and form. When cool and stable, the surface may be sculptured or otherwise elaborated with shallow relief. Although derived from the same material worked in the same way, sheep horn bowls and spoons from various geographical areas reflect the artistic traditions of their places of origin. This spoon is surely from the Columbia River, even though it was collected at Cape Flattery, the northwesternmost tip of the state of Washington. Utensils of this kind have been found in Indian possession in all parts of the state, but historic and stylistic evidence places their origin firmly in the area of the Columbia River, most likely centered on The Dalles.

The characteristic features of Columbia River mountain sheep horn bowls—and by extension spoons and ladles—include a broad, nearly round opening with a flat rim; a thickened, flat band running the length of the under surface; and a decoration of bands of interlocking, excised triangles forming rows of zigzag lines. Concentric circles or squares, or geometricized human figures often embellish the surface. On bowls, the thickened band continues above the rim to form at each end a square flange, which is often pierced with rows of vertical slots and sometimes capped with triangle/zigzag fretwork (Vaughan and Holm 1982:58–59). On ladles, the band and rim extend upward to form the handle, usually elaborated with a sculptured human or animal figure. This spoon illustrates the typical characteristics very well. Judging by its thick, drooping tail, the animal carved on the inner curve of the handle may be a wolf. From its shoulders extend what appear to be human arms, the hands of which grasp its snout. The carving exhibits the geometric detail and exaggerated chevron ribs that are features of Columbia River art.

Many bowls and ladles of this kind appear to be very old. Those held by Indian families are often considered ancient family heirlooms. They are almost invariably dark brown or black in color, with worn surface detail, in contrast to the pale whitish-amber color and crisp, sharp edges of newly carved horn. Their dark surfaces and striated texture have often caused them to be mistaken for wood, and they are sometimes catalogued as such in museum records. Wooden spoons very similar to this one were made on the Columbia, but they usually have a flattened base and a more compact, less curved handle. Careful examination of the surface will reveal the characteristic concentric growth pattern of wood, in contrast to the parallel arrangement of horn fibers and the transverse, wavy growth layers of the sheep horn.

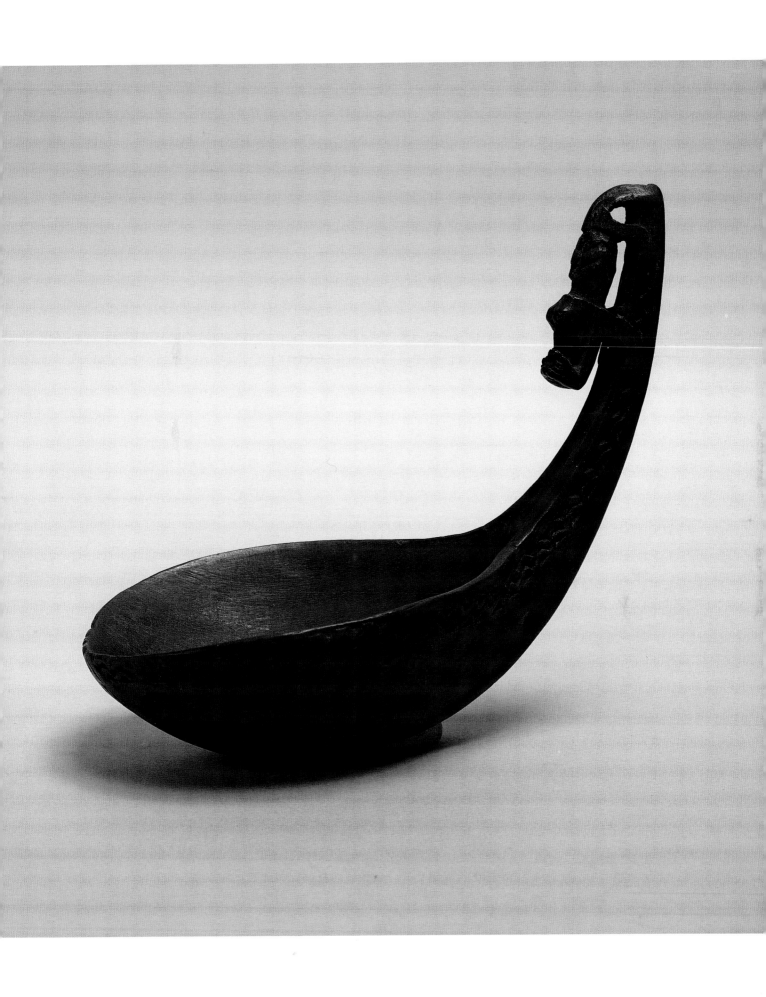

3. **Carved Human Figure** Multnomah (Sauvies Island); precontact

Elk antler; 19 cm × 5 cm × 5 cm

Museum expedition; received 1955; cat. no. 2–3844

Sauvies Island, just downstream from Portland, Oregon, is a low, sixteen-mile-long island lying between the Columbia River and the Multnomah Channel. There were at least fifteen large village sites on the island, almost all of them now obliterated or covered by dikes or farms, but over the years since the island was settled by Euro-Americans, thousands of artifacts have been recovered. These pieces hint at the culture that flourished there before it was destroyed by the epidemic of 1830 (Strong 1959:19, 21, 29). This elaborate sculpture of a mother and child was acquired from a collector who found it on Sauvies Island. It is a fine example of the Lower Columbia River style, with its geometric detailing and emphasis on the skeletal structure.

The history of Sauvies Island affords us considerable insight into the problem of understanding the art of the region. By the time of Lewis and Clark's first visit in 1805, its people had already been hard hit by disease brought by eighteenth-century European ships; thirty years later there were no more native people alive on Sauvies Island. By the time any serious interest in the traditional lives of the Lower Chinookan tribes began to develop, their last few remnants were scattered and demoralized. A good deal of information has been recorded from a few old people, but much more has been lost (Ray 1938; Boas 1894).

We do not know what function this object might have had within Chinook society. The emphasis on skeletal detail so often seen in the art of the lower Columbia and of southwestern Washington has often been assumed to be associated in some way with a cult of the dead. Perhaps this is a commemorative figure, but we really have no way of knowing. Throughout the Northwest Coast there is frequent depiction of internal organs and skeletal structure ("X-ray representation") in art, often in objects whose function and meaning are well known and which have nothing to do with the dead. Here we have a rather straightforward representation of a woman carrying a child in a cradle on her back, and wearing a kilt textured with zigzag patterns that may represent cedar bark fringe such as was described by Lewis and Clark in their journals (Lewis and Clark 1962:326, 368).

The artist has utilized the cylindrical beam of a massive elk antler for his sculpture. The Roosevelt elk, native to the region, is the largest of its kind, and the heavy, branched antlers of mature bulls furnished tough material for tools such as splitting wedges and adze handles as well as for objects of art and ceremony. Antler can be carved with stone and beaver tooth knives, as the Chinook mother and child may very well have been. The figure is carved in the round, but the porous core of the antler has been cut away, leaving a relief-carved cylinder. The southern coastal style of representing a figure frontally, with the face in the form of a flat oval shallowly relieved around the eyes and nose, is perfectly represented here. The concentric crescents of the ribs and the zigzag lines engraved on the forehead, cheeks, legs, and cradle are typical of the geometric surface detail so characteristic of Columbia River art. Both the proportions of the figure and anatomical details such as the kneecaps and the musculature of the legs are examples of typical straightforward naturalism.

Although elk antler is a tough, durable material, the sculpture has been weakened by long burial and was recovered in several pieces. It is fortunate that the figure has survived.

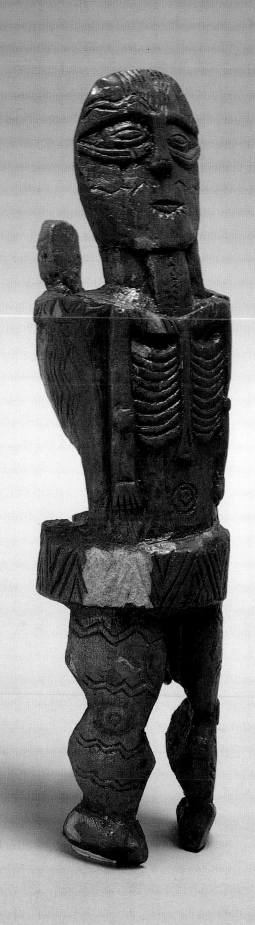

Coast Salish *Nos. 4–18*

Most of what is now western Washington and southwestern British Columbia was occupied by people speaking Salish languages; however, Chinookan, Athapascan, Sahaptin, Chimakuan, and Wakashan speakers also were among the many tribes that shared this most bountiful of Northwest Coast regions. Rich in all the produce of the sea and rivers, covered with often edible and otherwise useful vegetation, and favored with a mild climate, the country of the Coast Salish almost measures up to its popular image as a land free of care. That image and some of its reality were certainly factors in the early arrival of traders and then settlers to the region. The Coast Salish country became the earliest and eventually the most heavily urbanized part of the Northwest Coast; the original cultures of the area were the losers. Native life was drastically changed very early in the historic period, so that by the late nineteenth century, when systematic attempts to collect and preserve the artifacts and oral traditions of the Salish began, much was gone. The more northerly Salish groups lost much, but perhaps less than their cousins around Puget Sound and on the Olympic Peninsula, and certainly much less than the people of the lower Columbia, whose culture was nearly obliterated.

Quite surprisingly, some very significant features of traditional life survived the European onslaught, although with varying degrees of modification: the dependence on the sea for subsistence, the production of basketry, and certain religious activities. Some settlers, among them the members of the Young Naturalists' Society, made casual collections, and some of the items they acquired are now Burke treasures. Important additions to the museum's Salish collections came from Myron Eells and James Swan, perhaps the earliest systematic collectors in the area. Traditional Salish culture has not entirely disappeared even now, and recently renewed interest in old ways and concepts has inspired some young Indian artists to look to their roots, and others to record oral traditions and to gather archival material and artifacts into cultural centers for the education of both tribal members and people of the surrounding non-Indian communities. An outstanding example in the Puget Sound region is the Suquamish Museum and Cultural Center across the sound from Seattle.

4. **Straight Adze** Southern Puget Sound; 19th c.

Elk antler, steel, cotton cloth; 24 cm × 6 cm × 6.5 cm

Young Naturalists' Society, collected by P. B. Randolph; received 1904; cat. no. 4588

Woodworking was one of the special accomplishments of Northwest Coast artisans. Tools utilizing the materials available were developed for the making of beams and planks for winter houses, for shaping utensils, containers, and ceremonial objects, and for producing the kingpin of Northwest Coast culture—the canoe and all its equipment. Before traders brought iron and steel in abundance, carving tool bits were made of stone, shell, and beaver tooth. A few rare and highly prized tools were tipped with fragments of steel or iron salvaged from wreckage washed ashore on the outer coast. Some other iron blades, working their way overland in intertribal commerce, may have preceded seaborne traders. Whatever the source, the arrival of steel signaled both the abandonment of all other carving tool materials and a tremendous gain in efficiency.

Adzes take several forms, and this *straight* adze is a type confined to the southern Northwest Coast and the lower Columbia. The straight adze receives its name from the position of the bit: in line with the handle, rather than at an angle to it as with the elbow adze (no. 8), or aligned with the knuckle guard as in the D-adze (no. 19). Straight adzes without a knuckle guard and with handle and blade beautifully shaped of a single piece of stone have been found along the Columbia River.

As is typical of southern straight adzes, the haft of this one is of a single section of elk antler, pierced to form grip and knuckle guard. A narrow, upward-curved bit forged of steel is lashed to the carved socket with a strip of commercially woven cotton cloth. It may be that at one time the bit was more securely fastened with a lashing of hide or gut. A high, ivory-like polish on the grip attests to long use. The underside of the guard is detailed with carved ridges and pierced with a long triangle.

Crowning the butt of the adze is the sculptured figure of an animal, whose identity we can only guess. Most elk antler straight adzes are carved in animal designs, which are often unrecognizable or mysterious. Although they may be representations of supernatural helpers, their purpose is unknown. This animal appears to have four ears, or two ears and two stubby horns. The prominent ribs and backbone, as well as the naturalistic modeling of the legs, are southern sculptural features.

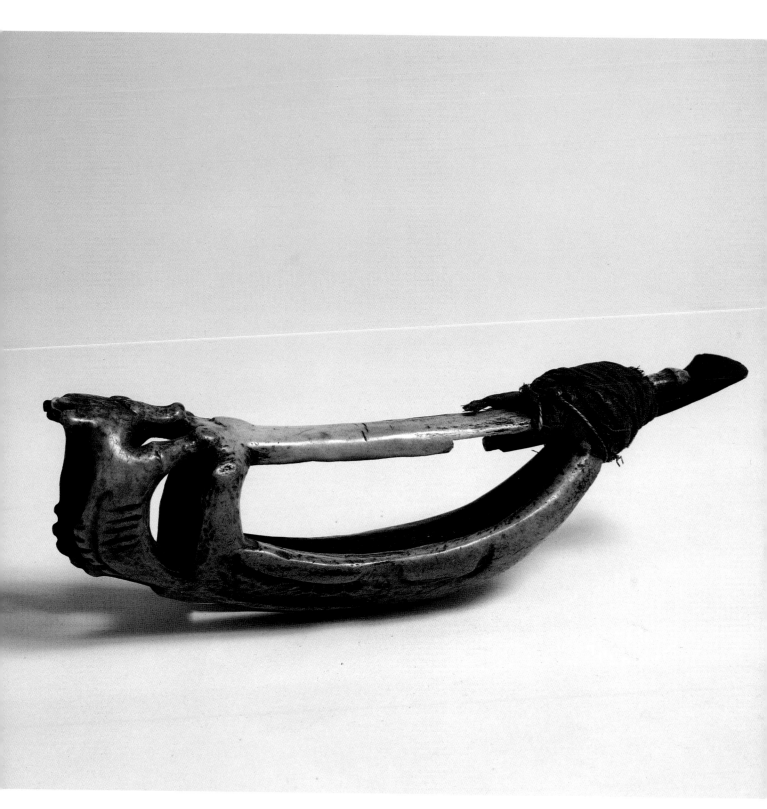

5. **Ceremonial Rattle** Quinault; late 19th c.

Maple, cotton cord, glass beads; 28 cm × 14 cm × 11 cm
Washington World's Fair Commission, collected by Myron Eells; received 1893; cat. no. 78

The Congregationalist missionary Myron Eells went to the Twana (Skokomish) reservation in 1874 and spent the remaining thirty-three years of his life in the area ministering to the Indians, observing their customs, writing hundreds of articles, and collecting artifacts (Ruby and Brown 1976:9). This simple bird rattle was one of the many objects he gathered for the Washington World's Fair Commission to be sent to the World's Columbian Exposition in Chicago in 1893, as part of the Washington State exhibit.

Although a missionary strongly opposed to native religious activities, Eells was a surprisingly sympathetic observer of most Indian ways. Even the "Black Tamahnous" (in Chinook Jargon, the Northwest Coast trade language, *tamahnous* is the term for supernatural power), as he termed the Winter Ceremonial of the local tribes, was described in far less prejudicial prose than was common for his day. He identified this rattle as used in the Black Tamahnous or Klookwalli of the Quinault.

The Quinault are a Salish-speaking people of the central west coast of the Olympic Peninsula. They were the southernmost people to practice whaling actively, and although linguistically unrelated to either their Quileute or Makah neighbors to the north, shared with them many other features of culture, including the Klookwalli (Olson 1936:120). This Winter Ceremonial apparently originated on Vancouver Island and spread southward along the coast. It featured masked dances (the only ones performed by the Quinault) in which the initiates were said to gash themselves or pierce their flesh with arrows or knives. Much of this may have been simulated, but nonmembers were certainly afraid of the performances; Myron Eells and other outsiders were convinced that the ceremony was evil.

Rattles were an integral part of the Klookwalli, just as they were important to ceremonial activities the length of the coast (Holm 1983a:25). Klookwalli rattles were usually made in the form of birds, often globular, with flattened breast and upright head. The two halves of the rattle were separately carved to thin-walled hollows of hard wood and then joined by lashing the handle and tying the edges through drilled holes. Usually the ties were small and unobtrusive, unlike the decorative tassels seen here. The eyes were often inlaid with trade beads, these of an amber color. The bird is not clearly identifiable, but probably represents one of the many sea birds known to the Quinault. It is painted in broad areas of color: ultramarine blue on the head and wings, vermilion on the neck and breast, and a dark red on the remainder. Of these, the blue and vermilion are probably powdered pigments obtained in trade. Both were popular everywhere and were commonly available from the trading companies' stock. The darker red may be a native mineral pigment. Although simple in form and detail compared to the elaborate bird rattles of the northern coast (no. 72), the little Quinault bird has an unpretentious elegance and strength often found in the sculpture of the south.

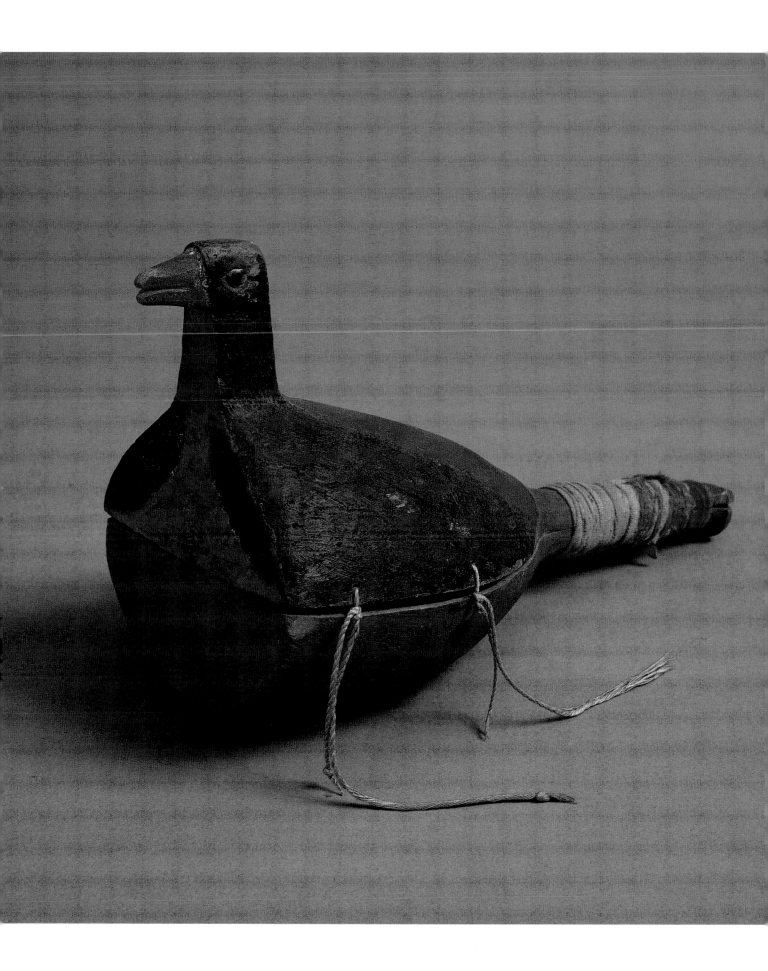

6. War Club Puget Sound Salish (Hartstene Island); precontact

Whale bone; 59.5 cm × 6 cm × 2.6 cm

Museum expedition, collected by A. G. Colley; received 1923; cat. no. 9033

Worn and weathered, carved detail softened by the years, this weapon remains one of the finest sculptural works to come from aboriginal Puget Sound. Its obvious similarity to whale bone clubs collected in the earliest days of European contact on the west coast of Vancouver Island (King 1981: pl. 47) as well as the greater availability of whale bone on the outer coast suggest that the club may have come to Hartstene Island at the southern end of Puget Sound as a consequence of trade or war. It is quite possible, however, that it originated in the region in which it was found.

The club is probably very ancient. Its closest counterpart is a bone club recovered from a cache of weapons in the Prince Rupert Harbor area of northern British Columbia, nearly six hundred miles to the northwest, and dated at 500 B.C. (MacDonald 1983a:110). This club may be just as old, and is a far more spectacular example of Northwest Coast sculpture.

The proportions and subtleties of form of the club, with its long, swelling blade tapering to a truncated tip, and its delicate, nearly invisible shoulders defining the juncture of grip and blade, would be enough to confirm it as a object of art. In addition there is the rich carving of the pommel. Here is the profile of a warrior, arched nose over broad, firm lips, brow sweeping over large, ovoid eye, an eye probably once inlaid with shell. A deep groove cut across the cheek must also have had a shell insert. Crowning the face is a bird-form headdress with elaborate incising delineating the mouth, cheek, and feather crest. The bird's eye too was probably once of shell. A round, drilled hole, now worn through at its rim, held a wrist thong. This pommel configuration—face surmounted by animal or bird head, with thong hole behind—conforms to the usual arrangement on clubs collected on Vancouver Island's west coast at the beginning of the historic period. Those clubs, however, usually feature a hook-beaked bird rather than a human face.

If this ancient weapon originated in Puget Sound territory it raises interesting questions about the relationship of earlier southern Salish art to that of Vancouver Island. The club may instead have lain in the grave of an invading warrior, or it may remain from a fortuitous trade or noble bride's dowry. Whatever the story behind its mystery, we are enriched by the sensitive expression of its prehistoric maker.

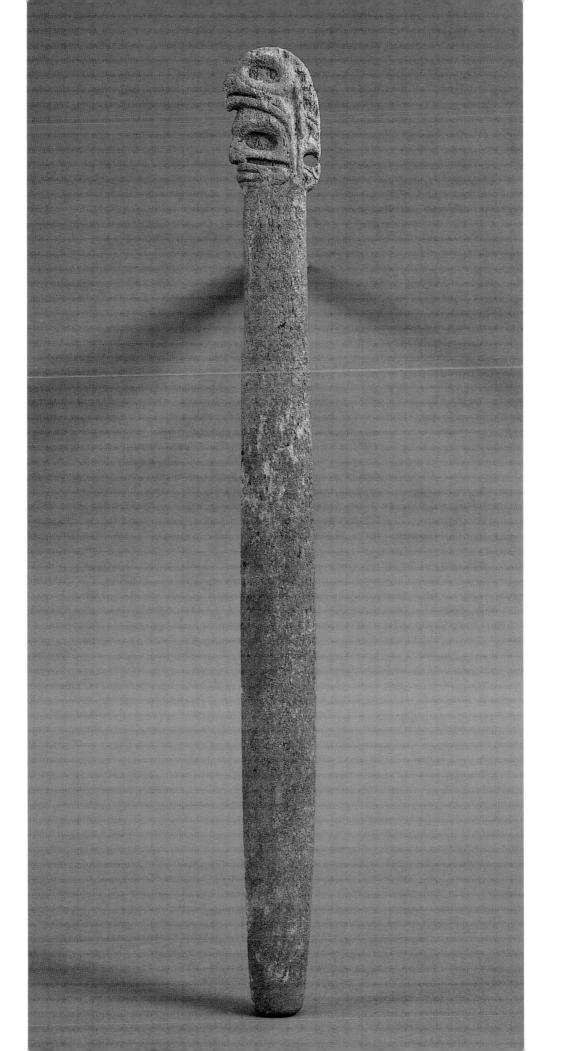

7. Gambling Bones Puget Sound Salish; late 19th c.
Bone (bear ?), wooden plugs; 8.5 cm × 3.5 cm
Washington World's Fair Commission, collected by Myron Eells; received 1893; cat. no. 226

ehal or *slahal* is the Chinook Jargon name by which a rousing, still-popular gambling game is known throughout the coast. The gaming pieces are bone cylinders from which comes the usual English name "bone game." In one form or another, this game has spread all over western North America and has always been an outlet for intertribal competition because the plays are made by hand signals understood by all. The great native trade fairs such as the one at The Dalles rang with the spirited songs that accompany the game, and today almost any native gathering on the southern coast or the Columbia Plateau will be the occasion for bringing out the bones. Rarely played just for the sport of it, *lehal* always features a "pot," contributed to by the members of the opposing teams and their backers: the winners take all. Important games, especially those between rival tribes, generate enormous stakes; if the stakes are high enough, the game is modified so that the winners must acquire the counting sticks twice. Eells described such a game between the Duwamish and the Puyallup which lasted for four days and nights and ended in a draw (Ruby and Brown 1976:52).

Lehal is played with two pairs of bone cylinders, one of each pair plain, the other decorated with an encircling band of black or a design of lines and nucleated circles. A set of counting sticks, usually ten in number, with a specially marked eleventh now called a "kick stick," completes the equipment. The two teams, of from three to a dozen players each, kneel facing each other in parallel lines, each member holding a short baton with which to keep time on a plank that lies on the ground in front of his team. Two players on one team each handle a pair of bones, and one player on the opposing team tries to guess the positions of the two plain bones. Exuberant gambling songs are sung by the team holding the cylinders, while their opponents try to confuse them with feints. Each correct guess wins a pair of bones, each miss loses a counter. When the guesser has won both pairs, his team takes over and the other side guesses. When all counters are on one side the game is over.

Bones which have a proven record are highly prized. We have no way of knowing whether this pair was lucky or not, but it is more highly decorated than many. The double-headed serpent is a mythical creature common to the traditions of many southern coastal tribes. Its representation here, encircling the decorated bone, resembles the heads of the lightning serpent that are often engraved on the barbs of the whaling harpoons of the Makah and their Vancouver Island Westcoast relatives. The other pair of this set is in the Field Museum of Natural History (Culin 1907: fig. 397).

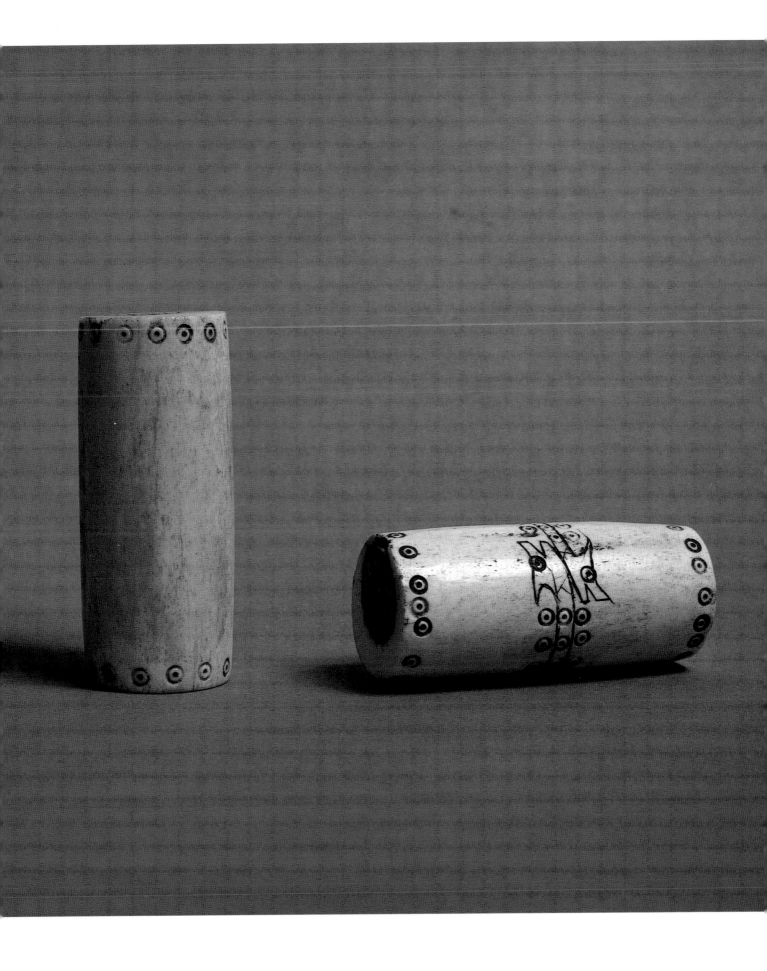

8. Elbow Adze Twana; late 19th c.

Yew wood, steel, hide; 21 cm × 12.5 cm × 8.5 cm

Washington World's Fair Commission, collected by Myron Eells; received 1893; cat. no. 18

Much of the Burke Museum's nineteenth-century Salish material was collected by the Reverend Myron Eells, who was in a position to acquire it and was commissioned to do so for the World's Columbian Exposition. The short elbow adze in the collection is of a type exclusive to the southern coast Salish. While it is assumed that stone or perhaps shell blades were once used in tools of this design, no adzes with blades other than steel are known to survive. As in the case of other tools, the steel blade of trade made all other materials obsolete.

This blade is forged from a file, a common source of steel for tools. The flared haft, polished and patinated by long use, allows the user to control the adze with a light, comfortable grip; the bulbous angle adds weight and momentum to the cutting stroke. The elbow adze of the northern coast has a much longer haft and a less acute angle to the blade. The short Salish adze is sometimes seen with a wood connection closing the end of the handle, so that it resembles the more common D-adze (no. 19).

Eells described this as a tool "used in digging out canoes." It was that and much more: a universal carpenters' tool for flattening, fitting, and shaping, and finally for finishing the wood surface with the rows of neat blade marks that are the signature of the skilled Northwest Coast woodworker.

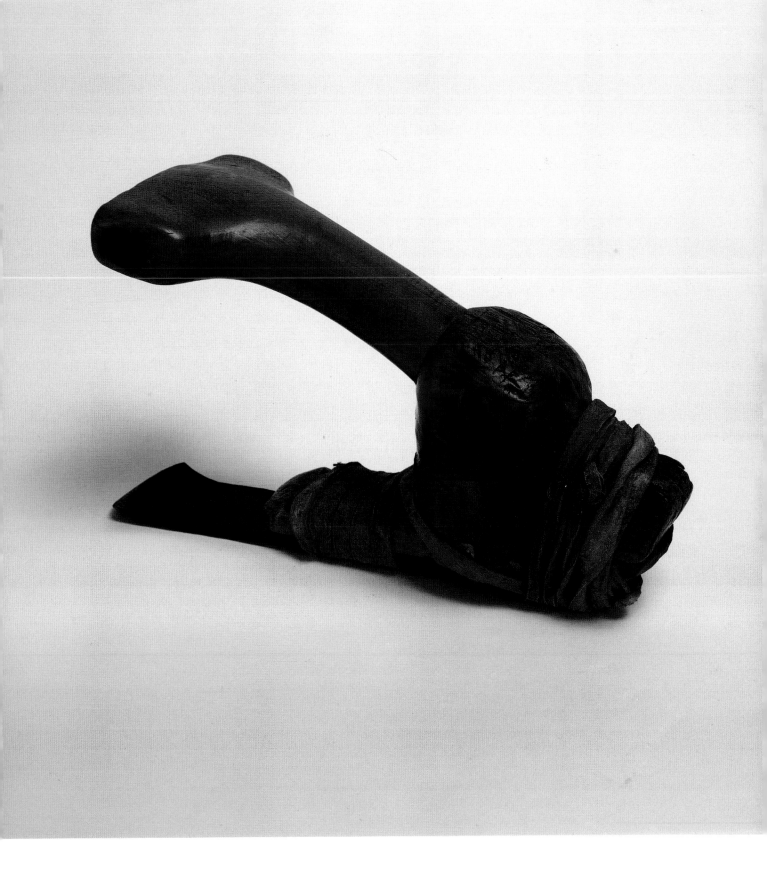

9. Basket Twana (Skokomish); late 19th c.

Cattail leaves, grass; 37 cm × 31 cm × 27 cm

Collected by Caroline McGilvra Burke (Mrs. Thomas Burke); received 1932; cat. no. 1–507

Perhaps popularly best known for its woodworking, the Northwest Coast is also renowned as one of the great centers of basketry. Without any question some of the finest baskets in the world, both in terms of the scale and perfection of technique and in aesthetic quality, were fashioned here. Each area of the coast produced baskets that were distinctive in material, technique, and decoration, these features in part determined by available material and projected use, and in part by tradition and aesthetic preference. The gathering and preparation of the necessary materials and the production of the baskets themselves were traditionally women's work, and since women frequently left their home villages in marriage, basketry techniques and concepts spread and overlapped. Even so, the provenance of baskets can be determined quite accurately from their appearance and materials. Probably one of the most narrowly limited basket types on the coast, and one which perfectly exemplifies the beauty and technical complexity of Northwest Coast basketry, is the soft-twined, overlay-decorated basket of the Twana.

The Twana occupied a group of villages on the shores of Hood Canal west of Puget Sound. Also the site of their reservation established by treaty in 1855, the largest village was Skokomish, from which comes the common name for the group. In prereservation times, Twana women made baskets in all the local styles. After the Euro-American settlement of Puget Sound and the increase in importance of basketry as a source of money, the Twana specialized in the production of their elaborately detailed soft baskets, for which they have become justly famous (Nordquist and Nordquist 1983:1–2).

This masterpiece from the collection of Caroline McGilvra Burke incorporates all the characteristics of the typical Twana soft-twined basket. The vertical warp foundation and the horizontal weft strands are of split cattail leaves, while the overlay materials, which cover the outer surface of the basket, are of finely split beargrass and dyed cedar bark. The weft is composed of pairs of cattail leaf strands which are twisted, one inside and one outside of each vertical warp, crossing each other between the warps in a technique called "twining." Overlaying each cattail weft is a strand of either beargrass or cedar bark, depending on the color desired. The yellow portions of the concentric rectangular patterns on this basket consist of beargrass dyed with Oregon grape inner bark. Cedar bark is dyed either red with alder bark or black with an acid mud. These colored overlay materials are exchanged to develop the design. Decorative loops at the basket rim were originally functional, laced with a thong to close the top of the basket when it was filled with clothing or other goods for storage.

Designs on Twana baskets as well as on those from other parts of the Northwest Coast often had names, usually descriptive of their appearance. Here the large, rectangular "boxes" are flanked by "Crow's shells," and the enclosed diamonds are called "flounder beds" (Nordquist and Nordquist 1983:72). The animals standing on the boxes are dogs, with curled tails, while those circling the rim, with drooping tails, are wolves. A rim-encircling design of animals is one of the most distinctive marks of Twana basketry. Between the wolves are "helldivers" (mergansers). The small figures within the diamonds are also helldivers (Nordquist and Nordquist 1983:72) or "pups" (Thompson and Marr 1983:73). Columns of men stand between the rows of boxes. This basket is unusual in design since the uppermost of the boxes is incomplete. Perhaps the maker decided that completing the box and the animal rim would make the basket too tall, and elected to begin the rim at the middle of the upper box.

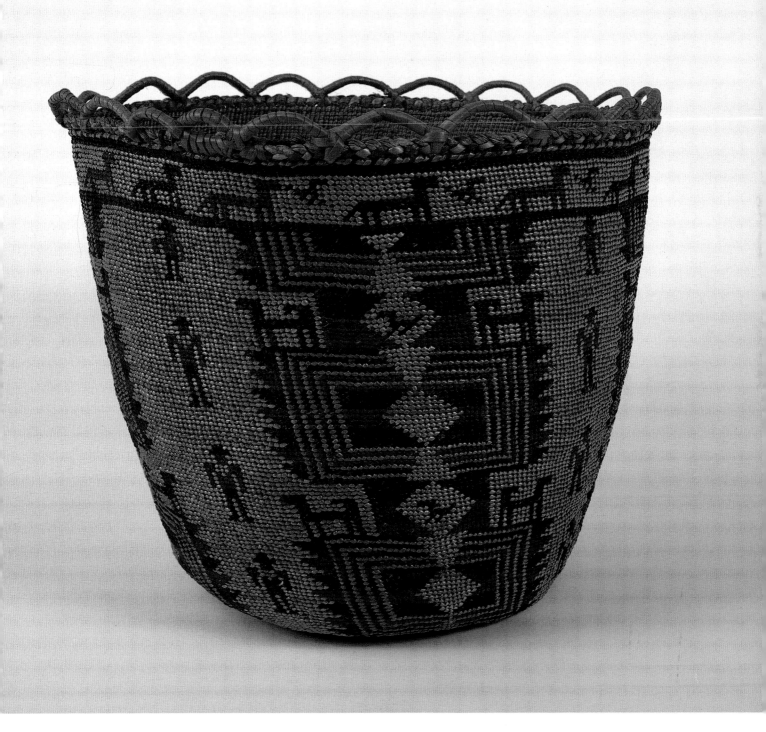

10. Basket Clallam; late 19th c.
Spruce root; 35 cm × 38 cm × 37 cm
Alaska Fur Company, received 1952; cat. no. 1–1218

Tumpline Salish; late 19th c.
Wool yarn, hemp.
Caroline McGilvra Burke, received 1932; cat. no. 1–400

T he most ordinary of utilitarian objects—an openwork burden basket with its carrying strap, or tumpline—transcends the ordinary in its symmetry, regularity, and functional perfection. Roots of spruce, or in some examples cedar, pulled up from sandy soils in tough, meandering lengths, were the material from which these practical containers were built. The roots were peeled of their thin bark by being heated in a fire and then drawn through a split stake. Coiled in handy bundles, they were carried home and dried for future use.

Building even a simple basket is a test of skill, patience, and knowledge of materials and techniques. In the technique called wrapped-twining, thin, very regular roots form the vertical rods or warps. Another root strip makes the inner, or standing weft, which circles the basket in ever-ascending spirals. The wrapping or working weft, made of flat split root, follows the inner weft around the basket, wrapping around it between the warps and diagonally across the outer side of each warp root. As the work progresses upward, additional warps are added at the corners, producing the flare of the sides. On every circuit of the weft, or sometimes, as in this basket, every two circuits, the weaver reverses the pitch of the wrap. If it were carried continually at the same pitch the warps would be forced into a slant, the corners would become twisted, and the basket would lose its form. Certain examples of wrapped-twined basketry retain a single wrapping pitch throughout, and are characterized by the resulting diagonal pattern of the stitches (no. 25).

Openwork root baskets were tough and light when new and were particularly useful for carrying heavy loads such as clams. The entire load could be rinsed of sand by dunking the filled basket in the water. A carrying strap, called a tumpline, was tied by its trailing ends to loops near the basket rim, with its broad center passing across the forehead or chest of the carrier. The long, tapered tails of the strap could be adjusted for various loads such as firewood, bundles of mats, or baskets. The tumpline forehead band was constructed by weaving over the hemp warps with wool yarn, using twining for the diagonal lines and plain weave for the triangular areas. Finally the tie lines were braided, gradually reducing the size of the braiding strands in order to taper them to the desired thickness. In the nineteenth century, using these techniques and patterns (Gustafson 1980; Orchard 1926), some Salish weavers made entire blankets from a combination of mountain goat wool and yarn from raveled trade blankets. The style has been revived in Salish weaving today.

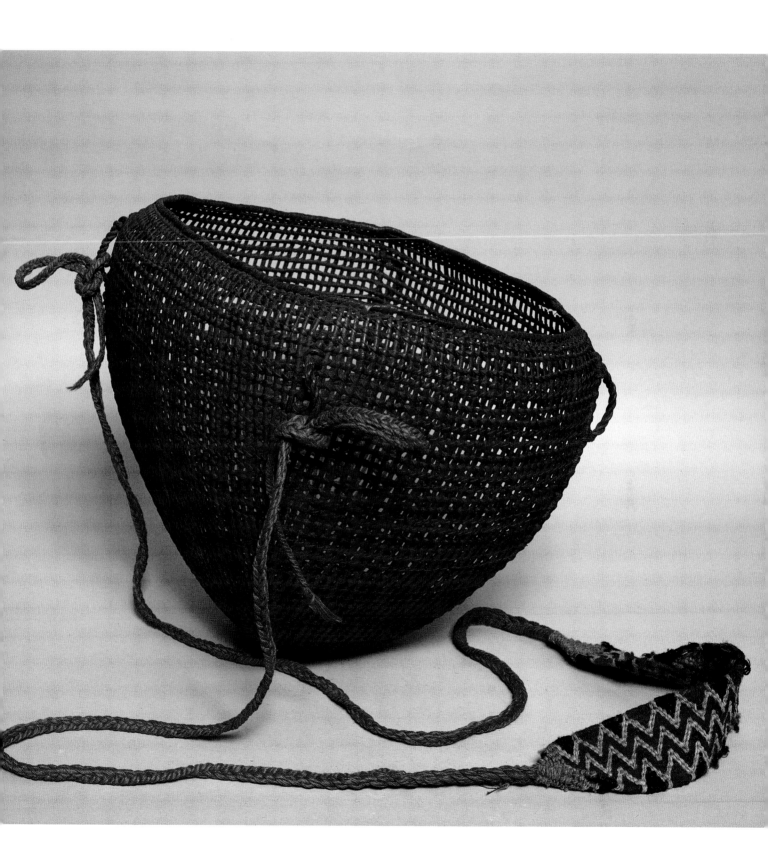

11. Spirit Canoe Figure Duwamish; 19th c.
Red cedar; 130 cm × 18 cm × 15 cm
"Old University Museum"; received 1890; cat. no. 3547

The belief that one of the principal causes of illness was the loss or theft of an individual's soul was widespread throughout the Northwest Coast. Among Puget Sound Salish, such a missing soul was thought to have been taken to the land of the dead, a mysterious country that lay under the earth and was occupied by the souls of those who had died. When such a sickness was suspected, the victim's family arranged for a group of shamans, all of whom had the proper powers, to try to rescue the lost soul. Surrounded by an audience of the assembled villagers, the mission was undertaken inside the firelit plank house typical of Salish villages. A dangerous and difficult canoe voyage was pantomimed by the shamans, mimicking the actions of their helping spirits, which were perceived as making the actual journey through the underworld. All the obstacles they encountered—deep, rushing rivers, windfalls, and the opposition of the ghosts of the dead—were dramatized, until finally the lost soul was rescued and returned to its living owner (Waterman 1930:129–47).

The Spirit Canoe was represented in the house by six upright planks set in the ground in two rows of three. These planks were shaped and painted in accordance with supernatural instructions received by the shaman owners. Set in the ground between the planks were carved cedar figures representing small "ground beings," supernatural helpers belonging to each shaman. The figures were said to represent the actual appearances of the spirit beings. When not in use in the ritual, the cedar figures were kept in secret caches in the forest, and were renewed by repainting each time they were brought out. The figures were very simply carved with a flattened frontal plane, a rounded back, an oval head often with a well-defined neck, and a pointed peg in lieu of legs. The arms, which crossed the chest, were usually merely painted, but in this Spirit Canoe figure they are carved quite naturalistically. This is probably the earliest documented of such figures, coming to the museum around 1890, and although the records from that period are incomplete there is some reason to believe that it may be one of the objects presented to the University of Washington by its president, A. J. Anderson, in the 1870s. The face, a flat oval with sharply cut recess under the brow and long, narrow nose standing out from the concave surface plane, is a common southern Salish form (Wingert 1949: pl. 8–21). The style is so unlike the much more familiar northern sculpture that examples are often not recognized as Northwest Coast.

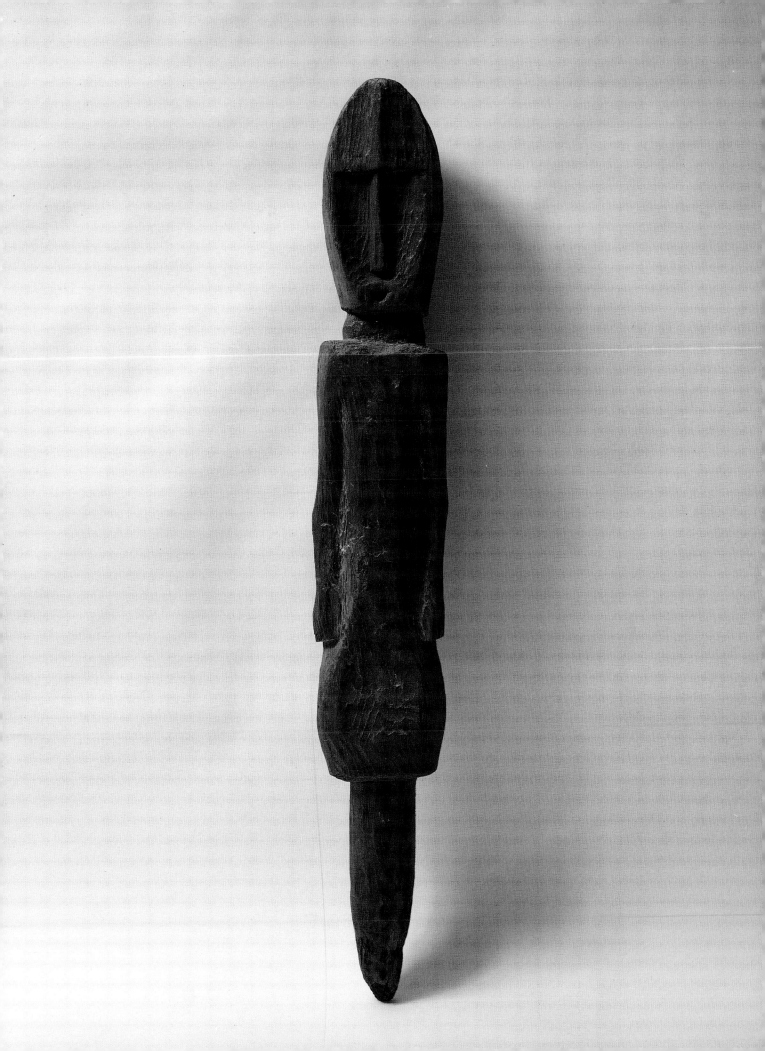

12. **Human Figure** Salish (Waldron Island); precontact

Bone; 7.2 cm × 2.6 cm × 1.5 cm

Gift of Richard and Orphalie Smith; received 1980; cat. no. 2.5E865

On the northern rim of the San Juan Islands, facing Boundary Pass and the Canadian Gulf Islands, lies Waldron. Shell middens on the island confirm its use as a food-gathering place by generations of Salish Indians. Scattered among the shells and black humus of the middens are the lost or discarded household items that tell us much about the everyday life of the ancient inhabitants of such places. But sacred objects, the things of power, are seldom found there. They have been kept apart, hidden in the woods or buried with shamans. Sometimes, by narrowest chance, they are brought to light in our world. A tree felled by a winter wind throws out of its roots a tiny bone man, the size of one's thumb. We have no idea how long he lay hidden there, nor do we know anything at all about why he was carved. It seems clear that this is no mere ornament, but we can only guess about its meaning.

"Waldron Man," as the figure is known in the museum, is carved of dense bone, probably with tools of stone or beaver tooth. He assumes the usual straight, frontal stance of southern Salish and Chinookan sculpture, with flat, oval face and angled shoulders, and with his legs separated and his arms defined by piercing. Subtle, naturalistic modeling of the torso, arms, and thighs sets him apart from the usual sculpture of the area. The representation of a penis also is unusual but not unknown.

Waldron Man's face, whether by chance or design, is remarkably expressive. He seems about to speak. If he could, I would like to hear his story.

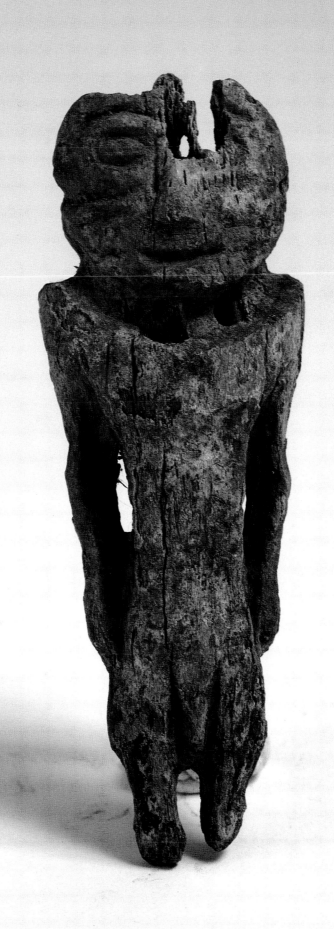

13. **Human Figure** Salish (Sucia Island); pre-A.D. 1200

Elk antler; 7.2 cm × 2.6 cm × 1.5 cm

Gift of Edwin Monk, collected by E. Monk ca. 1950; received 1976; cat. no. 2.5E603

Four miles to the northeast of Waldron Island and marking the southern end of the Strait of Georgia lies Sucia Island. Sucia is a series of long rocky ridges and narrow inlets hooked around a central bay. Surrounding reefs and strong tidal currents led Francisco Eliza, commander of a Spanish expedition of 1791, to name the island *sucia*, meaning "foul" (Meany 1923:295). Uninhabited, isolated, and just inside the United States near the Canadian border, it was, during Prohibition, a popular transfer point for smugglers who made use of the sandstone caves to hide their goods. Some thousand years before them a Salish shaman, perhaps an ancestor of the Lummi people, used one of the Sucia caves as a repository for this remarkable female figure. She remained there unseen by Eliza, the smugglers, and innumerable boaters until 1950.

One of four other similar carved women came from an ancient site at Kwatna Bay on the central British Columbia coast, and the other three from within a thirty-five-mile radius of Sucia Island (Carlson 1983:123–24). Two of these, from village sites on the delta of the Skagit River, are nearly identical to the Sucia figure except for their shorter proportions (Onat and Munsell 1970; Kirk 1978:87). Those that have been dated originated about A.D. 1000. The Sucia woman is the largest and the best preserved of the five.

All of these figures are thought to be shamans' power objects, but there is no real contextual evidence to show that. The naturalism and detail of the Sucia figure make it possible to identify it as a representation of a woman. Fringed kilt, bracelets and anklets, and hair parted in the center on a high forehead are all characteristics of southern Northwest Coast women's appearance at the time of first European contact. The heads of both male and female infants were shaped by controlled pressure in the cradle, but females were usually distorted further; in some Northwest Coast art traditions an elongated head is one of the symbols for a woman. Narrow flanges flanking the woman's head probably represent ears pierced for multiple ornaments, which may have originally been present on the antler figure herself. The Skagit Delta and Kwatna woman figures also have domed foreheads and pierced "ears." Recesses in the centers of the wide, oval eyes were probably once inlaid with shell.

Roy Carlson (1983:124) has suggested that the ovoid joints of her hands may be related to classic northern Northwest Coast art (no. 58) either as part of an art tradition ancestral to northern art or as a result of northern influence. Her broad, outlined lips are also suggestive of that relationship.

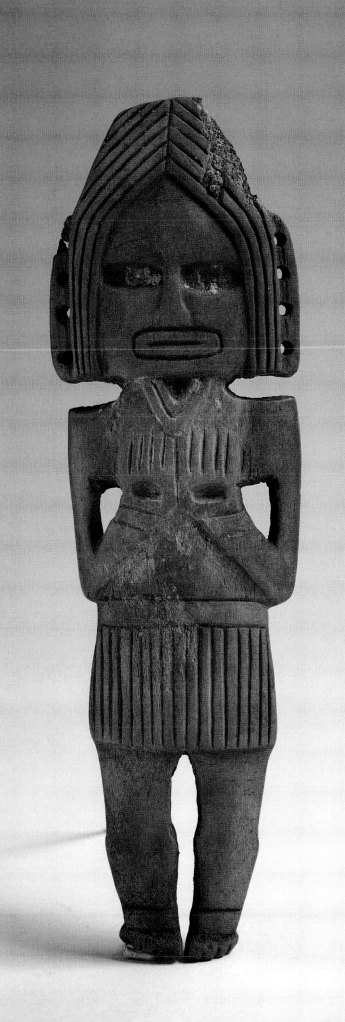

14. Oil Dish Lummi; 19th c.

Alder; 14 cm × 12 cm × 6 cm

Lummi Island, Washington; received 1918; cat. no. 7801

This graceful, elegant little bowl, deeply colored by the seal oil it had absorbed over years of use, was collected from the Lummi of the northern Puget Sound region. Its form—round with flaring sides and upraised, pierced, rectangular flanges—so closely resembles that of mountain sheep horn bowls of the lower Columbia that the two must be related in some way. A similar bowl form, with rows of upraised animal heads in place of the pierced flanges, is found along the coast of the Olympic Peninsula. One of these was recovered from the precontact village excavated at Ozette (Kirk 1978:104).

A universal characteristic of bowls of the Northwest Coast is the undulating rim: high on the ends and low on the sides. Sometimes Northwest Coast bowls are elaborately decorated with sculpture or shallow relief carving, but often their beauty is intrinsic, derived from a triumphant amalgam of craftsmanship, visually satisfying form, and truth to function. This little bowl, very thin and light, with rich evidence of age and use, has this intrinsic beauty.

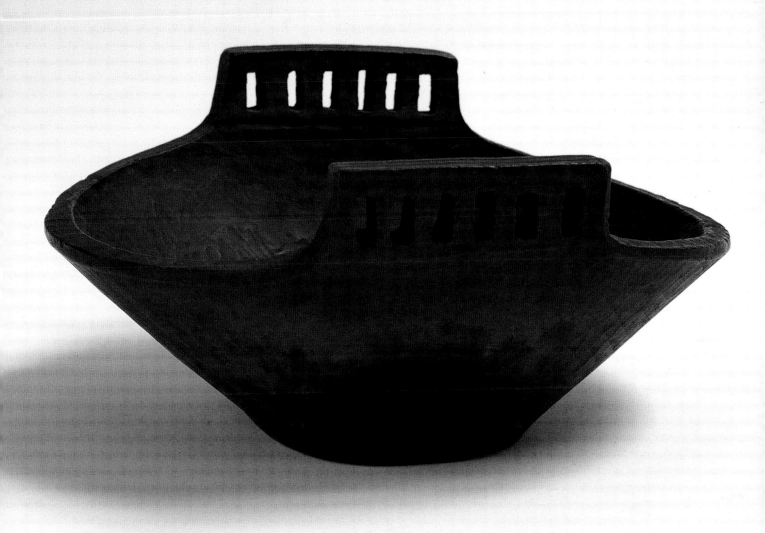

15. Spindle Whorl Squamish (North Vancouver); 19th c.

Maple; 19 cm × 18 cm × 2 cm

Collected by W. F. Shelley ca. 1920; received 1944; cat. no. 1–275

The first Europeans who sailed to the Northwest Coast found the inhabitants wearing robes woven of yarn spun from the white wool of an animal they had never seen nor heard of. If they had glimpsed the mountain goat leisurely browsing along the sheer face of an inlet cliff with no apparent footholds between it and the misty void below, they might have been even more amazed. However, the goat was there, and its meat, hide, horns, and wool were all put to good use by the native people who lived in the shadow of its craggy mountains.

Using a spindle fitted with a large, hardwood whorl, Salish women spun the wool of the mountain goat, as well as that of dogs bred especially for their wooly undercoat. The whorl is a flat wooden disk, which acts as a flywheel to provide the rotational momentum to the rod or spindle necessary to twist the wool fibers into yarn. Most Salish yarn was spun to a large diameter, requiring a long spindle and large whorl. Salish spindles average approximately eight inches (20 cm) in diameter although they may measure as much as twelve inches (cat. no. 1–1478). Not all Salish whorls are decorated, and many are engraved merely with simple lineal and geometric patterns. Spindle whorls from around the Strait of Georgia, however, are often elaborately carved in a style unique to that area and that has some very interesting similarities to classic northern coastal art (Suttles 1983:14, fig. 4; Feder 1983; see also p. 148). The figures depicted on spindle whorls are not merely decorative but relate in some way to ritual purification, although their exact meaning is unknown (Suttles 1983:86).

This spindle whorl is of average size. It appears to have once been wider and to have been reshaped to smooth the broken edges. Two human figures crouch with their feet encompassing the spindle hole. They are depicted in considerable detail, with fingers and toes defined by incised lines. The figures themselves are not outlined, their limits merely suggested by the fins of the surrounding fish-like carvings. The relationship of this carving style to that of the north can be seen in the crescentic grooves that have been used to outline the corners of the mouths of the fish and the humans; in the recessed U-forms with enclosed wedge-shaped incisions, which correspond to tertiary split-U's in the north; in the T-shaped relief cuts defining the wrists; and in the ovoid eyes with their pointed eyelids. In the past it was assumed that these features were late copies of the sophisticated northern system of design, but many now believe that they represent basic design concepts underlying both art traditions.

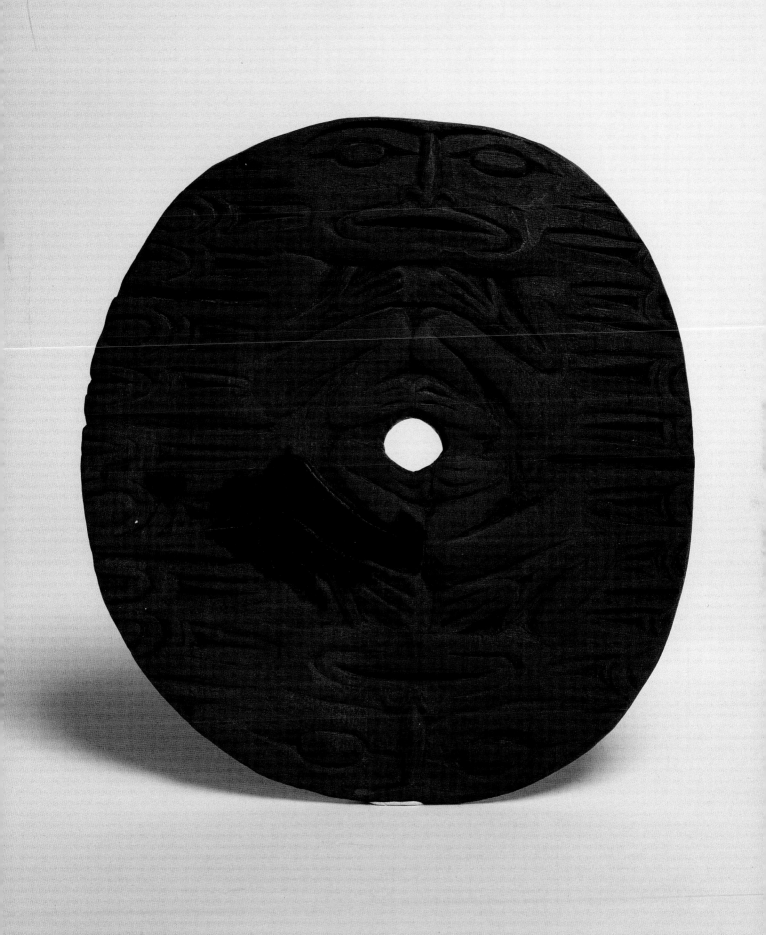

16. Cattail Mat Creaser Cowichan (Kenipsim village); 20th c.

Maple; 16 cm × 7.5 cm × 4.5 cm

Collected by Barbara Lane in 1951; received 1951; cat. no. 1–974

Acres of cattails grow in the marshes of the Salish country, close contenders with cedar bark for the title of most important fiber in the lives of the Salish people. From the leaves, which were gathered by thousands in the summer, ingeniously made mats were constructed. These mats became mattresses, carpets, "tablecloths," kneeling pads for canoes, raincoats, house partitions and insulation, and the walls and roofs of summer shelters. Some cattail mats were small, those used as pads in canoes and as lap covers while fishing, for example. Others were as much as a fathom wide (the length of outstretched arms, about six feet) and three fathoms long. Many were made double with elaborately braided selvages, so that they were thick and springy for comfortable mattresses.

The manufacture of a cattail mat required two tools: a long, very hard wooden needle made of a splint from the shrub called ocean spray (*Holodiscus discolor*), and a mat creaser of some hard wood, often maple. The needle, flat-triangular in cross section, was threaded with a cord plied of the cortex of the cattail leaf, and then used to pierce through a series of the dried leaves. While the needle was still in the leaves, the creaser, which has a smooth, shallow groove the length of its lower edge, was pressed over the needle and slid along its length. The edges of the groove creased the leaves on each side of the needle, minimizing splitting when the cord was drawn through. More leaves were pierced and sewn until the mat reached the desired length. Sewing was repeated across the width of the mat, leaving a pattern of parallel ridges formed by the creasing of the sewn lines.

Mat creasers are almost always elaborated by carving, and often take the form of a bird. Usually they are quite flat, but this one has the hand-comfortable shape of a fat duck. The bulbous body and smoothly sculptured head and tail are reminiscent of some Salish rattles. The creasing groove curves upward over the duck's breast, the shallow inverted-V surface smoothly polished from use. Commercial paints in yellow and black define the tail, bill, and wings on a bright blue body. The yellow and black five-pointed star is an unusual touch.

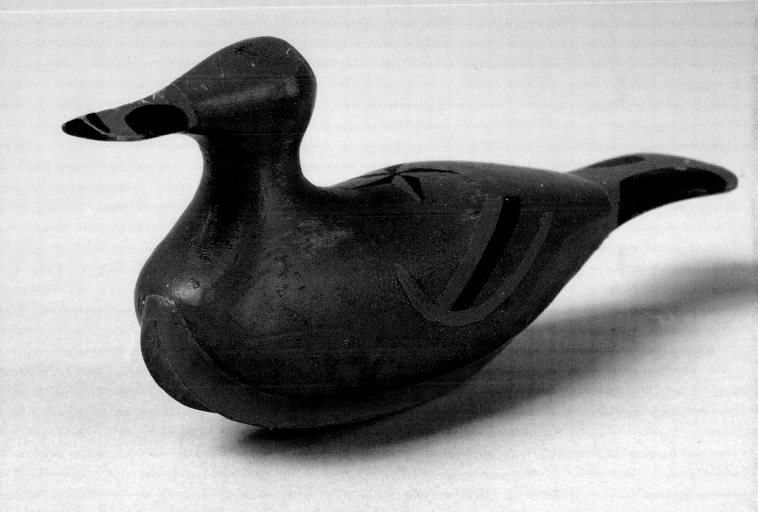

17. Coiled Basket Thompson?; early 20th c.

Cedar root, beargrass, cherry bark; 56 cm × 37 cm × 40 cm
Caroline McGilvra Burke; received 1932; cat. no. 1–846

This large, lidded basket of coiled cedar root was identified by Mrs. Burke as Cowichan. She could very well have collected it from that Vancouver Island tribe, although it probably was made on the mainland by a basket maker of the Thompson, who are Salish people living up the Fraser River and its tributary, the Thompson. The Fraser is another of those few available routes of contact and trade from the coast to the interior; the upriver tribes share an environment and many culture traits with their Columbia Plateau neighbors, much as the upstream Columbia River relatives of the Chinook are culturally plateau people. The Fraser River basket makers were renowned for their coiled basketry; many of the baskets used by the Cowichan and other Vancouver Island tribes were acquired from them in trade.

Coiling is a basketry technique widespread on the Columbia Plateau and in the Puget Sound basin. The usual material is split cedar root for the foundation of the coils and for the sewing strand, which joins the coils into a firm basket form. Leaves of beargrass and strips of cherry bark make up the decoration. With a long strand split from the smooth outer root surface, a bundle of split roots is sewn tightly to itself in an ever-enlarging spiral. A sharpened bone awl is used to pierce the edge of the preceding coil and its close stitching. The Thompson and some of their neighbors sometimes use flat splints of cedar, instead of the bundle of split root, as the foundation of the coiling. The bottom of this particular basket is constructed of splints tightly sewn with cedar root. On some baskets these tight stitches of cedar root are exposed over most of the outer surface except for the design areas, which are covered by catching tucks of beargrass or polished cherry bark strips under the stitches in a technique called "imbrication." Other baskets, like this one, are completely covered with imbricated designs, the light areas consisting of beargrass leaves and the red and black of natural and dyed cherry bark. There is a near mate to this basket in the Denver Art Museum (Conn 1979: fig. 331).

The large, covered hamper form of basket is an introduced one, very successfully achieved by the Salish, but not without the need to invent a new technique. It would have been an extremely difficult—if not insurmountable—task to match the basket and lid design perfectly if the lid were begun at its center and coiled outward to meet the basket rim in the traditional method of Salish basketry. Instead, the lid was begun at the end of the last coil of the basket side and coiled *inward* until at its center the final coils were sewn together, in this case, with cotton cord. An inner flange was built on the basket rim to seat the lid. The presumed sequence of technique can be substantiated by noting that the coiling stitches of each row always pierce the preceding row, which in the lid is the one toward the rim.

Cedar root coiling was used by many Salish groups to produce cooking utensils, berrying containers, burden baskets, cradles, and other utilitarian forms. As in this hamper, many of these were beautifully decorated with imbrication. They were prized by Indians on many parts of the coast and are often found far from their places of origin.

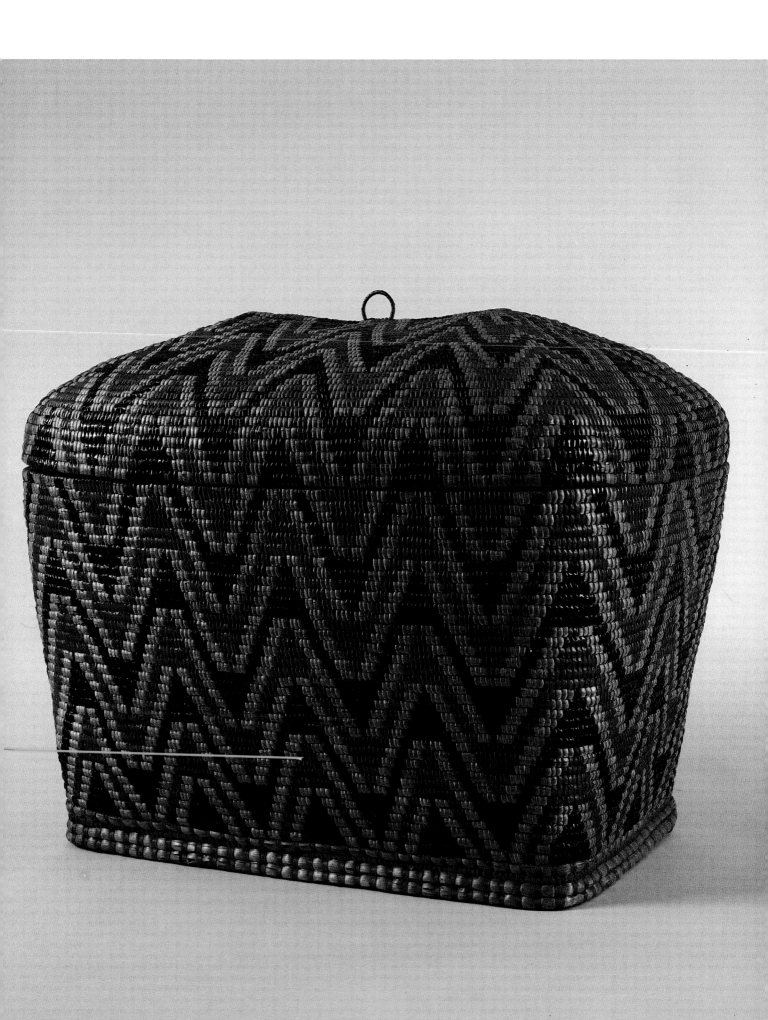

18. Spirit Dance Tunic Cowichan; early 20th c.

Woolen cloth, beads, maple wood, metallic braid, brass buttons; 150 cm × 81 cm
Collected by Erna Gunther in 1937; received 1937; cat. no. 1–11479

Winter is the time when the spirits that inspire humans to dance move through the Salish country. Some of these supernatural forces bestow great skills or powers upon those who become associated with them, while others work only for the well-being of their hosts (Jenness 1955:48–64; Amoss 1978:48–73). Not every person has such a contact with a spirit. Some strive for an association through ritual purification, fasting, and seeking the spirit in places known to be filled with power. To others, contact comes spontaneously, often unbidden and sometimes unwanted. And it is forced by ritualists upon some to whom it is seen as beneficial. The visible result of each of these spirit contacts is the apparent sudden illness of the recipient, his singing of a song given by the spirit, and a dance compelled by the spirit which renews his well-being. Singers, who are usually themselves spirit dancers, beat large, single-headed drums to accompany the dance which, with its song, refers cryptically to the character of the motivating spirit. This whole procedure of initiation and subsequent dancing is complex and forms an important part of traditional Salish religious life.

The Winter Ceremonial, of which spirit dancing is the principal activity, is a very important part of the social and spiritual world of the northern Washington and southern British Columbia Salish people. Traditionally, the dances take place in a long, earthen-floored building, locally called a "smoke house," with a central row of crackling fires reflecting from the beams and rafters and lighting the faces of the assembled people ranged on platforms along the walls. Spirits come to each dancer in turn, and each performs alone, followed by a cluster of singers with resonant drums, which can be heard, with the rising and falling song, far from the smoke house. Inside the walls the rhythmic pulse virtually lifts the watchers in their seats. In a large gathering the dancing may go on all night, with spirits coming to dancers in overlapping sequence. Watching the ceremonial is a powerful sensory experience now rarely available to outsiders, for the smoke house, increasingly active in the last decades, has become increasingly private to the Salish.

The dress of each dancer is personally prescribed by his guardian spirit, but there are patterns that can be seen. This tunic is of the sort worn by a seasoned dancer, past initiation. Along with it he wears knee-length trousers and knit or crocheted leggings. Buckskin fringes tipped with deer hooves, which clatter as he dances, ring his ankles and calves. If he is a "blackface" dancer, motivated by one of the aggressive spirits, his headdress is usually of cascading human hair, fastened to a conical cap and falling to the waist in the back and over his eyes in the front. At its peak two eagle feathers, lightly tied to an ingenious swivel, twist and twirl with each movement. Usually black, the tunic is decorated with bead embroidery, which may have reference to the dancer's spirit power. Rows of hardwood pendants, miniatures of ancient war clubs, fringe the shirt and clatter together in the dance. These pendants vaguely resemble canoe paddles and are sometimes referred to as "paddles" today. This tunic is a particularly fine one, with beautifully designed and executed beadwork in a pattern of stylized flowers, eagles, and eagle feathers. The Salish are not well known for their beadwork, but examples such as this one prove that they were capable of producing the art at its highest level. The shirt was said by its Cowichan owner to have been sixty years old in 1937 when it was purchased from him by Dr. Erna Gunther, then director of the Washington State Museum (now the Burke Museum).

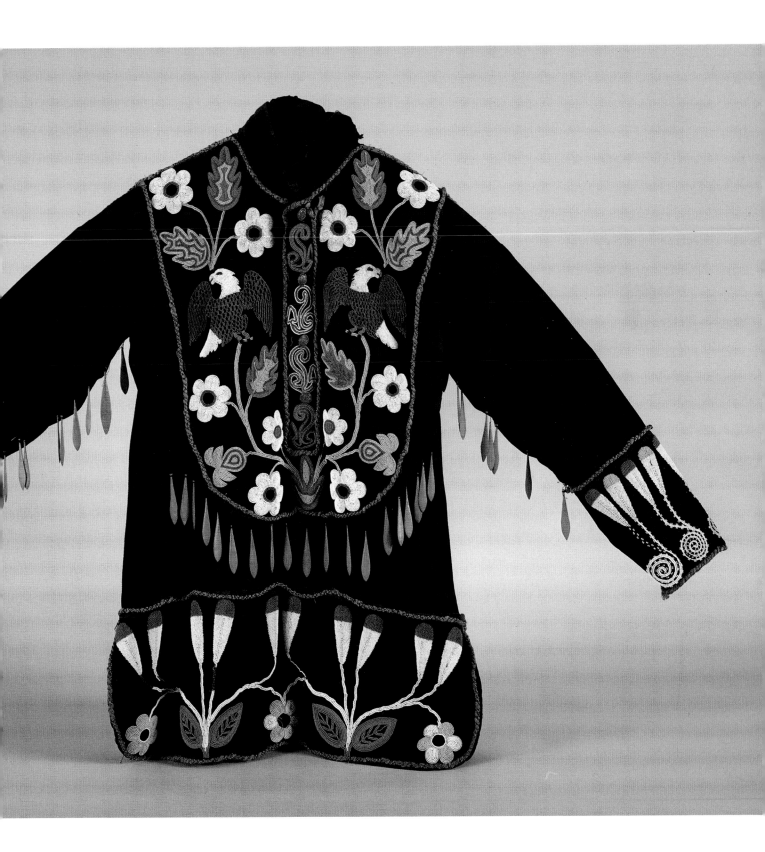

James G. Swan in his Port Townsend study, with some of the objects that he had collected for the Washington World's Fair Commission and that subsequently came to the Burke Museum. Among them is the Clayoquot dance robe (no. 29). *Photo: Washington State Historical Society, Tacoma.*

The Westcoast People Nos. 19–29

T he stretch of coast from the Brooks Peninsula, near the northwest end of Vancouver Island, down to the outer corner of the Olympic Peninsula in Washington is home to those tribes who share variants of the Nootkan languages and an orientation to the wild, open Pacific. They were the intrepid seamen-whalers of the Northwest Coast. In summer their villages crowded close to the outer coast, while in winter the people moved to their great plank houses in the more sheltered recesses of the sounds and inlets. There in the firelit sanctuary of those massive houses, the myths of family ancestors' adventures were dramatized in masked dances. These ceremonial pageants are more closely akin to those of the Kwakiutl of northeastern Vancouver Island, the Westcoast tribes' linguistic relatives, than to the dances of their Salish neighbors to the east. The graphic arts of the Westcoast people are also more northern in concept. In fact, a rather clear line separating the art and ceremonial traditions of the southern and the central coast can be drawn between the Nootkan and Salishan speakers of Vancouver Island.

The name "Nootka," which Captain James Cook mistakenly applied in 1778 to the Moachat people and their home territory of Nootka Sound, has been broadly applied to all the tribes speaking closely related languages along the west shore of Vancouver Island. Native people of western British Columbia, when speaking English, have used instead the term "Westcoast" to refer to those tribes. Today Nootka is not an acceptable name among the people themselves (except as "Nootkan," a linguists' term referring to the language family). The preference is Westcoast or "Nuu-chah-nulth," meaning "those living at the foot of the mountains," a name adopted by the combined Tribal Council in 1980 (Arima 1983:v). The southernmost of the Nootkan-speaking tribes is the Makah. These people occupy the northwestern tip of the Olympic Peninsula in Washington State, across the Strait of Juan de Fuca from their Vancouver Island relatives.

In the Burke collections, the majority of artifacts that could be called Nootkan are actually Makah, from the area of Cape Flattery and Neah Bay. James Swan, who collected many of them, lived intermittently in Neah Bay for nearly thirty years and knew the Makah well. Although the Makah and their Canadian cousins had been in contact with Euro-Americans since the eighteenth century, many of their old ways were still in force in Swan's time; he was able to collect good examples of artistic and utilitarian objects for the Smithsonian Institution as well as later for the Washington World's Fair Commission, the source of the Burke specimens. A few further pieces have come from the Young Naturalists' Society's collection.

19. **Hand Adze** Makah (Ozette village); late 19th c.

Oak, steel, cotton cord; 30 cm × 11 cm × 4.5 cm

Collected by W. D. Johns at Ozette around 1904; received 1922; cat. no. 7154

The village of Ozette, where this adze was collected early in this century, was the southernmost village of the Makah, occupying Cape Alava. The cape, which projects further west than any other land in the contiguous United States, was a favored place for whale and fur seal hunting and was occupied for many centuries until it was finally abandoned as a permanent village in the 1920s. An archaeological survey in the 1960s revealed the existence of buried house ruins; in 1970, following the exposure of many ancient artifacts in the storm-eroded bank, a full-scale excavation began. The result was the recovery of complete houses, smashed and buried by a massive mudslide several hundred years ago, before the first Europeans arrived on the Northwest Coast. Preserved by the oxygen-excluding Ozette clay, thousands of artifacts survived, enormously enlarging our understanding of ancient Makah life. Many of these objects, although precontact, are almost impossible to distinguish from those collected by James Swan at Neah Bay in the late nineteenth century, suggesting great cultural stability and conservatism.

Wood was the prime material of Westcoast culture and, as much as any Northwest Coast people, the Makah excelled in the skills of woodwork. The hand adze (or D-adze) is both an end of and a means to those skills. It is a versatile and efficient tool for shaping almost any form and for finishing surfaces with the texture of regularly spaced rows of crisp chips: at once the natural track of the tool and a tactilely and visually exciting surface. At the same time, the adze itself perfectly exemplifies Northwest Coast wood sculpture with its easy combination of function and form. Fit to the hand and effortlessly natural in its use, the unadorned handle is sculpture. But carvers often expanded that basic, functional design with representational or abstract elaboration, in the Northwest Coast artists' way. Here the extension of the handle both physically and aesthetically balances the blade. The pierced circle set in a teardrop recess suggests the eye of an animal's head with upturned snout or, if inverted, a hooked-beak bird. Although oak is not found in the Makah country, this adze appears to be fashioned from it. Native to southern Vancouver Island and the San Juan Islands, oak also would have been available to nineteenth-century Makah carvers from ship timbers or other European or Euro-American sources. Long use has polished the oak and deepened its color.

D-adzes with nephrite blades have been collected, but stone gave way to steel at the end of the eighteenth century. Many blades are cut-down axe heads, lashed to the grip with cordage of sea lion intestine, spruce root or, as in this adze, commercial cotton seine twine. The modified axe head, with its eye, has the advantage of protecting the binding cord from being damaged by striking the work. Some blades with long, extremely narrow eyes may have been blacksmith-made especially for use as adzes.

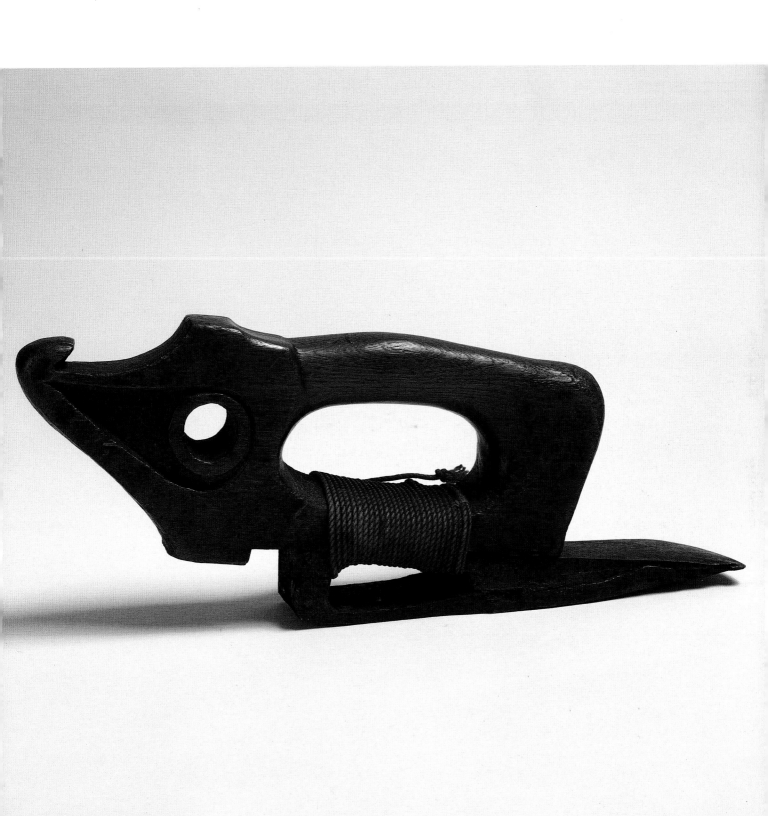

20. **Oil Dish** Makah (Cape Flattery); 19th c.
Alder; 21 cm × 12 cm × 8 cm
Young Naturalists' Society; cat. no. 4652

All along the Northwest Coast, native diet included oil rendered from fish and sea mammals. The Makah used oil rendered from the fat of seals, sea lions, and whales for their "grease." Especially prized by all coast dwellers was the oil of the candlefish or ooligan. Since this fish was not available directly to Makah fishermen, any of its oil used by them had to be acquired by trade from tribes with access to ooligan spawning streams. Fish and sea mammal oil was used as a condiment with other foods as well as a major ingredient in preserving berries and meats. When used to flavor dried or roasted fish, the oil was served in small dishes or bowls into which the pieces of food were dipped. Many of these grease dishes were of simple bowl form (no. 14), but hundreds of bowls carved more elaborately as animals, birds, and humans have been collected from different parts of the coast. Some of these animal-form bowls are shaped as hollowed sculptures of the creature represented; others are conceived primarily as a bowl with legs, head, and tail appended (Holm 1974:29–30, pl. 1–27).

This little beaver is of the latter type. The beaver's body forms an oval bowl with typically undulating rim, higher at the ends. Its surface is covered with the fine fluting often seen on Westcoast and Kwakiutl carvings, even those dating back to the earliest collected by Cook in 1778. The grooves were made with the curved-bladed "crooked knife," or probably with the beaver tooth knife in precontact times, the carver taking tiny diagonal chips in rows, much as he used the adze to finish surfaces on a larger scale. Characteristically, the grooves follow the contours of the sculpture. The beaver's head is smooth-contoured in typical Westcoast style, with raised snout, small ears, and enormous incisors, all natural features of the beaver and of beaver symbols in Northwest Coast art. A broad, crosshatched tail reinforces the beaver image. The four stumpy legs supporting the bowl are a feature fairly common to southern and central coastal bowls; northern coastal bowls usually rest on their stomachs with legs either extended or carved in relief on the sides.

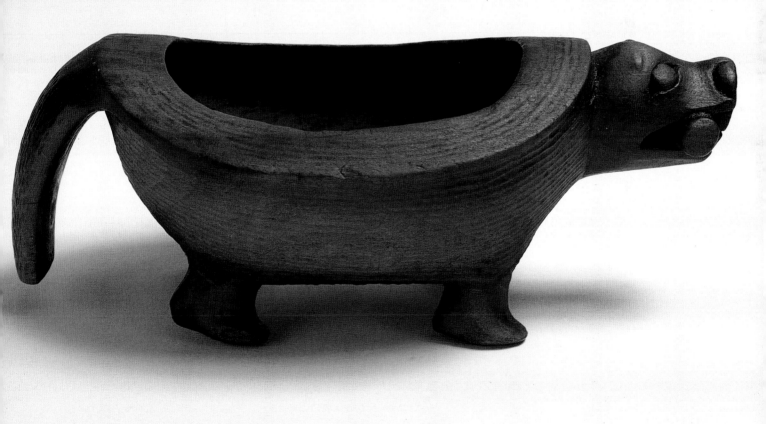

21. **Canoe Bailer** Makah; early 20th c.

Red cedar; 22.7 cm × 15 cm × 10.5 cm

Collected by S. W. Hartt; received 1913; cat. no. 4617

No canoe on the Northwest Coast can be without a bailer. Sloppy, steep seas, windblown spray, and rain make for wet bilges. Cracks and checks develop in thin, unframed hulls, strained to the limit by steam-spreading and vulnerable to the drying wind and sun, especially when the canoe is beached. Regardless of how carefully those cracks are patched and caulked, water seeps in. A canoe, no matter how perfectly designed and skillfully handled, can take green water over the gunwales. Paddlers need the means to get it out.

Northwest Coast bailers all work on the principle of the scoop rather than of the bucket. Water is thrown out of the canoe rather than dipped out. The bailer is made with a straight edge, which is slid up the inside of the flaring hull, catching the water and flinging it over the side. Bailers of the northern coast resemble sugar scoops; those of the Salish south are either spoon-like with pointed, diamond-shaped bowls, or scoops formed by ingenious folding and pleating of red cedar bark. This wedge-shaped style of bailer is unique to the west coast of Vancouver Island and the Olympic Peninsula.

The Westcoast bailer is a wonderful example of design resulting from tool use and function. A triangular block of suitable wood is split out with wedge and maul and shaped to its flaring form with an adze (no. 19). The same tool is used to hollow the inside to its final shape. This adze can shape the flat inner sides of the bailer but it cannot level the bottom, so the carver leaves a graceful ridge that gradually merges with the flattened end walls (below). Finally he grooves the outer bottom and anchors a loop of twisted cedar withe in the groove with a transverse peg (now missing from this bailer). In using the bailer, the paddler grasps the loop with the fingers and the upper edge with the thumb. The bailer forms a broad scoop which is thrust into the bilge and swiped up the side of the hull, stroke after stroke, until the water is removed.

Ordinary tools, the foundation of Northwest Coast material culture, shaped by need and the unique bite of a blade, are among the most elegant of artifacts. The Westcoast bailer is a perfect example of this melding of function and technology.

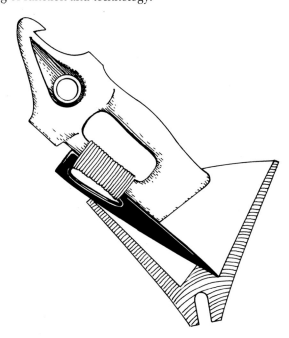

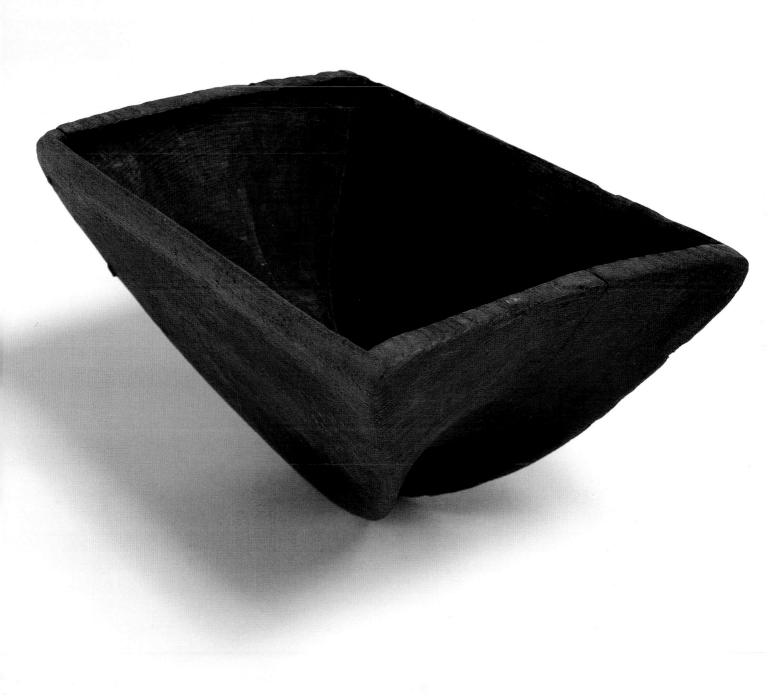

22. **Canoe Model** Makah (Cape Flattery); late 19th c.

Alder; 55 cm × 22 cm × 11 cm

Collected by James T. White ca. 1894; gift of Mrs. J. T. White; received 1912; cat. no. 4659

Expressive, action-implicit sculpture is much more a part of the art traditions of the central coastal people than it is of the better-known art of northern British Columbia and Alaska. In this elegant little Westcoast canoe, a high-ranking chief stands and invites the viewer to his potlatch. Cavernous mouth and exaggerated gesture emphasize the importance of his speech. His companion is less easily explained. We expect a paddler, but instead find a puzzling figure with either an enormously elongated red and blue tongue, or some writhing object held in his mouth. This, along with the peculiar position of his hands and arms, suggests that there is some specific symbolism, unknown to us, present here.

These two figures are clearly across that stylistic boundary line separating the southern from the central coastal sculptural traditions. Instead of the typically southern, flattened oval face with small eyes under straight-cut brow favored by Salish and Chinookan artists, the faces of these Makah canoemen are of a deep, prismatic form, with large, round eyes centered in open, pointed lids. Trade paint in blue and vermilion defines the features and colors the face of the chief in an asymmetrical pattern typical of Westcoast mask painting. His hat is of the northern pattern with its flat top, flaring brim, and formline-like painting, an unusual but not unknown style for the Makah (Devine 1980:102–4).

The canoe is a fine little model of the Westcoast seagoing type, in use from below The Dalles to the north end of Vancouver Island and in all the inland waters of Puget Sound and the Strait of Georgia. The Makah and their Westcoast relatives across the Strait of Juan de Fuca were the master builders of this style of canoe. Its seaworthiness was often praised by early writers, many of whom were seamen themselves and good judges of a boat's qualities. The proportions and lines of the Westcoast canoe, especially the bow, are subtle and complex; very few artists have portrayed them properly. Except for the snout or "tongue" and the small, angular projection at the throat, called by the Makah the "uvula" (Waterman 1920:18), each detail of form is functional. Anthropologist T. T. Waterman glowingly described the perfection of canoe design in his 1920 study, *The Whaling Equipment of the Makah Indians*.

Bow and stern pieces are so slender that they hardly seem adequate to keep off the seas. They have probably been reduced, as a result of long usage, to the slenderest design which will fulfill the purpose. Yet even in their present form they are highly useful. I dare say that their reduction to their present slender proportions has been equally for the artistic effect of delicacy, and for the practical consideration of reducing the total weight of the boat. The Indians have reached in this feature of the canoe what seems to my mind the highest artistic success, the making of what is a commonplace and practical contrivance, also artistically beautiful. (Waterman 1920:19)

The painting on this slender, dynamic bow is the work of an artist who was influenced by the formline designs of the northern coast (no. 58). Other examples thought to be his work illustrate this same tendency. Some of the deep, ultramarine blue has worn off, leaving a pale stain. Paint was mixed as used, and it may be that those areas had too lean a mixture of the painting medium, probably salmon egg oil.

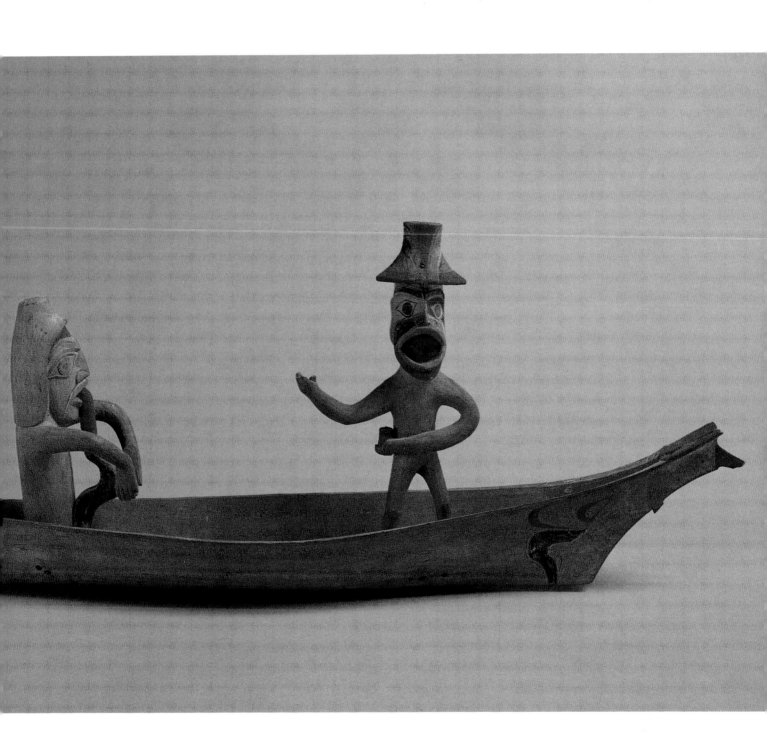

23. **Whaling Model** Makah; late 19th c.

Alder, mussel shell, bone, string; 79.5 cm × 17.5 cm × 17 cm (canoe),
35 cm × 13 cm × 7.5 cm (whale)

Washington World's Fair Commission, collected by James G. Swan at Neah Bay; received 1893;
cat. nos. 96, 97

It seems likely, although there is no record to substantiate this, that James Swan commissioned this model of the whaling crew with the harpooner about to strike the whale. Swan was impressed with Makah whaling, and he wrote about it in glowing terms. He collected examples of all manner of whaling gear—harpoons with their barbed points, lanyards, lines and floats, their special sheaths and storage bags of cedar bark, and the bailers and paddles of the canoe. This jaunty model explains it all.

Whaling canoes were about five fathoms long and carried a crew of eight: a steersman, six paddlers, and the harpooner who was the leader of the crew. These bright blue whalers, all carved in one piece with the canoe, are ready at their stations. Behind the harpooner, with his long shaft tipped with mussel shell point, stands a crewman poised with the killing lance. The other crewmen wield paddles or prepare to throw out the four sealskin floats which, attached to the hundred-fathom-long line of twisted cedar withes, slowed the whale and inhibited its diving. Indian whaling ceased early in this century, but the whole heroic venture has been recorded in detail (Waterman 1920:38–47; Curtis 1916:16–40; Drucker 1951:48–56).

The little whale is one of the more naturalistically carved in Northwest Coast art, but even if it represents a minke whale, the smallest of the finbacked baleen whales known to the Makah, it is only half as long as it ought to be in relation to the canoe. Designs painted on the canoe are more typical of Makah art than those on the small model (no. 22). Crosses and rows of dots, and broad S- and U-shapes joined in pairs characterize this style. If they have special significance, it is no longer known.

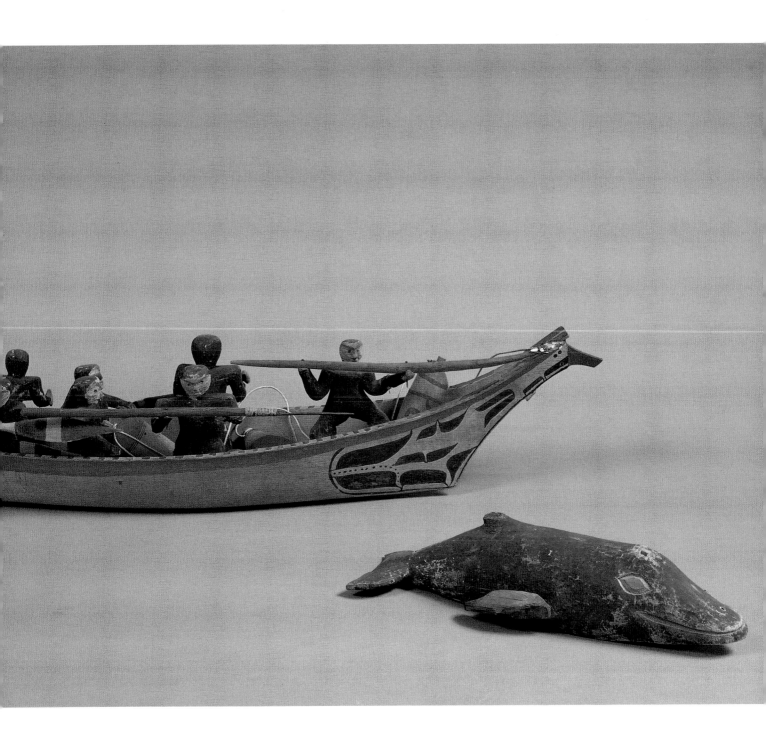

24. **Whaling Float** Makah; late 19th c.

Hair-seal skin, sinew, wood, cedar withe; 87 cm × 39 cm × 36 cm

Washington World's Fair Commission, collected by James G. Swan; received 1893; cat. no. 222b

Wood, stomachs, bladders, and skins were used by Northwest Coast fishermen and sea hunters to make floats of many sizes. The largest and most impressive were whaling floats made of the skins of hair, or harbor, seals. The seal was skinned by cutting around the head, around each front flipper, and just ahead of the hind flippers, so that there were only four openings in the cylindrical hide. The fat was carefully scraped from the skin, which was turned with the hair side in; the four holes were sealed by gathering the edges around plugs and lashing with sinew or gut. One flipper-hole plug was pierced to allow the skin float to be inflated for use. A yew wood stopper closed this hole. A long cedar-withe line was attached to the stoppers at each end of the float. This line served to fasten the float to the harpoon line. Red and black designs, which were individually owned by each whaler, were painted around the plugs (Drucker 1951:29–30). Painted designs on most whaling floats are similar to these. Concentric circles in various combinations of red and black, with simple geometric elaboration, make up the patterns. Diamond-shaped feather designs, singly or in clusters, appear on many floats.

Four of these floats made a set, and extra floats tied to a second line and point were carried in the canoe, to be inflated after the first harpoon had been thrown. Usually the whale would be harpooned several times, often by different crews, before it could be killed. The extra floats were also used to buoy up the whale for ease in towing. If all went according to plan, and if the ceremonial preparations had been correctly made, the whale was expected to tow the whalers toward their village. But frequently it took a contrary course, and long, hard paddling lay ahead for the crews. A whale floating high was much easier to tow than one deep in the water.

Ninety years away from the damp of Cape Flattery have dried the cedar-withe line to the point of brittleness. The tapered, trailing ends that linked it to the harpoon line are gone, but the regularity of the three-ply line is still apparent and impressive. When we recall that the total length of line in the harpoon gear is some two hundred times what we see here, we have a measure of Westcoast skill and technical resourcefulness.

25. Basket Makah; 20th c.

Cedar bark, grass; 37 cm × 19 cm

Gift of Pendleton Miller; received 1965; cat. no. 2.5E15 a, b

The basketry technique known as wrapped-twining, widely used to produce openwork burden baskets (no. 10), was also elaborated to enable the weaving of decorated storage and trinket baskets. Finely woven wrapped-twined baskets, embellished with geometric and animal figures, were collected by the Wilkes expedition on the lower Columbia River in 1841 (Marr 1984:49–50); wrapped-twining was clearly a well-established technique there by that time. In the Makah country, however, it seems that the mid-nineteenth century marked the beginning of decorated wrapped-twined basketry.

Finely woven basketry hats elaborately figured with whales, canoes, thunderbirds, and intricate geometric patterns were being made by the Westcoast people when Europeans first arrived on the coast, and were illustrated and collected by those early mariners (King 1981: nos. 91–94; Vaughan and Holm 1982:32–33). But these hats, which superficially resemble wrapped-twined work, are actually quite different in technique and materials from the late nineteenth- and twentieth-century Makah and Westcoast basketry. White settlers' interest in baskets may very well have been a motivating force in the development of decorated wrapped-twined baskets by the Makah. Certainly thousands of them were made for sale, and most of those were small, quite fragile trinket baskets, more decorative than useful.

There is a popular notion that objects made for sale are, almost by definition, bound to be inferior technically and artistically to those produced for the use of the makers. Much of the mass-produced "tourist art" we see around us reinforces that idea. Yet many of the fine Northwest Coast baskets in collections, if not the majority of them, were made for sale to Euro-American buyers and were never used by the Indians themselves. Some of the finest examples of the basket makers' art are Makah trinket baskets (Holm 1983a: no. 72).

The whales and canoe-loads of hunters endlessly circling Makah baskets are a legacy of design coming down the century from the famed whalers' hats of old. One of the largest wrapped-twined baskets known, this one adds a fresh twist to the time-honored theme. In a scene depicted on many baskets, the Makah hunters' canoe, towed by the harpoon line, rides the wake of a great whale. But the whale, in turn, is being towed by a steamboat, or perhaps a craft driven by the one-cylinder gasoline engine that powered many Northwest work boats in the early years of this century. Four anchors on the basket lid complete the modern nautical theme.

Technically, the basket is a tour de force. Most Makah wrapped-twined baskets are one-third this diameter, or less. Large baskets are much more difficult to keep regular in form. The typical diagonal texture results from the constant Z-pitch of the wrapped twining, which inclines the warp to the left. In contrast, Lower Columbia basket makers characteristically used an S-pitch, giving a right-hand slant to their weave. The lid is perfectly flat, requiring careful division and addition of warps. Makah basket makers had ample opportunity to perfect the technique of flat weaving, for they produced stacks of round and oval doilies for sale.

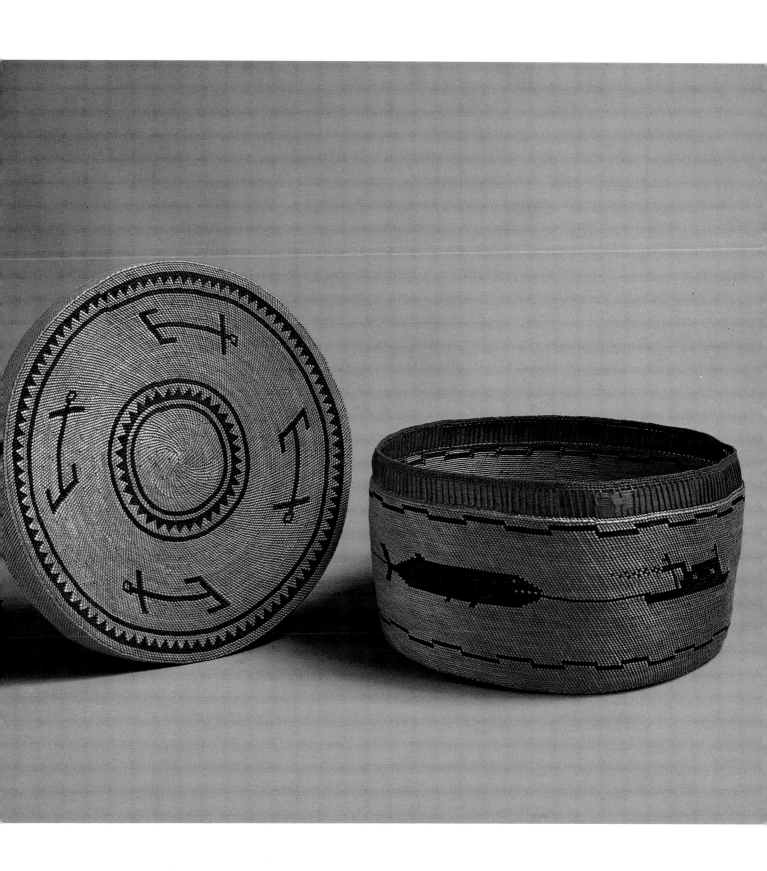

26. Halibut Hooks Makah; late 19th c.

Wood (fir?), bone, spruce root, sinew, nettle fiber; 15.5 cm × 10 cm × 2 cm

Collected by James T. White at Neah Bay, gift of Mrs. White; received 1912; cat. nos. 636, 637

The good life of the Northwest Coast was everywhere dependent on the efficiency of fishing techniques. Even for these expert sea mammal hunters the mainstay of diet was fish, so that fishing technology was surely the most highly developed aspect of the culture. Weirs, ingenious traps, nets of all kinds, and myriad hooks—each type designed to catch a particular fish under particular conditions—made the harvest possible (Stewart 1977). Early European explorers deplored their own inability to catch fish sufficient to their needs, and were frustrated at their dependence on the native fishermen who supplied them with plenty, caught with what seemed like crude gear. William Beresford wrote (Dixon 1789:174–75), "Thus we were fairly beat at our own weapons, and the natives constantly bringing us plenty of fish, our boat was never sent on this business afterwards."

Halibut are flat fish that feed close to the bottom at offshore banks, and which can attain a weight of two hundred pounds. They are powerful, and Indian fishermen in their small canoes, often far from land, took care not to catch one that was too big to handle. The hooks were size-selective, too big for small fish and too small for those of unmanageable size (no. 91). The halibut hooks of the Makah and their neighbors, for whom the white-fleshed fish was a staple of life, were of a graceful U-form, bent of wood and armed with a barb of bone, or later, iron. The usual material for the hook itself was fir or hemlock, typically split into a long, triangular splint from the imbedded butt of a branch in a rotten log. This slip of dense, heavy wood was steamed in a kelp stem and bent into its flowing shape by hand or with the help of a wooden mold. The barb was securely lashed with a band of split spruce root, following a fixed, traditional pattern of winding that was at once very strong and visually pleasing. Although iron was in common use at Neah Bay when these hooks were made, Makah hook makers continued to use bone for the barbs into the twentieth century. The hooks were not decorated in any way, but the combination of an elegant shape and the contrasting colors and textures of white bone, patterned lashing, and polished red-brown wood make them among the most visually satisfying products of Northwest Coast culture.

In use, the short snell of sinew or nettle fiber was tied to a leader, which in turn was fastened to a wooden spreader designed to keep the hook free of the sinker-weighted line of kelp stem. Wooden or inflated bladder buoys kept the line vertical. Strips of octopus tentacle were tied to the base of the barb for bait. Some modern hooks are made entirely of steel, and are frequently adapted from commercial gaff hooks, which require only simple modification to match the traditional shape.

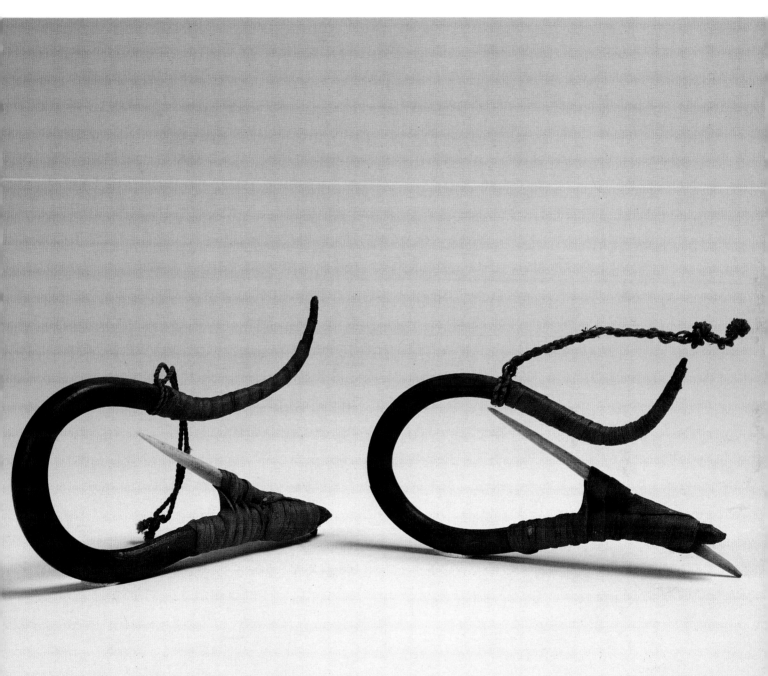

27. Ceremonial Rattle Makah; 19th c.

Wood (alder?), glass beads, pebbles, native cord, cotton cord; 32 cm × 11 cm × 11 cm

Collected by Mrs. H. B. Ferguson; received 1915; cat. no. 4857

A plump grouse, with stretched neck and bright eye, inspired the rattle carver. Grouse rattles make up a distinct category of Westcoast bird rattles. They are all similar in their globular bodies, flattened breasts, slim, craning necks, pointed beaks, and crest feathers (Holm 1983a: no. 24). The artist spent no effort on detailed elaboration of this fat body, instead playing its smoothly expanding form against the flattened, concave breast and taut neck. All detail is saved for the neck and head. Sharp and deep, the V-shaped recesses mirror the pointed beak and slit mouth, set apart from them by an angular face rim. At the same time, they lighten the rattle and lessen the deadening effect of thick wood on its resonance. Large, white beads glint as eyes, and smaller beads line the neck. A rich, gold-brown sheen of age and wear is mottled by the faceted cuts of the finishing knife. The grouse rattle is an especially fine exemplar of Westcoast sculptural style, with its naturalism, smooth transition of form, simple surface, and concentrated angular detail.

The rattle was identified in 1940 by Westcoast traditionalist Jimmy Johns as Kokhmin, "makes noise," and used for all dancing. The represented bird he identified as Khoo'oowik, the sooty grouse, although perhaps it is a ruffed grouse, judging by the prominent crest. The rattle is made of hard wood, probably alder. The piece is very light. The two halves, hollowed to near-fragile thinness, are joined with ties of finely plied native cord and a wrapping of commercial cotton seine twine at the handle. Small, smooth pebbles in the cavity of the body strike the resonant walls when the rattle is shaken or swung. Its sound accompanies the songs that were sung for the Winter Ceremonial, the Klookwalli.

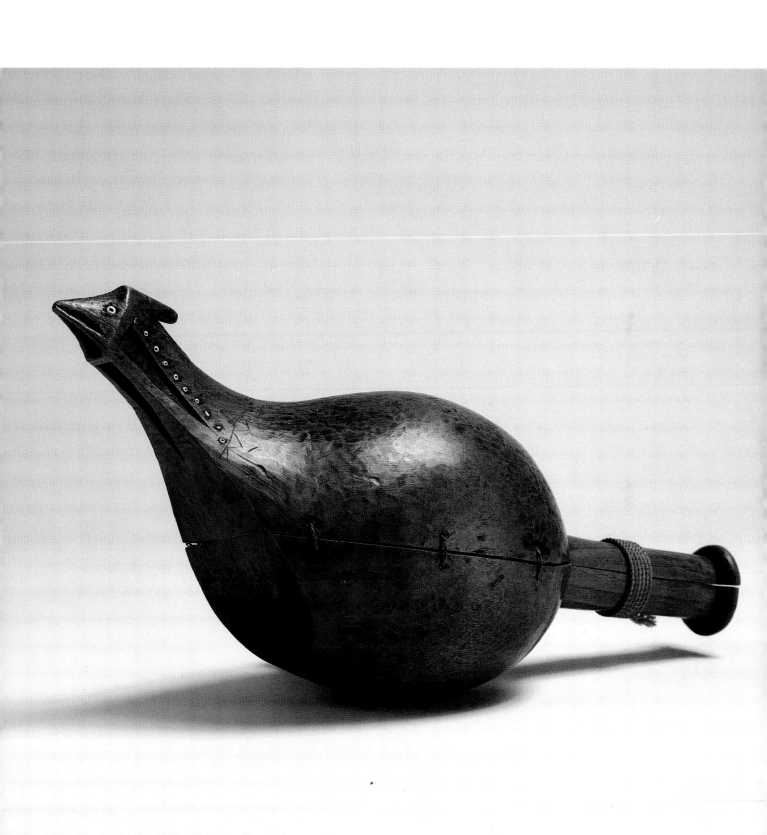

28. Wolf Mask Makah; late 19th c.

Yellow cedar, human hair; 47 cm × 18 cm × 18 cm

In exchange from the Museum of History and Industry, collection of Sophie Frye Bass; received 1980; cat. no. 2.5E1543

T he great ceremonial festival of the Makah, as well as of the related Westcoast tribes, was the Klookwalli (Makah) or Klookwana (Westcoast). Like the Winter Ceremonial of the Kwakiutl (nos. 35–37), its purpose was the initiation of the recipients of prestigious, inherited dances and their associated privileges. And like its Kwakiutl counterpart, it was a time of theatrics and pageantry (Drucker 1951:366–70). Everyone joined in the spirit of the festival occasion. When those who were to be initiated had been taken away by the supernatural wolves, according to the tradition of the ceremony, the villagers joined in a number of nights of ritual and dancing. Their purpose was to bring the novices back, or to rescue them from the wolves. When finally they succeeded, the new dancers' ornaments of evergreen boughs were burned, and they danced according to the privileges they had inherited.

Masks are important features of Westcoast Klookwalli, and the Wolf mask is chief among them. The wolves, those who carry off the initiates, formerly wore very small and simple wooden forehead masks representing the animals' snouts. In ancient times, wolf skins spread over their backs, and in later times, dark blankets. Sometimes the snout was represented merely by a corner of the blanket tied to project over the brow. In the early part of the ceremony, masks—carved usually of red or yellow cedar—appear, worn by dancers who imitate the actions of wolves. In subsequent parts of the ritual, more elaborate forehead masks appear. In "Whirling Wolf," a prestigious performance considered among some tribes to be reserved for the oldest son of a chief, the dancer wears a large, carved mask, elaborately painted and often fringed with human hair. John Jewitt, who was captured by the Moachat at Nootka Sound in 1803 and spent nearly three years among them, witnessed a dance by Chief Maquinna's son, wearing a wolf forehead mask and " . . . springing up into the air in a squat posture, and constantly turning around on his heels with great swiftness in a very narrow circle" (Jewitt 1974:38). This 183-year-old account graphically describes the Whirling Wolf as it is still performed.

Headdresses worn in the final performances of the Klookwalli are made of thin boards cut to profiles of wolf, lightning serpent, or thunderbird, joined into boxlike structures and elaborately painted. This mask is of the fully carved type, as worn by the Whirling Wolf. Shaped and hollowed from a block of yellow cedar and painted with formline-like abstract designs, the mask illustrates the spare, smoothly curved forms typical of Westcoast sculpture. A long mouth with many teeth separated by piercing, a round eye (once inlaid perhaps with mirror), and high, flaring nostrils—all are features of the Wolf mask. An old break has been repaired with a lashing of seine twine. Human hair set in drilled holes fringes the upper rim. The mask is worn tilted slightly upward on the forehead, and the dancer's face, usually painted in black, is visible. Covering his crouching body and draped to the ground, or flying outward as he whirls, is a painted robe (no. 29). Singers with round hand drums accompany the dance. The song is rousing and forceful, with startling changes of rhythm struck on the resonant drums. The bending and gesturing of the singers and their leader in response to the driving beat is a dance in itself.

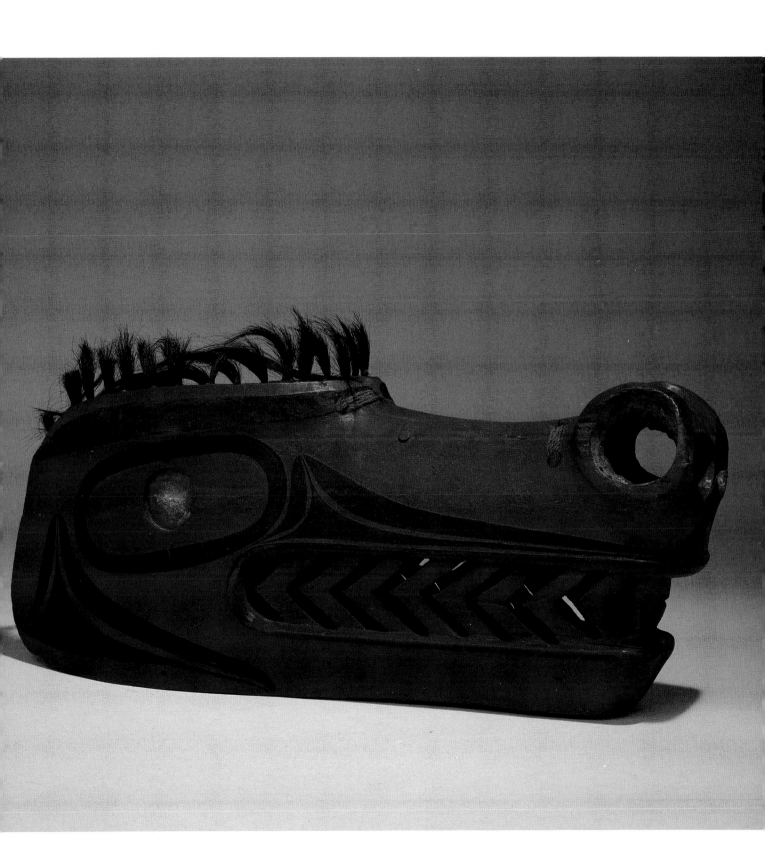

29. Dance Robe Clayoquot; late 19th c.

Muslin, wool yarn; 186 cm × 140 cm

Washington World's Fair Commission, collected by James G. Swan; received 1893; cat. no. 117a

Before canvas and muslin were available to Westcoast artists, ceremonial robes painted with designs from family stories were made of dressed skin or woven yellow cedar bark (King 1981: no. 101). But almost as popular as the iron brought by the first Europeans was cloth of all kinds. When they learned that cloth was in demand, many early traders quickly traded away all their ships' spare canvas, some of it as sails for canoes and some made into clothing. By the late nineteenth century, when this robe was made, most painted Westcoast dancing blankets were made of light canvas or muslin, as were many of the great painted curtains that hung in the ceremonial houses.

The outer form of the robe is traditional, with straight upper edge and sides, and rounded bottom. Cedar bark robes had the same shape, but their lateral edges were bordered with tight, broad braids of composite yarn made from mountain goat wool and cedar bark, and their lower borders were sometimes richly fringed. Triangular scallops substitute here for the border details of the earlier bark robes. The rounded edge is a practical feature: when the blanket is worn over the shoulders it hangs to a straight lower hem. If the corners were square they would droop at the sides.

A proud thunderbird spreads over the blanket. Although the painting is very Westcoast in concept and general appearance, it is clear that the Clayoquot artist was influenced by the formline art of the north, perhaps as filtered through the painting of his Quatsino Sound Kwatkiutl neighbors. Free use of color (including lots of yellow), geometric detail such as the bicolor chevrons on the tail feathers and the asymmetrical eyelid in a red socket, and the theme of thunderbird and lightning serpent are all good Westcoast characteristics. Freely rendered ovoids and U-forms in complex clusters, evenly spread over the remaining spaces, are derived from northern painting. They suggest, but do not conform to, northern formline rules. The undulating lightning snakes in seminaturalistic style at the lower edge add a particularly Westcoast touch. The lightning serpent is associated with the thunderbird, often described as his belt and his harpoon. A cloth dance apron (Burke cat. no. 117b), which James Swan collected along with this robe, pictures a thunderbird and two whales, one of which is a close copy of a Haida drawing that Swan had collected earlier and which was published in *The Coast Indians of Southern Alaska and Northern British Columbia* (Niblack 1890: pl. 52, fig. 283).

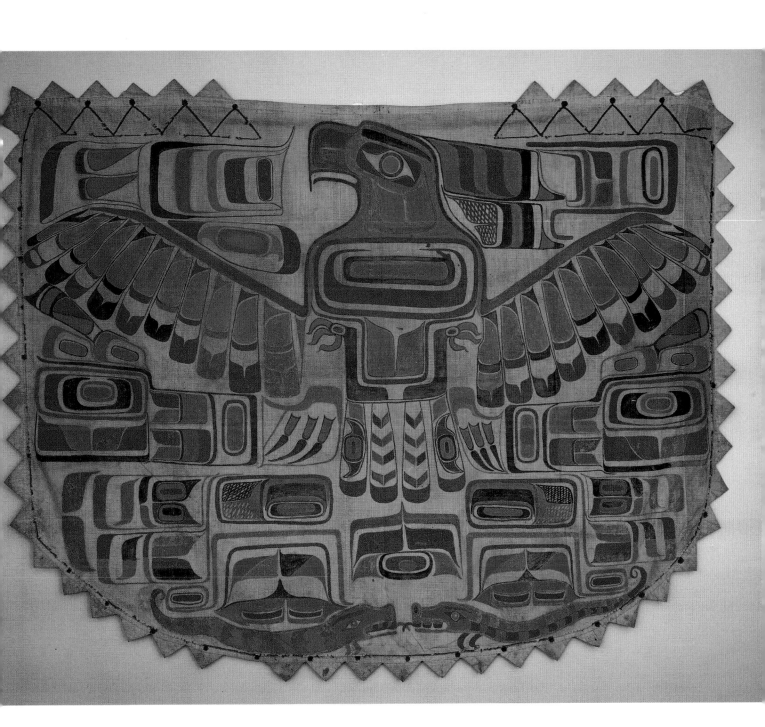

The Kwakiutl *Nos. 30–43*

The northern end of Vancouver Island and the mainland coast from Campbell River in the south to Smith Inlet in the north is the country of the southern Kwakiutl tribes. The collective name Kwakiutl, by which that score of tribes is best known, is a distortion of the name of only one of them, Kwagyoohl. Their art was, and is, flamboyant and their ceremonial life theatric and spectacular. No doubt it was in part those striking characteristics of their culture that drew anthropologists and collectors to the Kwakiutl at the turn of the century, but, for whatever reason, they are perhaps the most studied native people of the Northwest Coast. They have also retained more of their traditional culture than any of the others, in spite of the efforts of church and government in the early years of this century to erase every trace.

To the south, on the inside of Vancouver Island, the Kwakiutl abut the Georgia Strait Salish, into whose country they were pushing at the time of the first European arrival. On the outer coast, the Nootkan-speaking Westcoast tribes are their southern neighbors. North of Vancouver Island, at Rivers Inlet, live their close linguistic relatives the Owikeno. At each of these margins of contact, ideas spilled across the social and linguistic boundaries and art styles and ceremonial actions merged, making it difficult to distinguish between the artistic styles from those cultural frontiers. But Kwakiutl style in life and art is distinct and aggressive, and it holds its own and often overshadows its fellows.

The Burke Museum's Kwakiutl collection, although relatively small until the acquisition of the Walter Waters materials in 1953, included such fine pieces as James Swan's acquisitions, Mrs. Burke's large canoe, pieces assembled by Edward Curtis for his 1914 film (Holm and Quimby 1980:84, 89), and some important objects given by private collectors. In 1969, with the addition of the Sidney and Anne Gerber collection, the Kwakiutl representation in the museum was greatly increased and achieved national status. The Kwakiutl collection includes most of the objects for which the Kwakiutl are best known: masks of many kinds (including complex transformation masks), feast dishes and ladles, canoes, and cedar bark regalia, many among the finest of their kinds.

30. **Spoon** Kwakiutl; 19th c.

Wood (hemlock?); 16 cm × 5.5 cm × 5 cm

Collected by William Newcombe; received 1936; cat. no. 1–190

A simple utensil, small, dark and glossy with oil, its profile a swelling S, the wooden spoon is a mark of the Kwakiutl carver's skill. This one exemplifies the dainty spoons used by noble girls, sharp pointed ". . . because it is considered bad manners for a young girl to open her mouth wide" (Boas 1909:423). Wooden spoons range in size from utensils smaller than this one to massive serving ladles holding, when brimmed with food, a heavy load for a man (no. 31). Yet each one retains this graceful, reversed sweep and swelling bowl, regardless of its size.

Wooden spoons are closely related in form to horn spoons, although the manner of making each type is different in concept and technique. The horn spoon, whether from the massive, spiral horn of the mountain sheep or the slim, black, dagger-like horn of the mountain goat, is cut from the partially hollow, curved material and brought to its final form by steaming and then spreading the bowl and bending the handle. Wooden spoons, on the other hand, are carved to shape from solid blocks of wood. The shape of the material and the techniques of manufacture of each type of spoon influence its final shape, and yet the two types are nearly identical in form. The sheep horn and related wooden spoons of the Columbia River (no. 2) are very different from Puget Sound Salish spoons, which are in turn unlike the spoons of the Kwakiutl. They also have characteristics that differentiate them from the spoons of the north (nos. 61, 85). Kwakiutl spoons are usually somewhat more angular than their northern counterparts: this particular form, with its pointed tip, concave rectangular panel at the handle's bend, and angled, cylindrical finial, is known only from the Kwakiutl country. Although the resemblance is apparently not intentional, the thrust of the finial, the curve of the neck, and the rounded sweep of the bowl suggest a swimming bird.

All Kwakiutl men could probably carve spoons, and perhaps all did, but there were some who specialized in spoon making, and traded sets of spoons for other needed goods. Since spoons of this kind are still used in eating certain native foods, they are in demand to this day. Delicate as they are, the bowls are too big to be put in the mouth, so the eater sips the food from the end or side. Spoons were made of many different woods, but alder, yew, and particularly hemlock were the preferred materials among the Kwakiutl. Present-day spoon makers claim that the wood from a hemlock tree growing out of a steep bank, so that there is a sharp curve at the butt, will not absorb as much oil as the wood of a tree from level ground, and so is preferred for spoons. Kwakiutl spoons are ordinarily cut from a block split from a tree trunk, while more northern wooden spoons are usually carved from the whole cylinder of the trunk of a sapling (no. 85).

William Newcombe, who collected this spoon, was the son of Dr. Charles Newcombe, a Victoria physician who became one of the most important collectors of Northwest Coast artifacts and ethnographic information in the late nineteenth and early twentieth centuries. Some of the finest material in the major collections of North America was assembled by Dr. Newcombe for the British Columbia Provincial Museum, the National Museum of Man in Ottawa, the American Museum of Natural History, and the Field Museum in Chicago (Cole 1985:177–202).

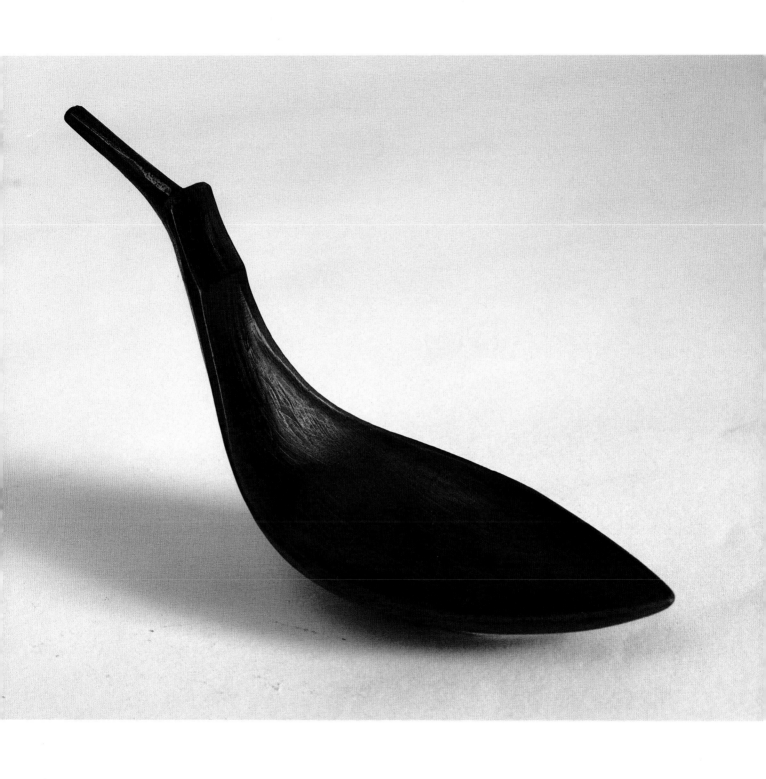

31. **Feast Ladle** Kwakiutl; late 19th c.

Wood (red cedar), copper; 117 cm × 32 cm × 35 cm

Gerber Collection, collected at Fort Rupert in 1954 by Sidney Gerber; received 1969; cat. no. 25.0/259

It would take some three hundred delicate little eating spoons to make up the volume of this giant ladle, yet they share much in form and detail. One of a pair, the ladle follows the characteristic Kwakiutl style, with flaring bowl, sweeping handle, and angled finial, but it is typical of the great feast ladles—elaborated with a sculptured heraldic creature. In the case of this ladle and its mate, the sculptured figure is the Sisiootl, a supernatural being whose usual form is a serpent with a head on each end and a humanoid face in the center (Holm 1983b:57–59). Each of the ladles depicts one of the terminal heads of the monster, with spiral horn, long mouth with many teeth, and spiral nostrils, each clearly represented. On this ladle the creature bites a miniature copper, the shield-like plaque representing wealth and prestige (Holm 1983b:61–67).

Kwakiutl sculptural and painting style of the turn of the century is very distinctive. Carving is deep and bold. Figures often have added parts, such as the horn, feathers, and tongue of the Sisiootl. Surface decoration, carved, painted, or both, is elaborate. The colors used are bright and strongly contrasting, often with a white background. Kwakiutl artists of the time were aware of, and sometimes influenced by, the northern system of two-dimensional design; the ovoids and U-forms in black and red on the ladle exemplify this influence. Typically, lips and nostrils are painted red and eyes and eyebrows black, while the usual color for the eye socket area is green. Since the Sisiootl is serpent- or fish-like, its scales are often depicted as seen here, on the cheeks and the top of the head. Formline details extending down the rim of the bowl may represent other body parts, but could have been chosen primarily for their decorative quality.

The two ladles (Holm 1972:61) were purchased from two different owners, although they had been made as a pair. They had been separated in the course of several marriages, in which part of the traditional formalities included the transfer of ceremonial privileges and ritual objects between the families of the bride and groom. Sidney Gerber reunited the pair in 1954. The great ladles were used with feast dishes, the use of which was among the most valued of the inherited prerogatives of noble families. Each dish—sculptured in the form of an ancestor or heraldic animal—had a name; special protocol governed the handling of these dishes and the distribution of food from them (Mochon 1966:88–91).

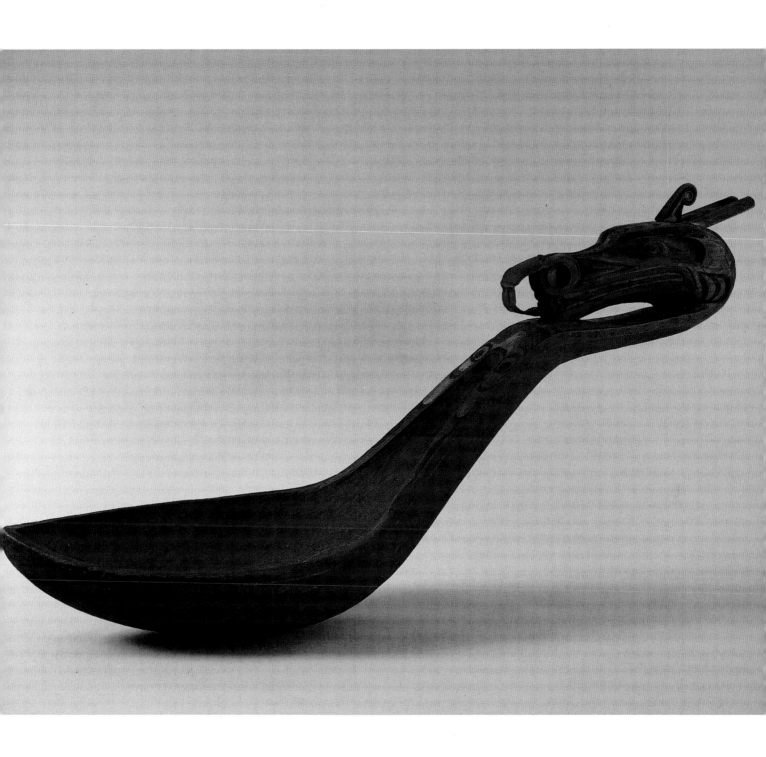

32. **Oil Dish** Kwakiutl; 19th c.

Wood (alder), brass tacks; 14.5 cm × 14.5 cm × 10 cm

Caroline McGilvra Burke (Mrs. Thomas Burke); received 1932; cat. no. 1–372

Enormous, sculptured feast dishes were not used for everyday dining. For this purpose, smaller bowls carved of alder were made in a number of rather standardized sizes. The largest of these, to be used by six men at a feast, is four hand spans long, while the smallest, to be used by "a woman whose husband is away" (that is, a single person), is only one hand span long (Boas 1921:59). Even smaller are those bowls that were made to hold the oil into which food was dipped. All of these alder bowls have a graceful, somewhat canoe-like shape, with flaring sides and a deep sheer, sweeping to raised ends. The little oil dishes are so broad that they are nearly round in plan, with high, narrow ends. Usually there is no sculptured decoration on everyday eating and oil dishes; their beauty rests in elegant form, deep, glossy patination, and geometric patterns produced by narrow, parallel grooves carved in the surface. The rims are sometimes inlaid with the white, oval opercula of the red turban snail (see no. 69) or, after they became available from traders, domed brass tacks.

Oil rendered from certain fish and from the blubber of seals, sea lions, and whales was an important food item to Northwest Coast tribes. Although its dietary importance is less today, oil (or grease, as it is also called) is still a highly prized luxury over most of the coast. Perhaps the most preferred oil is that of the candlefish or ooligan. In the early spring this little smelt-like fish is still netted in vast numbers, as it was in the past, in its favored spawning rivers. To prepare them for rendering, the grease makers heaped the fish into large, shallow, plank-bounded pits, where they remained for up to ten days. Canoes or large boxes were filled with water, which was heated with red-hot rocks nearly to boiling. Today the oil is rendered in large, sheet-metal-bottomed boxes heated over a trench fire; the oil rises to the surface and is skimmed (Macnair 1971). Formerly it was stored in wooden boxes or in containers made of kelp stems, but after tin containers became available, rectangular five-gallon (four imperial gallons in Canada) tin cans were used to store the grease. The present-day standard container is the one-gallon glass jug. Grease is a clear, amber liquid at room temperature, hardening to a white semisolid when cold. Diners dip their dried or broiled fish, boiled potatoes, and a number of other foods in the grease dish. Today, the grease dish is usually a small china or glass bowl, but formerly was carved of horn or wood, like this little one of alder.

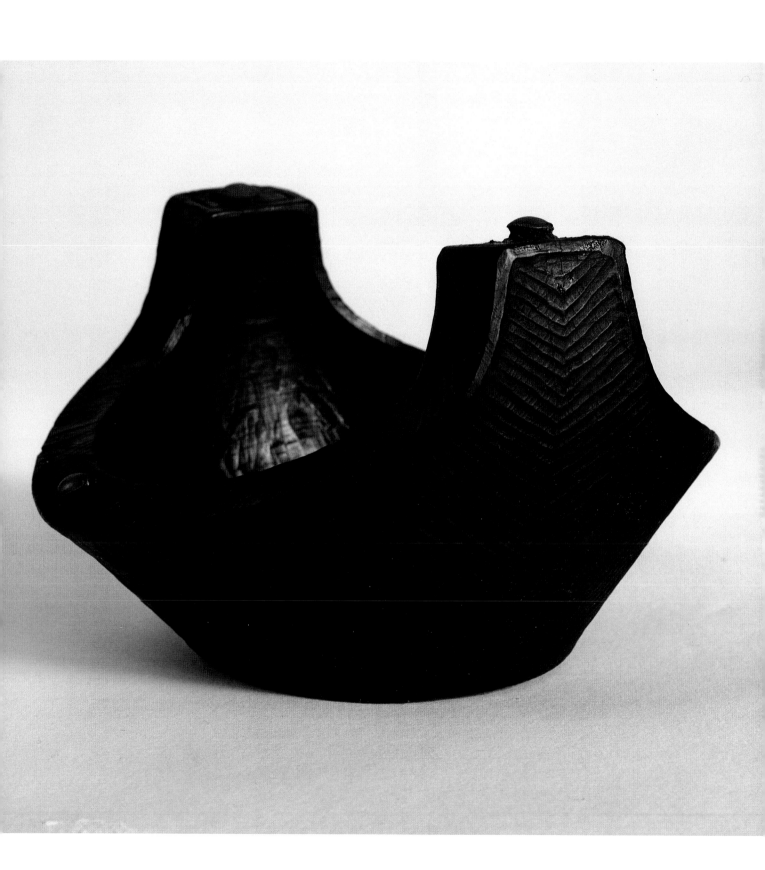

33. **Ceremonial Box Lid** Kwakiutl; 19th c.

Wood (red cedar), sea otter teeth; 75 cm × 23 cm × 24 cm

Walter Waters Collection; received 1953; cat. no. 2.5E535

Here and there in the museums of the world, usually relegated to storage shelves in the reserve collection, are peculiarly shaped, worn and dark wooden objects, studded on one face with apparently random rows of teeth. Although these pieces were once numerous, they are very rare today, probably because they are shabby fragments that had little appeal to the collectors of the turn of the century. At that time they were an important feature of every noble Kwakiutl marriage. Of the hundreds or perhaps even thousands of them that once existed, there are a handful only now. These peculiar objects, L-shaped in cross section, are the remains of ancient box lids that long ago lost their functional identity and became symbolic of wealth and prestige.

Kwakiutl box lids characteristically have a high, raised edge along one side (no. 33, small box) and it is this flange, painted with a stylized face and inlaid with sea otter teeth, which remains from the ancient lids and which had a prominent part in the ceremonial repayment of the marriage price. Some time after a noble marriage, usually after there were children, it was the custom for the father of the bride to return to the groom the value of the payment, with interest, that had been made at the time of the marriage. In addition to that, he gave important prerogatives, including ceremonial dances. The goods to be transferred, among

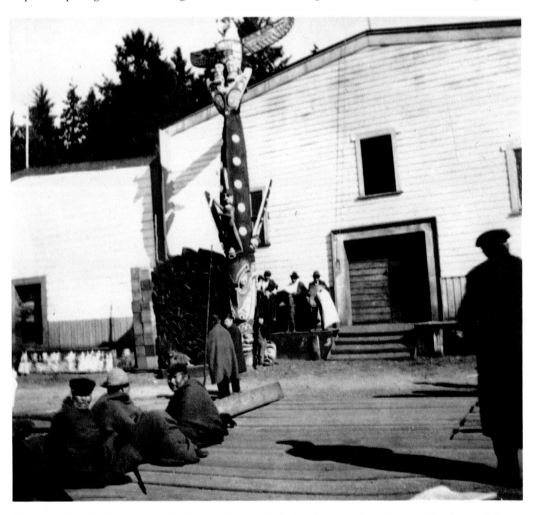

Ceremonial box lid flanges stacked between a totem pole and a pile of pilot bread boxes. Alert Bay, British Columbia, around 1900. *Photo: Newcombe Collection, British Columbia Provincial Museum.*

them a box containing ritual material symbolizing the dances, were gathered on the ground within a square bounded by a line of the archaic lids. This square and its enclosed payment—called *hawanaka*, referring to a ceremonial catamaran of canoes tied together—represented the fact that the goods and prerogatives were traveling to the groom's house. At the moment when the exchange was made, a member of the groom's party rushed up to the square and split a box lid forming one corner, "sinking" the catamaran (Boas 1897:421–24). It is likely that, after generations of marriages, the old box lids were progressively split so that by the beginning of this century only the flanges remained. At that time it was considered essential to the prestige of the wife that the ceremonial lids (called *gyisukhstola*) be a part of the repayment. According to Charles Nowell, referring to his own marriage when he was given six hundred of them, "Any girl that doesn't have that kind, it is a disgrace to her; when she quarrels with other women, they say she has no teeth, and is not fit to quarrel with—she has no teeth to bite with" (Ford 1941:178). Old photographs show the ceremonial box lid flanges piled like cordwood in front of the house (facing page); according to some accounts, many lids were burned when the custom declined, which may in part account for their rarity today.

34. Canoe Kwakiutl; late 19th c.
Wood (red cedar); 11.27 m × 1.37 m × 1.32 m
Collected by Mrs. Thomas Burke in 1896 from Jonathan Whonnock; received 1922; cat. no. 1–1963

Long, high-prowed canoes sliced the waves of the coast, driven by the paddles of northern warriors raiding the Salish for slaves, or carrying a chief, seeking a bride, and his retinue. When it was bought from its owner, Chief Jonathan Whonnock, this graceful and elaborately decorated canoe had just brought a party of Kwakiutl three hundred miles from northern Vancouver Island, to work in the hop fields of Puget Sound. On the Northwest Coast the canoe was a part of almost every human activity, from the deeds of fabled heroes and noble chiefs to the everyday business of fishing and traveling.

The canoes of the Kwakiutl and the tribes to the north of them shared some of the features of Westcoast canoes, but differed from them in a number of ways. Both ends of the northern canoe swept upward. The bow was similarly grooved to hold the harpoon or mast, but it lacked the "snout" and the smooth, concave curve under the prow of the Westcoast model. Instead, a vertical fin stretched forward under the bow to cut the waves. While the Westcoast canoe had a somewhat flatter bottom and harder chines, these features were variable and there was considerable overlap. Whether one form or the other was more seaworthy or efficient is probably a matter of its response to local sea conditions and the sorts of use it was put to.

Canoes of the northern pattern were made in sizes ranging from one- or two-person craft to great, seagoing ceremonial vessels up to seventy feet (twenty-two meters) in length and with a beam of up to ten feet (three meters). This canoe, at thirty-seven feet, is in the middle range, and represents the common size of traveling canoe of the Kwakiutl. It is more elaborately decorated than most, with carved figures applied to both bow and stern, carved supports for the thwarts and seats, and carved faces at the mast step and partner. Many large canoes had names that were the hereditary property of their owners (Boas 1921:775–801); named canoes were often decorated with figures referring to their titles. If this canoe had a name, it was not recorded. The figure on the bow represents an eagle with a salmon in each talon, while those on the sides of the stern show a spouting whale. The mast step, a block pegged to the canoe bottom under the forward, pierced thwart, is in the form of the Dzoonokwa (no. 38), who holds the foot of the mast in her round mouth. The whale and salmon are in a seminaturalistic style, while the eagle is elaborated with U- and ovoid forms representing its feathers and joints. This bold and flamboyant figure, with its spread wings and striking colors, is characteristic of Kwakiutl art of the turn of the century. All of the sculptured figures are made of separate pieces of wood attached to the smoothly functional surface of the canoe.

There is considerable controversy over the matter of whether or not Northwest Coast Indians sailed their canoes before Euro-American seamen came to the area. The journals of many of the early maritime visitors mention making sails for the local chiefs and teaching the natives to sail their canoes. These accounts have been interpreted to mean that there were no sails used on canoes before European contact, even though there are many mentions of sails in native traditions. It seems incredible that people so dependent on canoe travel and so expert in canoe use would not use the power of the wind. The discrepancy is probably a semantic one. "Sailing" to eighteenth-century seamen meant much more than running before the wind with a cedar bark mat or panel of thin boards set upright athwartship. The sails they made and taught the Indians to use were fore and aft spritsails set on masts, allowing the canoes to move *across* the wind (reach) even without any sort of keel or leeboard. This innovation made the canoe far more useful in traveling, and most nineteenth-century canoes, including this one, were equipped with masts and sails.

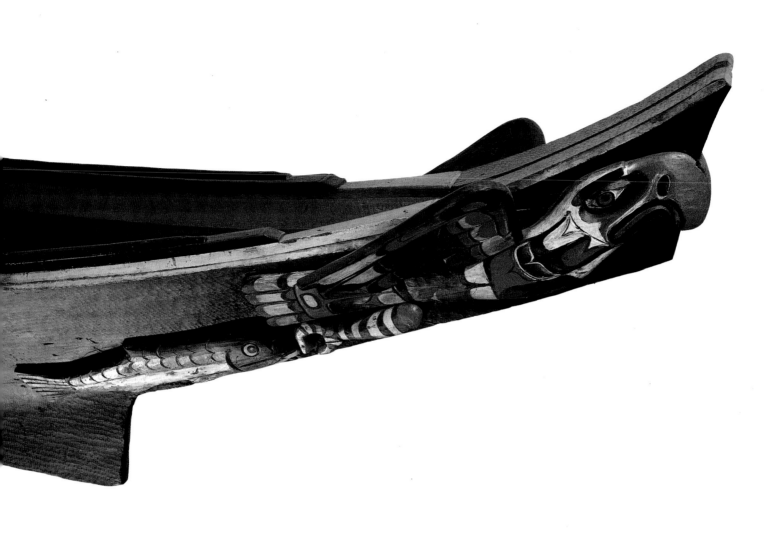

35. **Crooked Beak Hamatsa Mask** Kwakiutl; ca. 1920

Red cedar, shredded red cedar bark; 104 cm × 58 cm × 26 cm
Hauberg Foundation gift; received 1954; cat. no. 1–1669

Galokwudzuwis, Crooked Beak of the Sky, is one of a household of monster birds and creatures, associates of the Man-eater Bakhwbakwalanooksiwey, the motivator of the major dances of Tseyka, the Winter Ceremony of the Kwakiutl. Of these dances, the first is Hamatsa, impersonator of the Man-eater himself. The Tseyka dances come from ancestors' fabled experiences with the creatures of the supernatural world, and the public dramatizations of those encounters are among the most prestigious ceremonial acts. They are also the occasions of great drama.

The Hamatsa, protegé and personification of the Man-eater, returns from the monster's house and is captured and tamed by his tribesmen. His gradual return to human sense in a series of dances is disrupted when he loses his self-control and runs wildly around the firelit floor and out behind a painted curtain stretched across the back of the house. From behind that screen the snapping of a great beak sounds, the singers begin the song of the masks, and a figure, hung with heavy fringes of red-dyed cedar bark and wearing a great bird mask, appears. First stepping high from side to side, then circling in crouching jumps, and finally sitting on the floor, the dancer moves the great mask, sweeping and cocking the beak from side to side and finally snapping the voracious jaws. At each new verse another dancer appears and performs until as many as four are on the floor at once. Then they leave one by one and the Hamatsa returns for his final series of dances by which his wildness is removed and he is brought back to a tame, human state.

There are several varieties of Hamatsa mask, the Man-eating Raven, the Hokhokw with elongated, narrow beak, and the Crooked Beak of the Sky. This most fanciful of monster-birds is known by the flat beak and the curved ridge over the snout. Most are more restrained than this one, the nose ridge curling just to touch the top of the upper jaw. Here the carver has enormously exaggerated the curve, and repeated it in the small beaked creature over the forehead. Although there are many more elaborate Hamatsa masks (Holm 1983b:86–120) there is only one other in which the ridge curls all the way under the lower jaw, and that one is a small "Taming mask" probably by the same artist (Hawthorn 1967: fig. 85).

This stylish Crooked Beak mask, probably carved in the 1920s, has been attributed to the Kwakiutl carver Dick Price on the basis of its similarity to other masks made by him. The construction and rigging are traditional, with strips of woolen trade blanket for harness, and shredded cedar bark, partially dyed red, hung from the sides and back, clustered in the top, and framing the mask in rope-like plies. The paint is probably commercial enamel, but Price has used it exactly in the traditional way. The mask is primarily black, with white eye sockets and detail, and red lips, nostrils, and eyelid lining. It weighs twelve pounds, a cumbersome burden for the dancer, but average for a Hamatsa mask.

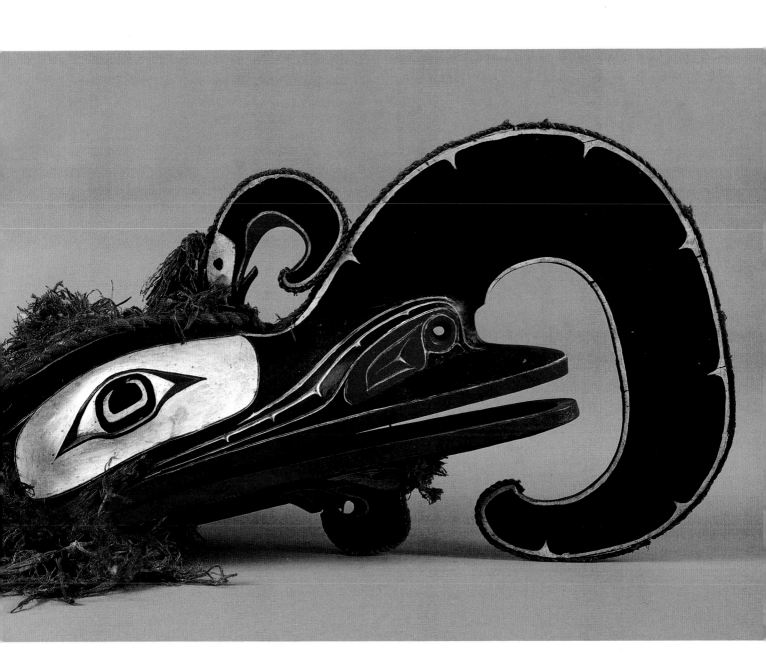

36. Sea Monster Mask Kwakiutl; ca. 1900

Wood (red cedar), cedar bark, cotton cloth; 29 cm × 27 cm × 17 cm

Walter Waters Collection; received 1953; cat. no. 1–1451

The stories of seafarers are often peopled by monsters of the deep: bringers of bad weather, capsizers, devourers of men. The Yagim is all of those. Described as a destroyer of whole tribes, a shark-like monster who lurks behind canoes, or the source of storms, his name means literally "badness." A song recorded by Franz Boas in 1894 expresses his character:

> He will rise, the ia′k·im of this world.
> He makes the sea boil, the ia′k·im of this world.
> He will throw up blankets, the ia′k·im of this world.
> He will throw up blankets out of the sea, the ia′k·im of this world.
> He makes the face of the sea ugly, tribes, the ia′k·im of this world.
> We shall be afraid of the ia′k·im of this world. (Boas 1894:713)

Yagim's face—massive and bold, with a grossly wide mouth—is, in company with some other sea monsters, studded with cylindrical pegs representing sea anemones. Truncated conical orbs deeply framed in angular sockets are typical of turn-of-the-century Kwakiutl sculptured faces, here even more forcefully modeled to emphasize the strength of the destroying monster. The contrasting color scheme is another mark of the flamboyant Kwakiutl art of the time. Red lips and nostrils, black eyes and eyebrows, and green sockets on a white ground fit the usual arrangement, with yellow and blue less common. Dashed yellow and red lines on the broad, black brows relieve some of the stark contrast. Most of the color appears to be commercial oil-based paint, but the mask has been overpainted at least once and may have been originally painted with native pigment and salmon egg tempera medium.

Claws grip the top of the Yagim mask, but the creature to whom they belong, and who once surmounted the mask, is gone. It may have been a puppet-like figure with movable parts. The Yagim's horrendous mouth is articulated, hinged at the jaw to open and shut, waggling the shredded cedar bark beard. This bark, once dyed red, identifies the mask as one used in the Tseyka. The dancer appears in the firelight, hung with fringes of shredded bark or draped with a dark blanket. His movements are slow and flowing, befitting a monstrous undersea being. He turns his head from side to side, staring into the shadows of the house. Raking light exaggerates the bulging eyes and flaring nostrils. Fanciful and unlike any credible, living creature, the Yagim comes alive for the hushed audience in the spirit-charged atmosphere of the Tseyka.

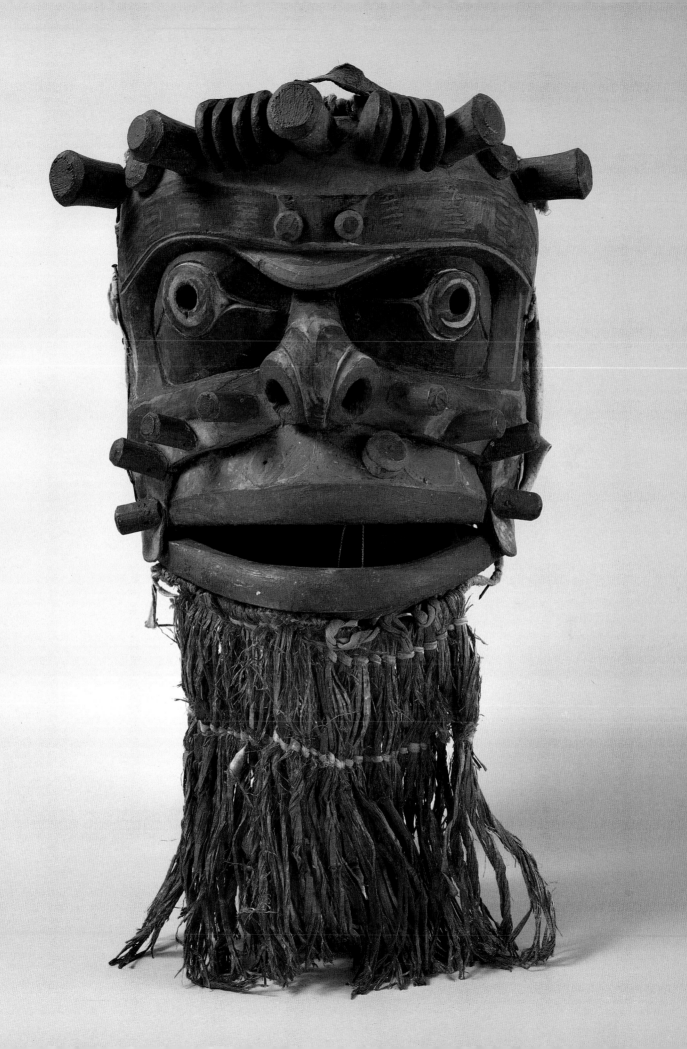

37. Ceremonial Neck Ring Kwakiutl; late 19th c.

Red cedar bark; 64 cm × 33 cm

Young Naturalists' Society; received 1904; cat. no. 4790

The inner bark of the great tree of the Northwest, the western red cedar, held a place in almost every phase of Kwakiutl life: from birth and infancy, through puberty and adulthood, to old age and death; and in every aspect of culture: functional, decorative, and symbolic. Kwakiutl cedar bark terminology is complex: words specify the thickness of the bark, its suitability for shredding, splitting, or other processes, and whether it has been shredded or dyed red. Slabs of rough bark formed roof boards for temporary camps and were even fashioned into makeshift canoes.

The thin bark of selected, small cedars was peeled at the optimum moment and stripped of its outer husk. The flexible bark, a moist layer a handbreadth wide and fathoms long, was hung to quickly dry. The dried bark could be resplit both in thickness and in width to form mat- or basket-making material, or it could be shredded to a loose, felt-like texture for cradle bedding and diapers, towels, menstrual napkins, clothing, and ceremonial regalia. It was in the construction of the emblems of the Winter Ceremonial (Tseyka) that red cedar bark reached the status of an art medium.

Bark to be used in the Tseyka was dyed to an orange-red with the inner bark of the red alder (Boas 1909:404). This dyed bark was used alone or was mixed with undyed bark to form red and pale buff stripes or patterns according to the traditional arrangement for each Tseyka participant. Strips of shredded and dyed bark to be made into headbands were distributed to everyone in the ceremonial house at the beginning of the festival; the donning of the cedar bark headring signified the arrival of the motivating spirits. Principal participants wore cedar bark neckrings as part of their insignia: some of them simple lengths of shredded bark tied into a loop and hung with bark tassels, some plied into red or candy-striped ropes, and others of varying degrees of elaboration in twisted, wrapped, and plaited work. This delicate triple neckring is one of the most elaborate and finely constructed of all.

Very fine cord, spun of fine, split cedar bark, is wrapped spirally over cloth-covered rings made of bundles of split bark. The cord is wound in an open spiral, and each succeeding course gradually narrows the gap on the uncovered base until it is entirely enclosed. The inner and outer rings are of red-dyed cord wound in a Z-spiral, while the central ring is wrapped in the opposite direction with undyed cord. The herringbone pattern resulting from this opposition is a favorite one in weaving, basketry, and wood surface decoration on the Northwest Coast, and is often seen in the elaborate bark regalia of the Tseyka. Continuing the concept, each of the two-ply, pendant cords making up the four tassels is spun in alternating twists: one Z, the next one S. This detail is nearly invisible at even a short distance, and certainly would have been unseen in the firelight of the ceremonial house. Yet great care was taken to achieve the subtle effect. The technique was common on Winter Dance regalia and appears elsewhere on the coast as well. For example, elaborately twined blankets collected at Nootka Sound in 1778 by the Cook expedition (Feest 1968: fig. 29; Kaeppler 1978:118; Holm 1982: figs. 4, 5) and a Chinook kilt acquired by Lewis and Clark at the mouth of the Columbia River in 1805–06 (Peabody Museum, Harvard) exhibit alternating Z- and S-plies.

38. Dzoonokwa Mask Kwakiutl; late 19th c.

Wood (alder), human hair; 34 cm × 23.5 cm × 10 cm
Walter Waters Collection; received 1953; cat. no. 1–1450

Sunken, hollow eyes under a heavy brow, bony face with strong, hooked nose and hollow cheeks, lips pushed forward—these are the marks of the Dzoonokwa, the fearsome giant, usually female, of Kwakiutl mythology. All Northwest Coast people have traditions of giant, often malevolent, human-like creatures who dwell in the dark wilderness and occasionally interact with humans. The Dzoonokwa is the archetypical monster-giant of the Northwest Coast. Sometimes described as an eater of human flesh or a stealer of children, she also can be the bestower of power and wealth. For those whose ancestors have met and bested her, the privilege of representing the Dzoonokwa in carved post, mask, and dramatic performance is a prized heritage.

Certain chiefs inherit the right to use a Dzoonokwa mask of special form when they speak to the assembled people about the greatness of their families (Holm 1983b:157–59). This mask is called Gyikumhl, or Chief's Mask. It is usually little more than human face size. The painting is simple—almost totally black with graphite paint, often with contrasting vermilion lips and cheeks and sometimes the inner rim of the eyes. A thick fringe of human hair falls over the forehead and shaggy eyebrows; a moustache and beard of black bear fur, as this one once had, mimic the coarse hairiness of the monster. In the firelit house the eyes of the Dzoonokwa recede into deep, shadowed sockets. Metallic reflections glint from the bulging forehead and bony ridges. Thrust lips focus her tremulous cry, shouted by the speaking chief.

The Dzoonokwa corresponds to the legendary Bigfoot or Sasquatch of the southern coast. It differs from most of the other creatures of Kwakiutl mythology, since it is thought by many to live today in the wild reaches of the mountains. Some people say that they have seen the Dzoonokwa and many believe in its existence. It has been suggested that the noise and smell of gasoline boat engines drove the last remaining Dzoonokwas away from the shoreline and into the nearly impenetrable wilderness of the British Columbia coast so that they are seldom seen by humans today (Holm 1972:33).

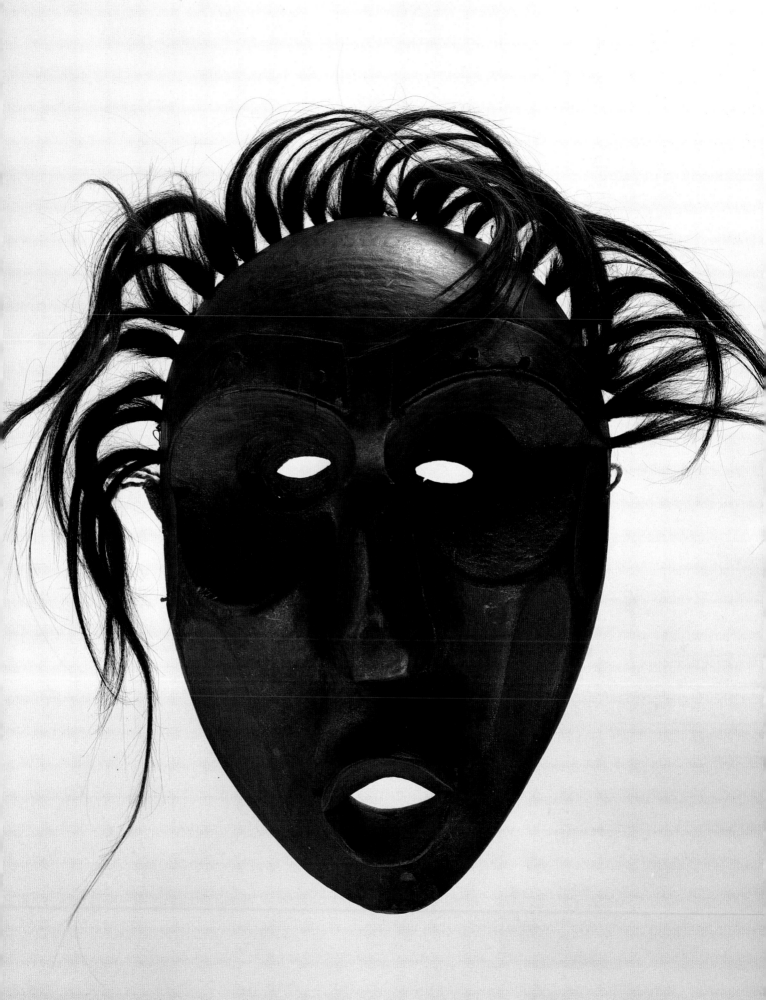

39. Owl Mask Kwakiutl (Gwasila); ca. 1920
Wood (red cedar); 24 cm × 19.5 cm × 12 cm
Collected from Willie Seaweed at Blunden Harbour in 1952 by Sidney Gerber; gift of Mrs. Anne Gerber; received 1969; cat. no. 25.0/215

The Kwakiutl are masters of masked drama. Long, dark winter months see the ceremonial reenactment of ancient stories chronicling the adventures of hero-ancestors. The dance-dramas are the treasured property of families, to be shown at the junctures of life: marriages, the naming of noble children, the raising of a house or a memorial totem pole. Many masked dances come in the dowry of a chief's daughter, to be claimed by her future children. Such is the dance in which this Owl mask was worn. Called "Great Mask," the dance came to Joe Seaweed, the son of the master Blunden Harbour artist Willie Seaweed, from his mother (Holm 1983b:124). It belongs to the Tlasula, one of the two principal ceremonial complexes of the Kwakiutl, and one in which masks of many different creatures are used (Holm 1972:33–50, 1983b:161–71).

A Tlasula mask dance is usually preceded by the performance of a Headdress Dance by the new recipient of the inherited privilege. The Headdress Dance is today and has long been performed by either men or women, while the mask dance is usually performed by men. While the recipient is dancing, crowned by the rich headdress emblematic of the performance (no. 73), an attendant teases him into losing his self-control and he runs out of the dance house and disappears. Some time later, the sound of reed horns echoes in the darkness outside the house and the attendants hesitantly investigate its source. They bring a masked dancer into the firelight—the being into which the disappeared novice has been transformed and who embodies the dance prerogative to which he is heir. The dance proceeds around the fire, the masked figure performing according to the character of the creature he represents.

In the Great Mask Dance, the dancer first appears wearing one of his masks, of which the owl is an example. He moves sparingly, posing like the bird with head thrust forward, round eyes staring straight ahead. Suddenly he crouches, drawing his head down between hunched shoulders, owl-like. He thrusts again, this time staring to one side, and again recoils. His movements are quick, separated by long moments of intense immobility. His song, sung by a seated chorus lined along the back wall of the house and accompanied by the striking of hardwood batons, mentions the owl. At a change of rhythm the dancer turns to face his attendants, bending low and holding his blanket to shield his head from view. The attendants quickly take his mask and he turns and dances with face exposed. One after another, the masks appear until finally the complete series has been shown and the dancer disappears behind a painted screen at the rear of the house.

The Owl mask is a powerful example of the sculpture of the Gwasila Kwakiutl master artist George Walkus of Smith Inlet. Carved about 1920, it is admired by contemporary Kwakiutl sculptors; a number of masks inspired by it have been carved in recent years. The round, staring eyes, short, hooked beak, and broad mouth perfectly evoke the bird of the night.

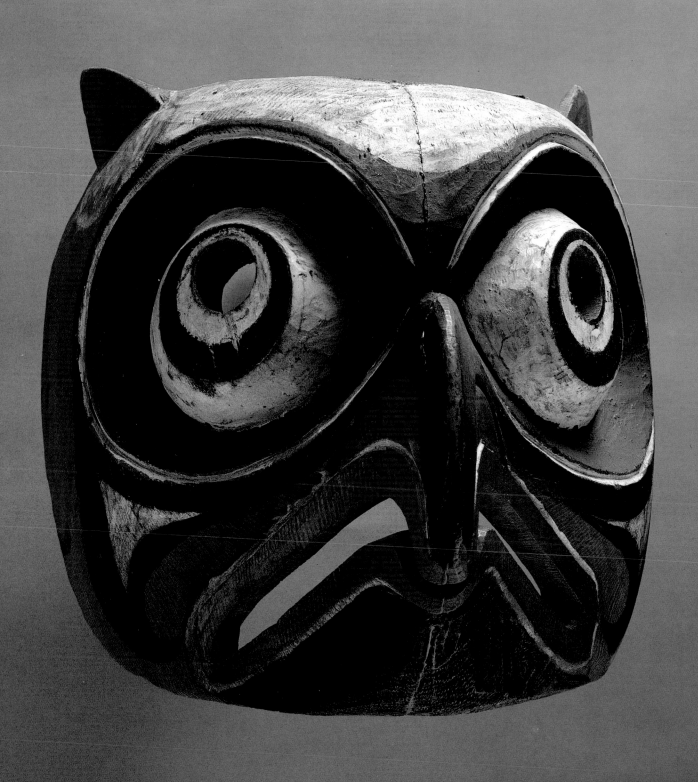

40. Kolus Mask Kwakiutl (Nakwakdakw); 1922

Wood (yellow cedar), leather, cotton cord; 38 cm × 21 cm × 26 cm

Collected from Willie Seaweed at Blunden Harbour in 1952 by Perry Johanson; gift of Mrs. Jean Johanson; received 1985; cat. no. 2.5E1605

The second mask worn by Joe Seaweed in the Great Mask Dance is the Kolus, a variety of thunderbird whose body is covered with thick, white down. Actually a forehead mask or headdress, the Kolus mask leaves the wearer's face exposed. When he first dons the mask, the dancer raises the borders of his button blanket up to conceal it, then lowers them under the bird's mandible so that his own face is concealed (Holm 1983b:125). He cocks the Kolus head to one side, slowly sweeping its piercing eye across the house, then tilts and reverses his swing as the song describes the Kolus, calling it "Screecher Mask." Hunched shoulders and falling folds of blanket intimate the Kolus' great wings.

The Kolus mask-headdress and its companion Owl are among the most completely documented objects in the Northwest Coast collection. The dates of their manufacture are known with reasonable certainty and their makers are known by name and tribe. They were both purchased from Willie Seaweed, the carver of the Kolus mask; the circumstance of his acquisition of the dance privilege has been recorded. The dance itself was filmed in 1950, performed by its owner, Joe Seaweed (Orbit 1951a,b). The song also was recorded. It was later rerecorded and explained by Joe Seaweed. And to underscore the significance of the Kolus mask to the Burke collection, the piece was given to the museum in 1985, the Centennial Year.

Willie Seaweed, the carver of the Kolus mask and the custodian of the privilege, was one of the great masters of Northwest Coast Indian art (Holm 1983b). His distinctive style of carving and painting is well illustrated in the Kolus mask. The most obvious characteristic of that style is the form of the eye, with deeply carved, pointed lids enclosing a strong, truncated, conical orb on which the iris and pupil are compass-drawn in three eccentric circles before being painted in black. Meticulous craftsmanship and constant attention to the relationship of positive and negative form are other stylistic features of Willie Seaweed's work. At about the time this headdress was made, Seaweed began to use glossy commercial enamel in his painting; this was one of the last on which he applied pigments ground in the native paint medium, probably a salmon-egg tempera.

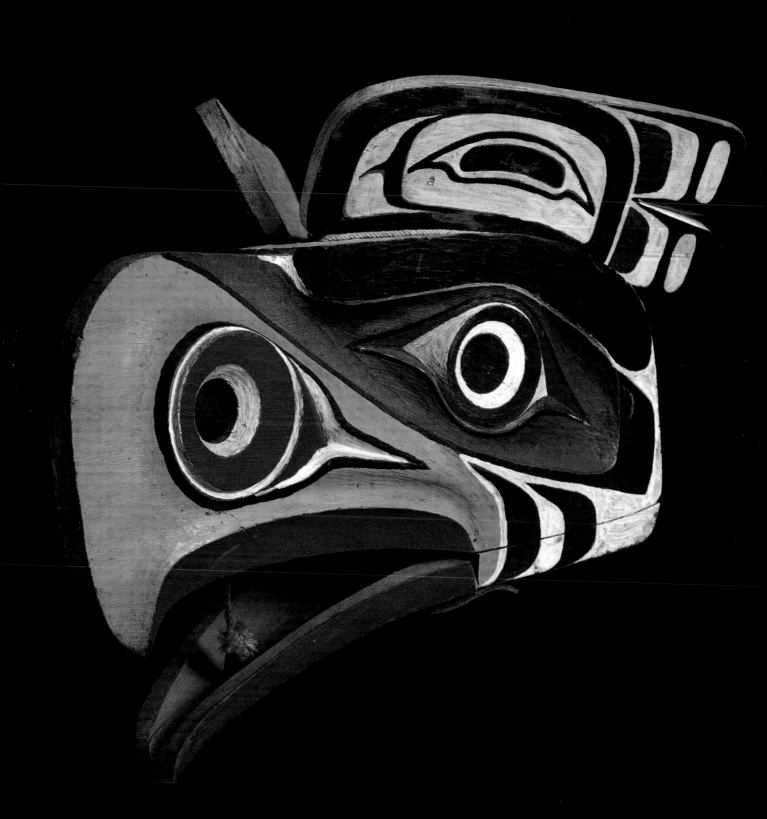

41. Human Mask Kwakiutl; late 19th c.

Wood (red cedar), cloth; 31 cm × 25 cm × 15 cm

Walter Waters Collection; received 1953; cat. no. 1–1634

This humanoid face mask, with powerful, deep modeling and elaborate detail carved and painted on its surface, is one of a number of fine Kwakiutl masks from the collection made by Walter Waters of Wrangell, Alaska. Unlike many of the Tlingit pieces that Mr. Waters collected directly from Indian owners, this mask is entirely without documentation. Its identification as a Kwakiutl mask is based on its formal characteristics, which are classic examples of Kwakiutl sculptural and painting style of the late nineteenth century. Although we do not have a reliable identification of the artist as we do for the Owl and Kolus masks (nos. 39 and 40), the forms are very similar to those seen in the work of the Denakhdakhw Kwakiutl carver Kheykhanius. Whoever he was, the maker of this mask was a master of form who followed closely the canons of Kwakiutl art while applying the distinctive markers of his individual style.

Just as the artist's identity remains shrouded, so does the exact significance of the mask itself. There are many figures, historical and mythical, peopling the traditions of the Kwakiutl. Many human-like beings, like Yagim (no. 36), Dzoonokwa (no. 38), and Bukwus (Holm 1983b:143–45; Mochon 1966:72), have exaggerated features which are unique and recognizable. The masks of the Gidakhanis (Holm 1983b: nos. 126–30) typically have forehead holes in which feather cockades are mounted, and which help to identify them. The Chief of the Undersea World, Goomokwey, frequently has radiating scallops on his cheeks similar to the ones on this mask, but has other features and details which are very different (Holm 1983a: no. 33; 1983b:162). We will have to be content to call this one "a man."

Strong orbs in sharply defined sockets, lips protruding from angled forecheek planes, and rounded, flaring nostrils are all in the classic Kwakiutl tradition. So is the elaborate surface detailing, much of it related to northern formline design (no. 58), in black and red with white background, and dark green in the eye sockets. The Kwakiutl tendency to treat each plane of the sculpture as a separate and discrete design area rather than to carry the painted detail across sculptural planes (nos. 44–49) is graphically illustrated in this mask. In the cheek area especially, the influence of the northern formline style of painting can be seen.

Carved very thin of the light wood, red cedar, the mask would have been easy to wear. Its strong planes were calculated to maximize the effect of firelight and shadow in a dramatic reenactment of an ancient story.

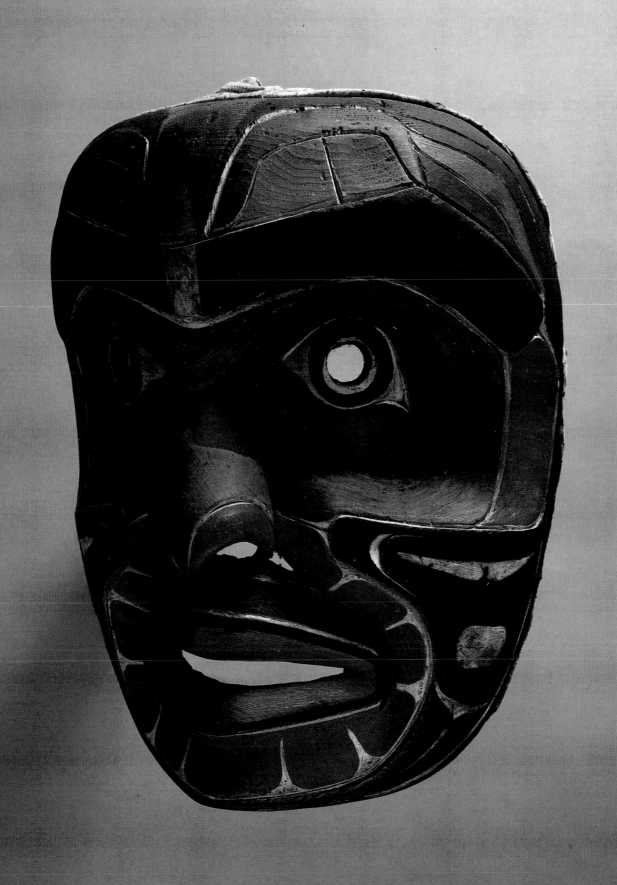

42. Heron Mask Kwakiutl; early 20th c.

Wood (red and yellow cedar), cotton cloth, cotton string; 150 cm × 85 cm × 48 cm
Walter Waters Collection; received 1953; cat. no. 1–1446

After the disappearance of the Tlasula Headdress dancer, the masked figure who returns to the dance house takes the form of some creature from the tradition of the Headdress dancer. When the attendants usher him from the darkness of the door into the increasing brightness of the central fire, his mask takes form and is recognized by the surrounding audience. He moves around the house as a great bird, an undersea monster, or an animal of the wilderness, his steps timed to the batons of the singers. Now he pauses and turns, silhouetting the mask to those at one side of the house and reflecting the full color and form to those across the fire. A change of time in the song—a staccato clattering of batons— is mirrored in the creature's action. He steps back, crouches, faces the fire. His whole form changes, he becomes another being, or another aspect of himself. The mask turns, displaying its altered form. Then, as suddenly, the original creature recomposes itself and dances on. This transformation is accomplished by a complex mask for which Kwakiutl theatricians are famous.

The mask of the heron is such a transformation mask. The most widely known transformation masks achieve their effect by splitting to expose an inner face. Some, like this one, change their form in other ways. When the Heron mask appears, its wings are closely folded behind a face which is the human aspect of the heron and at the same time the breast of the bird. The extended neck and snapping, dagger beak are pivoted to lie along the gray feather-painted back of the heron. In this position the image is of the bird at rest, its long neck compressed until the beak protrudes from shoulder level. At the change the heron comes alert, neck stretched, beak snapping and wings spread. The mask's wooden "bones" unfold, displaying elaborately painted feathers on the muslin wings. Pairs of strings run crisscross through the interlocking joints and over their extensions in such a way that a pull on one set extends the wings and a pull on the other folds them. The change is sudden and dramatic.

The renowned Kwakiutl artist Mungo Martin (Nuytten 1982:74–125) identified the mask as his own work. It was made for a chief named Lagius, probably around 1920. The style of carving and painting are recognizable as that of Mungo Martin or his stepfather and mentor Charley James (Nuytten 1982:12–41). Although the mask is called "Crane" in the museum records, the gray color and the hunched attitude when folded are reminiscent of the great blue heron, a bird common to the Kwakiutl country and often miscalled "crane" in English.

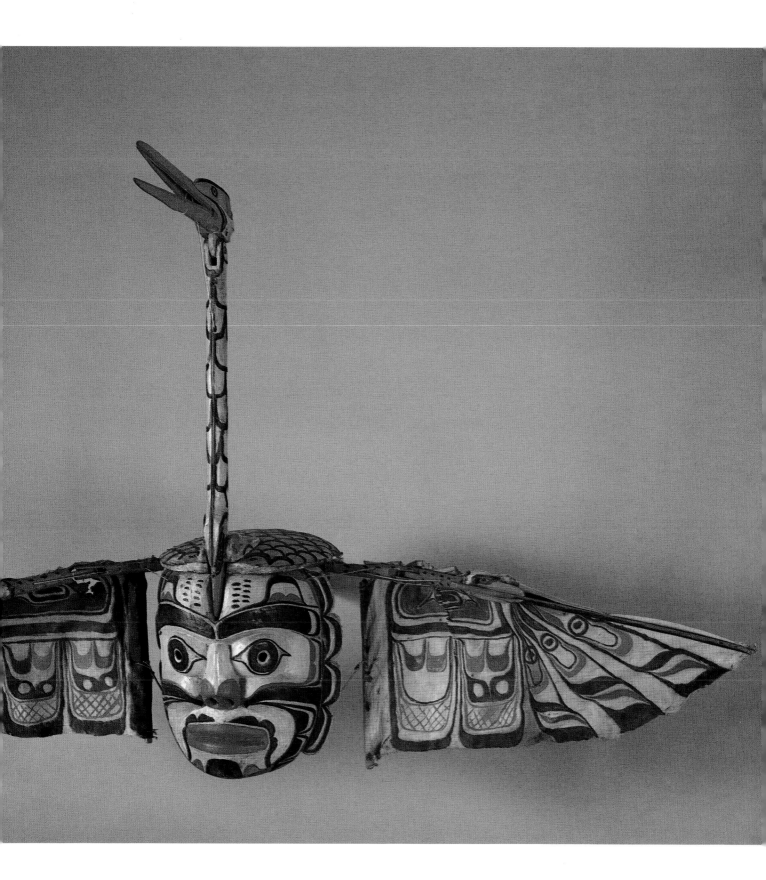

43. Sculpin Mask Kwakiutl; late 19th c.

Wood (red cedar), cedar withes, canvas, cotton cord; 172 cm × 61 cm × 49 cm
Walter Waters Collection; received 1953; cat. no. 1–1540

The sculpin or bullhead is a fish with an enormous head and mouth, many spines, and a fan tail. When seen in the masked dance, fish and whales often take the form of a large composite figure, sometimes worn on the back of a dancer crouched to move the creature as if it were swimming around the house. These back masks usually have articulated jaws and fins, so that, although constructed of stiff wood, they can be made to move with the appearance of flexible, living flesh. Because of their elaborate form, they are often constructed of many pieces joined by lashing and nailing. This sculpin combines more than forty pieces of wood. The sides and the hanging curtain (here folded under the mask), which conceals the dancer's body, are of painted canvas stretched over a light frame of cedar withes.

Ordinarily, a mask with only snapping jaws and moving fins would not be thought of as a transformation mask, but this one incorporates another action which so changes its form that it certainly qualifies. The dorsal spines stand erect along the length of the creature's back as it swims, its jaw working and its tail spreading and folding. The dancer's attendants follow his movements, watching to prevent mistakes or missteps, or to instruct him. From time to time they step close and from clenched handfuls blow eagle down over the swimming figure. At the moment of transformation the spines draw up at the ends to form an elaborate crescent painted with the figure of a man with raised hands and open mouth. This transmutation is related to the story behind the mask and dance, and is referred to in the dancer's song. Its meaning in this mask is not known. Here the mask is shown with half the spines spread and half of them joined to illustrate both aspects.

The Sculpin mask epitomizes the flamboyance of Kwakiutl theatrical sculpture. Jagged contours, bold, intertwined forms, and snapping, fanning, and waving appendages—all covered with contrasting and complex patterns of strong color—create creatures of startling fantasy. The subdued, wavering light of the dance house softens those contrasts and unifies the forms. The sculpin swims to the rise and fall of its song in a sea of firelight and swirling eagle down.

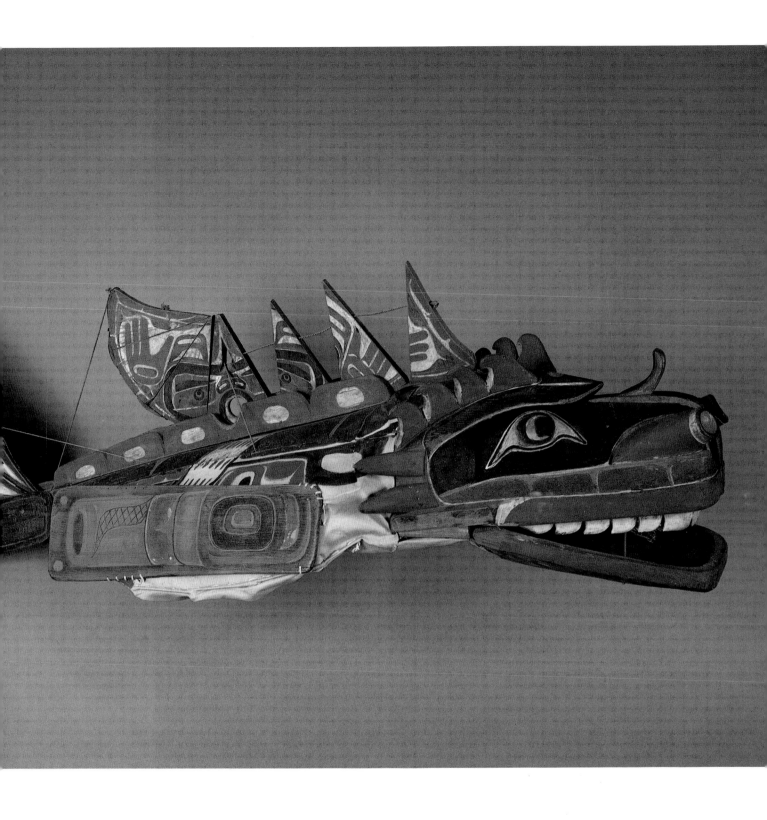

The Bella Coola and Bella Bella

Nos. 44–50

Adjoining the Smith Inlet Kwakiutl on the south and the Tsimshian on the north are speakers of languages closely related to that of the Kwakiutl. One of the tribes of that region is Heiltsuk, commonly known by the village name Bella Bella. In 1833 the Hudson's Bay Company established a trading post, Fort McLoughlin, on Lama Passage. Several nearby villages resettled close to the fort, and the one resulting village came to be known as Bella Bella. It was later moved about a mile north along the passage to where it stands today, now known by the native name Waglisla.

An attribution very broadly applied over the years, many of the artifacts that have been called Bella Bella are actually from other related tribes (Sawyer 1983:143–47). Recently the linguists' term "Northern Wakashan" has been used by scholars to designate those northern Kwakiutl-speaking tribes that include the Bella Bella. Except for certain objects with very distinct diagnostic features, it is difficult today to distinguish between the work of artists of those neighboring and linguistically related tribes. The Bella Bella and their relatives, the Owikeno, were the source for many of the ceremonial dances and privileges acquired by surrounding people; their influence on the graphic and dramatic arts has been strong and widespread.

Inland from the Bella Bella and separated from the outer sea by nearly one hundred miles of winding fjords are the Bella Coola, a Salish-speaking people whose villages once lined the mountain-rimmed heads of Dean Channel, North and South Bentink Arms, and the lower Bella Coola River valley. Although not related linguistically, the Bella Coola and Bella Bella have experienced a good deal of contact and intermarriage, so it is not surprising that there are similarities in the ceremonial activities and art traditions of the two groups. The Bella Coola, however, retained many of their Salish social and religious concepts, and thus their culture has remained in some ways distinct from that of their seaward neighbors.

Although it includes some fine examples, the Burke Museum's collection of Bella Coola and Bella Bella material is small. It was acquired from a variety of sources: early collections from the Young Naturalists' Society, pieces specially gathered for the Washington World's Fair Commission, gifts from individuals, and exchanges with other museums. Although a number of the pieces were actually collected elsewhere on the coast, they have been attributed on the basis of style to the Bella Coola and the Bella Bella.

44; 45. Masks Bella Coola; late 19th c.

Wood (alder); 25 cm × 20.5 cm × 12 cm; 24 cm × 19.5 cm × 12 cm

Washington World's Fair Commission; collected before 1893 at Fort Rupert, Vancouver Island, by James G. Swan; received 1893; cat. nos. 51, 52

Bella Coola mythology is very rich, describing the character and activities of the myriad supernatural beings who inhabit multiple layers of the world above and below the layer in which humans live. Those who control the world of the living dwell in the layers above, while the ghosts are in an underground world which, like that visited by Puget Sound Salish shamans in their Spirit Canoe (no. 11), is the opposite of the land of the living in all ways. In the lands above the earth dwell the spirits who control the lives of human beings and give them their culture and traditions, including the Winter Ceremonials. The most important of these ceremonials was the Kusiut, which corresponded roughly to the Tseyka of the Kwakiutl and Bella Bella (nos. 35, 36, 37), in which the dancers impersonated the inhabitants of the supernatural world.

Among those supernatural beings were four brothers, created at the beginning of time by the most powerful spirit, Ahlkuntam, to put the world and humankind into its present form. Responsible for the arts and culture of the Bella Coola (Boas 1898:32–33; McIlwraith 1948, vol. 1:39–40), the brothers are referred to collectively as Masmasalanikh or in English as the Carpenters. Each has a name which describes his prowess in accomplishing the tasks that he undertakes. The translations of these names differ from one reference to another, but in each the Bella Coola name is recorded with remarkable consistency. The oldest and most powerful brother is named Yula'timōt (Boas' orthography; no. 44). Boas translates this name as "the one who finishes his work by rubbing once," McIlwraith as "He Who Completes Any Task with a Single Smoothing Motion," and Swan, who collected these masks, as "created fire." The second brother is MaLapā'litsêk· (no. 45), variously translated as "the one who finishes his work by chopping once," "He Who Completes Any Task with a Single Stroke of His Adze," or "created rain."

The fact that the Burke Museum's set of four masks was collected by James Swan at Fort Rupert, a Kwakiutl village on Vancouver Island, adds a bit of mystery to their story. Although they were catalogued as Kwakiutl because of their place of collection, it is clear by the character of both sculpture and paint that they are originally from Bella Coola. And to settle finally the question of their source, the Bella Coola name of each of the Supernatural Carpenter brothers is written in pencil on the back of each mask! Swan apparently was unaware that the masks were intrusive at Fort Rupert. His translation of the names, probably gleaned from Kwakiutl unfamiliar with the Bella Coola terminology, is very different from those that Boas and McIlwraith acquired directly from the Bella Coola, although certainly in the spirit of the creative function of the Carpenters.

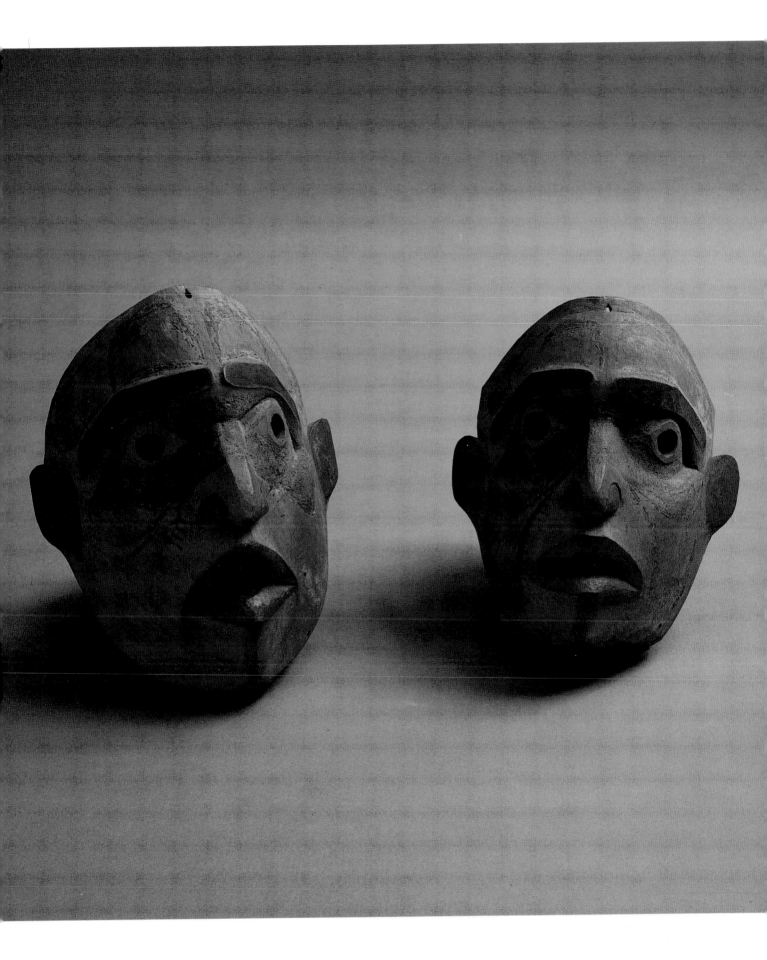

46; 47. **Masks** Bella Coola; late 19th c.

Wood (alder); 24 cm × 20 cm × 11 cm; 22.5 cm × 19 cm × 11 cm

Washington World's Fair Commission; collected before 1893 at Fort Rupert, Vancouver Island, by James G. Swan; received 1893; cat. nos. 54, 50

MaL'apē'exoêk· (no. 46), "the one who finishes his work by cutting once," "He Who Completes Any Task with Two Strokes of His Adze," or "created trees," is the third of the four Masmasalanikh brothers. The last is IL'iLu'lak (no. 47), which Boas does not translate, but which McIlwraith renders "He Who Completes Any Task in a Single Day," and Swan as "created the world." In the Kusiut performance in which the brothers are represented, it is said that they each carry a specimen of their work (McIlwraith 1948, vol. 2:245).

Although not in any way as elaborate as some of the Carpenter masks illustrated by Boas (1898: pl. 8, figs. 1, 2) the Burke Museum's masks are classic examples of nineteenth-century Bella Coola sculpture. They are very boldly and directly carved. It is obvious that the artist had complete mastery of his tools and material, and a full preconception of the form he intended his sculpture to take. There were no wasted strokes of the adze or knife. He truly "completed his task by adzing once." Many Bella Coola masks have this direct quality and must have been made very quickly. It may be that the custom of burning masks after their use (McIlwraith 1948, vol. 2:61–62), and the great number of masks that had to be newly made for each ceremonial season, worked to prevent carvers from expending unnecessary time on them. Fortunately for us, the practice of destroying masks was not followed as diligently as the accounts of the custom would suggest.

The Burke masks are very much alike in that they conform to the conventional Bella Coola style of humanoid representation, with boldly carved planes, receding forehead and jaw, broad eyebrows in strong relief, and strong conical orbs bounded by voluminous modeling of the under-brow and upper cheek. Typically, the broad, rounded lips are open and projecting. The masks are painted in classic Bella Coola color and form. A soft buff, the natural color of the aged alder, forms a background on which black eyebrows, as well as red lips, nostrils, and ears, are painted. Ultramarine blue, almost a trademark of Bella Coola painting, sweeps across the eye sockets and over the projecting cheek bulges. The masks are painted as pairs. Yula'timōt and MaLapā'litsek· have open formline U's on foreheads and cheeks, while MaL'apē'exoêk· and IL'iLu'lak have open formlines with split U's on the foreheads, and curved, split U's on the cheeks. These details are very similar to those on many Bella Coola masks; it is not clear whether they have any significance specific to the Supernatural Carpenters.

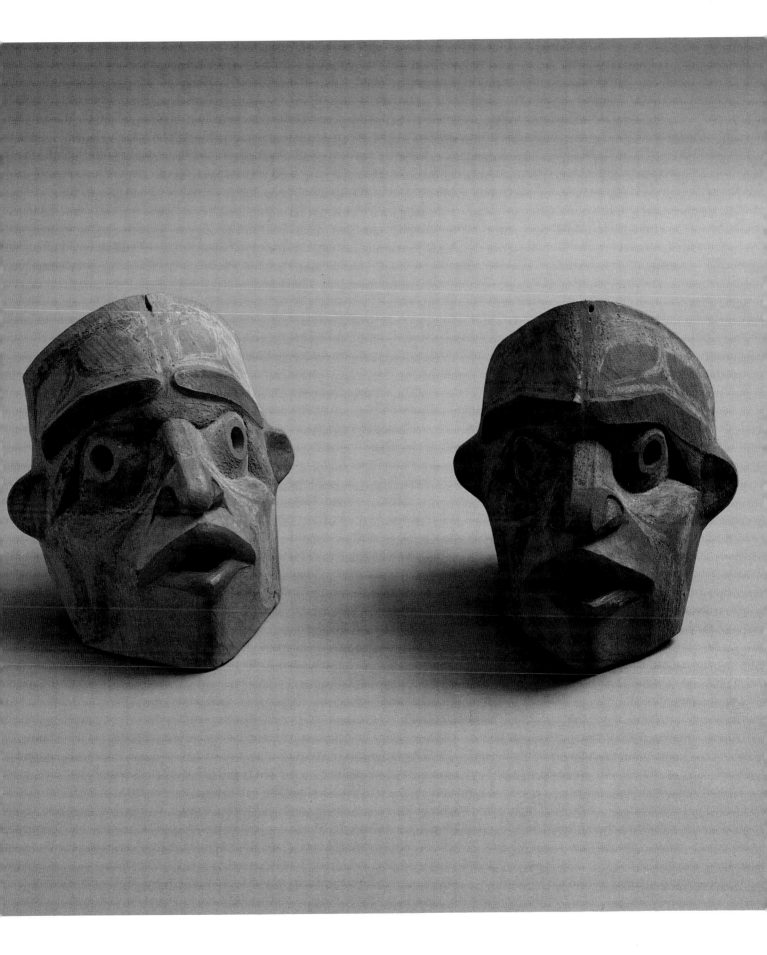

48. **Raven Headdress** Bella Coola; late 19th c.

Wood (alder), red cedar bark, glass; 50 cm × 20 cm × 12 cm

In exchange from the American Museum of Natural History; collected by George Hunt in 1901
from the Gwawaenokhw Kwakiutl; received 1936; cat. no. 1–11389

An elegant Raven mask, mounted on a thin, wooden ring covered with shredded and dyed cedar bark, illustrates both the power of classic Bella Coola sculpture and the problems of attribution. The headdress was collected at the turn of the century from the Gwawaenokhw, a Kwakiutl tribe whose isolated village, Heygums or Hopetown, has been continuously occupied since the time of the heroes of Kwakiutl mythology. George Hunt, principal collaborator of Franz Boas, for whom he collected the Raven headdress, can be relied upon for that record and for the Kwakiutl identification GwāwēsEmł Hămsiwē (Raven-of-the-Sea Cannibal-Forehead-Mask). The fact that the mask was in use by Kwakiutl dancers and referred to by a Kwakiutl term would ordinarily be reason enough to assume its Kwakiutl origin. However, it is Bella Coola in every other way, and must have come to Heygums, 180 miles away by canoe, through trade or marriage. The Kwakiutl name identifies it as a Hamatsa headdress, perhaps worn by the Hamatsa in his last, tame dance (Holm 1983b: nos. 73, 74), or by his female associate (Holm 1983b: no. 55).

There are a number of similar Bella Coola headdresses in collections. Their use is not clear. Perhaps they were worn as crest headdresses on ceremonial occasions such as the mourning ritual described by McIlwraith (1948, vol. 1:218). They all share many features with this one. The boldness of Bella Coola sculpture is exemplified by the angled brow overhanging the eyes, which are deeply cut under each orb so that they slant sharply inward. The cheek bulge, so prominent on the Carpenter masks, is more subtly carved but nonetheless present on the raven. Half-conical nostrils flare from the beak, which tapers to a gracefully curved tip. The paint is typically Bella Coola in color and form: the natural background is nearly covered with a rich blue relieved by tapering slits, black eyes and eyebrows, and vermilion lips, nostrils, and detail. The blue paint on Bella Coola sculpture is often fragile and, as seen here, wears away much more quickly than the red and black. As the mask turns the eyes glint, reflecting light from glass ovoids that have been set into the wood over the black-painted iris and pupil.

Very sensitive observation of the bird raven is apparent in the form of the mask's beak. It is as accurately rendered as an ornithologist's diagram and as expressive as an artist's impression (Angell 1978:35). The Bella Coola artist has merged this naturalism with the sophisticated stylization typical of his people's art. Everywhere that ravens and humans come together the bird is perceived both as a mysterious being and as a reflection of the flawed character of humans. Here the aggressive, cunning, boisterous raven merges, in the form of a headdress, with its human Bella Coola counterpart.

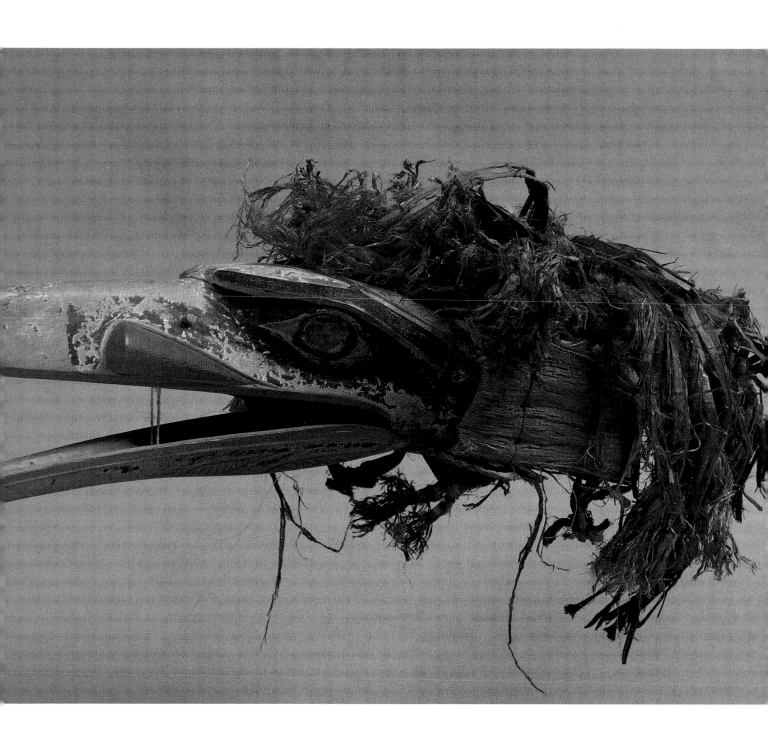

49. Bird Mask Bella Bella (?); 19th c.

Wood (alder); 32 cm × 27 cm × 22 cm

Young Naturalists' Society; collected in 1894 at Kasaan Bay, Alaska, by Dr. James T. White; received 1912; cat. no. 4797

Raptorial beak and round, staring eyes give this powerful mask the aspect of an owl. That may have been the artist's intent, but we have no information about the mask's use, and little documented material with which to compare it. It is superbly designed and carved, one of the finest examples of Northern Wakashan sculpture. James T. White, the collector of this mask, indicated its provenance as Kasaan Bay, Alaska, a Haida village. White's collection records seem to be accurate, so there is little doubt that the mask was collected there. However, it surely is Northern Wakashan in origin, and possibly Bella Bella. In the Burke accession records, there is a scrap from a notebook with part of a detailed description of another White piece. It hints at a wealth of information that the now-lost notes might have given us about this fine mask.

Similarity to Bella Coola design is most apparent in the use of large solid and split U-forms painted across the eye sockets and over the cheeks, chin, and forehead. These U-forms were probably originally blue, but the mask has been varnished, which turns the soft blue paint darker and greener. The natural color of the alder shows as the background. Those unfamiliar with the conventions of northern Northwest Coast painting often mistake these seemingly random patches of exposed wood, in the shape of concave points or curved T's, for positive design elements (Stott 1975:96) when, in fact, they are carefully positioned negative relief elements defining and elaborating the junctures and spaces between U-forms. These negative relief elements are particularly confusing if they are painted red, as they sometimes are. The T-reliefs on the cheeks define the rounded ends of the band that crosses the eye sockets and simultaneously relieves and elaborates the U's descending over the cheeks.

Strong as is the design of the mask, there are elegant subtleties in its form. Arching brow ridges flare gently outward over the sharply cut eye sockets. These sockets and the wide conical orbs are carved in the Bella Bella mode and are, along with the general shape and the style of painting, identifying features. They bear a close resemblance to the eyes on one of the best-documented of nineteenth-century Bella Bella objects: a magnificent chief's seat or settee made in the village of Bella Bella in 1881 and now in the Ethnographic Museum in Berlin (Holm 1983c: fig. 2:22).

The articulated mandible is hinged in an elegant old way that was retained by Bella Bella and Bella Coola mask makers into the twentieth century. The jaw is carved to fit between the cheeks and is fastened with pins, upon which it pivots, producing a more naturalistic effect than the leather strap hinge which superseded it in Kwakiutl articulated masks of the late nineteenth and twentieth centuries (nos. 35, 36).

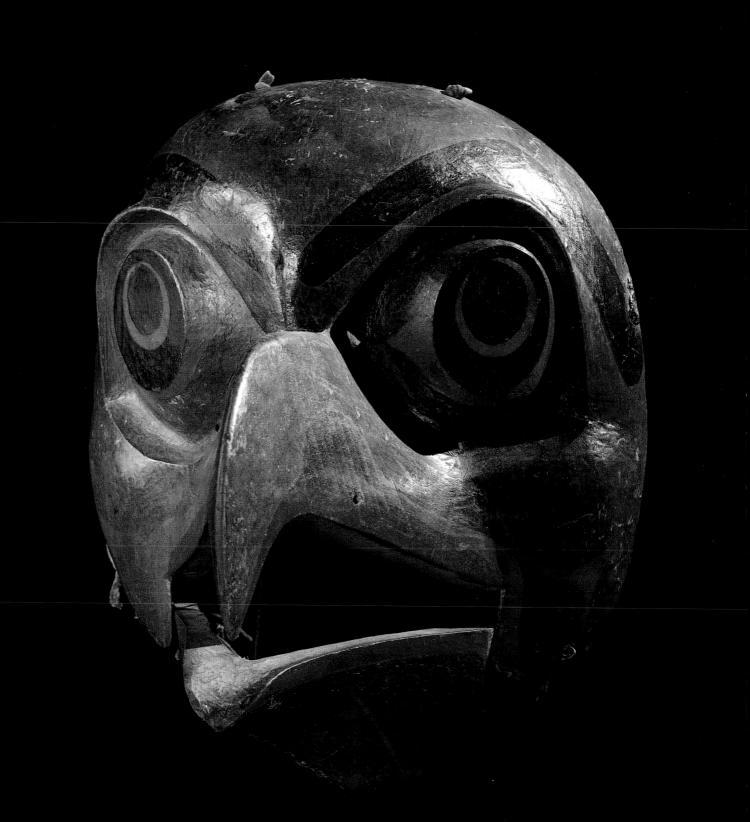

50. **Rattle** Bella Bella; 19th c.

Wood (maple ?); 24 cm × 15 cm × 16 cm

Collected near Nakwakto Rapids, Seymour Inlet, before 1938; received 1938; cat. no. 1–10

Weathered to featherweight and fragility, this globular rattle was recovered from a cache near the awesome Nakwakto Rapids at the mouth of Seymour Inlet. This is in the ancestral territory of the Nakwakhdakw Kwakiutl (Holm 1983b:16) and the rattle's appearance there, some eighty miles from the Bella Bella village of its origin, is less surprising than the presence of the Bella Coola pieces at Fort Rupert and Heygums. The Nakwakhdakw people had relatively frequent contact with the Bella Bella in trade, marriage, and war. Since many ceremonial privileges came from the Bella Bella through such contacts, one might expect to see objects such as this among the Nakwakhdakw.

The rattle is very closely related to the chief's seat in Berlin (see no. 49), and may have been carved by the same artist. The settee is of special importance because its source and date are known and because it combines two-dimensional design with sculpture, making it very useful in identifying Bella Bella work of its time. The rattle matches the settee stylistically in every way, and adds to the evidence that the Bella Bella were working in the highly organized northern formline design system in the early 1880s.

A globular, scowling humanoid face forms one shell of the rattle, while the other is covered with a stylized design of body parts in the classic northern formline tradition (Holm 1965; and see no. 58). The design is so abstract that it cannot be interpreted with any assurance, although close to the handle a pair of clawed feet appear. The workmanship in the sculpture, the painting, and the detail carving is superb.

A shaman probably owned and used this rattle. Among the Kwakiutl and related people, rattles shaped like birds (usually ravens) were used in the Tlasula dances. Globular rattles were reserved for shamans' work and for the Winter Ceremonial, Tseyka, consistent with the idea that all the active participants in the Tseyka were "shamans" (Holm 1983b: no. 38). The likelihood is that this particular rattle, found cached in the forest, was part of the paraphernalia of a shaman; its foreign, Bella Bella style would be particularly appropriate to the shaman's exoticism.

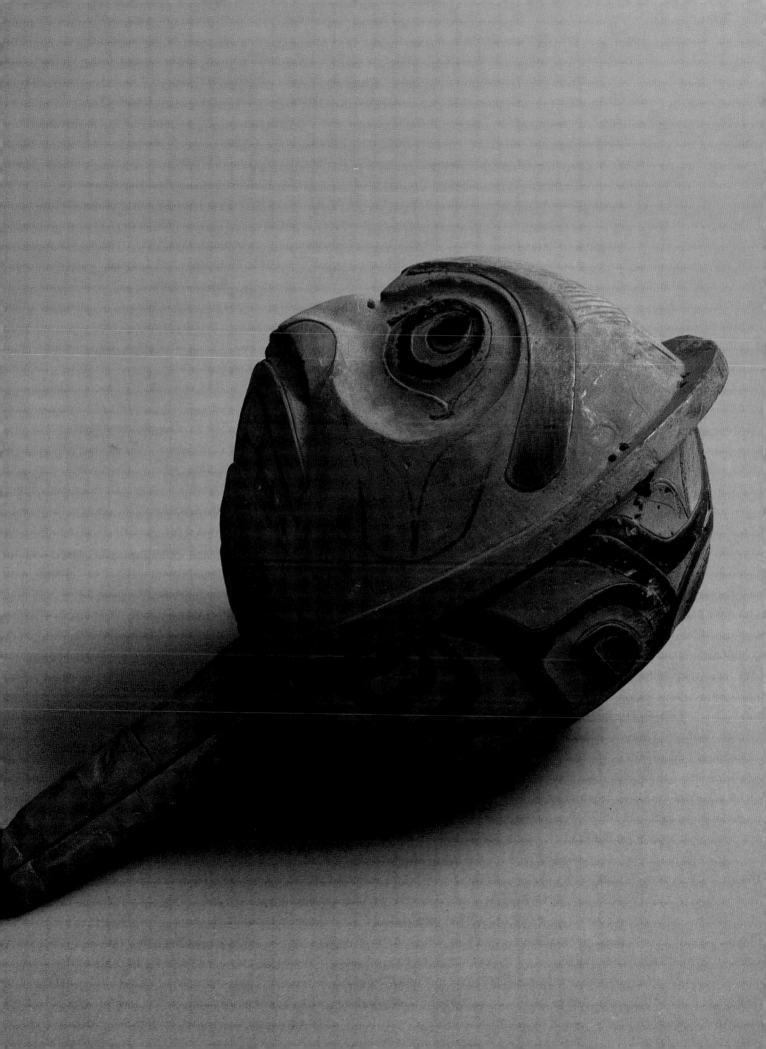

The Tsimshian *Nos. 51–55*

The northern neighbors of the Northern Wakashan tribes are the Tsimshian and their close cultural and linguistic relatives, the Nishga of the Nass River and the Gitksan of the upper Skeena. The Tsimshian have become renowned for their craftsmanship and art; articles of Tsimshian work have been collected from many parts of the coast where they were prized by their owners. Along with the Haida to the west, with whom they had frequent contact, the Tsimshian were at the center of the northern design tradition. Tsimshian art has the reputation of being very refined, and many examples of it reinforce that reputation. There are variations in the art traditions of the far-flung Tsimshian, due in large part to their contact with the work of other peoples; still, there are principles of form by which Tsimshian sculpture, in particular, can be recognized. Even the artists of the Gitksan, the people of the upper Skeena River, some of them living over two hundred miles from the salt water, worked in the Tsimshian tradition.

Art of the northern tribes is primarily motivated by the need to display hereditary family emblems, acquired by one's ancestors and passed from generation to generation in a strictly prescribed order. Display of the crests on houses, poles, headdresses, and other objects is a prestigious act and requires validation by potlatch. Crests and certain other valuable prerogatives, such as noble names, could also be captured in war or relinquished in reparation for damages to pride, for injury, or for death. These transfers of prerogatives, in addition to intertribal marriages and trade (in which the Tsimshian people were heavily involved, due to their strategic occupation of rivers leading to the interior), were means by which art objects and styles were diffused.

51. Mask Nishga(?); 19th c.

Wood (alder?), human hair; 26 cm × 23 cm × 17 cm
Walter Waters Collection; received 1953; cat. no. 1–1457

No documentation accompanies this striking piece, but it is probably a Nakhnokh mask—that is, a mask representing a hereditary spirit name. When the name is assumed by its owner, it is dramatized in a pantomimic dance using a mask illustrative of the name. Nakhnokh or spirit names refer to animals or to people, often foreigners or those with unusual physical or personality traits (Halpin 1984:290–98). The mask wearer acts the character of the spirit, whether an Athapascan hunter shooting his bow, a white man with his whiskey bottle, or a slave woman insisting on marrying a chief. Certain Nakhnokh are violent or antisocial. Sometimes the dramatic performance of the Nakhnokh involves stage devices, mechanical figures, or sleight of hand to make acts of supernatural power appear real, such as the revival of a supposedly murdered person, or the apparent splitting open of the dance house.

The meaning of this mask is unknown. When it was received from the Waters collection the hair was largely gone and the mask was painted entirely white, except for the black eyebrows and red nostrils, ears, and lips. Patches of the white paint had flaked from the chin and jaw, exposing traces of a strange vermilion design beneath. Since the overpainting had every appearance of Indian work, long soul-searching went into the decision to remove it. Many Indian masks have, for various reasons, been overpainted. Sometimes the intent is to renew the original paint, sometimes to change the mask's character or to use it in a different dance. Frequently it is to enhance a piece for sale. In this case, it appeared that the mask was overpainted to represent a different being, a person frozen or dead. Half-closed eyes in hollow, bony sockets, emaciated cheeks and thin, stretched lips contributed to that effect. The white paint had been hastily applied, and the intent of the original designer-artist had been grossly altered; these led to the decision to restore the mask to its first form.

The design that emerged was startling and mysterious. There is no way to interpret it with any assurance, but the suggestion of a corpse, desiccated skin stretched over bony skull, is even stronger than before. Writhing, bristled tendrils and ranks of sickle shapes radiate over the pale wood. A band of black-speckled vermilion stretches from ear to ear, a common feature of Tsimshian masks, although usually not in this color arrangement. The mask follows Tsimshian principles of sculptural form: a broad face with stretched, narrow-lipped mouth, an aquiline nose, and cheeks formed of three intersecting planes. Lank hair framing the face, cryptic wriggles of vermilion unfolding over a pale skull, the mask calls forth an enigmatic spirit.

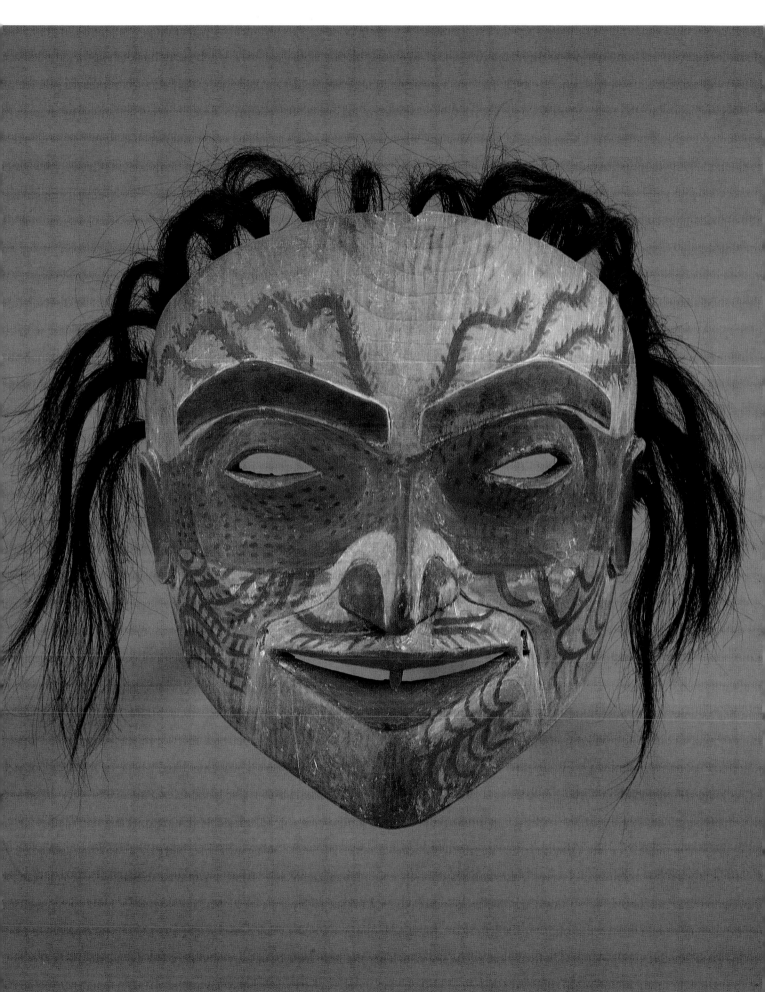

52. **Puppet** Tsimshian; 19th c.

Wood, buckskin, bird skin, cord; 40 cm × 15 cm × 9 cm
Hauberg Foundation gift; received 1954; cat. no. 1–1653

I t is not difficult to see how the theatrically sophisticated people of the Northwest Coast, people with traditions of representing in art and dance the creatures of history and myth, would conceive of and utilize puppets and marionettes. Articulated masks—particularly those that change form by splitting to expose an inner being or by altering their outer character (no. 43)—are marionettes by almost any definition. The imagination required to make lifeless wood seem alive is a requisite of the mask maker. Puppets and marionettes are extensions of the mask carver's work of bringing the myth-people to life.

Carvers who had skill and imagination were in demand everywhere on the coast. Dramatizations of violent death by beheading or stabbing and the subsequent miraculous revival of the victim were among the most memorable of the spectacular illusions of the Kwakiutl Toogwid performance (Boas 1897:491), the Bella Coola Kusiotem (McIlwraith 1948, vol. 2:128–61), and the Tsimshian Nakhnokh (Halpin 1984:293). These illusions were accomplished through the use of trick knives, false heads, and other artifices of stagecraft. We can only imagine how the stage managers in the performance of the Nakhnokh "Crack of Heaven" may have been able to

make the large house crack. One side of the large house moves backward from the other. It goes with the half of the large fire, and the whole congregation is still sitting on both sides. The roof is asunder, and the large beams go backward. This is the great wonderful enchantment among these chiefs in the Tsimshian nation. (Henry Tate, in Boas 1916:556)

The men responsible for these wonders—the masks, marionettes, and other illusory devices used in graphically displaying supernatural power—were secretive in their work everywhere on the coast. Among the Tsimshian they were organized into a powerful group called Gitsontk (Shane 1984:160–73). The members were trained in craftsmanship and the secret knowledge needed for their work. They were of noble status and wielded considerable power. They were also responsible for the successful operation of their products, the traditional penalty for failure being great shame or even death. The Nakhnokh mask (no. 51) and this marionette were probably made by members of the Gitsontk.

Head, torso, hands, and feet are carved of wood, probably alder, while arms and legs are of stuffed skin. A cord threaded through a hole in the neck enables the hands to rise and fall. Probably there were other controls, but none survive. The man's head is hollow, and is a rattle. Small tufts of bird down are attached to his hips. He may once have been dressed, perhaps in a dancing robe. There is no documentation with the figure, and the Tsimshian attribution is based solely on the stylistic character of the sculpture and its similarity to other documented Tsimshian marionettes. Nor is there information to indicate the puppet's use, although it seems likely to have been part of a Nakhnokh performance, the dramatization of a spirit name.

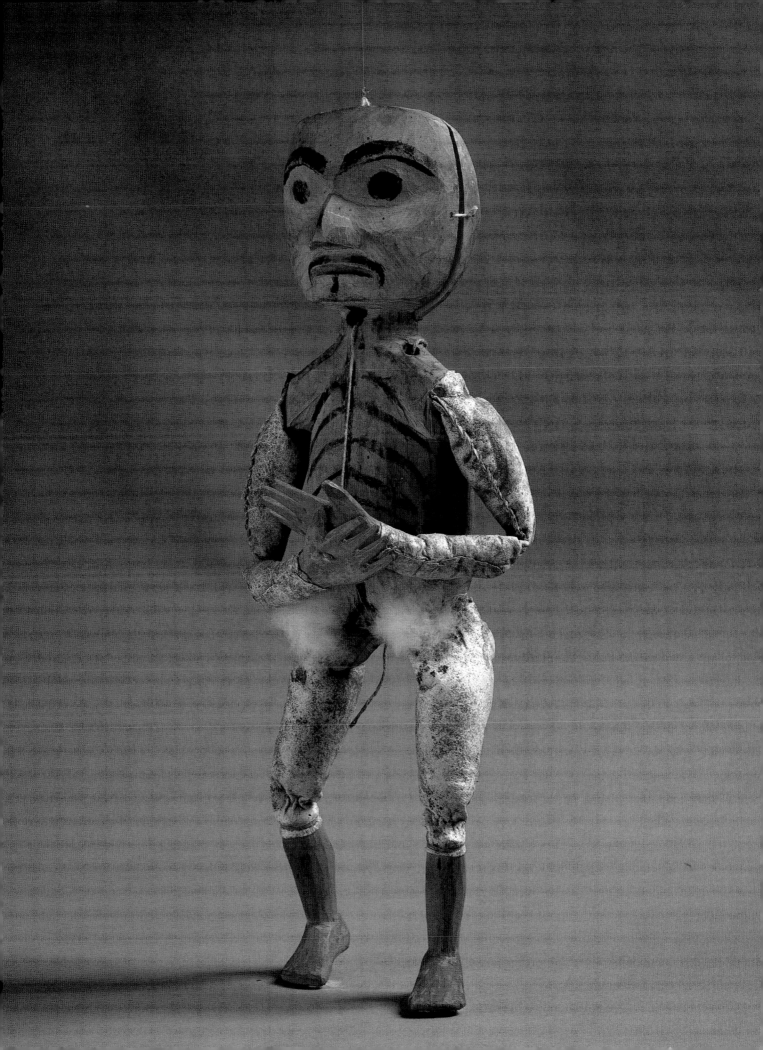

53. Trumpet Tsimshian (Gitksan); 19th c.

Wood (red cedar), spruce root; 66.5 cm × 11 cm × 6 cm

*Collected by George T. Emmons on the upper Skeena River in 1911; received in 1936,
in exchange from the American Museum of Natural History; cat. no. 1–11387*

In many of the cultures of the Northwest Coast, the presence of supernatural power is
signalled by whistles and trumpets. These wind instruments utilize almost every
principle of sound production known. The haunting sounds that represent the awesome
power of the human-eating spirit in the Kwakiutl Hamatsa dance are made on whistles with
mouthpieces somewhat like those of recorders (Holm 1972:23–24; 1983b: no. 34). Other
whistles use single or double reeds (Holm 1972:32; 1983b: nos. 35, 36) to produce their spirit
voice. Formerly, some instruments were made like a trumpet, the player using tightly closed
lips like a double reed to vibrate a column of air in a tube. The approach of the spirits
motivating the Winter Ceremonial of the Quatsino Sound Kwakiutl was heralded by the eerie
wails of trumpets made of long tubes of bull kelp looped over the shoulders of secreted
players (Curtis 1915:216).

An unusual sound-producing mechanism used in some Northwest Coast ceremonial horns
is the "lateral retreating reed" (Morris 1914:84–85). A thin-walled tube with one end closed is
made of two hollowed shells lashed tightly together at both ends. When air is blown in the
open end the edges where the shells are joined vibrate, producing the sound. This elegant
horn appears to combine the principle of the lateral retreating reed with that of the trumpet.
With split spruce root, two very thin red cedar shells are tied together at the narrowest points
to form a flattened, open-ended tube. At the lower end the opening is carved to fit the
player's lips. When the instrument is blown like a trumpet, the joining edges vibrate to
produce a resonant, rasping sound unlike any other.

Interestingly, the whistles and horns used as spirit voices are often beautifully made and
decorated, but they are never meant to be seen: they are always blown in secret. This one is
particularly elegant. Coinciding with the smoothly swelling contours of the horn is a simple
but expertly painted formline representation of a man. Three thin-lined, long ovoids in the
body probably represent vertebrae. Hips and shoulders are formline U's. The stylized face
lacks a surrounding formline, its place taken by the flaring outline of the horn. The fit of the
figure to the sculptural form is so perfect that it is hard to decide whether the shape was made
to accommodate the man, or the man made to fit the outline of the horn.

Whistles and horns were used by the Tsimshian in both the Nakhnokh performances and
the initiation ceremonies of the secret societies acquired from the Northern Wakashan tribes.
George Emmons, who collected the horn from the Nishga, did not specify its use.

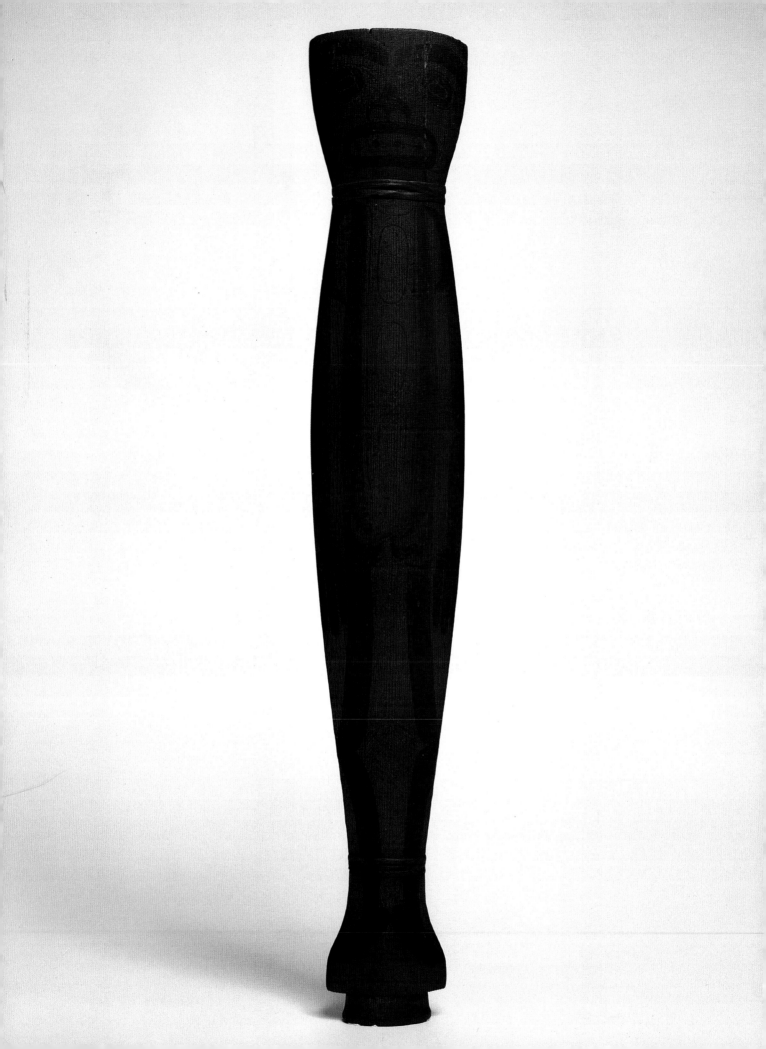

54. **War Pick** Tsimshian; 18th c. or early 19th c.

Stone; 29 cm × 4.5 cm × 3.5 cm

Collected by George T. Emmons from the Tsimshian before 1905; received 1909; cat. no. 2387

In the museum exhibition case, a long, angular slip of dark, gray-green stone, crisply faceted from end to end, gives little hint of its violent purpose. The blade of a war pick, an elegant minimalist sculpture, was once hafted cross-like in a wooden club designed to split helmets and shatter skulls. In bloody wars it was a weapon of remarkable efficiency, a long, dense spike with great penetrating power. War picks were ceremonial weapons as well, described by George Emmons, the weapon's collector, as " . . . highly valued, and were more often the property of chiefs, and were used to kill slaves with when giving away property, building a new house, or upon the death of the chief" (Emmons 1909:121). Clubs of many kinds, especially those of stone, have often been called "slave killers," but most were probably practical weapons like this one and only incidentally used in the ultimate potlatch gesture.

The stone from which the pick was made is hard and fine-grained. It probably was worked into shape by a combination of sawing and grinding. These techniques, together with pecking, were the means by which exceptional stone work was accomplished in ancient times on the Northwest Coast. In pecking, a hard pebble is struck against the stone to be shaped, pulverizing a bit of material at the point of impact. Repeated blows gradually bring the piece to the desired shape. Grinding involves rubbing the object on abrasive stone to refine the shape and smooth the surface. Sawing is a remarkable process in which the stoneworker cuts deep grooves in the boulder from which the tool or weapon is to come, finally separating out a blank which is finished by grinding. The "saw" was probably a thin slab of sandy shale or perhaps a wooden blade used to rub in a compound of sand and water.

In cross section the pick is a flattened hexagon, slightly curved from end to end, with the upper line broken by a raised lug. This protrusion is designed to help secure the pick in its handle, and seems to be related to the very similar detail found on northern splitting adzes (Niblack 1890: pl. 23; Stewart 1973:50). However, northern splitting adzes were lashed to an upper face of a T-shaped handle rather than fitted in the shaft. War picks went out of common use early in the nineteenth century when guns became widespread. The form survived as a shaman's weapon, usually with a wooden blade, with which he fought malevolent spirits (de Laguna 1972: pl. 187).

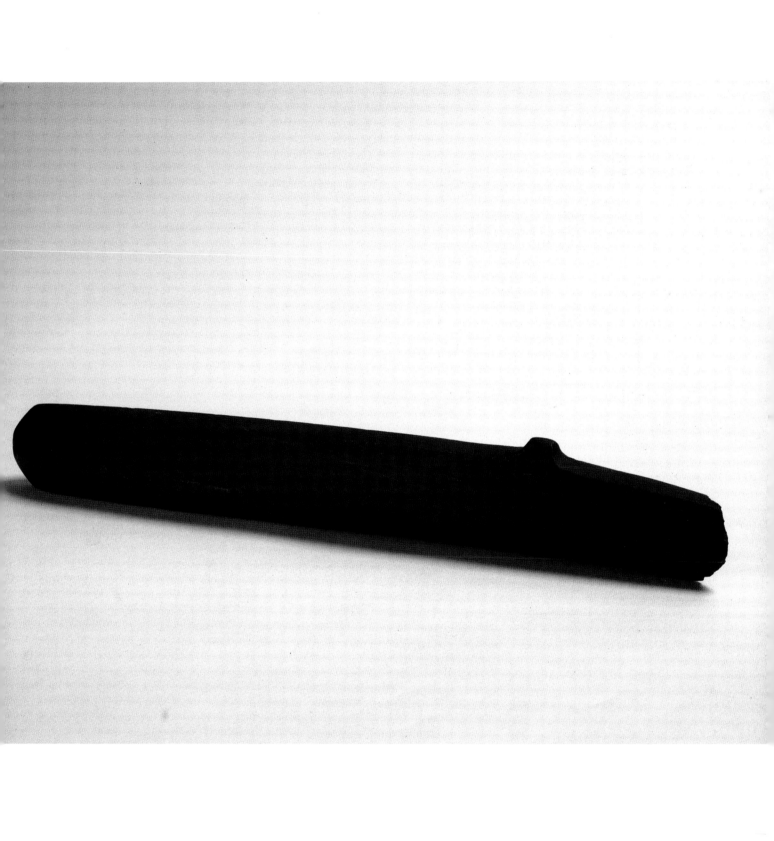

55. Leggings Tsimshian; 19th c.

Woolen cloth, buckskin, puffin beaks; 39 cm × 41 cm

Collected by George T. Emmons on Portland Canal before 1905; received 1909; cat. nos. 1970a, b

A Tsimshian chief in his role of Wihalait, Great Dancer, carried a raven rattle (no. 72) and wore an elaborate and distinctive costume: a spectacular headdress (no. 73, a Tlingit example), a Chilkat dancing blanket (no. 74), a fringed apron, and decorated leggings. The figures represented on this rich raiment were either hereditary crests or spirit beings appropriate to the dancer's role as custodian of supernatural power. The composite of materials constituting the panoply of a dancing chief is extraordinary; among them are wood, abalone shell, sea lion whiskers, ermine, bird down, cedar bark, mountain goat wool, buckskin, puffin beaks or deer hooves, and trade cloth.

Leggings, called *sakhsiksumsa*, "wraps one side of leg" (Halpin 1973:213), were sometimes made of cut pieces of Chilkat blankets and only rarely specifically woven as leggings (Samuel 1982: pl. F, G). They were also fashioned of buckskin painted with crest designs or decorated with porcupine quill embroidery, or were made of trade cloth with a design of beadwork or cloth appliqué. The Tsimshian leggings in the Burke Museum collection are of the latter kind. Navy blue woolen blanket material forms the background for the design, which is appliquéd in red trade cloth. The figure represented is recorded in George Emmons' collection notes as a sculpin, a spiny fish with a very large mouth (no. 43), which was a crest of the Ganhada phratry (see p. 167) of the Tsimshian (Boas 1916:504; Halpin 1984:409–11). The wide mouth and fish-like shape certainly suggest the sculpin, even though the lack of spines on the nose and over the eyes (usual specific sculpin identifiers in northern Northwest Coast art) is puzzling. On the other hand, the broad pectoral fins attached to the head, and the dorsal fins ("split" so that half the fin appears on each side) extending to the lower corners, along with the bifurcate tail, are typical killer whale attributes. The killer whale is a principal crest animal of the Gispawudwada phratry (Boas 1916:505; Halpin 1973:360–62) and would also be an appropriate theme for the legging design. In contrast to the often very specific family and clan identification in his Tlingit notes, Emmons attributed these leggings only to "Portland Canal, the Tsimshian people," so we have no way to judge the identification of the figure on the basis of crest ownership.

The appliqué figures are designed according to the tenets of the northern formline system (Holm 1965). All the dark blue areas are negative space—that is, either background or spaces between major positive forms, which are made of red trade cloth in this example. The creature's tail forms a flap that falls on the top of the wearer's foot, and the fringed sides are wrapped around the lower leg and tied in back. The upper edges of the leggings are bound with strips of hide, which are now nearly bare but once were furred. They are probably otter skin. Attached to the lateral buckskin fringes are upper beaks of tufted puffins (*Fratercula cirrhata*, a spectacular diving bird), which were often used by Northwest Coast people as rattles on ceremonial dress.

Haida *Nos. 56–66*

A chain of mountain peaks, 175 miles long, looms out of the Pacific Ocean, separated from the British Columbia mainland by fifty miles of some of the roughest open water on the coast. The Haida people occupying these Queen Charlotte Islands were the pre-eminent seafarers of the Northwest Coast. They produced, in their island domain, art and architecture of such power that theirs is often, and not without some justification, thought of as the epitome of Northwest Coast cultures. When fur traders and explorers—first Spanish and later English and American—met the Haida, they found them to be independent and aggressive, self-assured masters of a rugged land and sea.

From those early days until the present, Haida workmanship has been admired and desired. In the middle of the nineteenth century, collecting of Haida art by non-natives began in earnest. The great collections are replete with Haida material, including many of the monumental totem poles that once lined the beaches of Queen Charlotte Island villages like mystic forests. Those thickets of poles were in part a legacy of the fur trade, their great numbers the result of increased wealth and the new availability of steel blades. In the early nineteenth century there were many such Haida villages in the Queen Charlottes and on Prince of Wales Island in Alaska, and the advent of photography was in time to preserve enough of their appearance so that we can appreciate how spectacular they were (Blackman 1981; MacDonald 1983b). But the epidemics that were so devastating to tribes all along the coast were particularly ruinous to the Queen Charlotte Islands Haida, and one by one the villages were abandoned until, finally, nearly all the survivors were concentrated in the villages of Skidegate and Massett (now called Haida).

By the early twentieth century, much of what was left of Haida art was gone from the islands; very little new art was being produced except for small objects made for sale, of which the best known are carvings in argillite. In the last twenty years there has been a spectacular revival of interest in and production of traditional art, and some of the finest examples ever made are from the hands of the new generation of Haida artists.

The Haida collection in the Burke Museum is relatively small. Early pieces came from James Swan, who had collected in the Queen Charlotte Islands for the Smithsonian Institution and had made contacts among the Haida. When he made his collection for the Washington World's Fair Commission, he included Haida material, and when systematic cataloguing of the collections finally began in 1909, a Haida appliquéd dance shirt was the first to be numbered. More pieces came from collectors such as Dr. James White, George Emmons, and Walter Waters. The donation of the Gerber collection brought a number of fine argillite carvings to the museum; over the years more Haida pieces were added by gift and purchase. Through them we may catch a glimpse of the rich culture that flourished on those rugged, beautiful islands.

56. **Canoe Model** Haida; late 19th c.
Wood (yellow cedar); 111 cm × 24.6 cm × 24 cm
Mrs. Ray E. Dumett; received 1960; cat. no. 1–3004

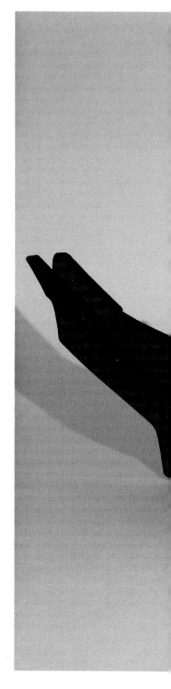

According to the archaeological record, the Queen Charlotte Islands were populated at least seven thousand years ago. Haida traditions claim the origin of humankind in the islands, but they also tell of the subsequent arrival of the ancestors of certain lineages by sea. In either case, the ancient Haida were of necessity expert canoeists, and generations of hard and practical experience made of them unsurpassed designers, makers, and users of canoes.

The islands themselves played a part in this development. As anywhere on the coast, the rugged, broken land and the bounty of the sea dictated a dependence on water transportation. Add to that the isolation imposed by Hecate Strait and Dixon Entrance: the importance of canoes becomes clear. And on the Queen Charlotte Islands grow the finest dugout canoe trees in the world—western red cedar of giant size and perfect grain. The skill of Haida canoe makers and the quality of their product was recognized by all the surrounding tribes; canoes were their most important export, traded to the Tsimshian and Bella Bella to the east, and to the Tlingit to the north. Fleets of new Haida canoes, loaded with dried halibut and the potatoes that the Haida grew in abundance after their introduction by whitemen, set out across the unpredictable waters to trade for ooligan oil, the hides, meat, and horns of the mountain goat and sheep, and other materials that were lacking on the isolated islands. Canoes were the means by which marriage alliances and wars were conducted; the invitations to potlatches and the subsequent arrival of guests were by canoe. In speech and ceremony, the canoe was a metaphor for chiefly prestige and power.

Model canoes were popular toys for Northwest Coast boys, but most of those in collections today were probably made for sale. Northwest Coast canoe models are often extremely accurate, small-scale representations of the full-sized canoes in every detail but length. While canoe models are invariably much too short for their height and beam, these proportions are pleasing and show the truly sculptural form to advantage. This elegant model otherwise accurately depicts the form of a large Haida canoe of the classic nineteenth-century style. Its upswept ends, graceful sheer, and fine, streamlined entrance at bow and stern are marks of the typical northern canoe. Large Haida traveling canoes had at the ends an exaggerated flare, which swept into a broad raised band running the length of the gunwales. Smaller Haida canoes and most other northern canoes (no. 34) lack this feature.

Many large northern canoes were painted, often with a black hull and elaborately detailed ends. The paintings represent creatures of mythology which sometimes, as in this example, are so abstracted that their identities are hidden. Here the painting is in the classic northern formline tradition and may be the work of the renowned Haida artist, Charles Edenshaw (Holm 1981:181–88). Red primary formlines with inner ovoids, and secondary formlines in black present a satisfying contrast to the black hull and gunwales. The painter demonstrated his skill by perfectly fitting the formlines to the shapes of the bow and stern, which are dictated in turn by the canoe design.

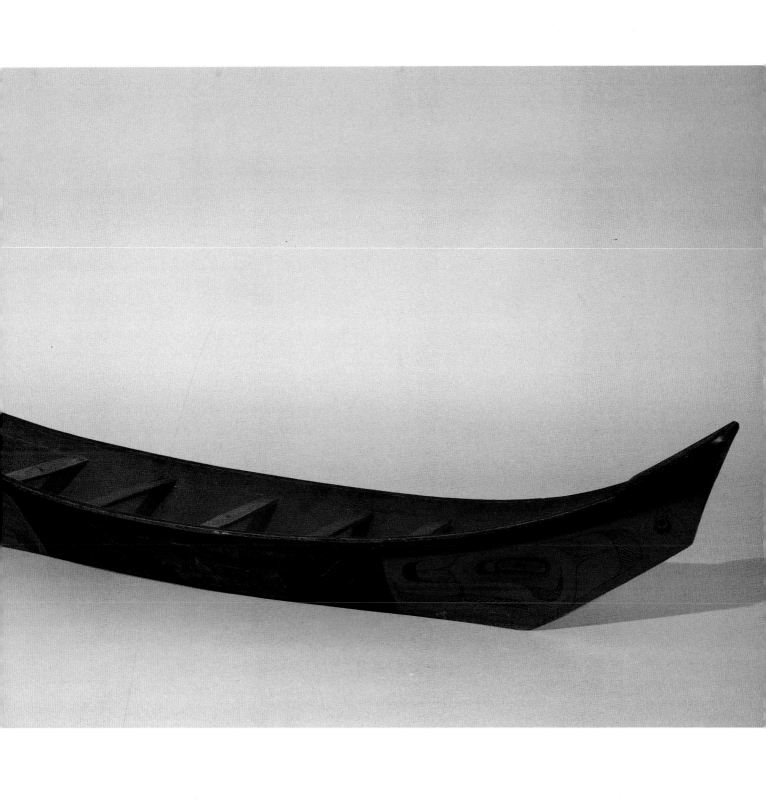

57. Dance Tunic Haida; 19th c.

Woolen blanket and trade cloth, pearl buttons; 82 cm × 63 cm

Washington World's Fair Commission; collected by James G. Swan; received 1893; cat. no. 2

The ethnological collections of the Washington State Museum (now the Thomas Burke Memorial Washington State Museum) were greatly enlarged by the acquisition of the Emmons collection of Tlingit material at the close of the Alaska-Yukon-Pacific Exposition in 1909. At that time, curator Frank S. Hall began to catalogue the collection. Perhaps arbitrarily, since Hall had to start somewhere, a pair of Haida dance shirts collected by James Swan for the Washington exhibit at the World's Columbian Exposition in Chicago were given the catalogue numbers 1 and 2. No. 1 has been illustrated elsewhere (Inverarity 1950: no. 4), and the designs of the two sides have become perhaps the most frequently copied Northwest Coast appliqué patterns.

Both tunics are very good examples of the application of formline design principles to appliqué. They illustrate both the simplification imposed on the artist by material and technique and a close adherence to the rules of structure. The design on the front of this tunic represents a sea lion, while that on the back is a killer whale or orca (Holm 1965: fig. 64). Killer whale and sea lion are crests of the Haida Raven phratry. John Swanton lists five Raven families holding both crests (Swanton 1909:114); Swan recorded only that the tunic was from the Queen Charlotte Islands, so we cannot tell from which of those families it came.

The two sides of the sea lion are shown joined at the shoulder. This is probably an example of the conventional means of showing a whole animal in two dimensions, rather than an illustration of the well-known Tlingit myth of the strong man who split sea lions. The sea lion is characterized by a large head with toothed mouth and small ears, a short tail, and large, clawed flippers. The bull sea lion's bulging forehead is graphically portrayed.

Appliqué designs are often confusing to one not familiar with the northern formline system. The usual broad, red formlines can be mistaken for background, while the narrow, dark blue relief slits and tertiary spaces appear to be positive designs. In fact, the blue designs form the background and define the edges of formline figures such as U's and ovoids. To add to the confusion, one of the crescent relief slits in this sea lion's body has been misplaced. A tiny crescent intended to define the lower ovoid in the right half of the animal's backbone has been rotated so that it fails to accomplish its purpose. Such an oversight can hardly be attributed to the master artist who designed this imposing sea lion. Perhaps the crescent was not clearly marked on the pattern or was even omitted, so that the maker of the tunic misplaced it. The importance of this detail lies not in its effect on the total image, but in its underscoring of the very sophisticated design system used to produce it.

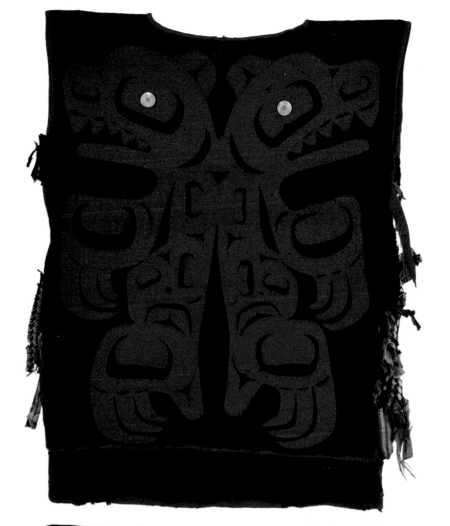

58. Chest Haida; 19th c.

Wood (yellow cedar, red cedar); 96 cm × 58 cm × 59 cm

Collected by George T. Emmons at Klukwan, Alaska, before 1905; received 1909; cat. no. 2291

Although Lt. Emmons collected this elaborate chest from Coudahwot, the chief of the Ganakhtedi clan at the Tlingit village of Klukwan, he was told that it had been procured in trade from the Haida of the Queen Charlotte Islands. This information is very likely accurate. In an old photograph of the interior of the Whale House at Klukwan (see p. 166), the chest appears inverted, without a bottom, and with the lid attached to the sides. In the chest's present form, the lid is separate and the sides are fastened to the bottom. Where the sides and lid come together there are traces of the former fastenings of spruce root, corroborating the fact that it was once a double, telescoping chest of an old type, in which the bottom was joined to an inner, usually plain, chest over which the sides and top of the outer chest were slipped. The sides of the chest are made of a single plank of yellow cedar transversely cut with a complex groove, nearly severing the wood, at three carefully measured places. These grooves or kerfs were steamed and the chest bent to its rectangular form. The fitted and hollowed bottom and top are of red cedar. A long patch has been fitted into the edge of the lid, apparently to repair an imperfection in the wood.

The long front and back panels are elaborately painted and carved with highly conventionalized figures that typically follow one of two compositional formats. Each panel represents the large head of a creature over a small, rectangular body flanked by arms and hands or claws. In the four corners are complex ovoids that appear to represent joints, and flanking the central head are two trapezoidal fields elaborated with a design that seems to be a side view of the body. The central head ordinarily takes one of two forms. One is more angular, with a long eye socket, a nose with nostrils, and a complex cheek design; the other is more rounded, with shorter eyes and no nostrils (see p. 166). The significance of the differences is not known, but there is some possibility that if they are used together on the same chest, as in this case, the simpler form may represent the hind quarters of the creature, rather than another head. Emmons recorded that the image on one side of this chest was that of the Gonakadet, an undersea monster who bestowed wealth; the painting on the chest ends represented its flippers. The other side of the chest was said to represent a bear. Almost identical chests were interpreted very differently, and perhaps owners from different lineages were expected to identify the designs according to their individual crests.

a b c

The system governing the character and placement of the design elements on this chest was known and adhered to from Bella Bella northward through Southeast Alaska (Holm 1965). The unifying element was the formline, a broad, linelike figure which was used to delineate the parts of the creature represented. As shown on p. 148, primary forms were defined by a formline grid, usually black (a), and were elaborated by secondary formlines in the opposite color, red (b). The remaining spaces were considered either background or positive, tertiary, forms. Background areas were left unpainted, and tertiary shapes were outlined with thin black or red lines and sometimes painted blue (c). Relief carving on a two-dimensional surface was usually done after the primary and secondary forms were painted. The shapes of design units and the ways in which they were joined to form the total composition were governed by rather strict and aesthetically effective rules. The degree of adherence to these rules over such a large area of the coast and for such a long time is striking. Yet artists' individual styles are apparent, even when the artists are working within such conventionally limited arrangements as chest designs (Holm 1983a: nos. 108, 109).

A chief's chest was used to store the treasured emblems of his rank: his dancing blankets, headdresses, and the heraldic emblems of the lineage. It also served as a sort of throne or seat on state occasions. Small chests of similar form held shamans' equipment or a chief's ceremonial material, and finally served as a coffin for his cremated remains.

59. Oil Dish Haida; 19th c.

Wood (alder); 30 cm × 16.5 cm × 12.5 cm

Collected by George T. Emmons from the Auk Tlingit before 1905; received 1909; cat. no. 2211

Emmons collected this seal-shaped oil dish, like the Haida chest, from the Tlingit, but he identified it as from the Haida of Prince of Wales Island. However, there is little about it to distinguish it from similar seal bowls made by Tlingit artists. The fat harbor seal was a favorite theme of northern bowl carvers, probably because it was an important source of oil, and because its meat and blubber were important foods at feasts. Perched on its round belly on a reef just above the tide, head and hind flippers arched upward, the harbor seal is a familiar sight to coast travelers. Seal bowls capture that pose.

The bowl is a fine amalgam of sculpture and flat design, a fusion at which the northern artists were masters. The whole bowl is a hollowed sculptural rendition of the rotund animal. At the same time it is a bowl with seal's head and flippers, a design concept emphasized by the curve of the bowl extending through the seal's throat. The front flippers and other anatomical details, abstracted in formlines, cover the surface. All the rules of composition and structure seen in the chest (no. 58) are followed here. The bowl may once have been painted as well, but bowls frequently lack almost all traces of former painting, probably because of the infused oil which continually migrates to the surface. The lack of paint is compensated for by a rich, dark patina, but the sticky residue of oil, if allowed to accumulate, can obscure the delicate formline tracery.

Since the Haida had no access to mainland rivers in which to catch ooligan, they rendered oil from seal and sea lion blubber. Trading trips to the Tsimshian brought back containers of ooligan oil from the Nass River, the most important source of that luxury on the northern coast.

60. **Horn Bowl** Haida; late 19th c.

Mountain sheep horn; 19.5 cm × 16 cm × 13 cm

Mrs. Ray E. Dumett; received 1960; cat. no. 1–3003

Haida trading canoes returning from the Nass brought with them as part of their cargo the horns of the mountain sheep, from which they made spoons and bowls. The species native to the northern coastal mountains is the Dall sheep, with amber horns somewhat less massive than those of the bighorn. Mountain rams' horns form large, tapered spirals of very tough, resilient material which can be carved with woodworking tools and has the quality of becoming soft and flexible when soaked and heated. The broad base of the horn grows over a tapered core of bone. When this core is removed, the base is hollow. To make a bowl, the inner curve of the horn is cut away and the remaining material carved to the desired thickness. Steaming or boiling softens it to the point that the sides can be spread apart, causing the ends to rise and giving the bowl its characteristic broad shape with high ends.

Although the process is simple in principle, the making of such an elegant vessel from rugged ram horn takes great skill. Conceptually, the procedure is much like canoe making, requiring the artisan to visualize the changes in form that take place during the spreading of the horn in order to achieve the bowl's perfect, final shape. The juxtaposition of concave and convex curves in the delicately flanged rim attest to this artist's sensitivity.

The carving of the surface detail is done after the bowl is shaped. If the figure carved on the bowl is to have a beak or snout, material must be left on the ends for it. Horn is close-grained and hard, so that finely detailed carving is possible. Northern horn bowls are usually covered with elaborate formline designs which, although never painted, follow the principles of the design system. This bowl is biaxially symmetrical—that is, one plane of symmetry runs from end to end and another from side to side (Holm 1965: fig. 73). Beavers are represented on each end, with an inverted frog in each one's mouth and contorted human figures between and through the ears. The beavers' front legs, with clenched claws, flank crosshatched tails. Their hind legs and claws fill the sides of the bowl, with the hip joints joined to form inverted formline faces. This kind of double meaning is common in northern art, especially on the sides of bowls.

A final elegant touch, always found in northern bowls of this shape whether of horn or wood, is a subtle, raised line paralleling the rim on the inside of the bowl, and joined to it by two raised lines to the upper corners. Aesthetically satisfying, this line may in fact be a vestige of a structural detail of certain birchbark bowls made by the ancestors of some of the coastal people before their migration from the birch forests of the interior (Holm 1974:28–29).

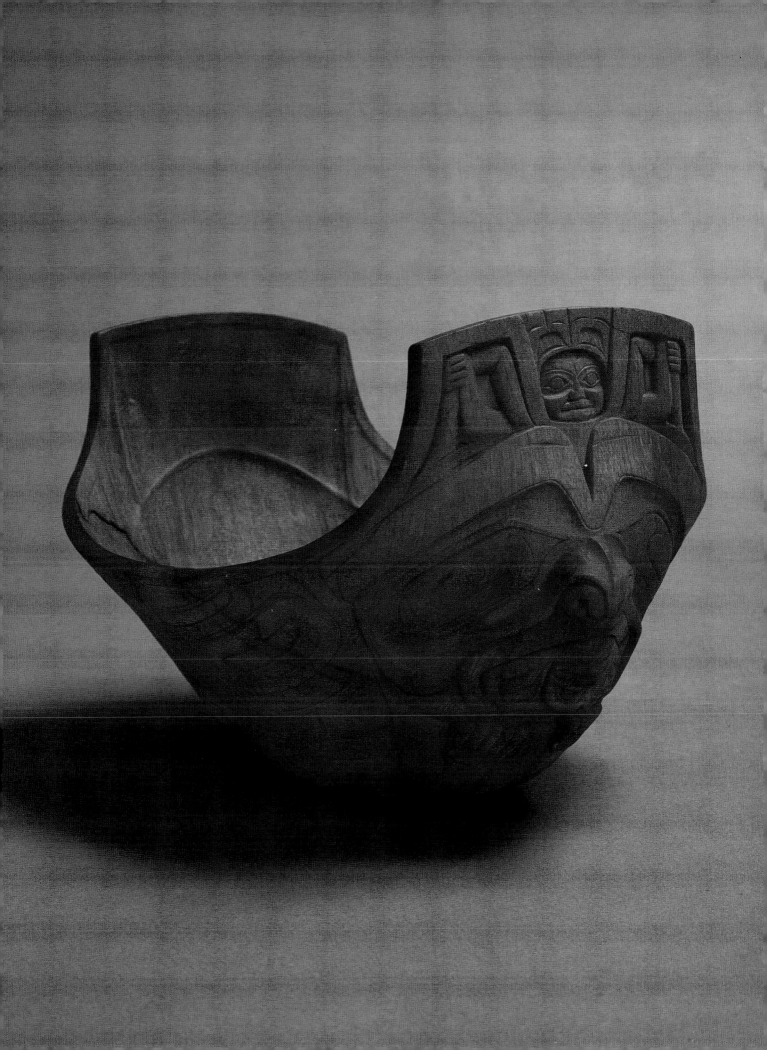

61. **Horn Spoon** Haida (?); 19th c.

Horn (mountain goat and sheep), copper; 28 cm × 6.3 cm

Collected by George T. Emmons at Wrangell, Alaska, before 1905; received 1909; cat. no. 1566

Although George Emmons gave no indication that this spoon, which he acquired from the Stikine Tlingit at Wrangell, was not of Tlingit origin, every stylistic indication is that it is of Haida manufacture. Spoon handles reflect the sculptural style of monumental totem poles, which they resemble in their long, cylindrical form. Haida and Tlingit poles are usually distinguished from one another on stylistic grounds, and the same can be said of spoon handles. The great Haida poles retain the basic cylindrical form of the tree from which they are carved, with figures organized like two-dimensional designs of massive formlines carved in the surface in strong relief (no. 62). Those figures tend to be very compact, with legs and arms flexed and held close to the bodies. Their heads are very large, often nearly equal to the body itself, and usually display a clear formline structure, with sharply defined ovoid eye sockets. The figures on Tlingit poles, on the other hand, are typically more naturalistically modeled, more attenuated, and less inhibited by the cylindrical form of the original log than their Haida counterparts. Characteristic Tlingit sculptural treatment of faces is seen on both totem poles and spoon handles.

Emmons identified the figures as an eagle, a raven, and a "bear man" surmounted by a ceremonial headdress. All the figures are rendered in crisp, precise formlines resembling the work on argillite pipes of the mid-nineteenth century. The carver of this spoon probably also worked in that material. At the base of the handle an inverted bird head, probably an eagle, protrudes its tongue into the beak of a raven. The eagle's body is wrapped around the back of the spoon handle, with long, ovoid shoulder joints and formline-U feathers extending downward along the sides. They flank the tail, whose joint takes the form of a human face. Above the eagle a raven perches with folded wings, its claws grasping the eagle's jaw and the tip of its long beak biting the lower bird's extended tongue. The raven's wings and tail are beautiful little formline compositions, with ovoids and U's which, in spite of their minuteness, are perfectly proportioned. The heads of both birds are rendered in precise, hard-edged Haida style. Between the raven's upright ears crouches a tiny figure with bear-like face and claws, but with a sea mammal's tail. It wears a column of cylinders extending from between its ears to the end of the spoon handle. These represent the basketry rings worn on crest hats (nos. 81, 86). The amount of detail on this miniature sculpture closely approximates that on monumental totem poles as much as fifty times its diameter.

The mountain goat horn handles of two-piece spoons usually retain the original form of the horn, a curved, tapered cylinder. This cylinder is attached with copper rivets to bowls of mountain sheep horn. The deep brown streaks in the sheep horn bowl are somewhat unusual in northern spoons, commonly made of the horn of the Dall sheep, which has a uniformly pale amber color. Spoons made at the turn of the century are often of domestic cow horn, which is usually streaked with dark brown or black, but this spoon bowl is not of that material.

Everyday spoons were of plain horn or wood. Elaborately sculptured spoons and ladles were reserved for formal occasions when the display of the family myths and crests on their handles was appropriate.

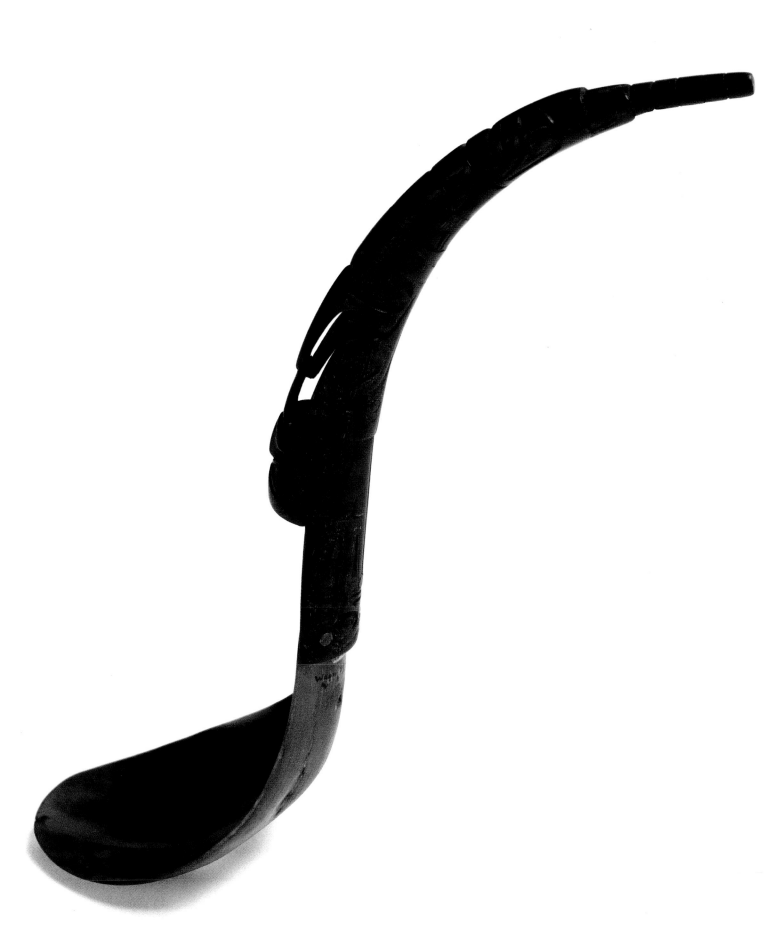

62. **Model Totem Pole** Haida (Howkan, Alaska); late 19th c.

Wood (red cedar); 185 cm × 32 cm × 19 cm

Gift of Reverend R. Pierce Beaver; received 1975; cat. no. 2.5E536

Whether due to an internal quarrel, to population pressure at the north end of Graham Island in the Queen Charlottes, or to a combination of the two (Swanton 1905:88–90), Haida people began, probably sometime in the eighteenth century, to migrate across Dixon Entrance to what is now Southeast Alaska. These aggressive migrants displaced the Tlingits, who formerly had lived on the southern part of the Alexander Archipelago, and occupied some of their village sites. The southernmost of the Alaskan Haida villages was Howkan on Long Island, facing Kaigani Strait. Kaigani was the name of a summer village near the south end of Dall Island where the people congregated to meet early European and American fur traders; the name now includes all the Alaskan Haida.

The sculpture of the Kaigani Haida is related to that of their close relatives of the northern Queen Charlottes. Large totem poles retain the cylindrical character of the log, but individual figures tend to be more modeled and less like formline design carved in relief than those of the central and southern Queen Charlottes. This very large model pole is a good example of the Kaigani style of carving, and is an almost exact miniature of the pole it represents, raised by Chief Skulka of Howkan. The original pole was a house frontal pole, which traditionally would have been joined to the center front wall of an old-style house, but is shown freestanding in front of a later frame house in the existing photographs. The lower two figures are typical Haida crest carvings, whose meanings are not certain. At the bottom is what appears to be a bear, with large, toothed mouth biting a small round-eyed creature whose pectoral fins spread over the bear's claws. Above the bear sits a thunderbird, identified by a heavy, downturned beak and coiled ears. No wing feathers appear, but feathers on the breast and bird-like legs further indicate that the creature was intended to be a bird.

The top third of the totem pole displays figures that are unlike the others in subject and style. Instead of compact, highly conventionalized creatures of mythology, we see floral motifs, a dynamic eagle clutching a leafy branch, and a naturalistic, bearded man in a military uniform. There are a number of other representations of whitemen on Kaigani Haida and Tlingit totem poles (Barbeau 1950:402–9), and a good deal of dispute has arisen about their meaning. George Emmons (1914:66–67) described Chief Skulka's pole as depicting "a military official of Sitka who had extended some kindness to a former member of this family." Who the "official" was and whether he was Russian or American is not known. The eagle surmounting him suggests that an American was intended. Its natural pose, with spread wings and turned head, and the branch it grasps resemble the American emblem much more than the heraldic double-headed eagle of Imperial Russia.

Flanking the officer are columns of crescent leaves topped with three-petaled blossoms. Many of the whitemen depicted on poles are accompanied by floral designs, and that may be the motivation for these. The leaves and blossoms resemble those—supposed to have been inspired by flowers seen in Victoria—on a pole originally carved in the northern Haida village of Yan (Barbeau 1950:409; MacDonald 1983b:165). On the other hand, the Fireweed crest of the upper Skeena River Gitksan can be represented in very much this same form, although it is not recorded as a Haida crest. Surmounting the whole pole are two crouching men wearing hats topped with stacked cylinders (nos. 81, 86). Almost all Haida house frontal poles had from one to three of these crouching "watchmen" which, in Haida mythology, warned the house owners of approaching danger (Swanton 1905:124).

The model is remarkable in its very close resemblance to the original full-sized pole. Most miniature poles are copies only in that they represent the same figures as the originals, but are otherwise carved in the modelmaker's own style. Perhaps this model was made by the carver of Chief Skulka's pole. The name "Skulka" is painted in large letters across its base.

Chief Skulka's pole at Howkan, about 1888.
Photograph by Edward de Groff. Alaska Historical Library.

63. Argillite Pipe Haida; ca. 1840

Argillite; 29 cm × 18 cm × 3 cm

Sidney Gerber Collection, gift of Anne Gerber; received 1969; cat. no. 25.0/282

Northwest Coast people discovered very soon after their first meeting that the strange, ship-borne visitors would buy almost any native-made item offered to them, and that certain kinds of objects were in particularly great demand. So in those very early days of maritime trade, Indian carvers produced masks and other exotic objects especially for the seamen and traders from Europe and the east coast of America. About 1820, enterprising Haida carvers began to make, exclusively for this trade, objects that were unlike anything they had ever made for themselves either in form or material. The material they used was argillite, a soft, very fine-grained black stone, which occurs in a single limited area on the slopes of Slatechuck Mountain on the Queen Charlotte Islands.

It seems probable that at least some argillite was carved by Haidas before the arrival of the seafarers, but the overwhelming majority of all known production was for trade. As one might expect, the earliest pieces were made in the sculptural tradition of the makers; they took, for the most part, the form of pipes. Tobacco smoking had only recently been introduced to the Haida by those same strangers, supplanting the chewing or sucking of native tobacco, and the Indians had begun making wooden pipes of their own design (Macnair and Hoover 1984:29–30). It must have seemed eminently appropriate to make elaborate, carved pipes of the readily workable argillite for those eager, smoking customers. The travelers, however, did not buy the pipes to smoke, but to take back home as souvenirs. Although an argillite pipe can certainly be smoked, it is brittle and easily abraded; the high rate of survival of nineteenth-century argillite pipes—nearly a thousand are known (Wright 1985:55)—can probably be credited to the fact that few were actually used.

Very soon after beginning to carve argillite, the artists introduced new motifs borrowed from the buyers: the structure and rigging of their ships, decorative details of their equipment, and the seamen themselves. This pipe, made perhaps before 1840, includes all of these in addition to purely native figures. The pipe's form, a roughly trapezoidal panel elaborately pierced, suggests that it was made some years after the beginning of the tradition, when the pipes were very compact in their design, similar to the wooden pipes made for native use. Native Haida motifs include a bear or wolf crouching over a bird-like creature at the bowl end, a native man stretched along the center of the pipe, and a native woman nursing a child at the stem end. All these figures are somewhat more animated than was typical of early Haida sculpture, but they are rendered in traditional formal detail. All the other figures are exotic. Reclining on the animal's back and holding the pipe bowl between his legs is a uniformed European, recognizable by both his dress and his large, pointed nose. The serpent writhing between the woman and the bowl is carved in the Haida style but the theme is derived directly from the brass "dragon" sideplate of nineteenth-century muskets made for the Indian trade. A number of native artworks, including argillite pipes, a flute, and a detail on an argillite chest, incorporate this motif in varying degrees of faithfulness to the original. The spray of leaves on which the native man rests his feet may also be derived from European models, although there were some native floral motifs (no. 62; see also Macnair and Hoover 1984:59). Finally, ships' tackle is the source of the ropes and blocks that outline the pipe. Several other pipes apparently made by the same carver are known. One of them is a near duplicate in composition and in many of its details (Wright 1985:230–40, fig. 71).

Many of the argillite pipes in existence have been broken, and some have parts missing or are fragmentary. Of the rope that once stretched along the bottom of this pipe, two sections are gone. Still, it is remarkable that this delicate carving of very fragile material, a century and a half old, has survived in its present condition.

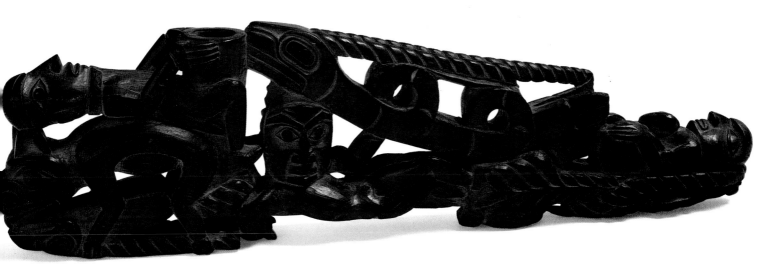

64. Argillite Figure Haida; ca. 1840

Argillite; 34 cm × 9 cm × 7 cm

Sidney Gerber Collection, gift of Anne Gerber; received 1969; cat. no. 25.0/286

At about the time that the argillite pipe (no. 63) was being carved, Haida artists began to make portrait-like argillite figures of Europeans. Perhaps the seamen who bought the pipes, seeing themselves portrayed in miniature, suggested that fully sculptured, standing figures would find a market. Many of these figures certainly do have the appearance of portraits (Vaughan and Holm 1982:140–43). Most of them appear to represent ships' officers in uniform, but some are in civilian dress and may represent traders or officials familiar to the Haida (Macnair and Hoover 1984:81). There are also many women in European dress among the argillite figures, but some of these certainly represent Haida women, perhaps wives of traders (Wright 1986:40–45).

This stalwart seaman assumes a stance that is almost standard for such figures: weight solidly on both blocky feet, and hands in pockets. Clothing patterns, and details of seams, buttons, and shoe soles and heels were usually emphasized by the Haida argillite figure carvers, who were fascinated by these unfamiliar adornments, but they are minimally rendered here, except for the details of the peaked cap. This artist lavished all his attention to costume on that headpiece, exaggerating its height and flare and the projection of its bill. A carefully carved network of seams and welts frames the cap and converges on the ornamental pompon at the top.

In the shade of the magnificent cap is the face of a self-confident young officer. His features follow Haida convention for a Caucasian: long, narrow face, prominent nose, and narrow lips. His ears, naturalistically carved, stand out to the sides and are framed by mutton-chop whiskers and patterned loops of hair. All these features, exotic to the Haida, are to be found in their depictions of European and Yankee seamen. No doubt those seamen enjoyed these caricatures of themselves as they were perceived by native carvers in the wilds of the Northwest Coast.

65. Rattle Haida; 19th c.

Wood (maple?); 30 cm × 15 cm × 13 cm

Collected by George T. Emmons in the Queen Charlotte Islands before 1905; received 1909; cat. no. 1454

Although Emmons described this rattle as "used in general dances," it is possible that it was a shaman's rattle. Both the spherical shape, characteristic of shamans' rattles, and the figure represented suggest that use. The carving on one side and the formline painting on the other represent the land otter, an animal associated with shamans' work and seldom represented on anything but shamans' material. On the northern Northwest Coast, the land otter was generally considered to be a supernaturally dangerous creature. Only persons with the power to control such a potentially harmful presence would be likely to use its image in this way.

The otter on the rattle presents a far from malevolent appearance. It has almost a whimsical face, with round, open eyes and a beguiling grin. Of course it is risky to interpret expressions in Northwest Coast art, and the suggestion of a friendly creature might be unintentional. What the rattle does illustrate very well is the skill of northern artists in combining, to good effect, sculpture with two-dimensional painting. Rounded nostrils, painted vermilion like the lips, push forward from the rattle's globular surface. The full cheeks round down to a sharp cheek line which curves out to define the nostrils. Open, thin-lidded eyes on bulging orbs resemble Tsimshian work, and there is a possibility that the rattle may have been imported from that tribe. Its general ovoid form and the fluted band rimming the juncture of the two shells are seen on some Tsimshian shamans' rattles.

Very imaginative use of formline painting distinguishes the rattle. The black primary rim of the eye socket extending down the ridge of the snout and curving to merge with the cheek line is unusual. Formline U's mark the otter's ears, which are elaborated with thin tertiary lines defining split U's. Usually, a painted design on the back of a round rattle with a sculptured face, such as this one, will represent the body of the depicted creature. In this case, however, another face is shown, apparently a conventionalized otter. It is a simple and elegant painting, in black only, of a formline face with large ears and a downturned snout.

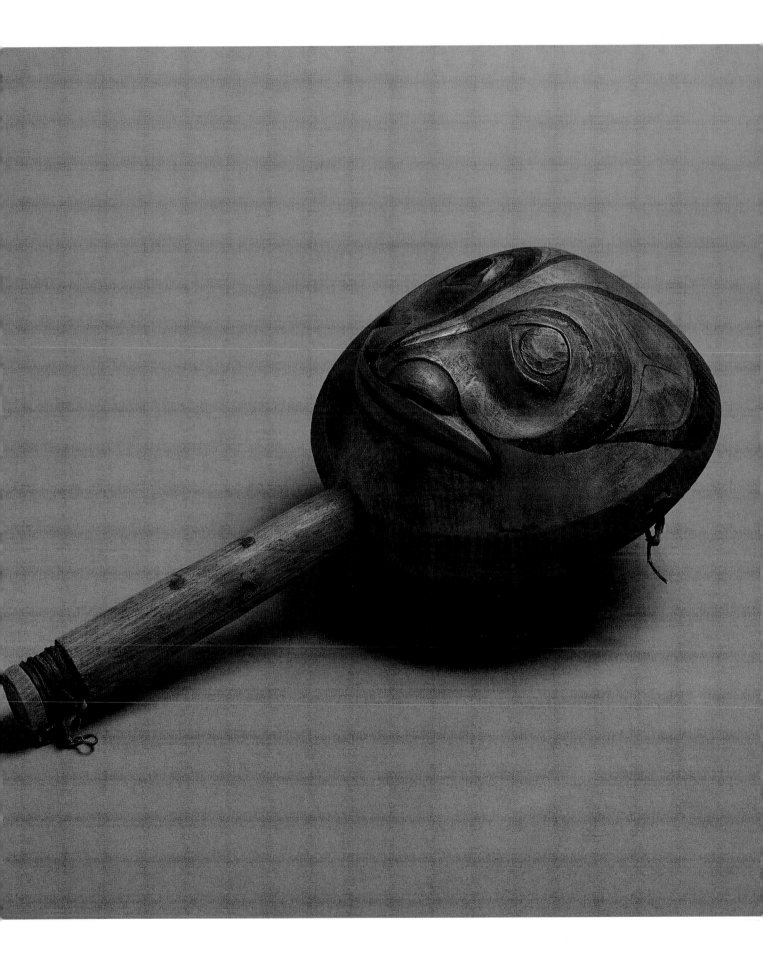

66. **Basket** Haida; 19th c.

Spruce root; 29 cm × 25 cm

Young Naturalists' Society; collected by James T. White; received 1904; cat. no. 4590

Northern basket makers excelled at the technique of twining, usually with finely split roots of the Sitka spruce. Spruce root furnishes a wonderful material for basketry. In sandy soil the roots spread out from the tree in long, meandering trailers lying just under the surface, so that they can be readily dug by those knowing how to locate the ideal groves. The roots are dug and coiled, then heated over a fire until the steaming sap bursts the thin, aromatic bark. Stripped through a split stick, the root comes white and smooth. To use it for baskets it must be split and split again, until each strand is fine, even, and long. Strands from the outer surface, with their natural gloss, are reserved for the twining wefts, while those from the core become the concealed warps. The strands are dampened before use to make them as flexible as when first dug from the sand.

The technique of twining involves twisting two horizontal, or weft, strands around succeeding upright, or warp, strands so that the wefts cross each other between warps. Since the twist is always in the same direction, the pitch of each weft stitch is always the same. In Haida and Tlingit baskets the pitch is down to the right, and is called Z-pitch. To begin the basket, a small bundle of warps is gathered at the center, and a pair of wefts is twined in a spiral around each warp, spreading the warps into radiating spokes. Twining proceeds around and around, and as the space between the spokes widens, new warps are added. At the outer edge of the base a row of three-strand twining is inserted, which shows on the outer surface as a raised, cordlike line and gives the weaver a firm point from which to start the upright sides.

Haida baskets are typically cylindrical, so that once the sides are begun, new warps need not be added. Usually, the simple decoration is divided into two fields, each of which utilizes a different decorative technique. The lower field, often about three-quarters of the height, is banded with black stripes, formed of dyed spruce root wefts. Where each stripe begins, a pair of dyed wefts is substituted for the undyed root. There is always a slight jog in the stripe where these wefts begin; since Haida baskets are typically woven from left to right and upside down, that jog is always up to the right. The upper field is not colored, but is patterned by alternating rows of two- and three-strand twining in various combinations, as in this example, or by crossing pairs of warps with twining stitches at intervals to form a raised texture in diagonal and diamond patterns. A complex twining stitch finishes and reinforces the rim.

Haida twined spruce root baskets seldom have elaborate patterns in false embroidery like their Tlingit counterparts (no. 93), but their simple, straightforward elegance of proportion, texture, and color make them favorites of basket fanciers.

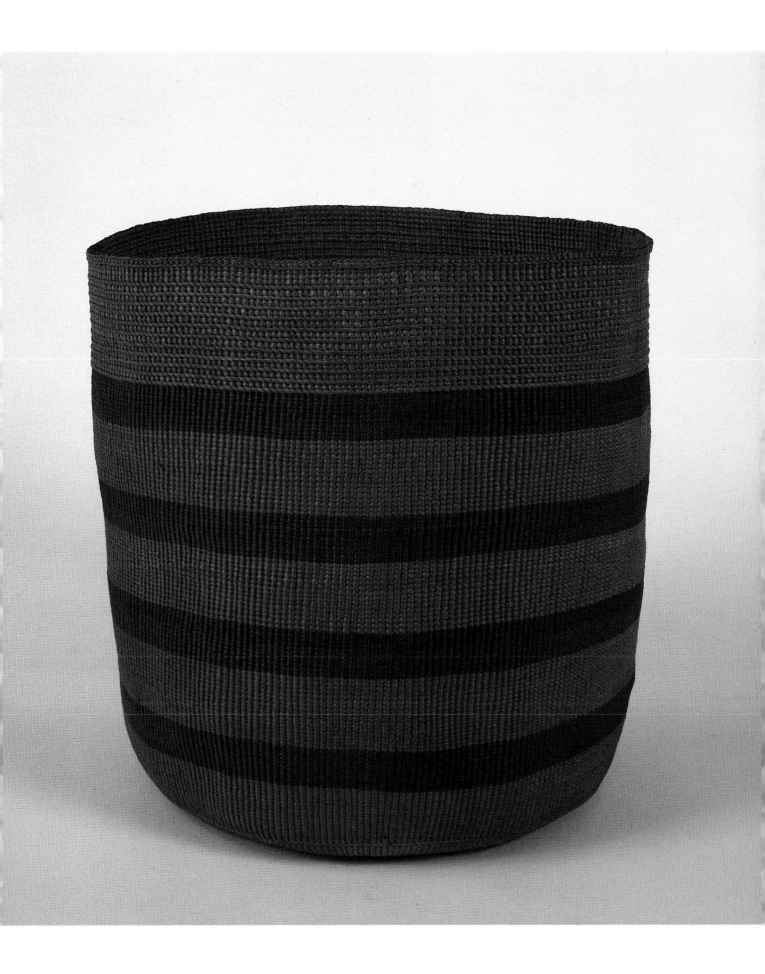

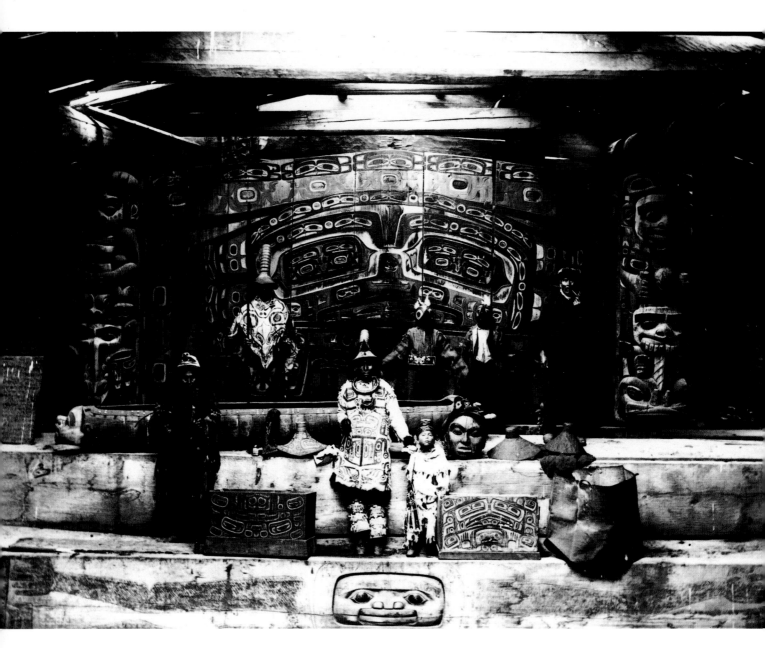

Interior of the Whale House at Klukwan. The Burke Museum's chest (no. 58, see p. 149) is inverted on the platform to the left of center. *Photograph by Winter and Pond.*

Tlingit *Nos. 67–100*

Southeastern Alaska consists of both a long, jumbled cluster of steep-sided islands, their shores ragged with countless bays and inlets, and a fjord-rent mountain barrier, ranging for nearly five hundred miles from Dixon Entrance to Yakutat Bay. The peaks of the Saint Elias and Coast ranges, marking the natural and political boundary between the Alaska Panhandle and British Columbia, pierce nearly continuous ice fields whose glacial snouts reach down their valleys to salt water at two dozen places. This grand amalgamation of rugged land and water is the home of the Tlingit people.

Like their Haida neighbors to the south and the Tsimshian to the southeast, the Tlingits trace descent through the female line. All tribe members belong to one of two sides (the Tsimshian are divided into four groups, which function as two pairs), whose members may only marry those of the opposite side. Tlingits designate these two as Ravens and Wolves, or Eagles. Each of these phratries, as they are usually termed, is made up of a number of subgroups (Tlingit *na*), which claim descent from a common ancestor and which are the basic and autonomous units of Tlingit society. The *na* are clustered in village groups (Tlingit *kwan*), in each of which both Raven and Eagle subgroups are represented. It is the ownership and display of the emblems of these social groups that is the motivation for most Tlingit art.

Spread as they are along such a convoluted stretch of coast, it is surprising that the Tlingit show such continuity, if not uniformity, in their art. Perhaps this consistency of style is related to linguistic unity. Throughout the coast the boundaries of art traditions coincide roughly with boundaries of language, and though linguistic relatives were not always friendly with one another (interclan wars were not uncommon on the Northwest Coast [de Laguna 1972:219–84; Swanton 1905:373–428]), most social interaction occurred within the boundaries of shared languages.

It is through circumstance rather than design that Tlingit material makes up nearly one-third of the Burke Museum's Northwest Coast collection. Acquisition of the Emmons collection of about eighteen hundred pieces, almost entirely Tlingit, which had been exhibited in the Alaska Building at the Alaska-Yukon-Pacific Exposition, established that ratio in 1909. With the addition of the Caroline McGilvra Burke collection in 1932, largely of baskets, and especially of the Walter Waters collection in 1953, the Burke Museum's Tlingit materials assumed even greater importance. It is without any doubt the largest collection of nineteenth-century Tlingit objects in western America, among them some of the finest examples of their kinds.

67. **Feast Bowl** Tlingit; 19th c.
Wood; 89 cm × 49 cm × 26 cm
Walter Waters Collection; received 1953; cat. no. 1–1465

Some of the most striking and aesthetically satisfying products of the Northwest Coast carvers' art are wooden bowls. We should not be surprised that a utilitarian bowl can be a work of art. It seems to be a universal human trait to regard food containers as worthy objects for aesthetic expression. Often without elaborate surface decoration, they depend on elegant proportion and relationships of pure form for their beauty. Complete mastery of tool and material is evident in this large, graceful feast bowl. The carving of such a large bowl, with its upswept ends and thin walls, is a remarkable technical accomplishment in itself. The wood fibers run parallel to the long axis of the bowl, so that the high, thin end walls are quite fragile. One was broken long ago and has been repaired. The bowl's rich, brown color and mellow surface are the result of long use and handling.

The relationship of this bowl to canoes is evident in its form and detail. It is not considered a true "canoe-form bowl," for it lacks representation of the cutwater and flaring ends (Holm 1974: nos. 27, 28; 1983a: no. 127), but the sweeping sheer, the broad, flared "gunwales," and especially the wide, shallow groove paralleling them are all features of classic northern canoes (no. 56). A complex interrelationship of canoes and bowls of wood, horn, and birchbark is evident in Northwest Coast art but little understood. Canoes and horn bowls are carved into a narrow shape with little or no sheer and are steamed and spread to produce their characteristic beamy, high-ended form. Wooden bowls are never spread but are carved to their finished form. The combination of high ends with low sides is so firmly established a convention that nearly all bowls of the Northwest Coast, whether of wood or horn, spread or not, with or without bent corners, show that characteristic form (nos. 14, 20, 32, 59, 60, 70). Many bowls have on the inner surface a pattern of grooves or ridges corresponding to the placement of folds and reinforcements of certain birchbark bowls from the North American interior (Holm 1974:28–29).

Unfortunately, most of the objects acquired from the Walter Waters collection are undocumented. Marius Barbeau, a Canadian scholar well known for his work with Northwest Coast material, examined the collection for Mrs. Waters and made some identifications, but after the fact, based on personal knowledge and experience rather than on original documentation. Furthermore, there is no distinction made in the Waters lists between the information that came with the objects, and that which was added later. Nevertheless, there seems little doubt that this bowl is Tlingit, and no doubt at all that it is a very fine example of Northwest Coast art.

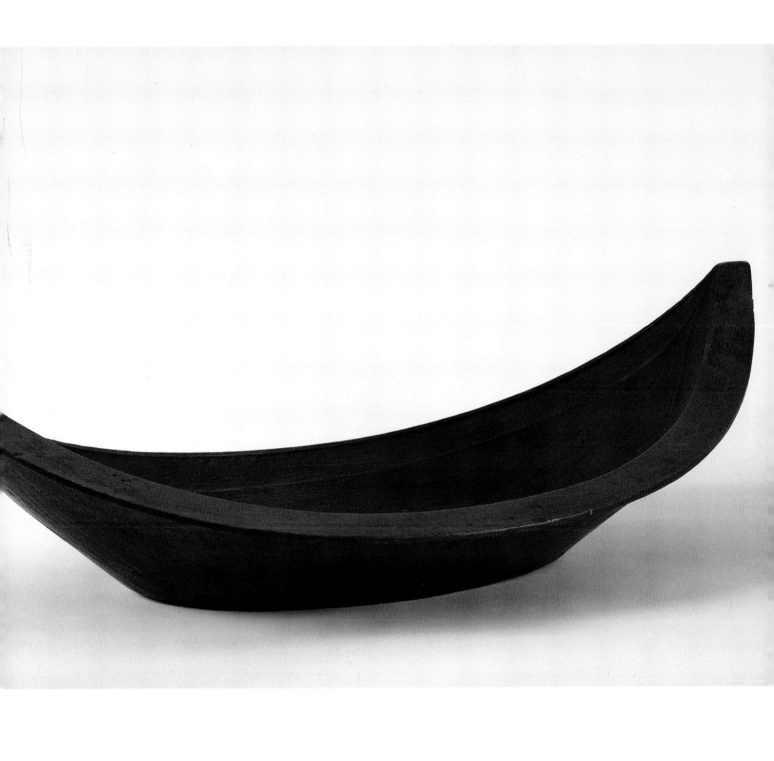

68. Chest Tlingit; early 19th c.
Wood (yew, red cedar); 52 cm × 36 cm × 21 cm
Walter Waters Collection; received 1953; cat. no. 1–1559

This superbly carved little chest is identified in the Waters list as a gambler's box. The identification is so specific that it was very likely noted by the chest's collector. If so, the box was probably intended to hold rolled skin containers of beautifully polished and painted gambling sticks, the shredded cedar bark in which they were shuffled, and the mat (sometimes of painted or even carved rawhide) under which the sticks were shuffled and on which they were thrown for display. On the other hand, the box is the size and shape of well-documented shamans' chests in which rattles, amulets, and other objects of the profession were kept.

Whatever its use, this chest is a fine example of northern Northwest Coast art and craftsmanship from the early historic period. Its two long sides display formline faces of the two standard types described for the Haida chest (no. 58). The character of the formlines is very different, however, reflecting both the differing styles of two artists and the earlier origin of this small piece. Basic structures of the depicted faces are identical, but here the formlines are more angular and massive with less taper, resulting in much narrower tertiary and ground areas, and a consequent compactness of design.

In the simpler of the two face forms seen here, the typical composition results in a broad space between the eyes; a stylized human face is used to fill it. The creature's great mouth, extending across two-thirds of the base of the design, holds what appears to be a frog with large, round eyes and a short snout. Its shoulders and legs stretch to the corners of the mouth, then double back as long, bent claws, reminiscent of the frogs in the mouths of the beavers on the horn bowl (no. 60). These small frogs within larger designs are probably not crests; they may be either incidental characters in a story or, as in many cases, artistic elaborations of available space in the composition.

The arrangements on the ends of the chest are very unusual, each featuring a large profile head with long mouth. One end shows a head with tongue and downturned snout (or perhaps incisor), the other a bird with wing and clawed foot. The face with the tongue, seen here, is extended to the rear by a long formline-U ear or fin and a human arm and hand. On the opposite end, a crouching figure occupies the area behind the large face. Imagination, formline mastery, and fine craftsmanship characterize the work of the unknown creator of this chest.

Beveled lid, rounded and protruding—fashioned of the usual red cedar—is typical of an early style and is another indicator of the age of the chest. An unusual feature is the use of yew wood for the sides. Yew tends to be both gnarly and sprinkled with small knots, a difficult wood from which to get a flat slab large enough for a chest. Yew does steam-bend very well and is crisp to carve, so it is an excellent choice if available. The open corner of this chest is closed with a neat dovetail joint. This rare feature underscores the close relationship that this chest has with a nearly identical piece in the Museum of Cultural History at the University of California at Los Angeles (X 65 7482). The two chests are almost perfect matches in size, composition, design detail, style, material, and workmanship, right down to the dovetail joint. They are surely the work of the same master artist.

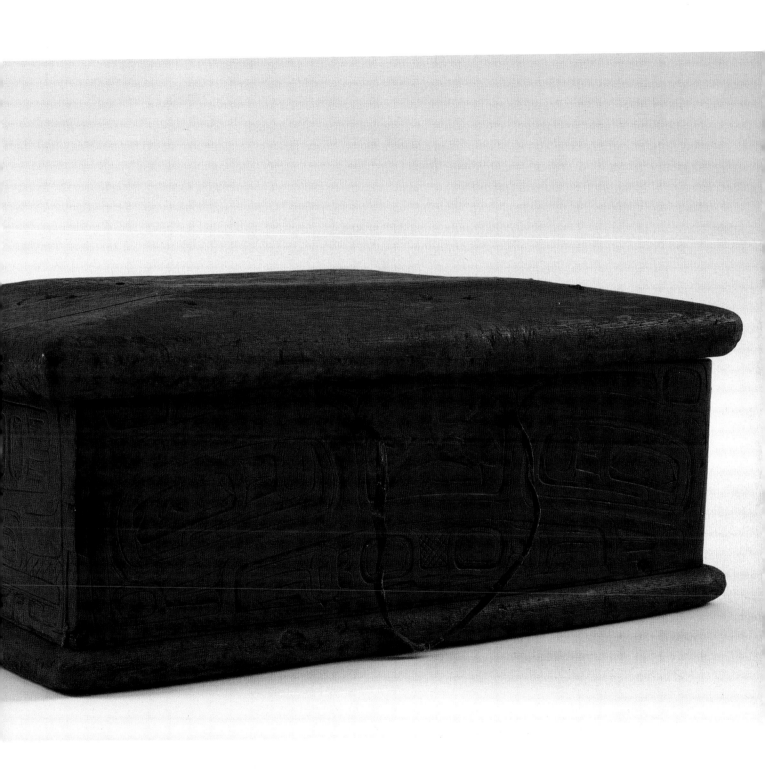

69. Painted Box Tlingit; 19th c.

Wood (red cedar), opercula, cedar bark cord; 36 cm × 36 cm × 49 cm
Walter Waters Collection; received 1953; cat. no. 1–1649

Square, bentcorner boxes were the principal furniture of northern Northwest Coast houses. Piled along the walls and between the bedroom partitions, they acted as shelves, seats, wardrobes, cupboards, pantries, containers for food and water, treasure chests, and even urinals. Many were plain; some were painted only with red stripes up the corners. Those most often seen in museums and private collections today are elaborately painted with formline designs and fitted with thick lids which are frequently studded with small white shells, the opercula of the red turban snail.

The great majority of designs painted on northern boxes follow a strikingly limited number of compositional arrangements (Holm 1974:22–23). Most of them consist of symmetrical patterns painted on two opposite sides of the box, and while related to the designs of longer chests, are modified to fit the vertical format. A smaller number of box patterns have their axis of symmetry on the box corner, so that two symmetrical designs cover all four sides. Because each of these designs covers two adjoining sides of the box, the designs' proportions are similar to those of chests, and the compositions, too, are often very similar. The primary formline pattern on this box follows the customary arrangement and is nearly identical to that on the Haida chest (no. 58), differing most obviously in the areas flanking the design animal's body and the sides of the head. A lighter, airy feeling pervades the box design, which has much narrower formlines and a resulting openness of the tertiary areas and ground. Very few square boxes are carved, but when they are they begin like this, with the black primary and red secondary formlines and the tertiary lines painted on the uncarved surfaces. Tertiary and ground areas are then carved in various bevels and hollows (nos. 58, 59, 68, 70, 81).

Opercula, the hard, glossy shell closures of the red turban snail (*Astraea gibberosa*), were inlaid in rows on the tapered, broad lids of boxes and chests and on the rims of bowls. Opercula also served as teeth in masks and other sculpture (nos. 79, 82, 89). Box lids were secured by an ingenious lashing which held them firmly in place, yet could be quickly released to open the box. A single cord was wound around the box and lid in a continuous wrapping that included the knots securing the crossings, and continued to the two ends, which tied the corner loops together at the center of the box's top. The lashing also provided convenient handles for lifting the loaded box and a strong reinforcement to the thinly kerfed (grooved) corners and the pegged joints.

Many painted boxes were collected on the northern coast and are found in museums all over the world, but since boxes were frequently traded from place to place on the coast, the point of collection may not be a good indication of tribal origin.

Fine bentcorner boxes are again being made today by native artists and other woodworkers interested in Northwest Coast art and technology.

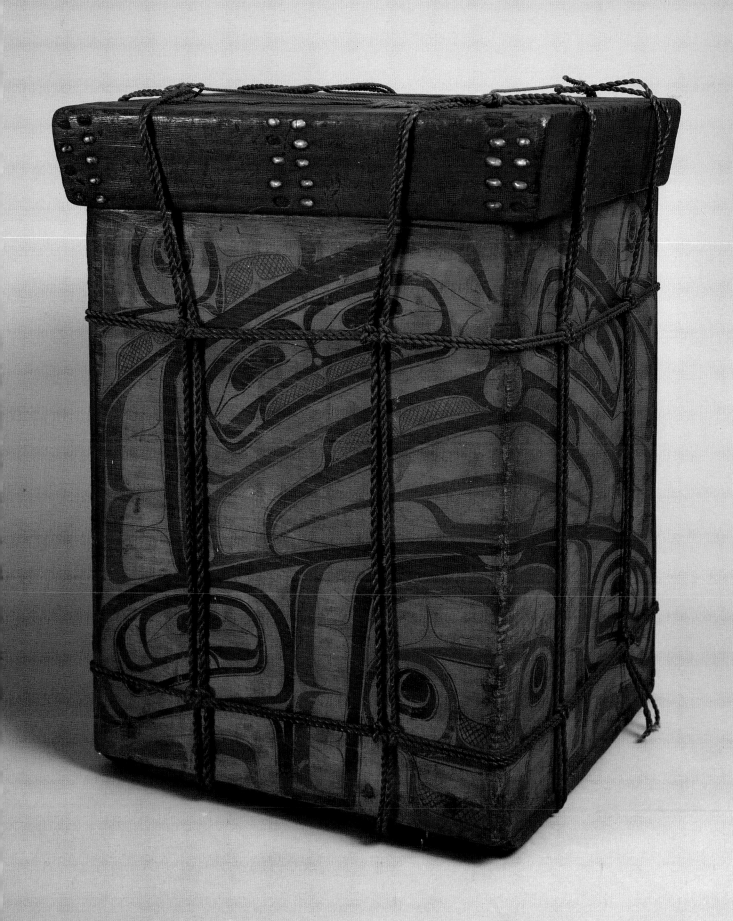

70. Bentcorner Bowl Tlingit; early 19th c.

Wood (yew?, red cedar); 29 cm × 26 cm × 15 cm
Gift of Sidney Gerber; received 1955; cat. no. 1–1779

The identification of this bowl as "early nineteenth-century Tlingit" is based entirely on the character of its carved detail and construction; it is without documentation. However, the bowl so well matches early and well-documented Tlingit pieces in the style of its formline detail and sculpture that there is little reason to doubt the attribution. The depiction is of the killer whale, head on one end, tail on the other, and body, flippers, and dorsal fin on the sides. The whale is represented in semihuman form, with a broad, human-like face with a very wide mouth and bulbous nose. The conclusive clue to the whale's identity is the asymmetrical oval band running diagonally across the nose, a Tlingit convention for the killer whale (nos. 78, 81, 89, 96). Often the whale's blowhole is filled with a human face; we see it here, centered above its eyebrows. To corroborate this interpretation, the formline surrounding the blowhole is open at the top, a detail apparently reserved for this one meaning. A very clear example of the blowhole represented by a face surrounded by a broken formline can be seen in one of the traditional Chilkat blanket patterns (Samuel 1982: fig. 437; Emmons 1907: fig. 572a).

At the opposite end of the bowl, the whale's tail stands out in high relief. On a bentcorner bowl designed with a clearly identifiable head and tail, the joined corner is *always* on the tail end. This implies that, on bowls with less clear representation, the joined corner indicates the back, while the end with two bent corners is the front. The same is probably true of boxes and chests. What seems to be a very significant statistic is that in all boxes and chests with "two step" or "double-eye" design (no. 58) on one side, and a "one step" or "single-eye" design (no. 68) on the other, the joined corner is *always* on the single-eye side (Holm 1983a: no. 103).

The killer whale's body is shown in highly abstracted form on the sides of this bowl. Long, smoothly curving fins stand out from the surface. They probably represent the prominent pectoral fins of the whale. The killer whale's most important recognition feature, a spectacular, upright dorsal fin, is indicated by the broad, horizontal formline-U extending back from the upper corner. This, together with the diagonal nose stripe, clearly identifies the animal.

An undulating rim defines a "bowl." Typically, the sides bulge, and are hollowed inside, leaving an overhanging rim. On this bowl the rim is rather narrow, and the sides only moderately swelling. Bent bowls are usually made of hard wood—yew, alder, or maple. Their bottoms, for some reason always of red cedar, are fitted with a carefully carved rabbet joint and sewn or pegged on.

Bowl wood usually becomes well saturated with oil; consequently, most bowls that have had long use have lost the paint that originally accented them. In some, a faint staining differentiating red and black areas remains, but this bowl retains no trace of any color it might once have had.

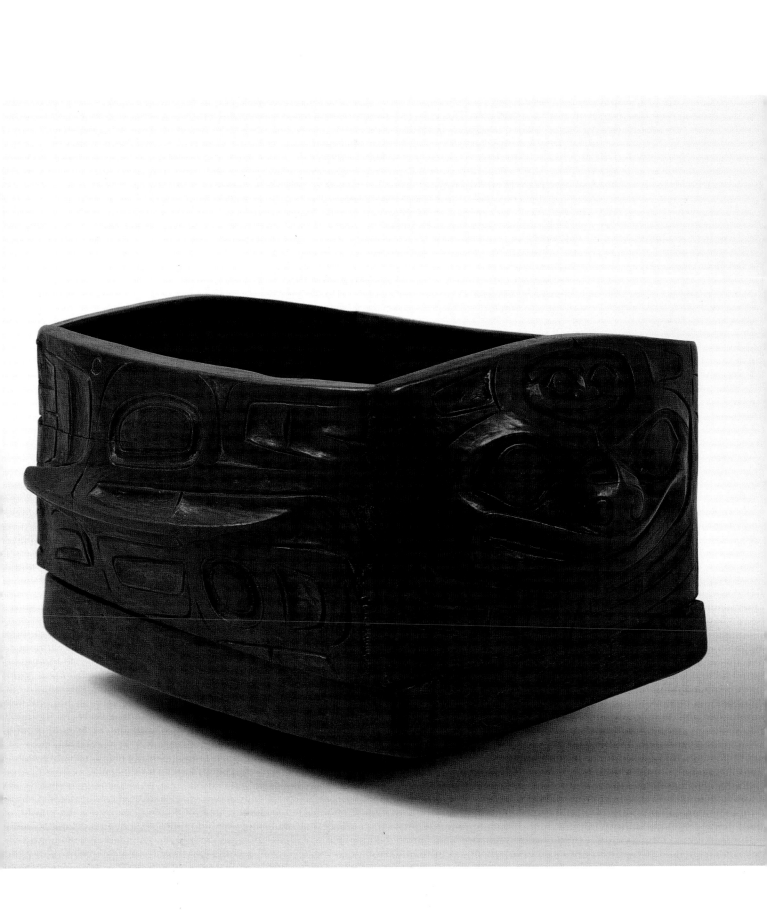

71. Box Drum Tlingit; 19th c.

Wood (red cedar); 90 cm × 54 cm × 30 cm

Walter Waters Collection; received 1953; cat. no. 1–1586

Although round skin-headed drums were used on the northern Northwest Coast, the box drum was the traditional bass instrument in the percussion accompaniment to singing and dancing. In the northern area the single-head skin drum, shaped like a large tambourine, was used primarily by shamans at their work. Salish religious dancers (no. 18) move to the powerful beat of skin drums, and everywhere on the coast this drum came into use for the universal gambling game, *lehal* (no. 7). But from Vancouver Island northward, it was the box drum that accompanied the dances dramatizing noble prerogatives.

The sound of a box drum is unexpected. Deep and vibrant, it underlies the sharp staccato of batons striking a resonant plank, the clatter of deer hooves, and the voices of singers. The sound is not loud, but full. It can be heard far from the dance house, farther than all the other sounds will travel. It relies for its power on the resonance of the cedar and the tightness and unity of the drum's construction. To sound properly, the drum must be hung from the beam of the house by a line looped through holes in its upper side; alternatively, it can be tilted to rest on one lower corner. To steady it, the drummer may hold either the lower or upper edge of the opening but not the sides, or the sound will be dead. He beats with the side of his clenched fist or with a well-padded stick. Drummers may beat on the inner wall to avoid wear on the painted outer surface (de Laguna 1972:705).

Box drums are constructed exactly like boxes or chests, except for their proportions. A long, wide plank is split and smoothed to size, kerfed, and steam-bent to form the sides, top, and bottom. A second, narrow plank is fitted and pegged to close one open end. The drum has the form of a very deep, narrow chest. Although this one is small as box drums go, it required a hand-split plank eight feet long for its four sides.

Designs on box drums usually are either crests or narrative illustrations of myths. A few box drums are known to have been made for the use of shamans. For example, a drum in the Burke Museum, which George Emmons acquired along with the rest of one shaman's equipment, depicts headless spirits in the mouth of a great bear (cat. no. 1221). This drum is probably a chief's possession. On one side is a raven, shown rather simply in profile. The formlines are bold and assured, but a number of unusual features suggest that the drum was made late in the classic period when the principles of formline painting had become imperfectly understood. This can best be seen in the unusual red inner ovoid in the raven's tail joint. The colors used here are black for the primary formlines, vermilion for secondary formlines and some inner ovoids, and blue for tertiary areas. As is often the case, the blue paint is fragile and much has worn away.

The other side of the drum shows four ravens, seen from above, flying outward from a central rounded rectangle, perhaps representing their nest. This is probably an illustration of a mythical incident, although its identity is unknown.

Commercial bass drums largely took the place of box drums in the twentieth century. Only recently, with the newly rising interest in reviving some of the traditional ceremonial features that have been omitted for many years, have box drums again been made and used. They offer modern native artists a fertile decorative field.

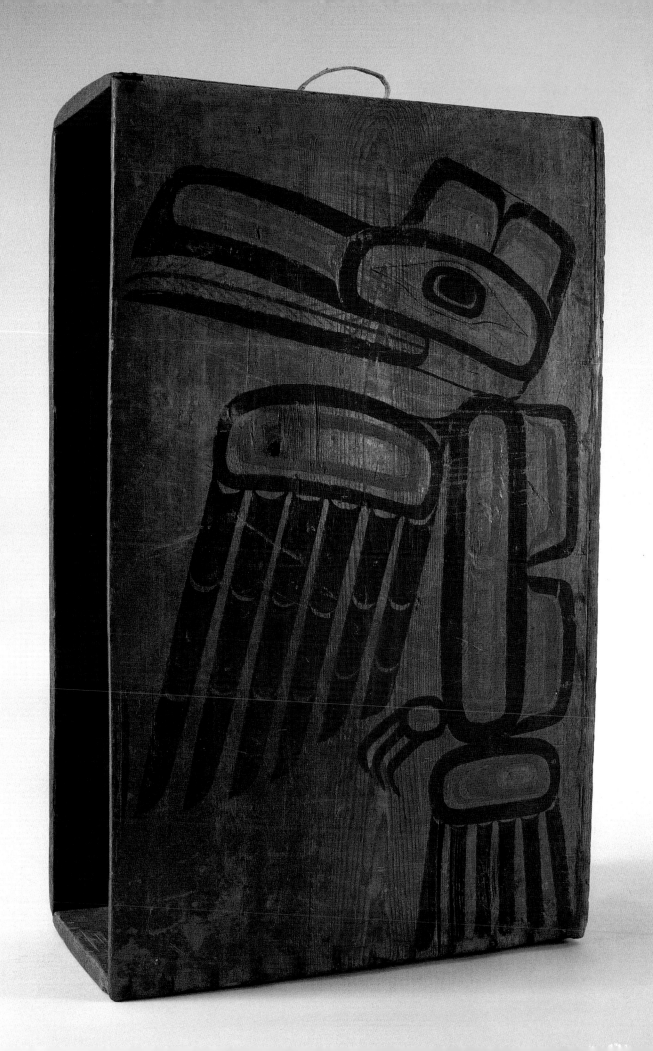

72. **Raven Rattle** Tlingit; 19th c.

Wood (maple), skin, lead shot; 32 cm × 11.5 cm × 12 cm

Collected by George T. Emmons at Sitka, Alaska, before 1909; received 1909; cat. no. 951

A mysterious complex of man, birds, and frog forms a rattle that is one of the best known, least understood, and most controversial of Northwest Coast objects. Usually called a "raven rattle," after the standard form of the principal figure, it combines many of the aspects of Northwest Coast art: sculpture, painting, relief carving, secular display, and references to supernatural power. Although all authorities agree that the complex composition refers to mystic events involving the supernatural world, and that the rattle must have originated as a shaman's instrument, the historical fact is that it was and is used by people of high rank in all the tribes from Vancouver Island to Yakutat Bay in ceremonies that are primarily secular. George Emmons acquired many of these rattles in his years of collecting, among them several associated with shamans. He always described the figures as representing the body of a dead man, with the frog or tail bird drawing secrets of life or spirit (power?) from him through his tongue, but he also insisted that

this type of rattle was used by the doctor in general festival dances and not in connection with his practice about the sick. This type of rattle is used by many of the coast tribes including the Tlingits, Haidas, Tshimpesians [sic] and the design is conventional. (Emmons 1894: no. E/349)

Although the Tsimshian chief in his role of Wihalait (no. 55) used the raven rattle in his performance of power throwing, he was not acting as a shaman.

Most of these rattles appear to depict ravens, but there are a few that represent other birds—hawks or thunderbirds, puffins or petrels among them. The bird with a long beak pointed forward, whose crest feathers double as the tail of the raven, was identified here by Emmons (apparently from native information) as a kingfisher. He described some others as mergansers and sandhill cranes.

The raven rattle is a traditional part of the paraphernalia of a dancing chief, which also includes an elaborate headdress (no. 73), a robe (ideally a Chilkat blanket [no. 74]), an apron fringed with rattling pendants, and leggings (no. 55). In use, the rattle was often held belly up in the dancer's extended hand and shaken rapidly and continuously throughout the dance. Occasionally rattles were used in pairs (Samuel 1982: fig. 12). Many of them were made, and there are a great number in museum and private collections (Holm 1983a:25–28).

The raven's long, extended neck and narrow beak, the thin body of the man arched high above the bird's back, and the fine features of the tail bird combine to make this rattle unusually graceful and delicate. A tiny frog with a human face, held in the tail bird's beak, bites the man's tongue. Both the carving and the painting are of the highest quality, forming an exquisite example of the northern carver's art. But what makes this rattle interesting, beyond its aesthetic quality and high standard of craftsmanship, is the fact that the carving is unfinished in a way that helps our understanding of the artist's methods and, by extension, the character of the art tradition. The formline design on the breast of the raven is typically carved in shallow relief in the same way as those on chests (no. 58). On this example the black primary and red secondary formlines, as well as the tertiary lines, have been painted as usual. But only the outlines of the painting have been incised, and the ground areas and all but a few of the tertiary spaces are still flush with the surface. For some reason, the rattle was put into use before the artist had completed the detailing of the breast. This feature makes it part of a large body of evidence which shows that such designs were ordinarily painted before carving, and suggests that painted forms preceded relief carving in the development of the art.

An almost identical rattle, undoubtedly by the same maker, is in the collection of the Ethnographic Museum in Munich (Haberland 1979:109). Others that may be the work of this carver are known. Certain carvers specialized in small, fine carvings like frontlets and raven rattles, and their work was widely spread on the coast, so that the object's documented place of collection may not actually indicate its place of origin. However, Emmons' identification of Sitka seems quite likely for this rattle.

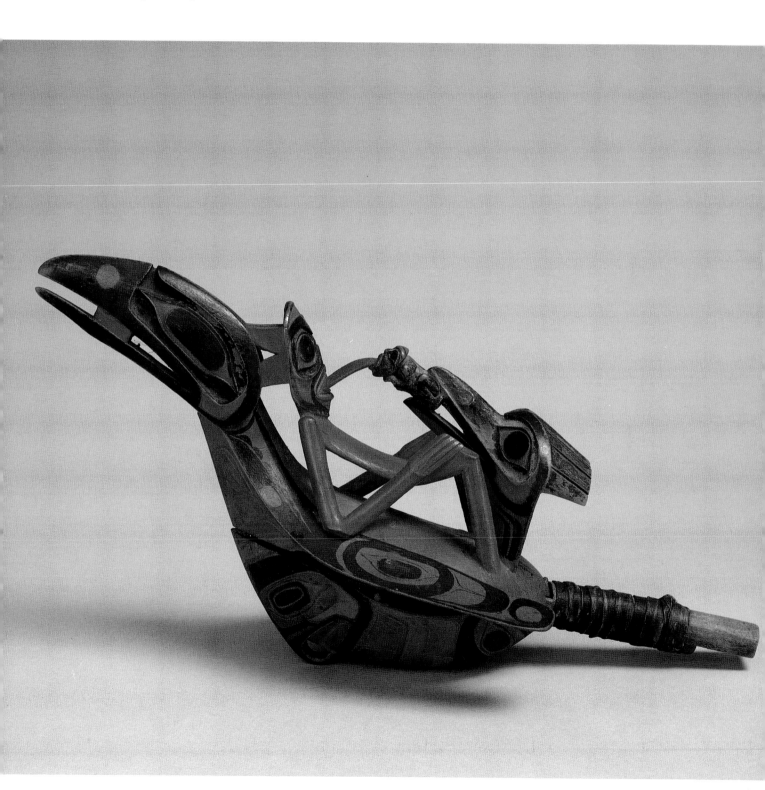

73. Dancing Headdress Tlingit; 19th c.

Wood (maple), ermine, flicker feathers, sea lion whiskers, swan skin, mallard skin, abalone shell,
whale baleen, buckskin, cloth; 129 cm × 23 cm × 20 cm

Collected by George Emmons at Sitka, Alaska, before 1905; received 1909; cat. no. 2312

From Vancouver Island to Yakutat Bay, the crown of a dancing chief is a fanciful composite of the richest materials known to Northwest Coast people. The focus of the crown is a carving in hard wood of a creature of myth. Inlaid with iridescent abalone shell and painted according to the traditional rules of color placement, the frontlet, as this sculptural plaque is called, is sewn to a frame—usually of whale baleen covered with cloth—from the top of which rises a circlet of the long, flexible whiskers of Steller's sea lion. On many northern headdresses, these whiskers are interspersed with flicker tail feathers. The back of the frame is covered with swan skin with its thick mat of white down. A broad panel of cloth shingled with rows of ermine skins hangs from this swan skin down the dancer's back. The forehead rims of Tlingit headdresses are often bound, like this one, with the iridescent green-feathered skin of a mallard drake's head. Such a magnificent assemblage makes a fitting frame for the frontlet. Many of these frontlets stand among the masterpieces of Northwest Coast sculpture.

The regalia that accompanies the dancing headdress is equal to it in richness. The favored robe is the Chilkat blanket (no. 74), augmented by a painted or woven apron and leggings. The raven rattle (no. 72) is almost inseparable from the headdress. Loose white eagle down fills this sea lion whisker crown, and the dancer, nodding and jerking his head from side to side, wafts the down into the air and over his guests, a sacrament of peace. Both men and women of nobility wear the dancing headdress, but their actions are very different: the men almost violent in their movements, the women sedate.

George Emmons collected this headdress from a chief of the Koskedi Raven clan at Sitka. Although Tlingit headdresses are often attributed to the Tsimshian (de Laguna 1972:443), many frontlets, including this one, are clearly Tlingit in style and unlike documented Tsimshian examples. The frontlet's height, the form and arrangement of figures, the blue-painted rim with its widely separated abalone plaques, the red trade flannel, and the mallard-skin border all point to Tlingit origin. There seems to be no doubt that the concept of the headdress and its dance came from the mainland to the south, but dancing headdresses of this kind were made by artists from every tribe from the Kwakiutl northward. Louis Shotridge's statement, that these were women's headdresses derived from Kwakiutl (probably Bella Bella) examples and of little prestige value to the Tlingit (Shotridge 1919:47–48), is refuted by the literature, by present-day Indian usage, and by many old photographs.

The figures carved on the frontlet are a raven and a large head that resembles a bear. Emmons identified only the raven, and without the story represented in the composition, the meaning of the lower face can only be guessed.

A Sitka chief in dancing posture, wearing the headdress now in the Burke Museum (no. 73). He holds a raven rattle (cf. no. 72) and wears a woven tunic (cf. no. 75) with the crest design of a cow. There are two explanations for this crest: one that it represents the bison of the interior plains, and the other that it was derived from the use of a cowhide to protect a pile of potlatch goods from a sudden rainstorm.
Photograph by George T. Emmons, 1888. British Columbia Provincial Museum, Victoria, British Columbia.

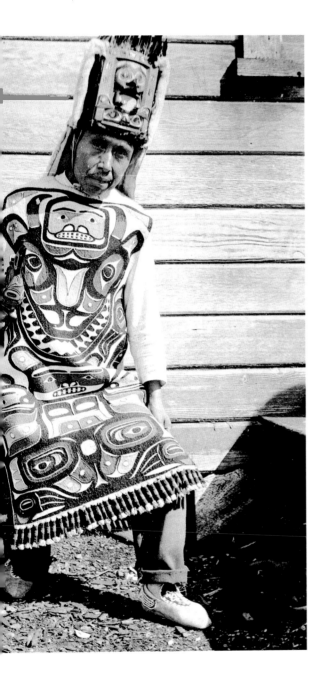

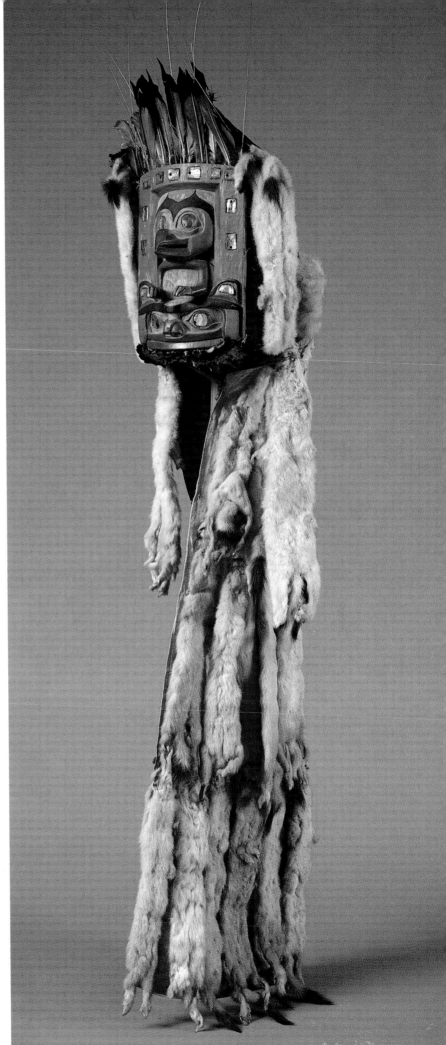

74. Chilkat Blanket Tlingit; 19th c.

Mountain goat wool, yellow cedar bark; 161 cm × 135 cm (with fringe)
Walter Waters Collection; received 1953; cat. no. 1–1587

No more royal robe ever draped a king than the dancing blanket of the northern Northwest Coast, universally named the "Chilkat blanket" after the Tlingit tribe whose weavers specialized in its making in the nineteenth century. Its characteristic five-sided form, richly fringed, with striking black and yellow bands bordering a complex tapestry of eyes, fins, or feathers, is instantly recognizable. Technically, it is an extraordinary accomplishment. The yarn of the warp is a finely spun composite of yellow cedar bark and mountain goat wool, while that of the weft is of wool only, spun and plied in different weights according to the part of the pattern in which it is to be used. The entire pattern is woven, using several different twining techniques, to achieve the subtly curved forms and fine lines that characterize it.

The most remarkable feature of Chilkat weaving is the ability of the weavers to copy in twining the curved lines of the painting style. Designs that are closely related to those on boxes and chests (nos. 58, 69) were painted by artists on wooden panels called pattern boards (Emmons 1907:342; Holm 1983a: no. 88; Samuel 1982: figs. 36, 441). The weaver followed the pattern meticulously, introducing the colors in the appropriate places. Extremely complicated (Samuel 1982), the technique evolved from a combination of manipulations used in basketry and earlier wool-weaving, and was the means to satisfy the desire to produce crest designs on chiefly robes. Classic Chilkat blankets date only to the beginning of the nineteenth century. Their predecessors were geometrically patterned twined robes of which only a handful have survived (Holm 1982).

There are dozens of different Chilkat blanket patterns. The most common are those called "diving whale," most of which are divided into three distinct panels, the central one depicting the whale. In this variant, the three panels are merged and the whale spreads nearly to the lateral borders. George Emmons recorded an interpretation of the design which describes it as a killer whale catching a hair seal (Emmons 1907: fig. 579). The seal's head is at the bottom with open mouth and downturned snout. Its front flippers extend outward from the sides of the head, while the hind flippers reach to the lower corners of the blanket from the eye-like hip joints. The killer whale's head with its toothed mouth is above the seal's. The human face above the killer whale's represents the blowhole (no. 70). On each side of the blowhole and extending upwards are the pectoral flippers, appearing as squared U-forms. Extending outward into the side panels are the two halves of the tall dorsal fin of the killer whale, bent back (or upward, here) at the tip. The upturned flukes of the tail, with their eye-like joints, touch the top of the pattern. Elaborate formline designs completely fill the remaining space.

Worn in the dance, the whale is centered on the dancer's back, with the upper corners falling over his chest. A sumptuous fringe rings the wearer, and gives the robe its Tlingit name *nakheen*, "fringe about the body" (Emmons 1907:329). As the dancing chief jumps and turns, the fringe sways and flares, emphasizing his action (Samuel 1982: title page). Half covered by the ermine trailer of the headdress, half covering the vibrating raven rattle, the blanket contributes to an effect of incredible opulence.

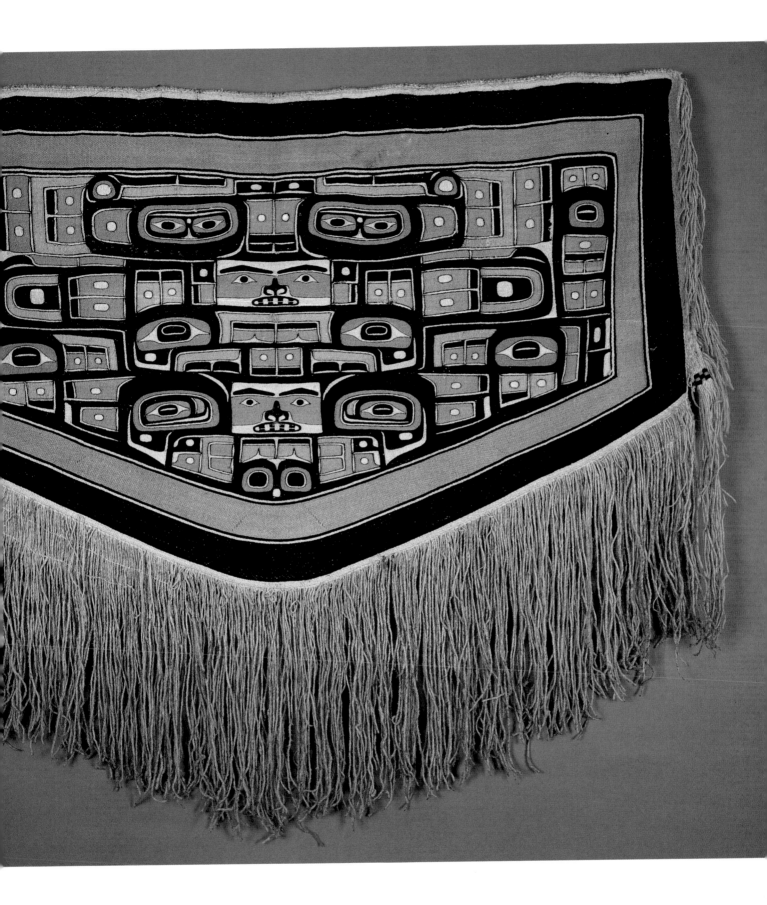

75. Chilkat Tunic Tlingit; 19th c.

Mountain goat wool and yellow cedar bark; 108 cm × 81 cm
Betty and Charles Gould Collection; received 1945; cat. no. 1–631

Tlingit weavers also used their skills to produce articles of ceremonial dress other than dancing blankets. Among these were aprons, leggings, and a few very rare pouches, cartridge boxes, and shamans' hats (Samuel 1982: figs. 5, 7). The largest and most spectacular of these ceremonial articles, however, was the tunic, either sleeved or sleeveless. Probably derived from a painted dance tunic, or perhaps from an armor shirt (Vaughan and Holm 1982: no. 49), it was modified and conventionalized by the weaving process. Some tunics are configurative in design, while others, like this one, are so stylized that the design is very difficult to decipher. This appears to be a sea mammal, perhaps a sea lion, which has a large head with a toothed mouth and flipper-like appendages down the sides. It has been called a beaver, but this interpretation seems unlikely, with the lack of the identifying tail and clawed feet (Holm and Reid 1975:60).

The tunic back is unique in its design. It is almost always banded with wavy or zigzag stripes set against a white background of spaced twining (Samuel 1982: pl. E; Holm and Reid 1975:60), and often shows an inverted, round-eyed face at the neck. The structure of the neck and shoulders presented the weavers with a complex technical problem. Although Northwest Coast women had traditionally woven conical capes on warps hung from circular headlines, those capes tapered evenly from top to bottom. Tunic shoulders sloped much more gradually and quickly reverted to flat front and back panels, requiring complex addition and deletion of warps. Although there is no seam as such, the major line of warp adjustment runs downward to the front from the neckline, rather than along the slope of the shoulders. It is very similar in placement to the actual shoulder seam of an Athapascan skin shirt, to which the tunic may be related. The Chilkat people had regular trading relationships with the interior Athapascans, from whom they acquired fine quilled and beaded skin clothing. Some tunics were fitted with sleeves, which were woven in tubular form like baskets, and typically decorated with two bands of eyes and U-complexes (de Laguna 1972: pl. 145; Emmons 1907: fig. 591b).

Chilkat tunics were not worn with blankets, but rather in lieu of them (see p. 181). Far fewer tunics were made than blankets, and consequently fewer are in collections. This one is of very high quality, with fine yarn, regular weave, and controlled form. The quality of Chilkat weaving may be judged by the similarity of the formlines, particularly the ovoids, to painted examples. In less expertly woven work, ovoids tend to be irregular, angular and asymmetrical. However, right-angle junctures and square U-forms are characteristic of Chilkat weaving, and in the best examples these corners are very sharp and crisp.

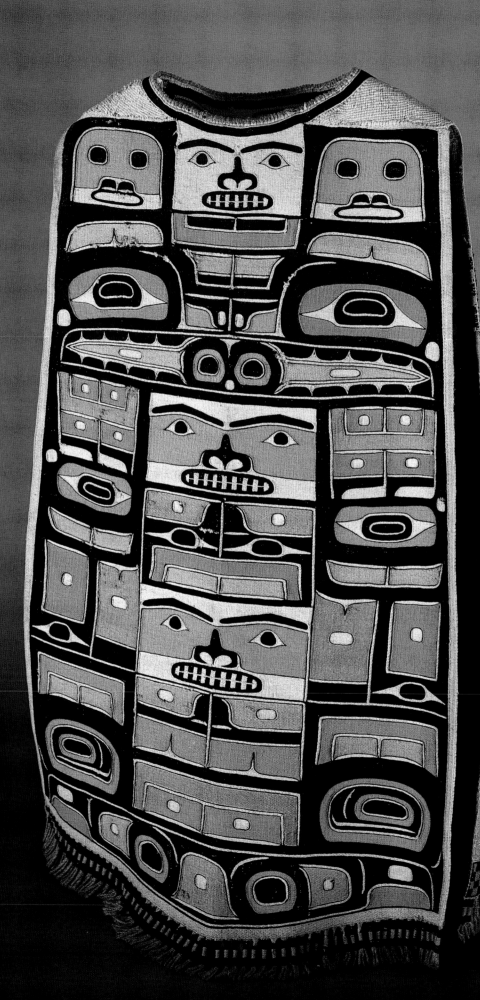

76. Button Blanket Tlingit; late 19th c.
Woolen blanket, trade cloth, pearl buttons; 170 cm × 139 cm
Walter Waters Collection; received 1953; cat. no. 1–1495

As spectacular in its own way as the Chilkat blanket, the ceremonial robe known as a button blanket is entirely a product of the period of white contact. The concept of a dancing blanket with elaborate borders and a crest figure in the center is an ancient one, and when woolen trade blankets, flannel, and iridescent mother-of-pearl buttons became available on the Northwest Coast, they were quickly adapted to the older use. The earliest known and recognizable representation of button blankets is a drawing by Ilya Voznesenskii made at Sitka in 1844 (Blomkvist 1972:150). Among the throng of mourners represented in this detailed picture of the funeral of a Tlingit chief are two women wearing bordered blankets with rows of disks which almost certainly represent buttons. Although one of the two women appears to be wearing a cape, it is probably a typical button blanket with the upper corners falling over the wearer's chest. By the end of the century, the button-decorated style of dancing robe had spread over much of the coast and was the standard ceremonial blanket among most of the tribes.

Typical northern blankets are of very dark blue woolen material—often Hudson's Bay Company blankets—with a broad border of red wool flannel. Older blankets are bordered with very fine, tightly woven, smooth-napped flannel, dyed like the typical trade cloth so that the selvages remain white. This contrasting stripe sometimes appears at the lower ends of the side borders, or occasionally elsewhere in the border, as a decorative touch. The inner edge of the red border is lined with a band of buttons. A figure representing a crest of the owner is displayed within this frame. Usually the crest is rendered as an appliqué design of red cloth outlined with buttons; occasionally, as in this example, the entire figure is of buttons, with only accents of red. Ordinarily the robe is worn over the shoulders and fastened at the front, but it can be worn wrapped around the body under one arm and over the opposite shoulder. Many northern blankets have buttons and loops as fasteners, as this one does.

Walter Waters collected this blanket from the Tlingit, probably at Wrangell, Alaska. The chief crest of the Kiksadi, the principal Raven clan at Wrangell, is the frog, here depicted in a flamboyant triple row of buttons. Red flannel lines its mouth and underlies the large buttons in the eyes, nostrils, vertebrae, feet, and hips. The bands of buttons are utilized as modified formlines. The same exuberant use of buttons in multiple rows characterizes the border. Saltwater pearl buttons are very reflective, and the rippling of the button appliqué in firelight suggests molten silver.

Many old accounts describe button blankets as "women's blankets," but they were and are worn by men. Another type of button blanket, sometimes called "Tahltan style," has a cape-like division across the top third, and the lower two-thirds divided into three panels, all with red borders.

Button blankets exemplify the integration of introduced materials and traditional concepts on the Northwest Coast. They have become a major vehicle for art expression which continues today. New blankets appear at every ceremonial occasion; contemporary artists design them for use and sale (Haberland 1979:277; Blackman 1985: figs. 3, 4, 5); exhibits entirely devoted to modern button blankets have been mounted (Jensen and Sargent 1986). But old blankets are relatively rare in the major museum collections. With their non-native cloth and buttons, these blankets were probably considered too acculturative by the turn-of-the-century collectors who were looking for "traditional" material.

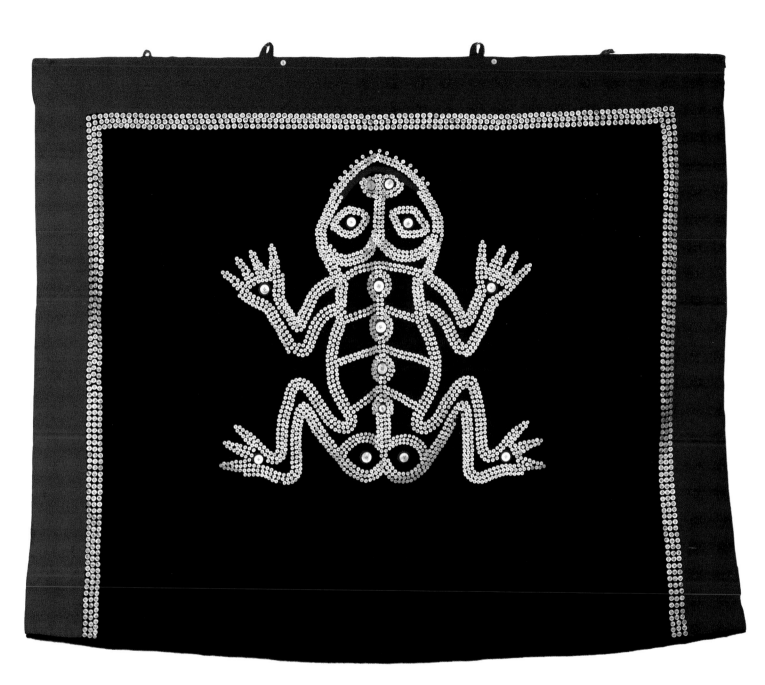

77. Crest Headdress Tlingit (Stikine); 19th c.

Wood (alder, cedar?), human hair; 133 cm × 20 cm × 22 cm

Collected by George T. Emmons at Wrangell, Alaska, before 1905; received 1909; cat. no. 959

Tall, glossy black dorsal fin, hair streaming from the trailing edge, is the mark of the killer whale: the most imposing natural animal of the Tlingit world and a crest of the Wolf phratry. Here the orca is combined with the wolf itself in a powerful crest headdress, collected by Emmons from the Stikine Tlingit. The Gonakadet, sometimes represented as a wolf-like creature with dorsal fins, is also a crest of the Wolf phratry, but this headdress probably represents the wolf and killer whale crests combined. Emmons did not identify the clan that owned the headdress, but described it as "of totemic significance," worn by the chief—to whose care it was entrusted—only upon special occasions when the whole family was present.

The headdress is built on a frame of bent withes, covered with long locks of dark red-brown, partially braided hair. Emmons' notes identify it as woman's hair. The effect is of a full head of long hair on which the wolf's head and killer whale fin stand. One of the most impressive sights of the Northwest Coast is the emergence from the sea of the glistening, black, dorsal fin of a great killer whale. The upright, graphite-painted fin of the headdress recalls that sight. Long locks of black hair stream back from the fin, perhaps referring to the whale's wake. The wolf's head, carved in the round, shows a long snout with bared teeth. The nostrils are realistically carved, but painted in red, a conventional color use in Northwest Coast art. The sculpture of the wolf is typically Tlingit. Rounded forms with broad, arched eyebrow and large, wide open eye are characteristic, as is the all-over light blue paint with black and vermilion detail. The blue pigment, so characteristic of northern art, has commonly been identified as a copper derivative. Recent and ongoing analyses, however, indicate that copper is an uncommon source for the blue and green colors in Northwest Coast painting, and that other minerals, such as celadonite, an iron silicate, are more likely materials (Vaughan and Holm 1982:37; Miller 1985:47; Portell 1985).

A great Tlingit potlatch, with all the clan emblems, hats, staffs, and blankets worn by their proud custodians in the firelit feast house, must have been a grand and imposing sight.

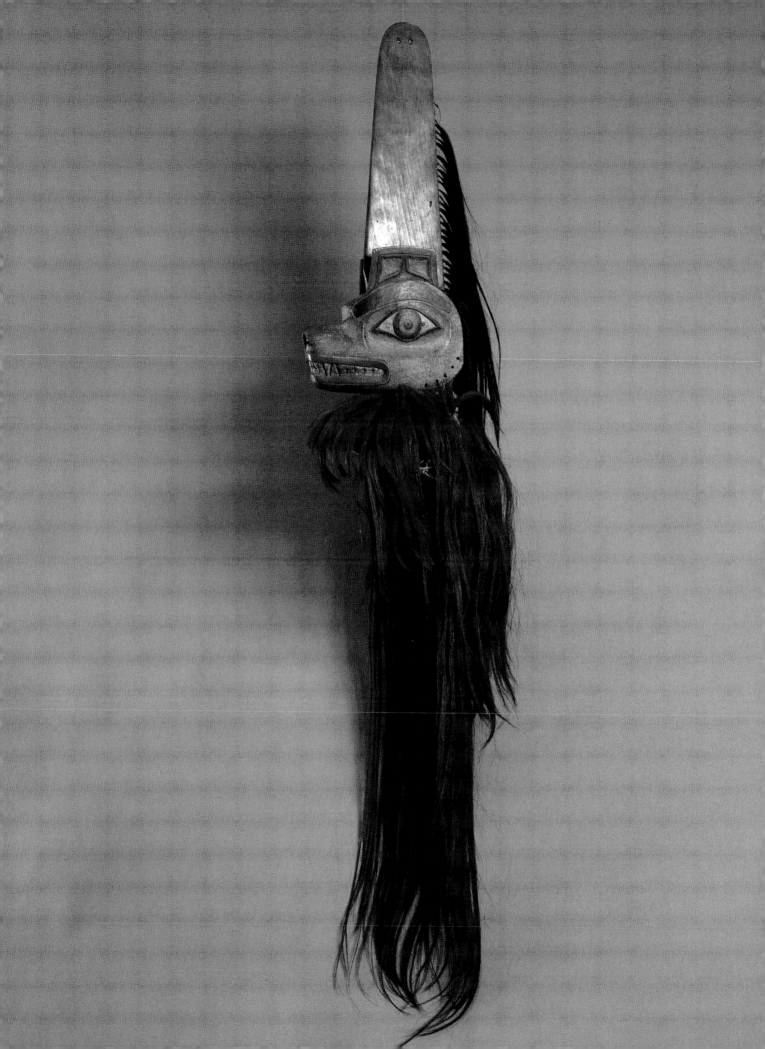

78. Crest Headdress Tlingit (Henya); mid-19th c.

Wood (red cedar), sea lion teeth, hair, mirror; 68 cm × 24 cm × 46 cm
Collected by George T. Emmons at Shakan, Alaska, before 1905; received 1909; cat. no. 2313

A killer whale in full form—great mouth, broad flippers and tail, and a salient dorsal fin—makes a noble crest headdress of the Henya Tlingit. Every feature of a Tlingit killer whale is here; the fin and fluked tail immediately proclaim it. Tlingit killer whale images frequently show the pectoral flipper divided into long claws or fingers, perhaps indicating an awareness of the hand-like skeletal structure of the fin. Its joint is seen as a great ovoid with the outlining formline implied. A bold, oval stripe curves diagonally across the creature's snout, an exclusively Tlingit attribute for a killer whale (nos. 70, 81, 82, 89, 96). The stripe was once painted white but is now nearly obliterated. The whale's eyes are perfectly round, a form usually reserved for sea creatures. They are set with mirrors, which glint in the firelight. Broad, formline lips are opened to show fierce carnivore's teeth, probably from a sea lion.

The tall fin, a special mark of the killer whale, is often pierced with a round hole, or marked with a circle (nos. 74, 81, 82, 83). One Tlingit story explains that the man who first carved killer whales of yellow cedar (he had tried unsucessfully to make them of cottonwood bark, alder, hemlock, and red cedar) carved holes in their dorsal fins and, using them as handholds, was towed away from an island on which his brothers-in-law had marooned him. Later he sent his spirit whales to revenge him by smashing their canoe (Swanton 1909:230–31).

Except for the prominent ovoid joints of the flippers and the blunt proportions dictated by its function, the killer whale headdress is quite naturalistically rendered both in form and color. This naturalism is frequently seen in Tlingit art, although highly abstracted forms are also part of the tradition. The conventionalized killer whale in the bentwood bowl (no. 70) can be deciphered fairly easily, but one needs special knowledge of the rules of the art in order to recognize the same animal in the Chilkat blanket (no. 74). The animal represented on the Chilkat tunic (no. 75) is so abstracted that its identity is conjectural.

Emmons collected this headdress at Shakan, a Henya Tlingit village on the northwest coast of Prince of Wales Island. Shakan had been a summer fishing village of the Henya, and later was occupied year-round after a sawmill was established nearby (Swanton 1908:410). Emmons did not identify the clan from which he acquired the killer whale headdress, but the animal is a crest of the Wolf phratry.

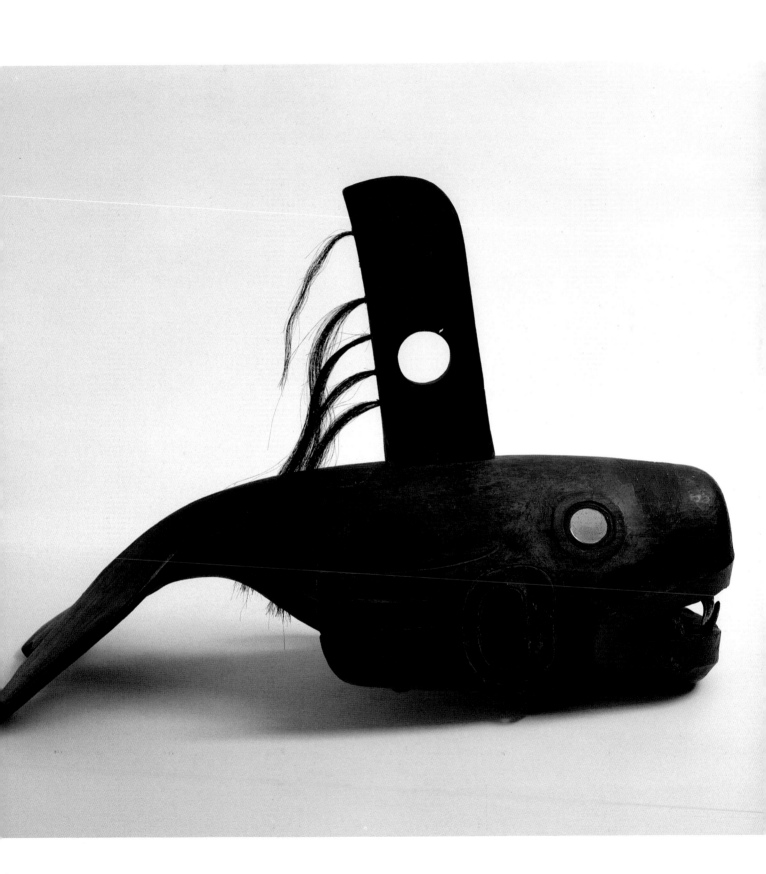

79. Grizzly Bear Mask Tlingit (Stikine); early 19th c.

Bear skin, wood, copper, iron, abalone shell, opercula, bear teeth; 40 cm × 30 cm × 20 cm
Collected by Axel Rasmussen at Wrangell, Alaska; received 1974; cat. no. 2.5E604

The crests of Tlingit noble families and those of other northern Northwest Coast tribes are usually graphic representations of the creatures with which the ancestors interacted in the distant past. At least some of these encounters took place within the historic period, and so there are such crests as "The First White Man" and "The Cow Hide" (see p. 181). Only a very few relics of these momentous incidents have been preserved.

Perhaps the most important of these rare treasures is the Grizzly Bear Mask of the Nanyaayi clan of the Stikine Wolf phratry. The story of the acquisition of the Grizzly Bear crest by the Nanyaayi was recorded by John Swanton in 1904 from Katishan, chief of the Stikine Kaskakwedi.

At the time of the flood the Nanyaā'yî were climbing a mountain on the Stikine river, called Sēku'qłe-ca, and a grizzly bear and a mountain goat went along with them. Whenever the people stopped, these two animals stopped also, and whenever they moved on the animals moved on. Finally they killed the bear and preserved its skin with the claws, teeth and so forth, intact. They kept it for years after the flood, and as soon as it went to pieces, they replaced it with another, and that with still another up to the present time. This is why they claim the grizzly bear. During the times when this bear skin has been shown, thousands of dollars worth of slaves and furs have been given away. Shakes (Cēks), head chiefs of this clan, would go up to a row of slaves and slap each one, upon which the slave would either have to be killed or sent home. This is why they gave great names to their children. They were very proud of owning this bear and did all kinds of things toward it. That is why all Alaska speaks of the Nanyaā'yî as the chief ones owning the grizzly bear. Very many songs were composed concerning it, with words such as these, "Come here, you bear, the highest bear of all bears." (Swanton 1909:231)

The Bear Mask and skin costume were considered the clan's most noble relics and always were given a prominent place in the funeral displays of each succeeding holder of the Shakes title (see p. 194). The whole costume was worn on important potlatch occasions and at times, apparently, for pure entertainment. The famous naturalist John Muir witnessed the bear in action at a party hosted by Chief Shakes for visiting dignitaries at Wrangell in the summer of 1879. He described its action as " . . . so true to life in form and gesture we were all startled . . . " (Muir 1915:34–35). The other important Grizzly Bear crest objects of the Nanyaayi, among which are the great Bear Screen now in the Denver Art Museum (Conn 1979: no. 460), dentalium-shell decorated shirts with bear designs (see p. 194, above), and the Grizzly Paw rattles (no. 80), were all derived from the encounter represented by this relic.

The mask is based on an armature of wood skillfully and naturalistically carved. Over this form, the raw skin of the bear's head has been stretched and secured with hardwood pegs. The eyes are iron domes set inside the eyelids, the lips are copper, and the teeth are opercula and bear's canines. Thin wooden ears covered with bear hide have been elaborated with humanoid bears' faces worked in repoussé on very thin copper sheet and finished with abalone shell inlay for eyes and teeth. Although the fur is worn and bleached, the mask is in remarkably good condition. The earliest photographs of it, taken over a century ago, show that it was in nearly the same condition at the time (see p. 194, below). Although the account given by Chief Kadashan to Swanton describes the replacement of the skin from time to time, this must refer to the bear skin worn by the performer, rather than to the covering of the mask, which appears to be the only skin ever applied to it.

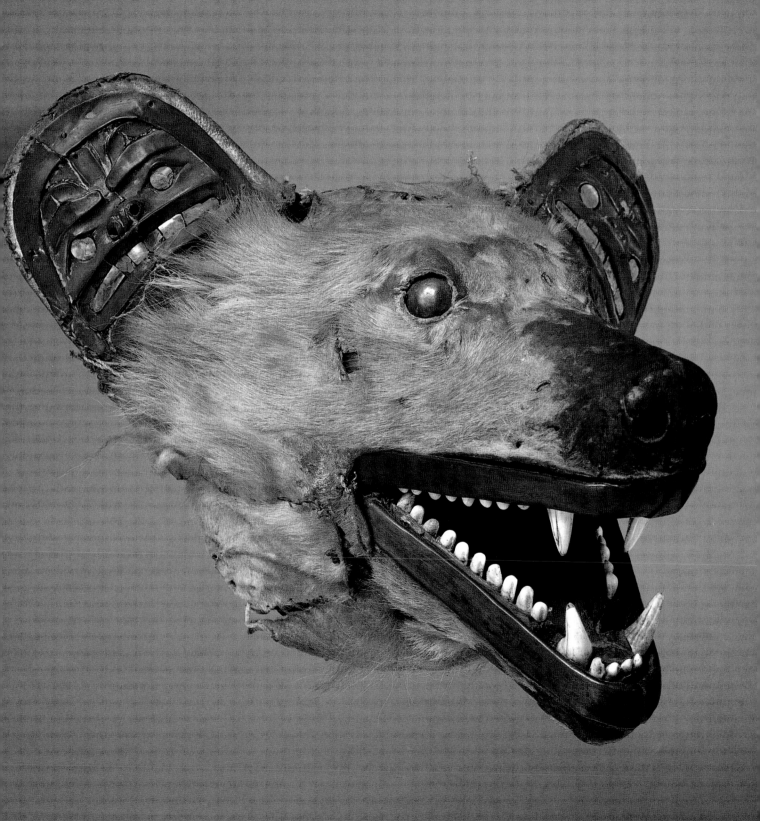

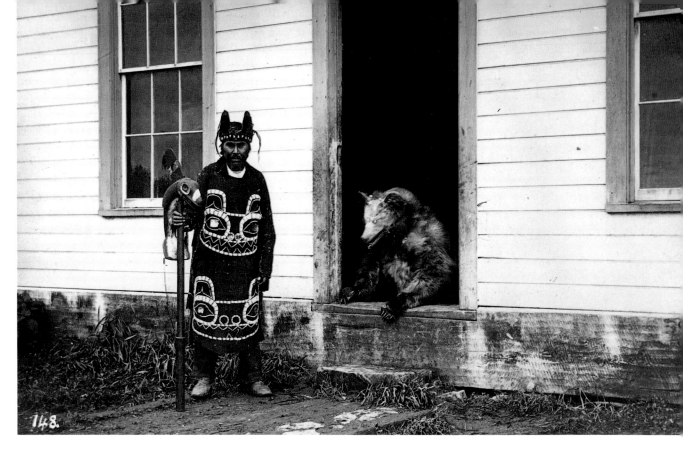

The Nanyaayi Grizzly Bear Mask (no. 79) and costume worn by a performer in 1885. The standing man wears one of the two Shakes dentalium shell–embroidered bear tunics and a bear's ears headdress. He holds the Killer Whale Staff (no. 82). *Photograph by Albert P. Niblack. British Columbia Provincial Museum, Victoria, British Columbia.*

Chief Shakes V lying in state in 1878, surrounded by the Nanyaayi treasures. The Killer Whale Hat (no. 81), the Grizzly Bear Mask (no. 79), and the Killer Whale Staff (no. 82) are prominently displayed. *Photograph by Mr. Davidson, Wrangell, Alaska. Burke Museum Collections, University of Washington.*

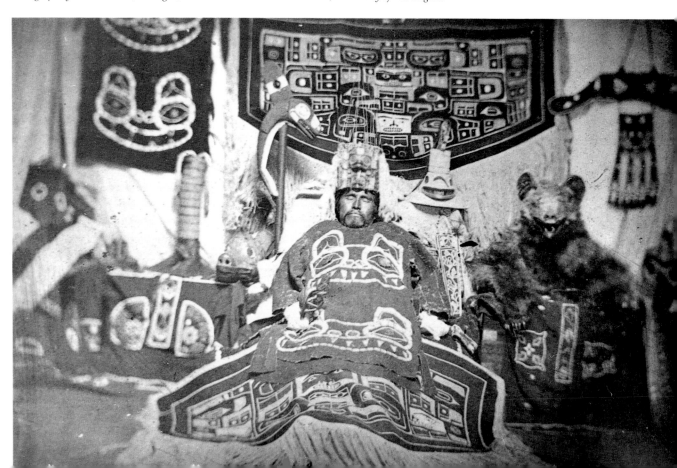

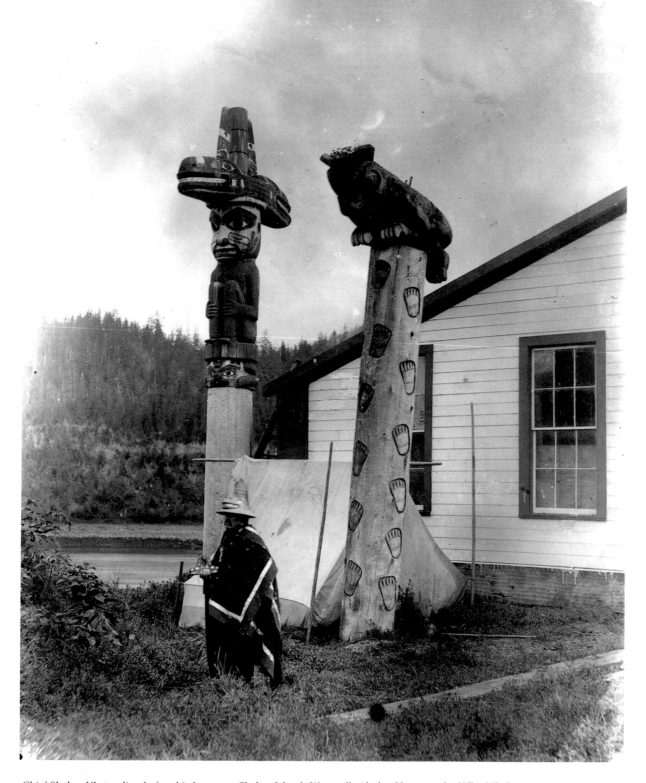

Chief Shakes VI standing before his house on Shakes Island, Wrangell, Alaska. He wears the Killer Whale Hat (no. 81) and holds the Double Killer Whale Pipe (no. 83). The mortuary pole behind him depicts a predecessor wearing the Double Killer Whale Hat, from which the design of the pipe was derived. The other pole, called "Bear up the Mountain," represents the grizzly bear who accompanied the Nanyaayi in their escape from the flood, an incident from which they claimed the grizzly bear as a crest (no. 79). The bear's tracks are seen on the shaft of the pole. *Photograph by Partridge, ca. 1886. Peabody Museum, Harvard University.*

80. **Rattle** Tlingit (Stikine); 19th c.

Wood (maple), rawhide; 29 cm × 13 cm × 9.5 cm

Collected by George T. Emmons at Wrangell, Alaska, before 1905; received 1909; cat. no. 955

The Grizzly Bear Mask (no. 79) was the source of a crest that has been manifested in many of the ceremonial treasures of the Nanyaayi chief, Shakes, among them a pair of powerful rattles. These rattles are shaped like the broad forefeet of the grizzly, with bony knuckles standing out on the backs and massive claws arching upward over human faces. The faces are tense and intent, smoothly carved of hard wood with only the features—lips, nostrils, eyes, and eyebrows—painted on the deeply patinated surface. Because of that, and because of the pyramidal cheek form, they resemble Tsimshian sculpture. Emmons thought they showed Haida influence. Taken as a whole, their form suggests that they are indeed of Tlingit origin; however, the problems of attribution are apparent.

Made to be held one in each hand, the rattles represent the upraised, threatening paws of the grizzly, the fearsome crest animal of the Nanyaayi. The claws curving over the face from the naturalistically rendered foot on the back of the rattle show that the intent was to represent the bear's foot with a human face on the pad. Human faces often appear on the palms of hands and soles of feet of humans and animals in northern Northwest Coast art. On one level, these faces derive from the representation of joints as eye-like ovoids that can be progressively elaborated into faces. But these extraneous faces can and often do have more specific meanings which, unless we know the traditions involved, can only be guessed.

Emmons collected both rattles at Wrangell. In 1904, he sold one of them to the American Museum of Natural History (#16/9378; Wardwell 1978: no. 54); the other was exhibited in the Alaska Building, along with his spectacular Tlingit collection, at the 1909 Alaska-Yukon-Pacific Exposition in Seattle. After the fair, the Emmons collection was purchased for the Washington State Museum, as it was then called, and thus the two rattles had permanent homes three thousand miles apart. In 1967 they were together again for a few months when both were loaned to the Vancouver Art Gallery for the exhibition "Arts of the Raven." They are as nearly identical to one another as two rattles can be.

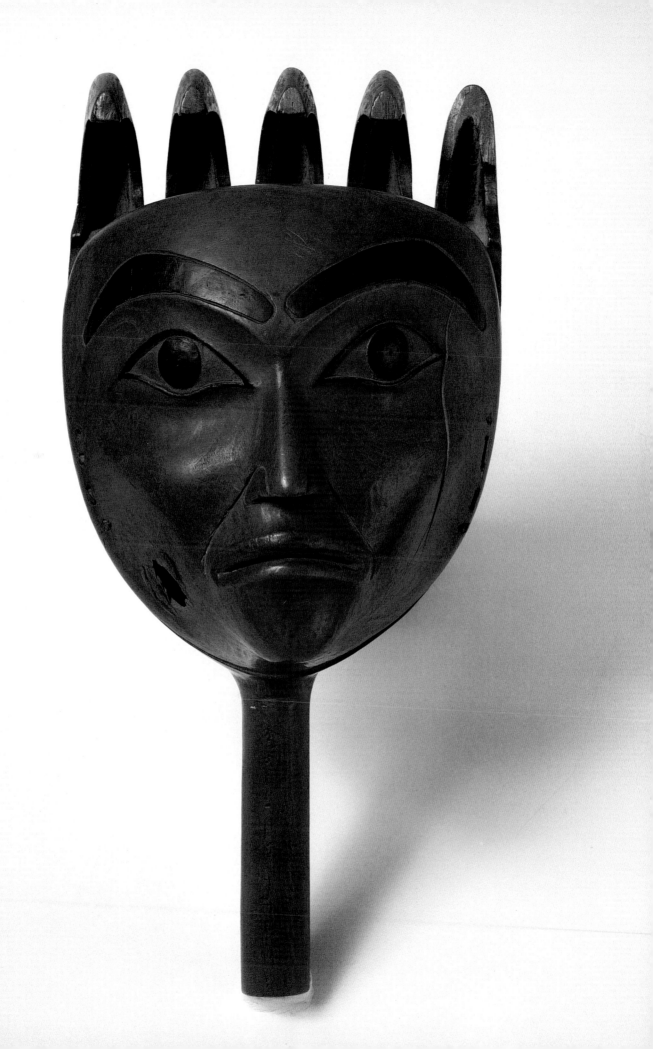

81. **Crest Hat** Tlingit (Stikine); early 19th c.
Wood (alder?), spruce root, abalone shell, human hair, copper, hide; 38 cm × 32 cm × 33 cm
Walter Waters Collection; received 1953; cat. no. 1–1436

The most prestigious object in any Tlingit clan is the crest hat. It is the physical manifestation of lineage traditions, and can be properly likened to a crown of royalty. On the momentous occasions when it is worn before the people by its noble custodian, it reminds all who see it of its history and of the glorious deeds of the clan ancestors. Each crest hat is given a name, and the circumstances of its original acquisition and the names of its subsequent owners and their accomplishments are all part of its history. Chief Shakes' Killer Whale Hat is the royal crown of the Nanyaayi clan of the Stikine Tlingit.

Judging on the basis of style, the Killer Whale Hat must date at least to the early nineteenth century. It is carved of hardwood, probably alder, in the form of a spruce root basketry hat and, like many Tlingit wooden crest hats, it shows a band of grooves encircling the rim in imitation of the skip-stitch twined patterning of the woven hats. The image of the killer whale appears in a combination of two- and three-dimensional design. The boldly sculptural head merges with a flat representation of the body, flippers, and tail spread over the sides and back of the subtly concave cone of the hat. This flat design is very old-fashioned in its heavy formlines and narrow relief slits. Broad, vermilion pectoral fins are shown as massive formline U's bordering shallowly hollowed, blue tertiary areas. The body and tail are in black formlines, with red secondary and blue tertiary details. Spiral tail flukes, an old Tlingit convention, recall those sometimes seen on Chilkat blankets (no. 74). The smoothly rounded snout, large mouth set with abalone shell teeth, and round, shell-inlaid eye (although here with pointed, open eyelids) are all killer whale characteristics. The familiar nose stripe was once shallowly recessed and painted white, but was overlaid with copper before 1879, when the hat appears in a photograph taken at the funeral of Chief Shakes V (see p. 194, below).

An upright, curved dorsal fin is separated from the whale by a stack of four woven spruce root disks. These are emblems of prestige whose full meaning, although often explained, is not at all clear (no. 86). They are very old, probably as old as the hat itself. The fin is a complex one, with a crouching man carved in high relief on both sides. A round hole pierces his stomach. A broad flange surrounding the fin is inlaid with abalone shell on the front edge and set with human hair on the back. Tethers of twisted gut cord hold the fin upright. In Tlingit art, many killer whale fins incorporate human faces or figures at their bases; these faces are often interpreted as the human aspect of the animal, or sometimes as an illustration of a mythical incident. There are a number of stories about humans traveling on the backs of killer whales, a feat thought to occur only in myth, until the fall of 1965 when Ted Griffin, the first man to do so (at least in modern times), rode the famous whale Namu.

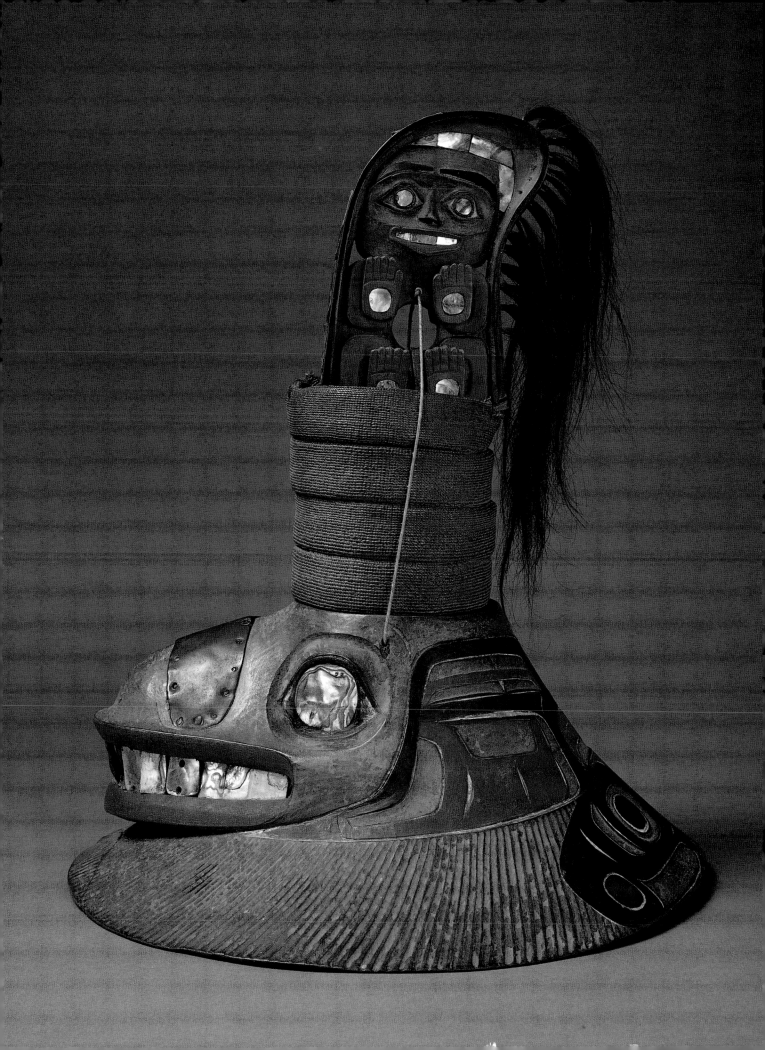

82. Crest Staff Tlingit (Stikine); early 19th c.

Wood (red cedar), abalone shell, opercula, human hair; 145 cm × 32 cm × 17 cm
Walter Waters Collection; received 1953; cat. no. 1–1443

I f the Killer Whale Hat is the royal crown of the Nanyaayi, the Killer Whale Staff is the
scepter. Possibly even older than the hat, the staff is an emblem of high esteem. Like the
hat, it was brought out only on occasions of great importance, carried by the bearer of the
lineage title, Shakes, or by his speaker or representative. A dynasty of seven consecutive
chiefs held the name Shakes, dating back to the capture of the name Weeshakes in a war
with the Nishga (Keithahn 1940:4–5). This must have been a very long time ago, for when
the Nanyaayi moved to the site of present day Wrangell in 1833 the title was already held by
Shakes IV (Keithahn 1963:97). His nephew and successor, Shakes V, held the position until his
death in 1878 (see p. 194, below), when his nephew, Shakes VI, inherited the title. The
seventh and last chief to assume the name of Shakes died in 1944.

Included in the booty with the title of Weeshakes (later shortened to Shakes) was the Killer
Whale crest. The present hat and staff are very Tlingit in style and were likely made after the
capture of the crest, but they (and especially the staff) have every appearance of great age.
The staff appears little different today from its condition in the 1878 photograph of Shakes V
lying in state (see p. 194, below). A very clear photograph taken in 1885 shows the whale
figure almost exactly as it is today, with most of the opercula and hair missing, except that the
white paint on the whale's belly, snout, and fin appears less worn (see p. 194, above).

Arched over the staff as if leaping from the water, the finned master of the sea makes a
fitting emblem for a powerful chief. It was once painted naturalistically in black and white,
perhaps with blue in the eye sockets. The tail alone is elaborated with a formline painting of
a face, done in black and blue on a natural cedar background, and doubling as the joints of
the whale's flukes. The lips may have been painted red, and the long mouth was once
studded with turban shell opercula. Much of the hair that streamed from the pierced dorsal
fin has long ago worn away. Traces of white paint remain on the nose stripe, belly, and dorsal
fin; abalone shell inlays still glisten in the eyes.

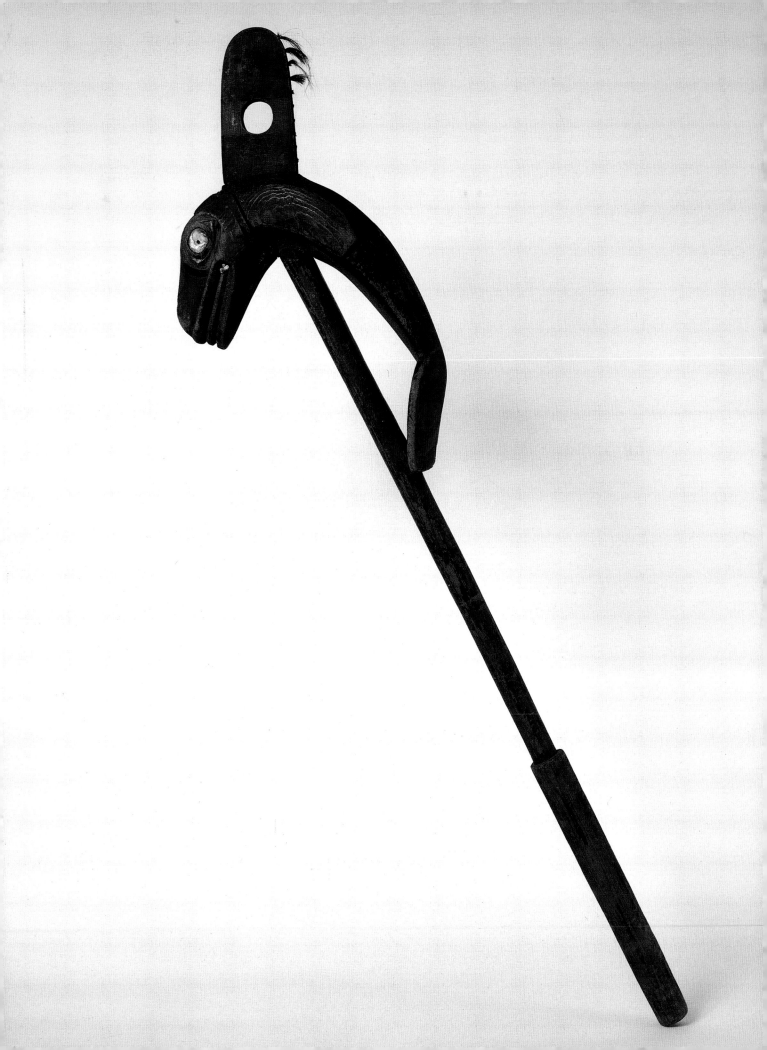

83. Crest Pipe Tlingit (Stikine); 19th c.
Wood, iron (gun barrel), abalone shell, human hair; 25 cm × 16 cm × 6 cm
Gift of Leonard M. Lasser, in memory of his daughter Kathryn; received 1972; cat. no. 2.5E561

As soon as northern Northwest Coast people acquired from Euro-American seamen the custom of smoking tobacco rather than chewing or sucking it, they began to make pipes. Those they made for their own use were usually of wood, with the bowl reinforced or made of metal. Sometimes this metal, which protected the wooden pipe from the heat of the burning tobacco, was merely a lining of copper. The favorite material for pipe bowls, however, was a section of musket barrel. By the early nineteenth century firearms had come into common use all over the coast, even though some traders had tried to prevent their falling into Indian hands. Many of these guns were surplus military firearms, but most were muskets produced (primarily in England) specifically for the fur trade. When they wore out, or were damaged beyond repair, resourceful craftsmen salvaged the useful parts. Iron barrels and walnut stocks are the remnants seen most often in the surviving artifacts of that period.

One of the ancient Nanyaayi clan treasures is the Double Killer Whale Hat. A very old and beautifully carved but incomplete wooden hat, collected by Emmons at Wrangell, is in the collection of the American Museum of Natural History (E2092). It may be the original hat from which the Double Killer Whale emblem was derived. In 1870, an old mortuary pole topped by a carved man wearing the Double Killer Whale Hat stood beside Chief Shakes' house. It has since been replaced three times. The hat represents the heads of two killer whales with their flippers back to back and their dorsal fins flanking a central column of hat rings (no. 86). This same theme, with all its details, is depicted in the Shakes pipe. It is a very large pipe, carved of hardwood, but probably not from a gun stock. The bowl is a tall section of a heavy musket barrel, filed in segments to simulate the basketry rings of a hat ornament. The bore of the barrel is approximately .70 caliber, in the range of military muskets of the early nineteenth century. Trade gun barrels are uniformly smaller, typically .58 caliber, and have thinner walls.

Abalone shell fills the eyes, teeth, and tertiary U-forms. All of the abalone shell in old northern pieces (nos. 73, 79, 81, 82) was imported, mostly from California. None of the local shell has the thickness and color preferred by traditional carvers. There are old traditions of deep blue and green abalone from the northern waters, but historically, at least, that shell has come only in trade. Human hair once fringed the whales' dorsal fins. The whole pipe was painted in the traditional colors of black, red, and blue, traces of which are still visible.

One of the most interesting features of the pipe is the oval rim centered on the bottom. It demonstrates graphically that the pipe represents not the "double killer whale," but the Double Killer Whale Hat, which is the crest in itself. We are fortunate that Chief Shakes VI was photographed standing beside the pole with the same crest, wearing the Killer Whale Hat (no. 81) and carrying the Double Killer Whale Pipe (see p. 195). Elaborately carved pipes, especially those with crest figures such as this one, were not ordinarily used for casual smoking, but were reserved for use at feasts and potlatches, especially in ceremonies for the dead (Krause 1956:156, 158; Macnair and Hoover 1984:29–30).

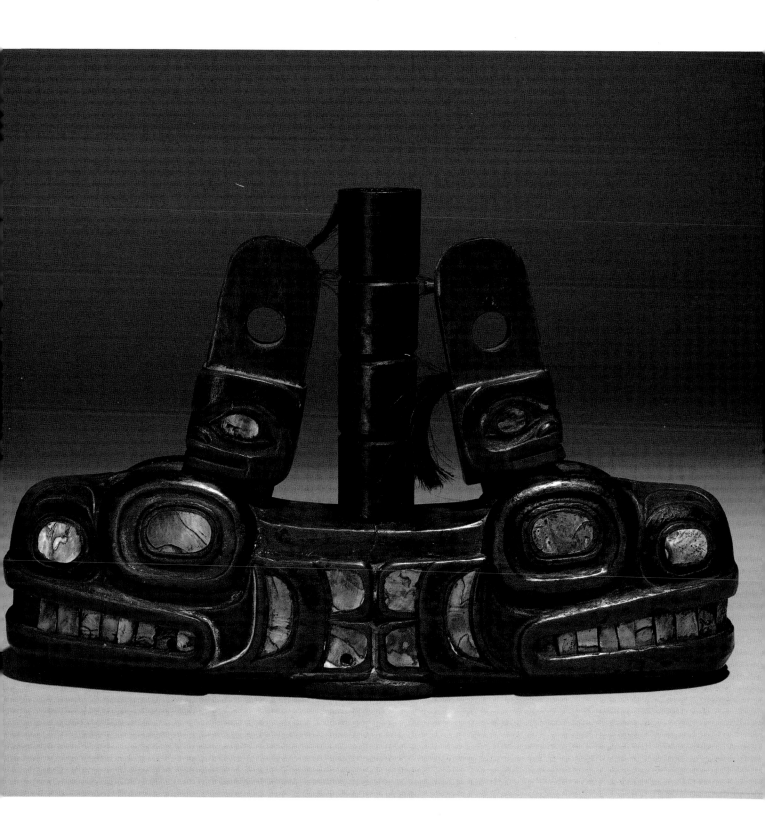

84. Groundhog Mask Tlingit (Stikine); 19th c.
Wood (alder), hair, buckskin; 24 cm × 19 cm × 14 cm
Walter Waters Collection; received 1953; cat. no. 1–1442

Old photographs can be very useful in identifying the context and ownership of artifacts. Although there is no written record to relate it to Chief Shakes, this mask appears in two old photographs of the clan treasures taken during the reign of Shakes VI, probably in the 1880s. Nor is the animal represented identified. We are tempted by the importance of the beaver in Northwest Coast art and myth to jump at the clue of rodent incisors and identify the mask as a beaver. However, the beaver is a crest of the Tlingit Raven phratry, and would be unlikely to be found in a mask of a Wolf clan. Furthermore, John Swanton states that "the Nanyaā'yî showed masks of the killer whale, shark, *ground hog*, grizzly bear, and gonaqAdē't . . . " (1908:436), all of which appear in the early photographs of Shakes' collection.

Swanton also wrote that the "masks were used in the shows (yîkteyî') which each clan gave at a potlatch, but they were not valued as highly as the crest hats and canes" (Swanton 1908:436). These shows were dramatizations of the clan myths. The performance John Muir witnessed in 1879 (no. 79) was probably of this sort.

The Groundhog or Marmot mask is a good example of mid-nineteenth century Tlingit sculpture. It is conceived as a humanoid face with a protruding animal snout. Large eyes with wide open lids are set on rounded orbs. The smooth run of the upper cheek plane from the deepest part of the eye socket to the groundhog's protruding, formline lips is typical of Tlingit face masks. In a somewhat unusual bow to naturalism, the marmot's lips and nostrils are black, rather than the more frequent red. Blue paint in broad U-forms crosses the sculptural planes of the mask, reminiscent in some ways of the painting style of the Bella Coola artists (nos. 44–48). However, the arrangement of painted forms on the cheeks is quite different from the usual Bella Coola mask painting.

The marmot is an appropriate animal for a part in the dramatization of Nanyaayi tradition. In ancient times an interior people, they migrated down the Taku River to the coast and eventually settled near the mouth of the Stikine, retaining contact and a trade monopoly with the Athapascan Tahltan of the interior (Keithahn 1963:97). The marmot, the mountain goat, and the grizzly bear all came to the traditions of the Nanyaayi during their adventures in the mountains.

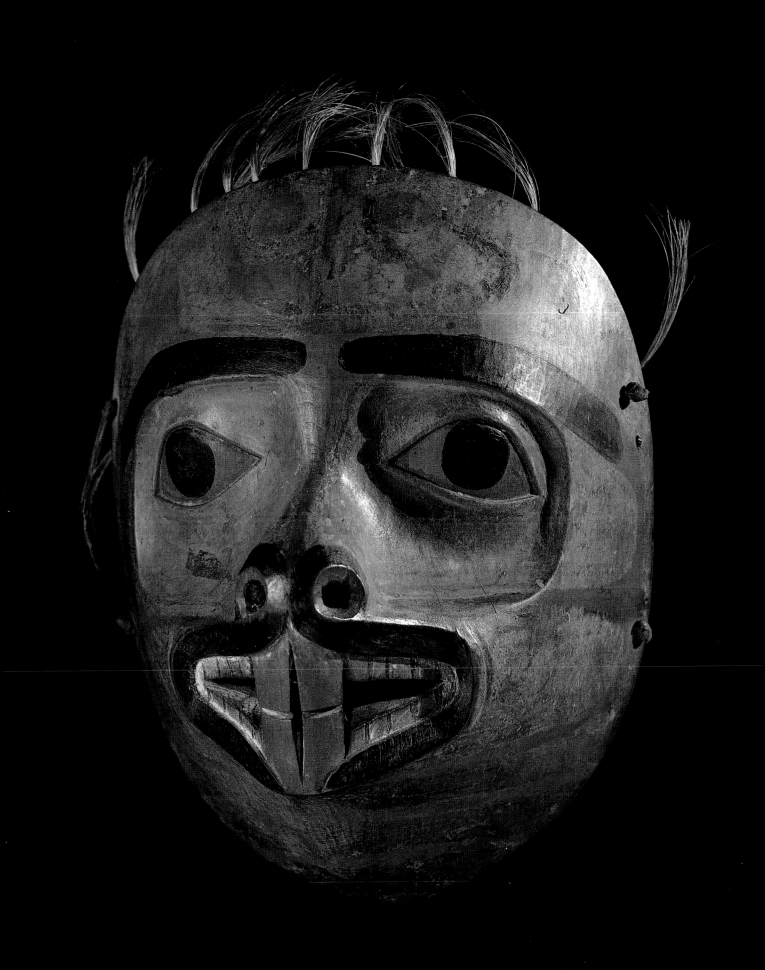

85. **Wooden Spoons** Tlingit (Stikine); 19th c.

Wood (maple); 37 cm × 10 cm × 11 cm; 37 cm × 10 cm × 11 cm; 33 cm × 9.5 cm × 11 cm
Collected by George T. Emmons at Wrangell, Alaska, before 1905; received 1909; cat. nos. 2334, 2335, 2333

Feast spoons were often made in sets, matched in size and with similar decorations. These three painted wooden spoons are probably part of a much larger set. Lieutenant Emmons collected them at Wrangell and identified the creatures represented as (left to right) a petrel, a frog, and an eagle. These may all be crest animals, but in this case it is not likely that they represent crests. Although each painting is different in detail, and each represents a different animal, they all share a general compositional and stylistic character. Paintings with red primary formlines are less common than those with black, but they do occur with some frequency. These designs all follow the specific rules for red primary painting: secondary formlines, some tertiary lines, and all inner ovoids are black. In some areas, the artist has used single and double hatching in black to introduce other values and textures to the composition.

The paintings are expertly and elegantly done. Each figure exactly fits its somewhat difficult format without any apparent forcing or distortion of its elements. Master artists of the Northwest Coast excelled in composition for awkward shapes or on complex, three-dimensional surfaces. In each of these examples the animal's beak or snout occupies the tip of the spoon bowl, the eye curves along the upper edge opposite the foot, and the tail or wing feathers stretch to the end of the handle. These paintings were very likely made without any preliminary graphic planning, except in the artist's mind. In some paintings, especially those that require careful symmetry as for chests and boxes, artists used patterns or templates of yellow cedar bark or rawhide to draw some of the forms, especially ovoids. Given the asymmetrical character of the designs and the three-dimensional surface, it seems unlikely that such templates were used here.

Northern wooden spoons are typically carved from a section of a small tree, using almost the entire cylinder of the wood. The shallow S-profile of the spoon runs through the block in such a way that the center of the tree is visible at two places in the spoon, once in the bowl near the tip and again at the base of the handle. This means that the wood grain at the tip and in the handle lies at an angle to the spoon's surface; when it is carved very thin, as here, the spoon is quite fragile. The frog spoon (center) has been broken and repaired in several places.

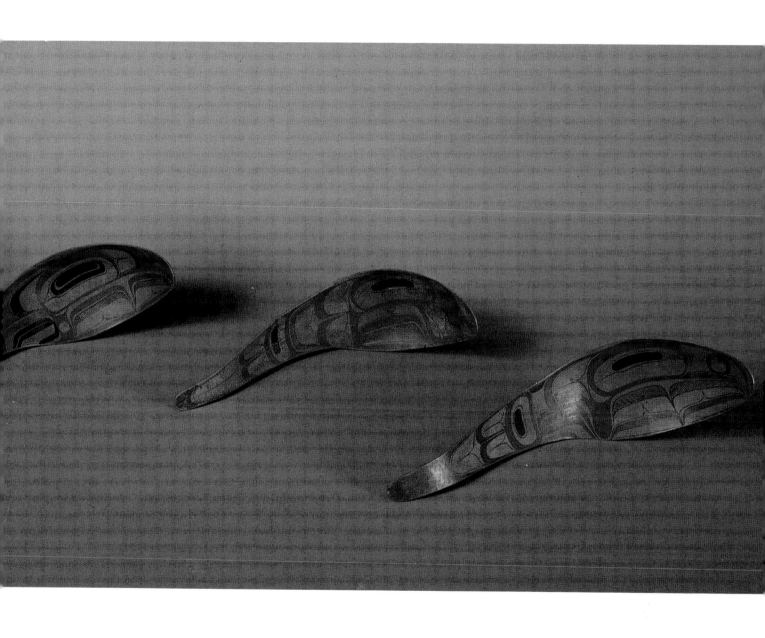

86. Hat Ornament Tlingit (?); 19th c.

Spruce root, cedar, sinew; 97 cm × 11 cm

Collected by Israel W. Powell between 1881 and 1885; received in 1936 in exchange from the American Museum of Natural History; cat. no. 1–11396

The stacks of basketry cylinders crowning crest hats or replicated on totem poles are at once emblems of status, objects of controversy, and the basketmaker's tour de force. This enormous pile—at thirty rings tall, the longest ever known—was acquired in the early 1880s by Israel W. Powell, Indian Commissioner for British Columbia, who was collecting for the American Museum of Natural History in British Columbia and Alaska. It would be very interesting to know why and for whom the stack had been made, but it unfortunately lacks further documentation. The hat ornament has nearly twice as many rings as the largest mentioned in the literature, and three times as many as the largest seen in old photographs. Chief Shakes' Killer Whale Hat (no. 81), one of the most prestigious Tlingit hats known, has only four cylinders. It is clear that this set was made for use on a hat, for the lower ring is provided with a heavy cord of twisted sinew wrapped around its juncture with the second ring and led down through the central hollow. This cord was used to attach the stack to the hat, probably to a hat of wood. When the ornament was new—strong and flexible—it would have swayed grandly above all the other noble crest hats at a potlatch.

Almost all popular accounts of Northwest Coast culture and even many contemporary Northwest Coast native elders state that each ring of the stack on a hat top represents a potlatch given by the chief who owned the hat. That this cannot be the real meaning can be seen by examination of the hats themselves, of old photographs, and of the ethnographic literature. Old hats with stacks of cylinders apparently as old as the hats themselves appear in early photographs. The same hats today, over a century later, are unchanged, even though some of them—the Killer Whale Hat for example—remained in use for generations. Early descriptions collected by Marius Barbeau and John Swanton make it clear that stacks of specific numbers of rings represented crests of particular lineages. Barbeau recorded one of nineteen rings, "the largest of its kind" (Halpin 1973:385), as a crest of a Coast Tsimshian family. He also recorded a stack of ten rings and another of four. In some way or another, the number of rings on a particular crest hat has become a fixed part of the crest. Perhaps this spectacular column was made for a chief with delusions of grandeur.

Or was it perhaps merely a weaver's masterpiece? The making of hat rings is one of the more technically difficult accomplishments in Northwest Coast basketry. The entire stack is woven as one continuous basket, beginning at what is to be the top of the finished piece by doubling the warp strands over a ring of split root and weaving up the side in very tight, fine, three-strand twining over a thin-walled cedar cylinder just the diameter of the upper ring. The weaving then rounds the edge and, in two-strand twining, nearly closes the cylinder, whereupon it turns outward again and up over the next wooden form. (In contrast to Tlingit basket makers, Haida weavers would typically twine from the top *down*.) In, out and up, over each form in turn the twining progresses, until what will be the bottom, nearly a meter (over three feet) from the beginning, is reached. The cylinders are gradually increased in diameter toward the bottom, giving the entire stack of rings a graceful taper. Each ring is painted deep blue, while the accordion-like joints are painted red. The whole column is flexible, and in the dance sways like the stalk of wild celery (*kookh*) from which the Tlingit name for the hat and its crown of rings, *shadakookh*, is derived.

87. **Model Totem Pole** Tlingit; 19th c.

Wood (alder); 107 cm × 29 cm × 17 cm

Gift of Mrs. Otto Roseleaf, collected before 1920; received 1957; cat. no. 1–2053

Although Burke Museum records indicate only that this fine model totem pole is from the Northwest Coast, the style of the carving is convincingly Tlingit. Although the pole was certainly made for sale and had no traditional function in native Northwest Coast life, it is a superb example of late (or possibly mid-) nineteenth century Tlingit sculpture.

It is usually fairly easy to identify the figures on Tlingit poles, for they are often quite naturalistic with reasonably obvious recognition features. To know what their significance is beyond that, or what their relationship to one another might be, requires special knowledge. No doubt there is a story or an incident in a myth illustrated here, but we have no documentation, and the combination of figures is not like that on any well-known pole.

The lowest figure appears to be a crouching bear, forming a base for the vertical pole. At the bottom of the pole itself is a squatting bear. The style of the carving of this figure, as of the whole piece, is much like that in some of the old poles that once stood in the southern Tlingit villages of Tongass and Tuxecan. The figures on those poles are seen in fully sculptured form, deeply carved in the round; some of them are seated on, or are surrounding, a plain shaft, as in this model. Even the features of the bears, in rounded form on a broad, short face, are similar to those in the old carvings. Eye socket and eye structure resemble that of the groundhog mask (no. 84). The three little men show the same carving style. All three wear hats, two of them with prestigious rings. Painted with traditional colors—black, vermilion, and blue, the last much darkened by handling and age—the model pole is the work of a skilled and knowledgeable artist.

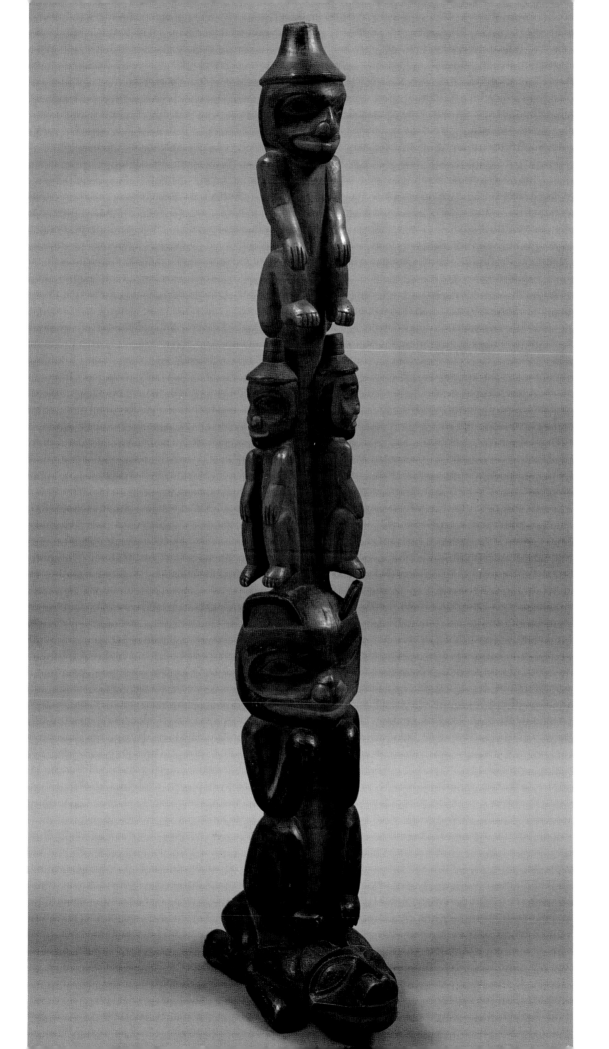

88. House Post Tlingit (Sanya); 19th c.

Wood (red cedar); 333 cm × 92 cm × 31 cm

Collected on the Harriman Alaska Expedition in 1899 at Cape Fox, Alaska; received in 1931 in exchange from the University of Michigan; cat. no. 1–10831

The massive posts that supported the great roof beams of Northwest Coast houses were often carved in the form of figures of mythology. In some cases these posts represented crests or various characters in ancestral stories, while in others the posts were replicas of those visualized as part of a complete mythical house given to an ancestor by a supernatural patron. Because Tlingit carved house posts commonly were detachable shells that concealed the plain but functional supporting post, many of them have been preserved, for they could be removed from the old plank houses that were abandoned for the frame housing of the turn of the century. It was this quality of ease of removal that enabled the members of the Harriman Alaska Expedition to take a pair of grizzly bear house posts out of a house in the abandoned village of Gash, on Alaska's Cape Fox, without tearing down the structure.

The Harriman Expedition entailed a two-month-long sortie to Alaska by a group of distinguished natural scientists, the guests of railroad magnate Edward H. Harriman. When they came upon the Sanya Tlingit village of Gash in July 1899, they found it empty; the former inhabitants had moved to Saxman, near Ketchikan. Before the expedition left Alaska, they had gathered totem poles, house posts, and masks aboard their vessel. Two of the houseposts were later given to the universities of Michigan and Washington. In 1935 Dr. Erna Gunther, then director of the Washington State Museum, exchanged a representative group of Northwest Coast artifacts with the University of Michigan for the other post, reuniting the pair.

As is often the case, the documentation of these poles is frustratingly meager. They apparently represent grizzly bears, each holding an inverted human in its jaws. There have been many explanations put forth both for inverted figures and for figures held in the mouths of animals. Some are explained as representing a rival or a debtor, while others are said to represent slaves killed at the raising of the pole or house; it is perhaps equally appropriate to suggest another explanation. One of the houses at Gash was called *Kaats hit* (Kaats house, Swanton 1908:400). Kaats was a hunter of the Tekwedi clan who was captured by a grizzly bear and later married the bear's wife, who had concealed him. This story is the source of the grizzly bear crest of the Tekwedi (Swanton 1909:228–29). It may be that the grizzly bear house posts commemorate the capture of Kaats.

The grizzly bear post is a simple, monumental sculpture. Although carved from half of a log, the great bulk of the bear is convincingly expressed. A separate block of cedar brings the man's head into greater relief, and his two hands, also of added pieces, stretch the boundaries of the sculpture. The surface is finished with lines of adze marks, a characteristic of large sculpture, canoes, and house timbers from Vancouver Island northward.

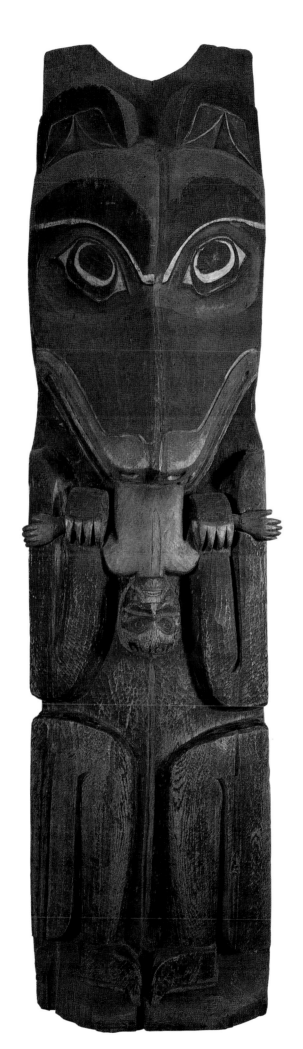

89. Helmet Tlingit (Hootsnuwoo); late 18th or early 19th c.
Wood (maple?); 40 cm × 26 cm × 26 cm

Collected by George T. Emmons at Angoon, Alaska, before 1905; received 1909; cat. no. 2452

The Tlingit warriors who captured and destroyed the Russian fort Archangel Michael in 1802 wore helmets "shaped in imitation of ferocious animals with gleaming teeth and of monstrous beings" (Kyril Khlebnikov, quoted in Miller and Miller 1967:140). When Alexander Baranoff (supported by the guns of the *Neva*) retook Sitka in 1804, he captured some of those helmets and sent them back to Russia with the *Neva*'s commander Urey Lisiansky. They are among the many old Tlingit helmets in the Museum of Anthropology and Ethnography in Leningrad today. The killer whale helmet in the Burke Museum is from that period, and could even have been worn in the 1802 battle since, according to Russian accounts, the plan for a general uprising was made at Angoon, the Hootsnuwoo village. In addition to those in Russia, there are a number of helmets with the tradition of having been worn in that historic battle; at least one of them is also from Angoon (Holm 1983a: no. 49).

The warriors who wore these ferocious helmets and elaborate wooden slat armor were noblemen. When widespread use of firearms made wooden armor impractical, the helmets were retained as crest hats, to be worn as emblems of family greatness. They can be distinguished from other wooden clan hats by their greater thickness and by the lack of a broad rim. To make them more resistant to splitting from the blow of a war club, they were often carved of wood with a twisted, burly grain. Some of them were covered tightly with heavy rawhide, sometimes with the hair left on. Heavy buckskin ties, run through holes drilled in the rim, served to anchor the helmet in place. A thick face guard of bent wood circled the warrior's head just below the helmet, leaving only a narrow gap for vision. Helmets almost always depict powerful or terrifying animals or men; much of their usefulness must have been psychological.

Emmons collected this helmet at Angoon from the Wushkiton, a Wolf clan with the Killer Whale crest. The helmet depicts the fierce hunter of seals in admirable Tlingit fashion. The streamlined head with broad, red lips rimming two rows of gleaming opercula teeth juts upward, as killer whales do to survey their surroundings. The whale has just captured a seal, clamped crosswise in its great jaws. The snout stripe, round eyes, and dorsal fin complete the killer whale identity. White pectoral fins and red tail in bold, minimal formlines wrap the sides and back of the helmet. The subtly raised median ridge, running over the snout from lip to dorsal fin, is a feature of many Tlingit carvings. It is aesthetically satisfying and may have no other significance.

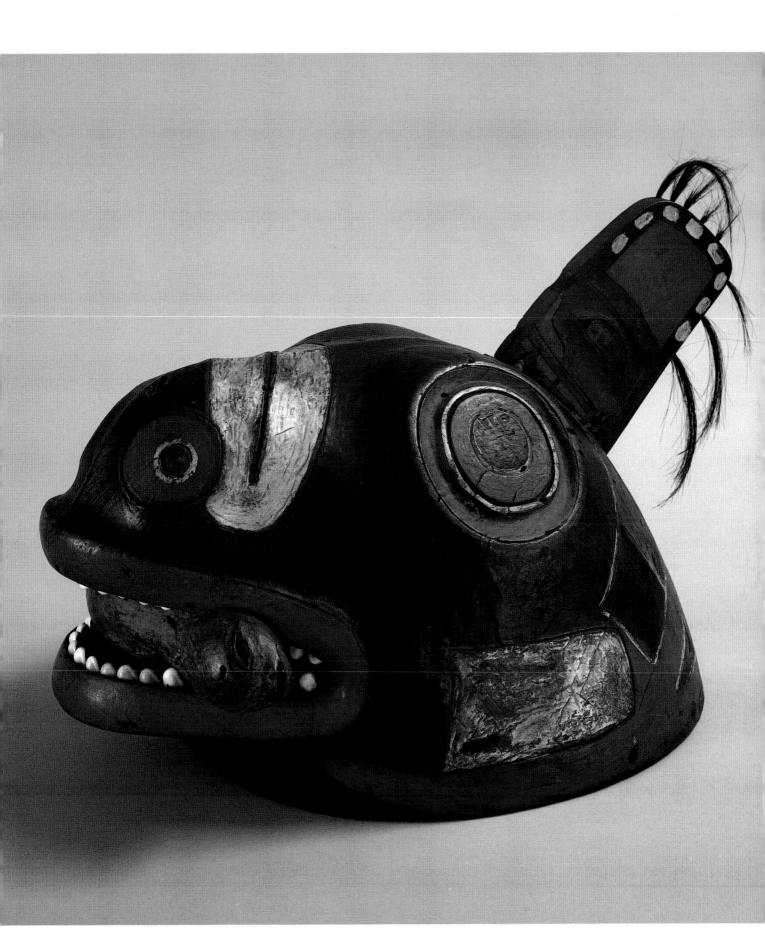

90. **Salmon Trap Stake** Tlingit (Stikine); 19th c.
Wood (spruce?); 96 cm × 6.5 cm × 3.7 cm
Collected by George T. Emmons at Stikine before 1905; received 1909; cat. no. 1390

Northwest Coast Indian fishing techniques were very highly developed and efficient (nos. 26, 91). Fish furnished a large part of the diet of most groups, and success in fishing was essential. However, a good part of the successful taking of fish and other subsistence animals was considered to be dependent upon the good will of the prey. All animals that were essential to humans for food and other materials were thought to be willing to be killed providing that their sacrifice was appreciated and that they were respected and properly treated. Many native traditions held that killed animals that were handled according to rules (given to humans by the animal people themselves), were reincarnated to return to the hunters or fishermen in the future. The salmon trap stake is a manifestation of the concept that animals can be supernaturally encouraged to come to their hunters.

This carved stake was fastened upright to the frame of a fish weir set near the mouth of a salmon spawning stream. Its intent was to attract the salmon to the fish trap. The weir, which was a barricade of closely spaced slats supported by poles or pilings driven into the stream bottom, directed the fish into traps. The traps either were similar barricades arranged to restrict the swimming salmon to a compact enclosure (where they could be caught by harpoon, gaff, or dipnet), or were long, wicker-like baskets into which the fish could swim but from which they could not escape. If all the customs of purification and entreaty to the salmon people had been properly observed, success was assured.

The subject of this carving is the Salmon-Boy (de Laguna 1972:889–90), who was taken away by the salmon people because he had made disparaging remarks about one of their dead, calling it "moldy." He didn't know he was among salmon; they seemed like humans to him. When the salmon tribe dispersed to go to their various spawning streams the boy, now a salmon, was caught by his grieving parents. They found him inside the salmon and, when he came to life, he taught his people how to treat salmon so they would continue to give themselves to men.

The boy appears as he was found when the salmon was butchered. The fish itself is very naturalistically carved, with the gills, opercula of the mouth, dorsal and caudal fins, and tail graphically rendered. The little sculpture on the fish trap stake probably reminded the approaching salmon that they were respected by the fisherman, who intended to treat them according to Salmon-Boy's instructions.

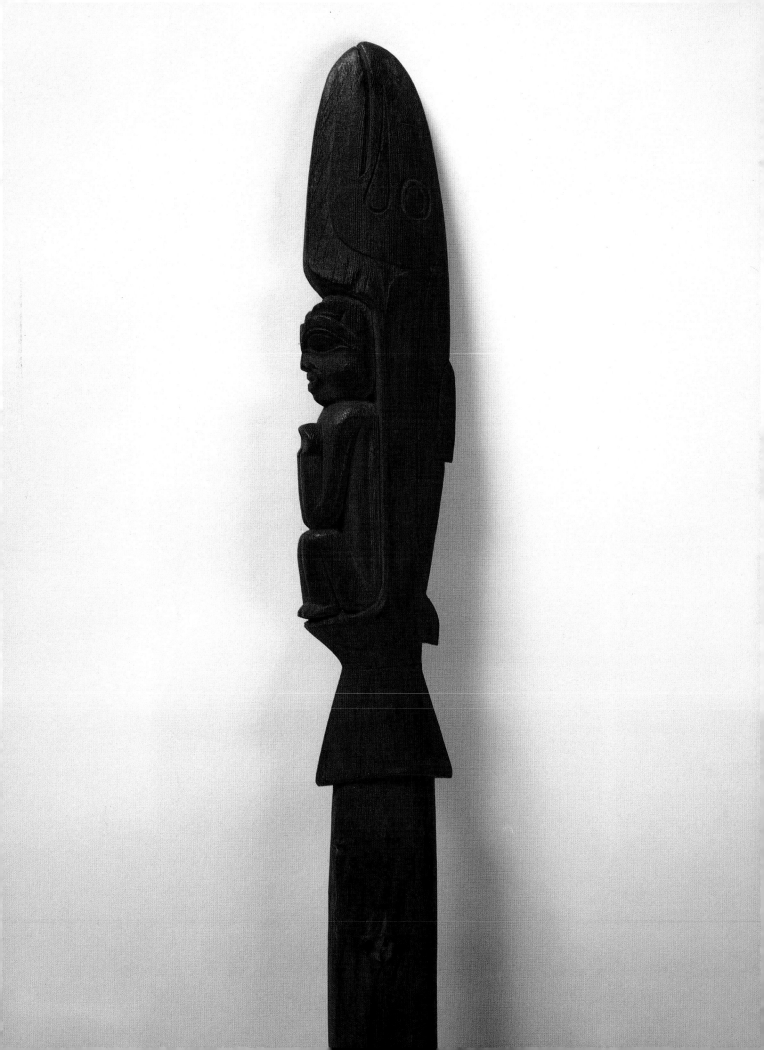

91. Halibut Hook Tlingit; 19th c.

Wood (alder, yellow cedar), iron, cotton cord; 24 cm × 11.5 cm × 5 cm

Collected by L. S. Robe in Southeast Alaska; received 1909 from the Alaska Commission, Alaska-Yukon-Pacific Exposition; cat. no. 4259

Halibut hooks, of which there are a great many in collections, furnish another illustration of the concept of supernatural assistance in fishing. The hook is a very ingenious invention, whose efficiency prompted Beresford's 1787 comment that seven English sailors' "success was greatly inferior to that of two Indians, who were fishing at the same time, which is rather extraordinary, if we consider the apparent inferiority of their tackle to ours" (Dixon 1789:174). Rather than being inferior to the Englishmen's gear, the Tlingit halibut hook was a marvel of practicality. Each detail had been worked out to function in concert with the others in order to capture the discriminating fish (Stewart 1977:46–55). The size of the whole contrivance, the angle and spacing of the two arms and the barb, the distance above the bottom that the hook floated—all were calculated to catch halibut, and halibut of a size range limited to those just small enough to be boated by the fisherman.

A universal feature of northern halibut hooks is the sculptural decoration of the lower arm, the one that faces the ocean floor on which the halibut lie. The figures carved on this arm are intended to influence the fish to take the hook, and so exceed the decorative. They very often depict creatures combining the attributes of different beings. This one is half man and half halibut. Others combine humans with diving birds, octopus tentacles, halibut fins, the grips of canoe paddles, and various other subjects, which are almost always related to the world of the sea (Jonaitis 1981:35–40).

Few halibut hooks are expertly carved, although their artistic power is often considerable. The half man/half halibut hook is of much finer workmanship than most, although there are some hooks that can truly be considered masterpieces of sculpture. A few of these have been illustrated (Collins et al. 1973: no. 360; Coe 1976: no. 343; Wardwell 1978: no. 95). Most hooks, however, are fairly crudely crafted. Although it has been suggested that this apparent crudeness is deliberate and is related to the hooks' sacred character (Jonaitis 1981:11–14), it seems much more likely that most fishermen (who made their own hooks) simply were not trained artists. And since hooks were not part of the crest-display complex, the subject of the carving (and its power) was far more important than adherence to the norms of crest art. Those halibut hooks that are of artistic excellence seem to refute the idea of deliberate roughness.

The half man stares at the sea bottom with his human eye, luring the great flat fish to taste the bait lashed around the iron barb over his head. He sways slowly in the deep current, pushing power downward. Far above, the fisherman waits.

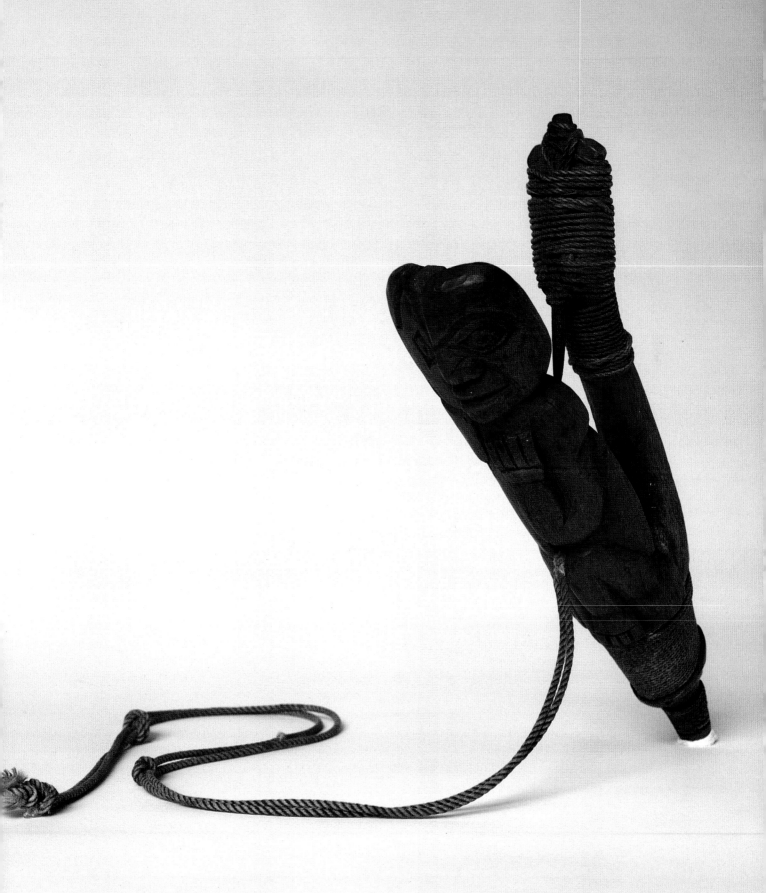

92. Trap Stick Tlingit; 19th c.

Whale bone; 26 cm × 4 cm × 1 cm

Collected by George T. Emmons before 1905; received 1909; cat. no. 2319

The Northwest Coast tribes were so clearly oriented to the sea and its resources that it is easy to overlook the considerable use they made of the land. The great trees furnished wood and bark for much of the region's material culture, and many native plants were utilized for food. In addition, the flesh and furs of land mammals played a part in Northwest Coast life which was nearly equal to that of their maritime counterparts, the hair and fur seals, sea otters, and sea lions. Land animals were hunted with bows and arrows, spears, snares, and various kinds of traps and deadfalls, and sometimes also with the aid of dogs. Long familiarity with the habits and habitats of their prey enabled Indian hunters and trappers to develop techniques specific to the different animals hunted. Although it was the sea otter that brought European and Euro-American fur traders to the coast, the furs of land mammals made up an ever-increasing proportion of the trade. Much of the native trapping effort went toward supplying the demands of the traders, although the natives continued to trap for their own needs.

Among the land animals trapped were marten, mink, ermine, ground squirrel, and marmot. Special snares and deadfalls were developed for each of these, and part of one type of trap was a peculiarly shaped whale bone rod with a carved figure at one end. Emmons collected many of them, calling them "trap sticks." In his catalogue notes for the large collection of Tlingit material that he sold to the American Museum of Natural History in 1888, he described them simply as stakes that held the noose of a snare for marmots and ermine. In his later notes, both for his 1893 American Museum collection and for the material in the Burke Museum, Emmons always describes them as the "key" or "trigger" of a deadfall. That they are more than merely stakes seems apparent from their very uniform shape, with its swelling curve, and the peculiarly carved smaller end. A few trap sticks in collections are accompanied by two other objects that are undoubtedly parts of the mechanism, pieces of a puzzle that has not been satisfactorily solved in our time.

All bone trap sticks are carved at the upper end. The figures are varied: animal and bird heads, crouching figures of humans or animals, and even a helmeted and visored warrior's head. The figures probably have a purpose similar to that of those on halibut hooks (no. 91) and salmon trap stakes (no. 90)—to entice and perhaps honor the prey. With its raptorial silhouette, this figure is particularly striking and powerful. It represents an eagle's head with open beak, well carved in the tough bone.

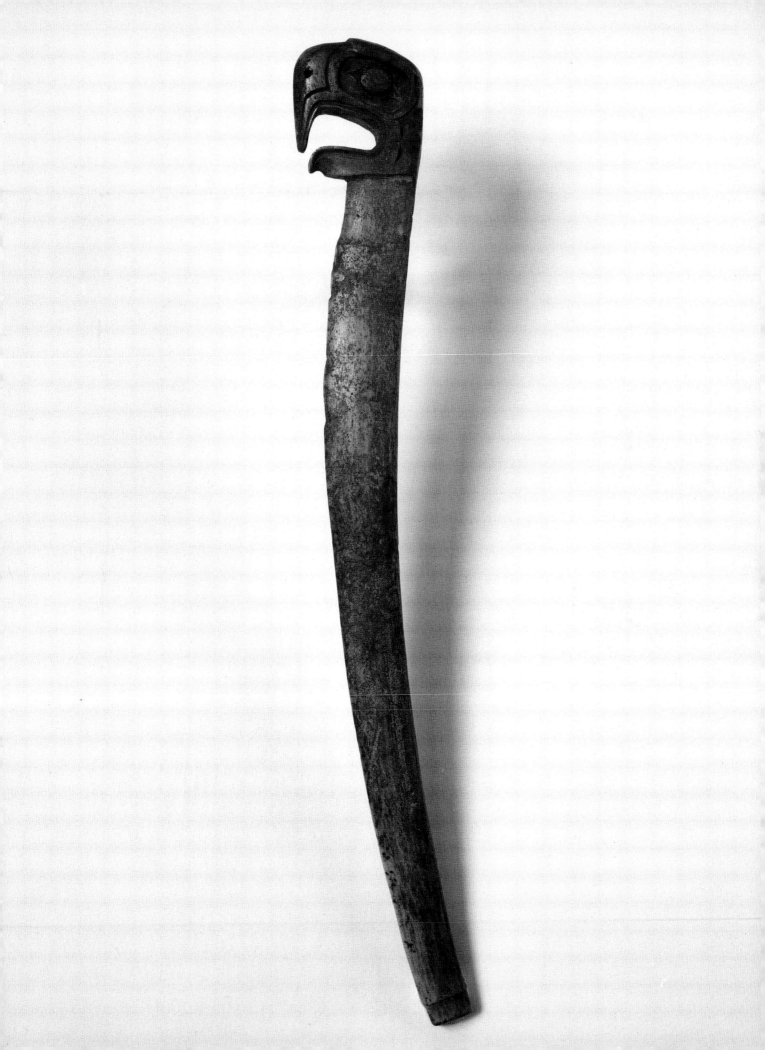

93. Basket Tlingit; 19th c.

Spruce root, grass; 31 cm × 32 cm

Collected by Mrs. John Winslow in Alaska; gift of her daughter, Mrs. R. S. Hawley; received 1943; cat. no. 1–612

The Tlingit are nearly as famous for their basketry as they are for their sculpture, and rightly so. From at least the last quarter of the nineteenth century Tlingit women have been weaving baskets for sale to an ever-increasing market of white Alaskan residents and visiting tourists. For at least fifty years, from the 1870s through the 1920s, basketry was a major source of cash income for Indian women on many parts of the coast, and Tlingit baskets always sold readily. The weavers, quick to assess the fashions of the basket trade, modified their wares to suit, making baskets smaller and finer and introducing new shapes and designs (Corey 1983:137–38).

Fortunately, the basket makers also continued to make some of the old types, both for their own use and for sale, and many of these found their ways into private collections and museums. This fine old berry basket is a good example of a traditional Tlingit work basket: strong, functional, and of great beauty. It is of the size carried on the berry picker's back and into which berries from the small picking basket are emptied. The basketry material is split spruce root, woven primarily in two-strand twining—the same basic technique used in making Haida baskets (no. 66). True to its character as a work basket, this container has a bottom firmly and solidly twined, and reinforced with several spaced, concentric rows of three-strand twining. At the base of the sides two more closely spaced rows of three-strand work appear, and at the very top, tight against the rim, are three very close fine rows. Although the thickness of the root strands in this berry basket is greater than that in the later fine baskets made for sale, and although the stitches are correspondingly larger, they are perfectly regular throughout the basket.

Although Tlingit basket makers, especially the Chilkats, did produce baskets without applied decoration, most of those made for native use were decorated in a technique called "false embroidery." Bleached grass stems, some of them dyed, were wrapped around the spruce root wefts at every stitch, forming bands of multicolored geometric designs. Many traditional baskets were decorated with three of these bands, the upper and lower of which were usually alike. The makers named the elements that made up the designs according to their resemblance to familiar sights or objects. Although the original dyed colors in this basket have faded almost entirely away, enough can be seen to identify the patterns. The upper and lower bands, decorated with now faded parallelograms of dyed grass false embroidery on a background of dyed root, show a pattern called "leaves of the fireweed" (Emmons 1903:266). The design of the middle band, called "tying," is an elongated zigzag made up of staggered, narrow rectangles. It may be one of a number of Tlingit basketry designs influenced by the quillwork of the interior Athapascans (Emmons 1903:275). The broad design extending below the horizontal bands—a feature not seen on later baskets—is called "half cross." A last, elegant touch of embroidery—short dashes in a line—appears just under the rim. Tlingit baskets are woven upward, in the opposite direction from Haida weaving. A result is that the design jog, visible on the edges of false embroidery bands, goes down to the right.

Large baskets like this one take up a good deal of room on the museum shelf. The Tlingits of old solved this space problem by making use of a flexibility the baskets no longer possess. To facilitate their storage between uses, the baskets were dampened and folded flat, the bottoms tucked in with a V-shaped fold. A vestige of that tuck can be seen as two converging ridges at the bottom of the basket.

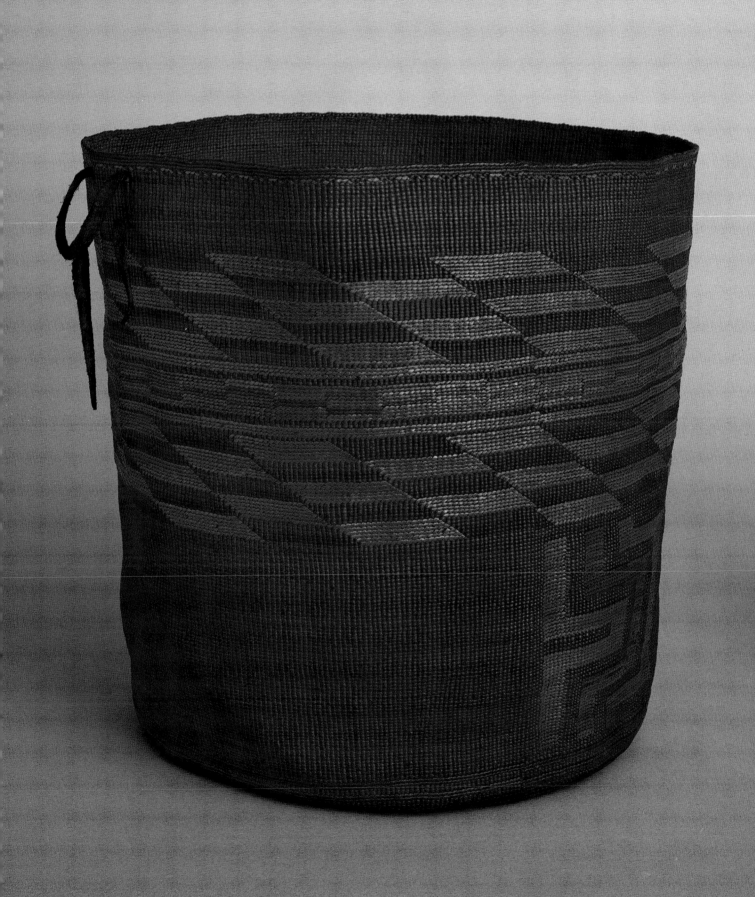

94. Basket Tlingit; late 19th c.

Spruce root, glass beads, wool cloth, cotton thread; 10 cm × 8.5 cm

In exchange from the Museum of History and Industry, Seattle; received 1980; cat. no. 2.5E1192

A very rare variant of Tlingit spruce root weaving is the bead-covered basket. Beadwork is not a major art form of Northwest Coast people, although it does occur all over the coast and there are many very beautiful examples. The best known Tlingit beadwork is that on dancing shirts, collars, and bags, and is done with the overlay or couched technique in foliate scroll designs (Duncan 1982:403–17). Geometric designs are not unknown, however. Among the Tlingit, the best known use for geometric beadwork was on the elaborate hair ornaments worn by northern Tlingit noble girls, consisting of a broad beaded pendant suspended from a bead-covered tube worn on a back braid. Although the beadwork on these ornaments resembles the familiar loom technique of the Great Lakes region, it probably was done directly onto the tube, in the same technique used for this little basket.

The basket itself is of plain twined spruce root, probably originally intended as a foundation for the beadwork. It appears that the beadwork was done from the bottom up, in the same direction taken by Tlingit basket workers in spruce root weaving. To form pairs of warps, heavy cotton thread was sewn through a strip of black wool cloth circling the bottom of the basket. A pair of fine cotton wefts then spiraled up the basket. The wefts passed through single or paired beads between warps, and enclosed single warps between beads. At the top of the basket, the ends of the warps were turned inside the beadwork and sewn to the basket rim with a running stitch.

Typical Tlingit basketry designs were used in the beadwork, arranged in the familiar three-banded composition. The upper and lower bands resemble the design recorded by Emmons as "blanket border fancy picture" (Emmons 1903:276), while the central band is apparently the design "fish flesh" (Emmons 1903:267). Some interesting variations appear in the designs, especially the single L-shaped figure in the upper band which, unlike all the others, includes yellow and blue in addition to green. The vertical bar in the lower band is apparently a spacing adjustment, inserted at the end of the first row of beadwork in the design (it adjoins the "jog") because the L-shape to its left came too soon. The designs in the upper band are narrower, allowing room for the complete pattern. The jog typical of designs formed by a continuous spiral can be seen at either end of the vertical bar and at the base of the central L in the top band. The jog goes down to the right, showing that with the usual right-hand spiral the beadwork was woven from bottom to top.

The use of this unusual little basket is not known. It may have been made for some very special purpose, perhaps as a shaman's cup, or even to catch the eye of a tourist. Whatever her motivation, this unknown Tlingit artist produced an intriguing rarity.

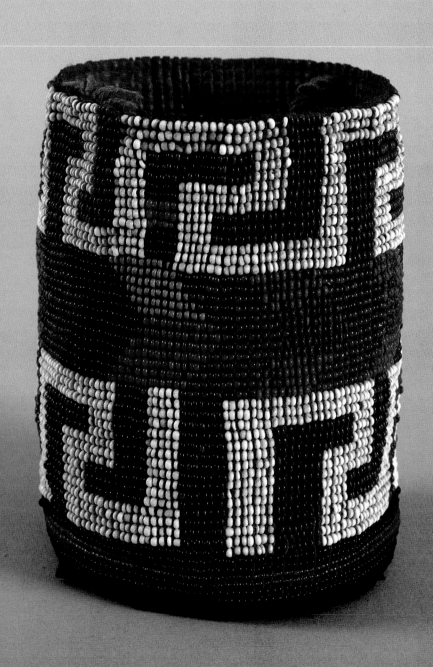

95. Amulet Tlingit; early 19th c.
Bear's canine tooth, abalone shell; 8.5 cm × 2.5 cm × 0.6 cm
Hauberg Foundation gift; received 1956; cat. no. 1–2194

Spirits of animals and humans were believed to be controlled by shamans who could use the supernatural powers of those spirits to cure the sick, forecast the future, and influence events for the benefit of the people. Although the shaman's position was one of great personal power, it was an onerous occupation in many ways. Successful control of his spirit helpers required the shaman to adhere to myriad taboos and requirements of behavior (de Laguna 1972:683). While practicing, he fasted and observed sexual abstinence. His hair was never cut. He often went deep into the woods to renew his power, fasting and depriving himself of sleep. The work of a shaman also was believed to be a calling of great danger due to its constant involvement with powerful spirits, both those which the shaman himself controlled and those called up by rival shamans with which he might contend.

New shamans often inherited the powers of a predecessor, usually an uncle with whom they had worked as assistant. Some time after the death of a shaman his successor would remove his masks, amulets, and other powerful material from his grave, which was usually a tiny house erected for the purpose, and continue to practice with them until his own death. Because of this, shamanic objects are often of great age, and show the wear of long use. This little amulet, although of very tough, wear-resistant material, a bear's canine, shows the smoothed form and deep color characteristic of ancient amulets. It is carved in the form of a land otter.

Of all animals, the land otter was the one most firmly associated with shamans' work. It was feared as a manifestation of dangerous supernatural power. Shamans acquired their most powerful supernatural help from otters; a slip cut from an otter's tongue was hidden away by the shaman as a repository for that power. Before the economic motivation of the fur trade and before the missionaries' inroads on the power of the shamans broke down earlier reluctance, no Tlingits, except for shamans, trapped otters or used their furs. This was due to the belief that otters were really transformed humans who had drowned or become lost (de Laguna 1972:744), and that they took drowned people and made them into land otters or land otter men. These attitudes about otters have not entirely disappeared.

Land otter representations appear with many variations in shamans' material. One of the most frequent forms they take is that of an amulet, often carved from a canine tooth because the ovoid form of the root and the hard, conical crown perfectly fit the silhouette of the otter's body and thick, tapered tail. The animal's short snout and rounded ears are easily recognized in this old carving. Brilliant abalone shell fills the eye, whose circle is echoed in seven round, drilled holes. Along the back, depressions separated by incised lines represent vertebrae, which are often seen represented in shamans' objects. The hole that pierces the amulet at the center of the backbone is well worn, indicating its use as a means of suspension or attachment to the shaman's robe or apron. Streaks of brown and amber color deep in the amulet's surface have developed after years of the handling that has also rounded the contours of the carving and polished its surface.

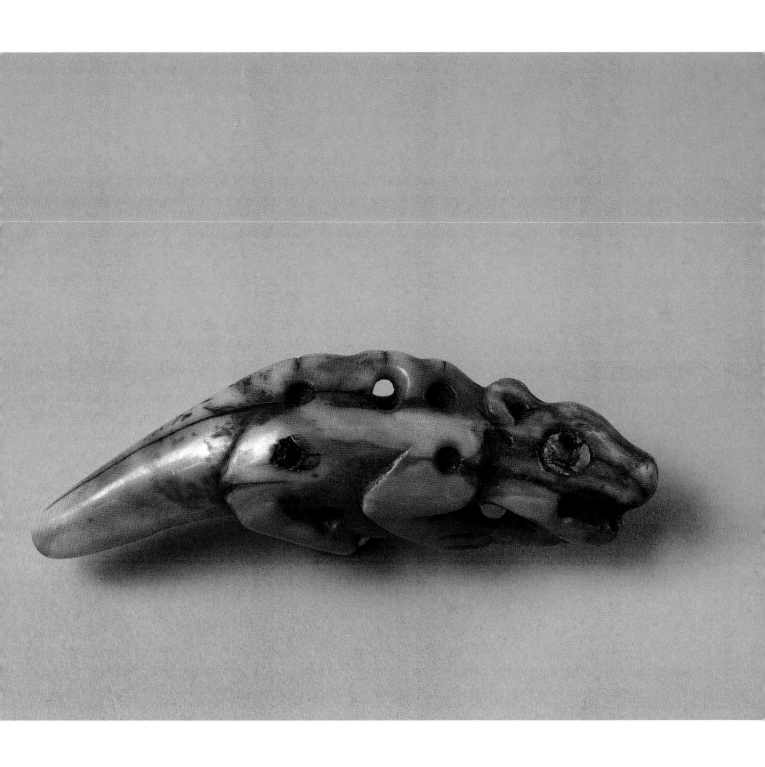

96. **Amulet** Tlingit (Stikine); 19th c.

Antler; 13.5 cm × 5.5 cm × 3 cm

Collected by George T. Emmons at Wrangell, Alaska, before 1905; received 1909; cat. no. 920

Another spirit often seen in shamans' art is that of the killer whale. Here the artist (who was very likely the shaman himself) has included all the Tlingit recognition features of the whale: tall dorsal fin, fluked tail, flipper divided into "fingers," toothed mouth, round eye, and nose stripe (nos. 70, 78, 81, 82, 89). In the joint of the tail is a stylized face; a man rides the whale's back, his head and torso filling the dorsal fin, in a way reminiscent of the human in the fin of the Nanyaayi Killer Whale Hat (no. 81). Antlers, with their protruding tines, furnish particularly good material for carvings of finned whales. The material is less brittle and easier to carve than bone or ivory and it takes a fine polish and gains a rich color in patination.

Figures on a shaman's charms were carved in response to visions or supernatural experiences, or represent the form of spirits that he controlled. The charms were worn as pendants hung around his neck, or sewn to his skin robe or apron. When the shaman worked to cure illness, he might press an appropriate amulet against the part of the patient's body affected, or even leave it with the sick person in order that the power of the spirit represented in the amulet might do its work.

Emmons collected the killer whale charm from a shaman's grave house near Fort Wrangell. An unusually large percentage of Tlingit art in museum collections is made up of the paraphernalia of shamans. There is no doubt that this relative abundance is due in part to the availability of the objects in shamans' graves, from which they were taken by collectors or by Indians who were opposed to the old shamanic practices and who sold them to the collectors. At the end of the nineteenth century faith in the power of shamans had been severely shaken, largely through the efforts of missionaries, and some practicing shamans were even converted to Christianity (de Laguna 1972:177, 723).

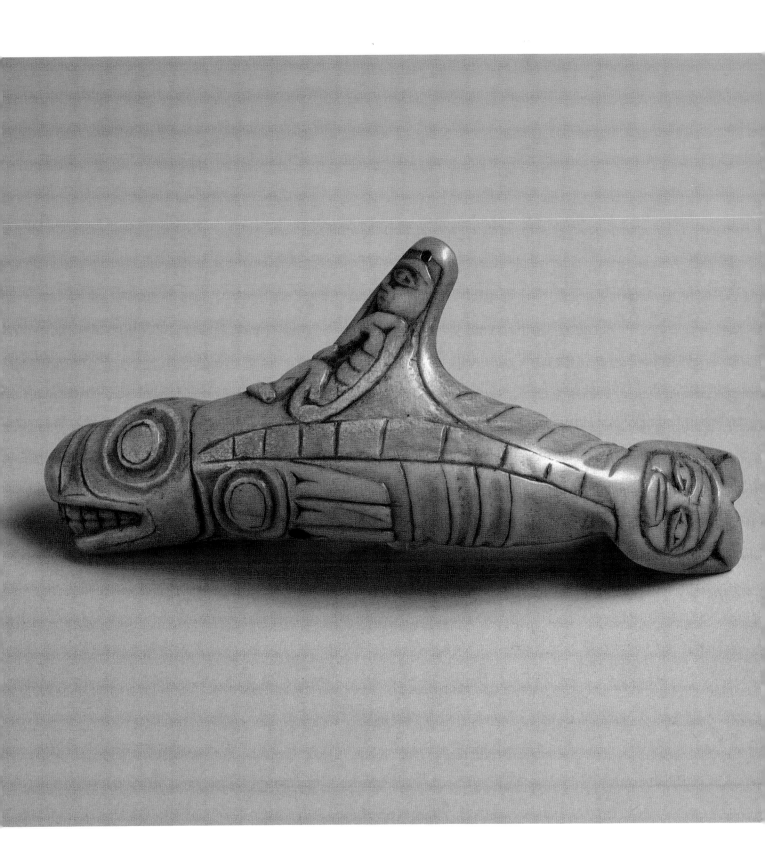

97. **Amulet** Tlingit (Stikine); 19th c.
Bone; 6.5 cm × 3 cm × 1.3 cm
Collected by George T. Emmons at Wrangell, Alaska, before 1905; received 1909; cat. no. 904

Amulets were made from a variety of materials including ivory and teeth, bone, antler, stone of various kinds, and wood. The hardness and density of ivory, bone, and antler were especially well suited to the intricate carving characteristic of the early examples. These materials all had the additional attribute of having once been part of living animals, many of which had an association with shamans' work and were represented in the carvings. Bears' teeth and bones, for example, were often utilized for amulet material. Some of the finest were made from the teeth of the sperm whale, a superb carving ivory (Wardwell 1978: no. 64). Many old amulets are beautifully crafted and some are among the very finest examples of traditional northern art. On the other hand, there are many shamans' amulets that are roughly made. Because the figures represented would be unknown to laymen and would be full of dangerous powers, some shamans probably carved their own amulets, rather than commission trained artists to make them. If this is the case, then these shamans must also have been among the most gifted carvers. However, Emmons noted that "the objects may be made by himself or by anyone else according to his direction. They possessed no power until used by him" (Emmons ms.).

This little amulet is of bone, perhaps from a bear. The crouching figures at each end were identified by Emmons as bears, and are surrounded by the tentacles of the devilfish, or octopus. The octopus was a creature identified with the shaman, and its image—especially the tentacles with their round suckers—often appears on shamans' paraphernalia. The suckers are shown as circles with deep, round centers. This circle-dot motif was widely used in North American native art both decoratively and symbolically and works very well as a representation of the devilfish's suckers. An eagle with wings folded stands erect in a loop of the tentacle. The meaning of this assemblage of creatures is unknown, as is the significance of most of the shamanic art of the northern coast. The designs originated in the supernatural experiences of the shaman; to divulge their significance in any detail would lessen their power or make it vulnerable to the attack of a rival.

Without question the carver of this bone charm understood the conventions of Tlingit art and probably produced carvings other than amulets. The bears' bodies, legs, and claws are true formlines, and the structure of the heads, with their ovoid eye sockets, converging eyelids, and formline lips conforms to classic tenets of northern art. The little eagle, neatly filling the U-shaped space bounded by the formline tentacle, is classic in stance and detail. Considerable wear is apparent; many of the circles are nearly worn away. Hard bone resists the wear of handling, and the condition of this small piece therefore suggests great age.

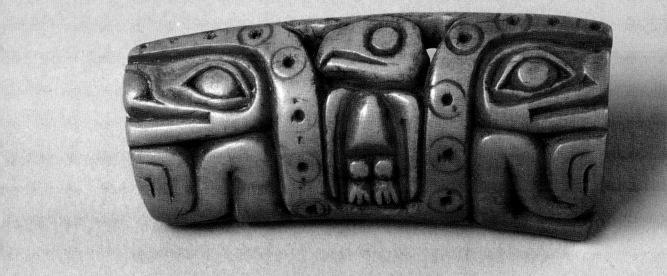

98. **Shaman's Mask** Tlingit (Yakutat); late 18th or early 19th c.

Wood (alder?); 22 cm × 16 cm × 13 cm

Collected by George T. Emmons at Yakutat Bay, probably in 1886; received 1909; cat. no. 2271

Second only to the animal tongues, especially those of the land otter, that he had cut and secreted, the greatest concentration of a shaman's spirit power resided in his masks. When he put one on he became the manifestation of that power, which was often represented as the soul of a dead person.

Tlingit shamans' masks generally were not provided with eyeholes; they were hardly necessary, as the practicing shaman worked in a limited area, often in direct contact with his patient. Some very naturalistic, sensitively sculptured, portrait-like masks may have been intended to represent specific individuals (de Laguna 1972:692). One of the finest of these spirit portrait masks is this one, collected by George Emmons from a shaman's grave at Yakutat Bay. He identified it as from the "Thlar-har-yeek (Yakutat) tribe" (Emmons 1909:110) but did not specify the clan affiliation of the shaman. Frederica de Laguna identifies Tłaxayık as ". . . the Eyak name for Yakutat Bay . . ." (de Laguna 1972:222). In any case the mask is very old, possibly from the eighteenth century, and even its weathered and worn condition fails to disguise its impressive sculptural power.

The mask represents the spirit of an old Tlingit woman of high rank. Her lower lip is distended by a large labret, the wooden plug worn by noble women of the northern tribes. Although early European seamen's descriptions of the appearance of Indian women wearing labrets are unflattering, the classic features of this mask overshadow the ornament's disfiguring effect. The face is relaxed, with eyes half closed in the expression of death. In the modeling of the eyelids, stretched over underlying orbs, the swelling cheek bones, and the subtle sculpture of the musculature of the cheeks and lips, this is one of the most sophisticated renditions of a human face in Northwest Coast Indian art.

Another startlingly naturalistic mask by the same artist, representing a dead man with protruding tongue, was collected by Emmons from a shaman's grave house on the Akwe River forty miles down the coast from Yakutat Bay and is now in the American Museum of Natural History (Wardwell 1978: no. 2). Although these two masks were apparently collected from different sites, they are unquestionably by one carver, and are unique in Tlingit art.

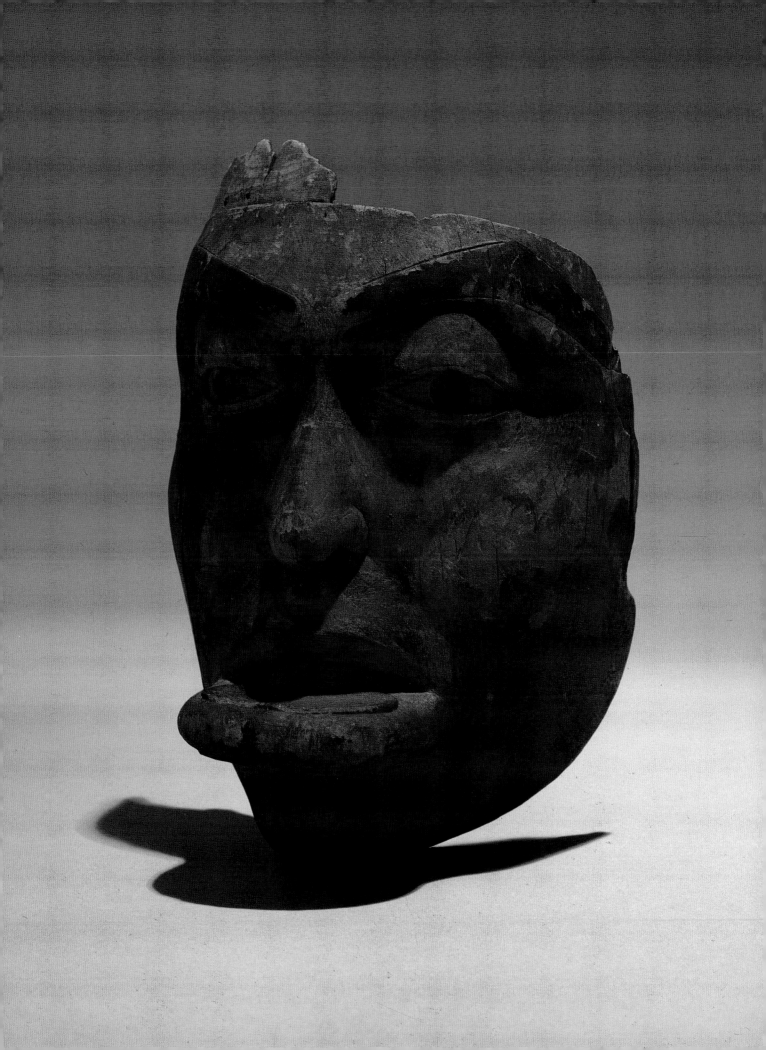

99. Shaman's Maskette Tlingit (Chilkat); 19th c.

Wood (maple?), human hair; 10 cm (without hair) × 9 cm × 4 cm

Collected by George T. Emmons at Klukwan, Alaska, before 1905; received 1909; cat. no. 2264

A miniature fist-sized mask, attached to an elaborate headdress, was sometimes worn by a shaman when working to cure a person of a spirit-induced sickness. The maskette was similar in all respects except size to the full face mask worn by the shaman when he acted as the personification of a spirit. A humanoid beast, a scowling warrior, or the haunting, sunken face of a dead Tlingit hovered on the forehead of the doctor's headdress as he sang over his patient, shaking a rattle in the form of a black oystercatcher and "pressing" power against the sickness from a carved amulet (see p. 238).

Like lowered lids half covering the round, raised iris of the eyes, a tongue swelling past bared teeth denotes death or trance in Northwest Coast sculpture. Either condition is appropriate for a spirit manifestation, but in this maskette a sharp ridge of bone above stretched cheeks and lips suggests death. The meaning of the painted design—red cheek and forehead on one side, rows of circles of bare, wooden skin against black on the other side—is unknown. Other Tlingit shamans' masks with similar asymmetrical, spotted paintings are known, but their meaning has not been recorded.

There is a monumental quality to much of Northwest Coast sculpture that is independent of physical size. One would hardly guess from the photograph that this powerful image can be covered by a hand.

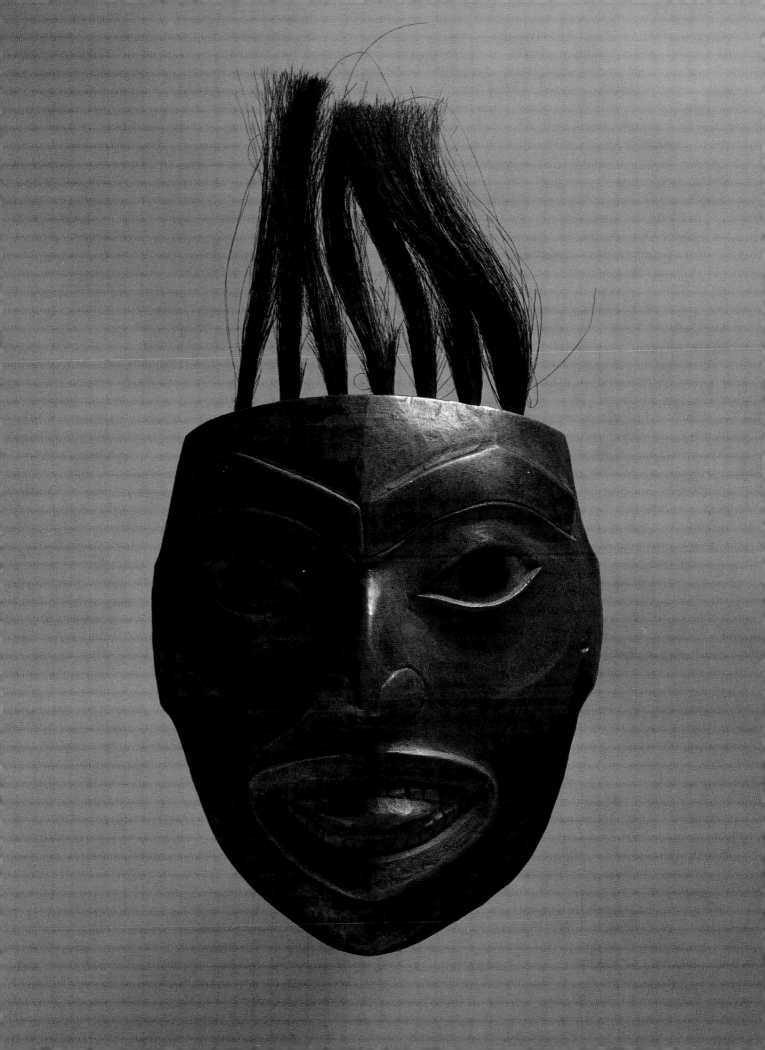

100. **Shaman's Headdress** Tlingit (Hootsnuwoo); early 19th c.

Wood (maple?), human hair, swan skin, eagle feathers, antler, fox tail, buckskin;
30 cm × 23 cm × 20 cm

Collected by George T. Emmons near Angoon, Alaska, before 1893; received 1936 in exchange from the American Museum of Natural History; cat. no. 1–11392

Between 1888 and 1893 when he sold the collection to the American Museum of Natural History, George Emmons bought, from the nephew (and potential successor) of a Hootsnuwoo shaman who had died a quarter of a century before, a rich assemblage of more than forty pieces of Tlingit doctors' paraphernalia. Included in this fine and comprehensive collection were headdresses of various kinds, rattles, dancing robes, aprons, spirit clubs, amulets of ivory and bone, and seven "thlu-gu" (maskette headdresses). In 1936, the Washington State Museum obtained one of these headdresses, by chance the same one worn by the shaman in a photograph taken in Alaska by Edward de Groff (see p. 238). The identity of the man in the picture is not known; he may have been the person who removed the objects from his long-dead uncle's grave house at Chaik Bay and later sold them to Lt. Emmons. Although Emmons received a good deal of assistance from Tlingit people in collecting shamanic material, it is very unlikely that one of them without experience as a shaman would, in the nineteenth century, actually have worn those objects while acting the part of a practicing shaman for the camera.

The headdress is a complex construction, built on a framework of spruce withes covered with a band of swan skin from which the feathers have been plucked, leaving a mat of deep, white down. Standing upright along the sides of the band are rows of bald eagle tail feathers, clipped short and square. Over the temples rise two spikes of antler, and in the center back a fox tail sways. At one time, long, finely braided locks of human hair hung from the back of the band, but no trace of them is now to be seen. The focal point of the shaman's headdress is the boldly sculptured maskette of a human face, expertly carved of hard wood and painted in black, vermilion, and dark blue-green. This blue paint was once much lighter and more brilliant, but it has darkened to a near black with accumulated oil from handling. Eyebrows, eyes, mustache, beard, and hairline of deep brownish black, and lips and ears of vermilion red complete the painting. A few wisps of hair remain of the shock that once swept over the forehead.

Tlingit stylistic features abound in the maskette. Small nose with rounded nostrils, wide, round eyes on broad, full orbs, arched brows, and full, continuous, open lips standing well out from the cheeks are all Tlingit carving characteristics. The finely cut, seminaturalistic ears, painted red, are much like those on some other fine Tlingit masks.

The Hootsnuwoo shaman who used the headdress died about 1865, according to Emmons' notes; the piece probably had seen some years of use before that time. Some twenty years later, when Emmons bought it, the Young Naturalists had just built their museum on the campus of the University of Washington. In 1936, a half-century later, the headdress joined the collection, and has been on view nearly continuously for the fifty years since.

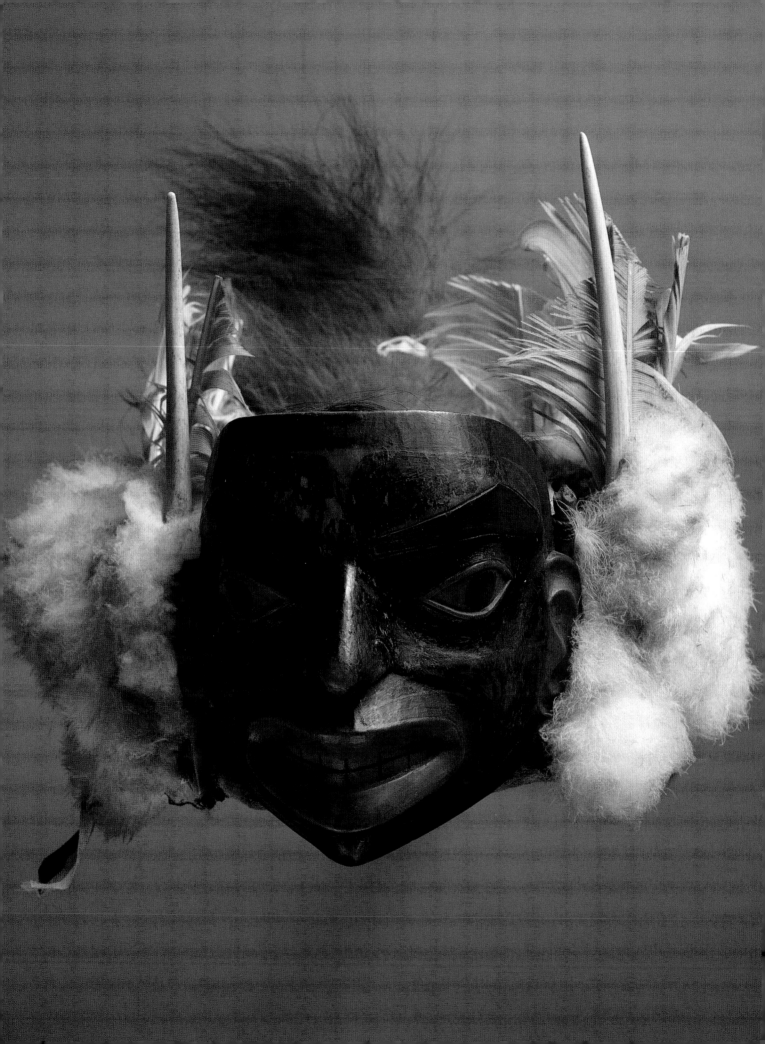

A Tlingit shaman, wearing the headdress now in the Burke Museum (no. 100), at work over his patient. All the shamans' paraphernalia in the photograph was acquired by Lt. Emmons. This picture is one of a series made in 1889 illustrating various actions of the shaman, who may have been the man identified by Emmons as Dr. Pete, a Sitka shaman who had forsworn his practice (Emmons ms.). *Photograph by Edward de Groff. Special Collections Division, University of Washington Libraries.*

Bibliography

Amoss, Pamela
 1978 *Coast Salish Spirit Dancing: The Survival of an Ancestral Religion*. Seattle: University of Washington Press.

Angell, Tony
 1978 *Ravens, Crows, Magpies, and Jays*. Seattle: University of Washington Press.

Arima, Eugene
 1983 *The Westcoast (Nootka) People*. Special Publications, no. 6. Victoria: British Columbia Provincial Museum.

Barbeau, Marius
 1950 *Totem Poles*. National Museums of Canada Bulletin, no. 119, vols. 1 and 2. Ottawa, Ontario: National Museums of Canada.

Benson, Keith R.
 1985 "Exploration in a Pioneer Land: The Young Naturalists' Society and the Birth of the Museum Idea in the Washington Territory." *Landmarks* 4(1): 28–31.

Blackman, Margaret
 1981 *Window on the Past: The Photographic Ethnohistory of the Northern and Kaigani Haida*. Canadian Ethnology Service Paper, no. 74. Ottawa, Ontario: National Museums of Canada.
 1985 "Contemporary Northwest Coast Art for Ceremonial Use." *American Indian Art Magazine* 10(3): 24–37.

Blomkvist, E. G.
 1972 "A Russian Scientific Expedition to California and Alaska." *Oregon Historical Quarterly* 73(2): 100–170.

Boas, Franz
 1894 *Chinook Texts*. Bulletin of the Bureau of American Ethnology, no. 20. Washington, D. C.
 1897 "The Social Organization and Secret Societies of the Kwakiutl Indians." *Report of the United States National Museum, 1895*. Washington, D. C.
 1898 "The Mythology of the Bella Coola Indians." *Memoirs of the American Museum of Natural History*, vol. 2, part 2: 25–127. New York.
 1909 "The Kwakiutl of Vancouver Island." *Memoirs of the American Museum of Natural History*, vol. 8: 301–522. New York.
 1916 "Tsimshian Mythology." *Thirty-first Annual Report of the Bureau of American Ethnology*. Washington, D. C.
 1921 "Ethnology of the Kwakiutl." *Thirty-fifth Annual Report of the Bureau of American Ethnology*. Washington, D. C.

Carlson, Roy
 1983 "Prehistoric Art of the Central Coast of British Columbia." In Roy Carlson, ed., *Indian Art Traditions of the Northwest Coast*. Burnaby, British Columbia: Archaeology Press, Simon Fraser University.

Coe, Ralph T.
 1976 *Sacred Circles: Two Thousand Years of North American Indian Art*. London: Arts Council of Great Britain.

Cole, Douglas
 1985 *Captured Heritage*. Seattle: University of Washington Press.

Collins, Henry B., Frederica de Laguna, Edmund Carpenter, and Peter Stone
 1973 *The Far North: Two Thousand Years of American Eskimo and Indian Art*. Washington, D. C.: National Gallery of Art.

Conn, Richard
 1979 *Native American Art in the Denver Art Museum*. Denver: Denver Art Museum.

Corey, Peter
 1983 "Tlingit Spruce Root Basketry Since 1903." In Bill Holm, *The Box of Daylight*. Seattle: Seattle Art Museum/University of Washington Press.

Culin, Stewart

1907 "Games of the North American Indians." *Twenty-Fourth Annual Report of the Bureau of American Ethnology.* (Reprinted 1975, New York: Dover Publications.)

Curtis, Edward S.

1915 "The Kwakiutl." *The North American Indian,* vol. 10. Norwood, Connecticut: Plimpton Press. (Reprinted 1970, New York: Johnson Reprint Corporation.)

1916 "The Nootka and Haida." *The North American Indian,* vol. 11. Norwood, Connecticut: Plimpton Press. (Reprinted 1970, New York: Johnson Reprint Corporation.)

Devine, Sue E.

1980 "Basketry Hats of the Northwest Coast." Master's thesis, School of Art, University of Washington, Seattle.

Dixon, George

1789 *A Voyage Round the World.* London: G. Goulding.

Duncan, Kate Corbin

1982 "Bead Embroidery of the Northern Athapaskans: Style, Design, Evolution and Transfer." Ph.D. diss., School of Art, University of Washington, Seattle.

1988 *Bead Embroidery, The Art of the Northern Athapascans.* Seattle: University of Washington Press.

Drucker, Philip

1951 *The Northern and Central Nootkan Tribes.* Bulletin of the Bureau of American Ethnology, no. 144. Washington, D. C.

Emmons, George T.

1894 Catalogue notes. American Museum of Natural History, New York.

1903 "The Basketry of the Tlingit." *Memoirs of the American Museum of Natural History,* vol. 3: 229–77. New York.

1907 "The Chilkat Blanket," with notes on the blanket designs by Franz Boas. *Memoirs of the American Museum of Natural History,* vol. 3: 329–401. New York.

1909 Catalogue notes. Accession no. 1909–39. Thomas Burke Memorial Washington State Museum, University of Washington, Seattle.

1914 "Portraiture among the North Pacific Coast Tribes." *American Anthropologist,* new series 16: 59–67. "The Tlingit Indians." Manuscript, American Museum of Natural History, New York.

Feder, Norman

1983 "Incised Relief Carving of the Halkomelem and Straits Salish." *American Indian Art Magazine* 8(2): 46–55.

Feest, Christian

1968 *Indianer Nordamerikas.* Vienna: Museum für Völkerkunde.

Ford, Clellan

1941 *Smoke from Their Fires: The Life of a Kwakiutl Chief.* New Haven: Yale University Press.

Gustafson, Paula

1980 *Salish Weaving.* Vancouver, British Columbia: Douglas and McIntyre.

Haberland, Wolfgang

1979 *Donnervogel und Raubwal.* Hamburg: Hamburgisches Museum für Völkerkunde und Christians Verlag.

Hall, Frank S.

1910 *Sketch of the State Museum, University of Washington.* State Museum Series, Bulletin no. 1. Seattle: University of Washington.

Halpin, Marjorie

1973 "The Tsimshian Crest System: A Study Based on Museum Specimens and the Marius Barbeau and William Beynon Field Notes." Ph.D. diss., Department of Anthropology, University of British Columbia, Vancouver, British Columbia.

1984 "'Seeing' in Stone: Tsimshian Masking and the Twin Stone Masks." In *The Tsimshian: Images of the Past, Views for the Present.* Vancouver, British Columbia: University of British Columbia Press.

Hawthorn, Audrey

1967 *Art of the Kwakiutl Indians and Other Northwest Coast Tribes.* Seattle: University of Washington Press.

Holm, Bill

 1965 *Northwest Coast Indian Art: An Analysis of Form.* Seattle: University of Washington Press.

 1972 *Crooked Beak of Heaven.* Seattle: University of Washington Press.

 1974 "Structure and Design." In William C. Sturtevant, comp., *Boxes and Bowls: Decorated Containers by Nineteenth Century Haida, Tlingit, Bella Bella, and Tsimshian Indian Artists.* Washington, D. C.: Smithsonian Institution Press.

 1981 "Will the Real Charles Edensaw Please Stand Up?" In Donald N. Abbott, ed., *The World Is as Sharp as a Knife: An Anthology in Honor of Wilson Duff.* Victoria, British Columbia: British Columbia Provincial Museum.

 1982 "A Wooling Mantle Neatly Wrought: The Early Historic Record of Northwest Coast Pattern-Twined Textiles—1774–1850." *American Indian Art Magazine* 8(1): 34–47.

 1983a *The Box of Daylight: Northwest Coast Indian Art.* Seattle: Seattle Art Museum/University of Washington Press.

 1983b *Smoky-Top: The Art and Times of Willie Seaweed.* Seattle: University of Washington Press.

 1983c "Form in Northwest Coast Art." In Roy Carlson, ed., *Indian Art Traditions of the Northwest Coast.* Burnaby, British Columbia: Simon Fraser University.

Holm, Bill, and George Irving Quimby

 1980 *Edward S. Curtis in the Land of the War Canoes: A Pioneer Cinematographer in the Pacific Northwest.* Seattle: University of Washington Press.

Holm, Bill, and Bill Reid

 1975 *Form and Freedom.* Houston, Texas: Rice University Press. (Republished 1976 as *Indian Art of the Northwest Coast: A Dialogue on Craftsmanship and Aesthetics.* Seattle: University of Washington Press.)

Inverarity, Robert Bruce

 1950 *Art of the Northwest Coast Indians.* Berkeley and Los Angeles: University of California Press.

Jenness, Diamond

 1955 *The Faith of a Coast Salish Indian.* Anthropology in British Columbia Memoirs, no. 3. Victoria, British Columbia: British Columbia Provincial Museum.

Jensen, Doreen, and Polly Sargent

 1986 *Robes of Power: Totem Poles on Cloth.* Museum Note, no. 17. University of British Columbia Museum of Anthropology. Vancouver, British Columbia: University of British Columbia Press.

Jewitt, John

 1974 *The Adventures and Sufferings of John R. Jewitt, Captive among the Nootka.* Toronto: McClelland and Stewart.

Jonaitis, Aldona

 1981 "Tlingit Halibut Hooks: An Analysis of the Visual Symbols of a Rite of Passage." *Anthropological Papers of the American Museum of Natural History,* vol. 57, part 1: 1–48.

Kaeppler, Adrienne, ed.

 1978 *Cook Voyage Artifacts in Leningrad, Berne and Florence Museums.* Honolulu: Bishop Museum Press.

Keithahn, Edward L.

 1940 *The Authentic History of Shakes Island and Clan.* Wrangell: The Wrangell Sentinel. (Reprinted 1981, Wrangell, Alaska: Wrangell Historical Society.)

 1963 *Monuments in Cedar.* Seattle: Superior Publishing Company.

King, J. C. H.

 1981 *Artificial Curiosities from the Northwest Coast of America.* London: British Museum.

Kirk, Ruth, with R. Daugherty

 1978 *Exploring Washington Archaeology.* Seattle: University of Washington Press.

Khlebnikov, Kiril (see Miller 1967.)

Krause, Aurel

 1956 *The Tlingit Indians.* Translated by Erna Gunther. Seattle: University of Washington Press.

de Laguna, Frederica

 1972 *Under Mount Saint Elias: The History and Culture of the Yakutat Tlingit.* Smithsonian Contributions to Anthropology, vol. 7 (in three parts). Washington, D. C.: Smithsonian Institution Press.

Lewis, Meriwether, and William Clark

 1962 *The Journals of Lewis and Clark.* New York: The Heritage Press.

MacDonald, George

 1983a "Prehistoric Art of the Northern Northwest Coast." In Roy Carlson, ed., *Indian Art Traditions of the Northwest Coast:* 99–120. Burnaby, British Columbia: Simon Fraser University.

 1983b *Haida Monumental Art: Villages of the Queen Charlotte Islands.* Vancouver, British Columbia: University of British Columbia Press.

Macnair, Peter

 1971 "Descriptive Notes on the Kwakiutl Manufacture of Eulachon Oil." *Syesis* 4: 169–171. Victoria: British Columbia Provincial Museum.

Macnair, Peter, and Alan Hoover

 1984 *The Magic Leaves: A History of Argillite Carving.* Victoria: British Columbia Provincial Museum.

Marr, Carolyn J.

 1984 "Salish Baskets from the Wilkes Expedition." *American Indian Art Magazine* 9(3): 44–51, 71.

McIlwraith, Thomas F.

 1948 *The Bella Coola Indians,* 2 vols. Toronto: University of Toronto Press.

Meany, Edmond S.

 1923 *Origin of Washington Geographic Names.* Seattle: University of Washington Press.

Miller, Judi

 1985 Letter. In *Council for Museum Anthropology Newsletter* 9(3): 47–48.

Miller, Polly and Leon G. Miller.

 1967 *Lost Heritage of Alaska.* Cleveland: World Publishing Co.

Mochon, Marion Johnson

 1966 *Masks of the Northwest Coast.* Milwaukee Public Museum Publications in Primitive Art, no. 2. Milwaukee.

Morris, Frances

 1914 *Catalogue of the Crosby Brown Collection of Musical Instruments,* vol. 2, *Oceania and America.* New York: Metropolitan Museum of Art.

Muir, John

 1915 *Travels in Alaska.* Boston: Houghton Mifflin Co.

Niblack, Albert P.

 1890 "The Coast Indians of Southern Alaska and Northern British Columbia." *Report of the United States National Museum for 1888:* 225–386. Washington, D. C.

Nordquist, D. L., and G. E. Nordquist

 1983 *Twana Twined Basketry.* Ramona, California: Acoma Books.

Nuytten, Phil

 1982 *The Totem Carvers: Charlie James, Ellen Neal, Mungo Martin.* Vancouver, British Columbia: Panorama Publications, Ltd.

Olson, Ronald

 1936 *The Quinault Indians.* University of Washington Publications in Anthropology, vol. 6. Seattle: University of Washington Press.

Onat, Astrida, and David Munsell

 1970 "Skagit Art: Descriptions of Two Similarly Carved Antler Figurines." *The Washington Archaeologist* 14(3): 4.

Orbit Films

 1951a *Blunden Harbour.* Seattle.

 1951b *Dances of the Kwakiutl.* Seattle.

Orchard, William

 1926 *A Rare Salish Blanket.* Museum of the American Indian Leaflet, no. 5. New York.

Portell, Jean D.

 1985 Letter to author.

Ray, Verne

 1938 *Lower Chinook Ethnographic Notes.* University of Washington Publications in Anthropology 7(12). Seattle: University of Washington Press.

Ruby, Robert, and John Brown

 1976 *Myron Eells and the Puget Sound Indians.* Seattle: Superior Publishing Co.

Samuel, Cheryl

 1982 *The Chilkat Dancing Blanket.* Seattle: Pacific Search Press.

Sawyer, Alan R.

 1983 "Toward More Precise Northwest Coast Attributions: Two Substyles of Haisla Masks." In Bill Holm, *The Box of Daylight.* Seattle: Seattle Art Museum/University of Washington Press.

Shane, Audrey P. M.

 1984 "Power in Their Hands: The Gitsontk." In Margaret Seguin, ed., *The Tsimshian: Images of the Past, Views for the Present.* Vancouver, British Columbia: University of British Columbia Press.

Shotridge, Louis

 1919 "War Helmets and Clan Hats of the Tlingit Indians." *Museum Journal* 10(1): 43–48. Philadelphia: University of Pennsylvania Museum.

Stewart, Hilary

 1973 *Artifacts of the Northwest Coast Indians.* Seattle: University of Washington Press.

 1977 *Indian Fishing.* Seattle: University of Washington Press.

Stott, Margaret A.

 1975 *Bella Coola Ceremony and Art.* Canadian Ethnology Service Paper, no. 21. Ottawa: National Museums of Canada.

Strong, Emory

 1959 *Stone Age on the Columbia.* Portland: Binford and Mort.

Suttles, Wayne

 1983 "Productivity and Its Constraints: A Coast Salish Case." In Roy Carlson, ed., *Indian Art Traditions of the Northwest Coast.* Burnaby, British Columbia: Archaeology Press, Simon Fraser University.

Swan, James G.

 1874 *The Haidah Indians of Queen Charlotte's Islands.* Smithsonian Contributions to Knowledge, no. 21. Washington, D. C.

Swanton, John

 1905 *Haida Texts and Myths.* Bulletin of the Bureau of American Ethnology, no. 29. Washington, D. C.

 1908 "Social Conditions, Beliefs and Linguistic Relationship of the Tlingit Indians." *Twenty-sixth Annual Report of the Bureau of American Ethnology:* 391–512. Washington, D. C.

 1909 *Tlingit Myths and Texts.* Bulletin of the Bureau of American Ethnology, no. 39. Washington, D. C.

Thompson, Nile, and Carolyn Marr

 1983 *Crow's Shells.* Seattle: Dushuyay Publications.

Vaughan, Thomas, and Bill Holm

 1982 *Soft Gold: The Fur Trade and Cultural Exchange on the Northwest Coast of America.* Portland: Oregon Historical Society.

Wardwell, Allen

 1978 *Objects of Bright Pride: Northwest Coast Indian Art from the American Museum of Natural History.* New York: The Center for Inter-American Relations and the American Federation of Arts.

Waterman, T. T.

 1920 *The Whaling Equipment of the Makah Indians.* University of Washington Publications in Anthropology 1(1). (Reprinted 1955, 1967, Seattle: University of Washington Press.)

 1930 "The Paraphernalia of the Duwamish 'Spirit Canoe' Ceremony." *Indian Notes* 7:129–148, 295–312, 535–561.

Wingert, Paul S.

 1949 *American Indian Sculpture.* New York: Augustin.

Wright, Robin K.

 1985 "Nineteenth Century Haida Argillite Pipe Carvers: Stylistic Attributions." Ph.D. diss., School of Art, University of Washington, Seattle.

 1986 "The Depiction of Women in Nineteenth Century Haida Argillite Carving." *American Indian Art Magazine* 11(4): 36–45.

Index

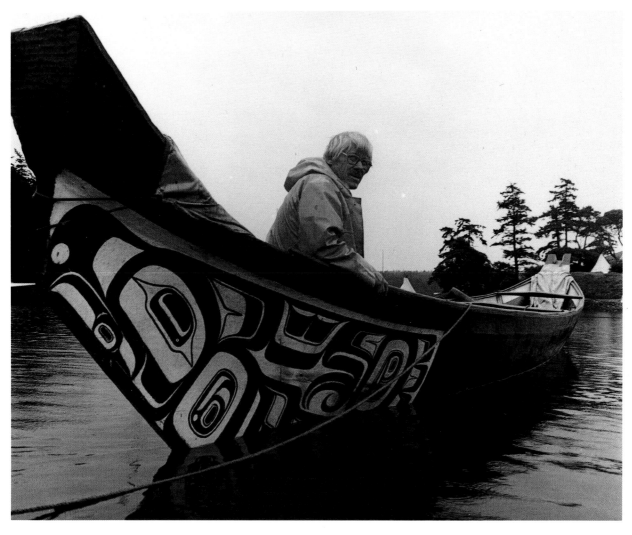

Bill Holm about 1982, on Lopez Island, in the Haida-style canoe he carved. *Photograph by Peter Fromm*

Bill Holm, curator emeritus of Northwest Coast Indian art at the Burke Museum and affiliate professor of art history at the University of Washington, is the author of the classic *Northwest Coast Indian Art: An Analysis of Form*, first published in 1965. Among his more recent works are *Smoky-Top: The Art and Times of Willie Seaweed;* and *Indian Art of the Northwest Coast* with Bill Reid.